MARK WALLINGER

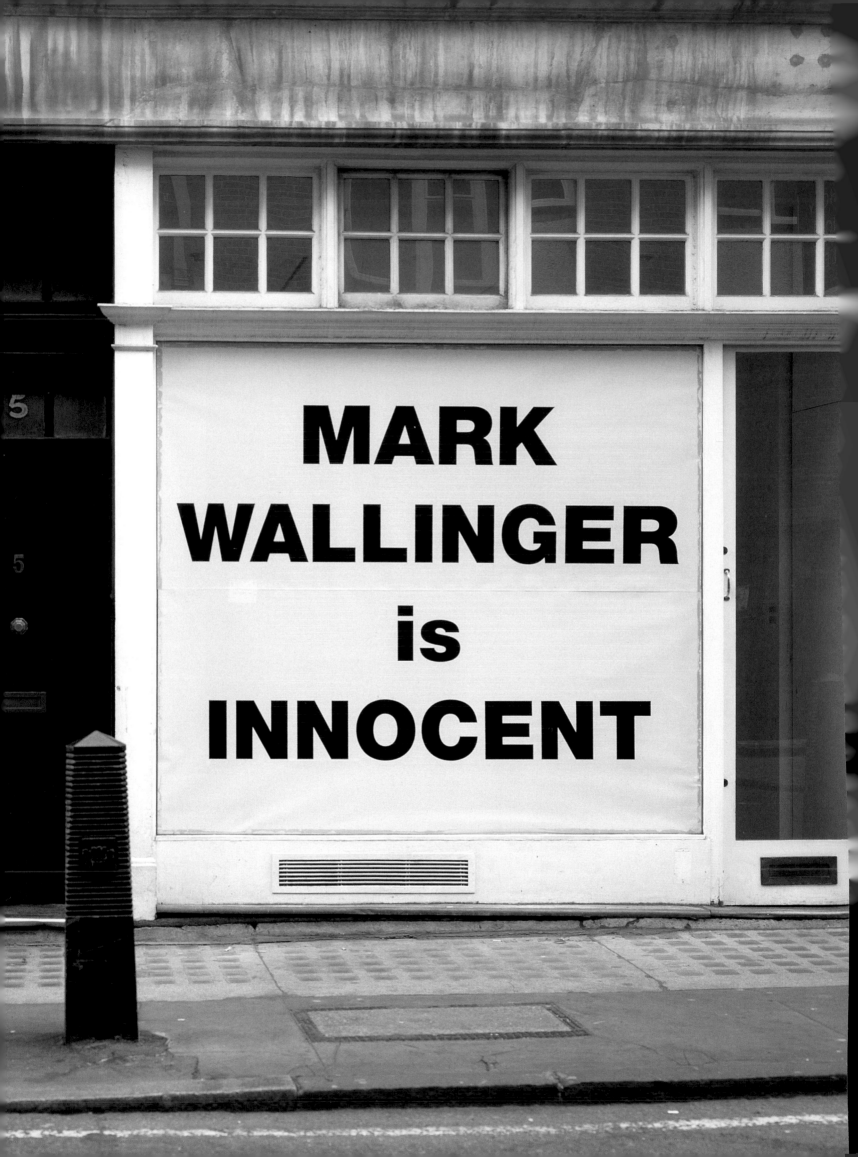

MARK WALLINGER

Martin Herbert

with 456 illustrations, 446 in colour

 Thames & Hudson

Frontispiece
Mark Wallinger is Innocent, 1997
Ink on paper
Dimensions variable
Installation at Anthony Reynolds Gallery,
Dering Street, London, 1997

Titles of works by Mark Wallinger follow the
format adopted by the artist.

First published in the United Kingdom in 2011 by
Thames & Hudson Ltd, 181A High Holborn,
London WC1V 7QX

Copyright © 2011 Thames & Hudson Ltd, London

All works by Mark Wallinger © 2011 the artist
and courtesy Anthony Reynolds Gallery, London

British Library Cataloguing-in-Publication Data
A catalogue record for this book is available
from the British Library

ISBN 978-0-500-09356-6

Printed and bound in China by Imago

To find out about all our publications, please visit
www.thamesandhudson.com. There you can subscribe
to our e-newsletter, browse or download our current
catalogue, and buy any titles that are in print.

Contents

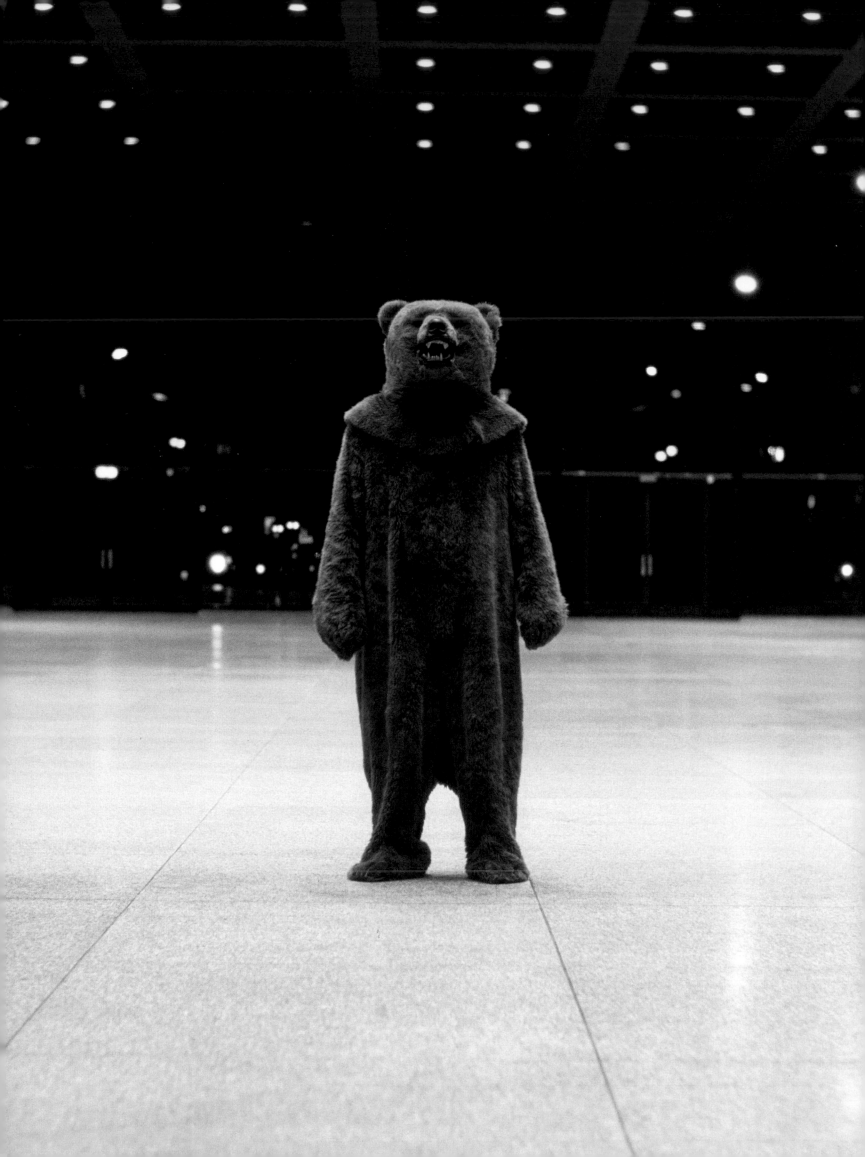

Bearings:
An Introduction

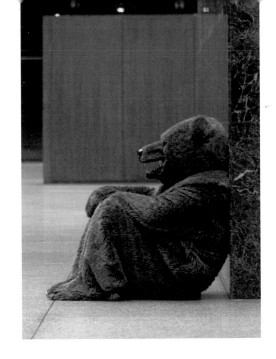

In October 2004, Mark Wallinger spent ten nights in Berlin's museum of modern art, the Neue Nationalgalerie, costumed as a brown bear. As curious city dwellers pressed their faces against the glass walls of Mies van der Rohe's illuminated modernist icon, the artist made various moves, pursuing no obvious plan. He lurched aimlessly around or lay flat on his back, scratched his brown flanks bearishly or raced wildly across the floor, slowly descended the basement steps or ascended them for an unassuming encore. Here, it appeared, was a bear of many moods. Deep into one of those nights, Wallinger sat down and, turning inward, pondered how he had ended up there: a 45-year-old Englishman sweltering in a suit of fake fur, delivering an improvised performance in a German museum after dark. 'I was alone, no one was watching me, and there was something both absurd and glorious about this solitude,' he says. 'And I remember thinking, "How did I get from Chigwell to here?"'

The steps from his Essex hometown have been at once sure-footed and wonderfully wayward, as this book's chronological study of Wallinger's career so far – drawing on extensive interviews with the artist and discussions with those who have worked with him – aims to demonstrate. Since his first London solo exhibition in 1986 (essentially a reprise of his MA degree show at Goldsmiths' College from the previous autumn), Wallinger has made technically superb oil paintings depicting racehorses and the homeless, videoed himself singing a sentimental hymn while inhaling helium, been photographed in drag as a suffragette jockey, separated the passengers on a New York harbour ferry into biblical 'sheep' and 'goats', and exhibited a perpetually gushing hosepipe poking out of a gallery window. He has mounted virtually the only public religious statue to appear in England since the Reformation, the Christ figure *Ecce Homo* (1999). He has won the Turner Prize for *State Britain* (2007), a 43m- (141ft-) long meticulous recreation of English peace campaigner Brian Haw's anti-war protest camp, described by Yve-Alain Bois in *Artforum* as 'one of the most remarkable political works of art ever'. He has been commissioned to make Britain's largest public figurative sculpture – a white horse 52m- (170ft-) tall for Ebbsfleet, Kent – and, thanks to a stringent work ethic, done much more besides. What he has not done, in an ongoing display of imaginative flexibility that stands in contrast to certain ideological *idées fixes* that his art prowls around, is repeat himself.

Of course, anyone can be a dilettante, a scattershot jack-of-all-trades and master of none. In our post-medium, easy-outsourcing artistic era, such a position might even be considered the new orthodoxy. Yet Wallinger's work is tied together by consistent, if evolving, thematic concerns, and, furthermore, by a conscientious outlook that has

Opposite and above
Sleeper, 2004
Performance
Neue Nationalgalerie, Berlin

Mark Wallinger's studio
Vauxhall, London, 2010

real bearing on his long-term resistance to commodifying his art via the adoption of a signature style. In this regard, the particular character of Wallinger's formative years, in terms both of its political temper and the cultural theories that were developing contemporaneously, is hardly incidental to his mindset – or to his long-term potency as an artist.

While he first came to widespread attention in the early 1990s alongside the Young British Artists, Wallinger is a half-decade older than the YBA generation, who were mostly born in the mid-1960s. And this, it appears, is a crucial temporal gap. It meant that Wallinger was politically conscious in the ideologically fractious 1970s, when the British art world was more *engagé*, too (if often lacking in visual flair). When as a student he absorbed the semiotic and deconstructionist theories then filtering into art schools, he saw that the idea of contested meaning had implications in the socio-political sphere.

This informed his art, which elevates the viewer's subjective participation and has been described (not inaccurately, and, fitting Wallinger's taste for wordplay, almost palindromically) as concerned with both the politics of representation and the representation of politics. The YBAs, meanwhile, would reach adulthood after the overwhelming ideological success of the Thatcherite revolution and after various battles had been decisively won; and the entrepreneurial spirit and made-you-look tactics many of those artists have displayed clearly advertises a conception of the art world as a crowded marketplace in which a signature style might be an asset, if not necessarily a long-term one. Wallinger's story could, accordingly, be considered that of two distinct eras in British art: an age of militant thought allied to moribund aesthetics and an age of visual acuity in which moral or political intent was, not infrequently, downgraded.

His practice bridges these in a unique fashion, taking something like the best of both. It partakes of the YBA generation's thrusting awareness of the art world's economy of attention, yet its maker is an intellectual (albeit, in person, a deceptively avuncular one) possessed of a social conscience, a deep curiosity and a widescreen frame of cultural reference. Wallinger has said that he has 'two heroes, John McEnroe and James Joyce'. He makes assured reference in his work to classical music, poetry, the geopolitical conflicts of the last century, and the sublime comedy of Tommy Cooper. And he once, while at a loose end, set himself the task of understanding Einstein's theory of special relativity. He is the kind of thinker who could discern, in the mid-1990s, that religion was likely to be *the* political issue of the post-glasnost era – and risk confusing his viewers by adjusting his work to assert as much. When his art buttonholes its audience on the plane of the visual, it does so purposefully, to encourage them to think.

Wallinger's method is often to set up a perceptual ambiguity, visual pun or Janus-faced construct, one that unravels to suggest how large ideological forces shape our identities and our experience in multifarious ways, for better or worse. At its fullest stretch, his art might be construed as a survey of cultural accommodations to the mystifying and anxiety-producing fact that we are here at all. Religion could be characterized as one of those, alongside all manner of other things that humans find to believe in to give purpose to life, with whatever consequences. Yet if that makes Wallinger's artistry sound wholly calculated, premeditated, it is misleading. This book, hopefully befitting an artist who has no interest in presenting himself as a magus living several cerebral leagues above the viewer, aims additionally to foreground the contingencies that shape Wallinger's work: the ways in which an apparently conceptual practice can arise out of a combustible mix of deliberation, intuition, situational influence and coincidence. (When, in 2008, Wallinger produced

a Y-shaped tree sculpture that looked something like a divining rod, it might have been a self-portrait.)

As a broader illustration of how he works, let us briefly return to *Sleeper* – the title given to Wallinger's performance at the Neue Nationalgalerie in the city where he happened to have recently been living, and consequently to a two-and-a-half-hour video of unedited footage. What could be more surreally attention seeking, more look-at-me, than a roving bear in a brightly lit museum at night? And yet *Sleeper*, with a little interpretation, reveals itself as exemplary of a thoughtful, layered, allusive but non-didactic approach.

For example, the bear is the civic symbol of Berlin; and so *Sleeper* presents an Englishman going to farcical lengths to 'fit in' on foreign soil. It is also the emblem of Russia, bringing into the work's orbit the Cold War history of 'sleeper' agents, spies in deep cover. The motif of the bear additionally references *The Singing Ringing Tree*, a 1950s film/television programme made and broadcast in East Germany (and the UK, where Wallinger saw it in the 1960s) but never in West Germany. Staged in a city formerly split by both ideology and architecture, *Sleeper* in this light is a spacious poem about viewpoints, what serves to divide us and connect us, how what we see depends upon where we stand and how all manner of formative and ongoing influences make this so. If we were truly to empathize with others – other nations, other cultures, other religions – we would have a grand task of undoing ahead of us. Quite possibly it is unachievable. Maybe, though, common ground is present yet obscured. The Germans and the British, so Wallinger noted in a lecture he gave at Tate Britain in 2007, are in his experience oddly similar peoples, or at least the yin to the other's yang.

Under such vexed but perhaps unobvious circumstances, art can diagnose, or, better, invite viewers to reach their own diagnosis. It might also ameliorate, offering such unlikely, briefly flaring epiphanies as a wandering bear in a museum at night. Pulling back, it is perhaps not surprising that Wallinger, when he donned his furry suit, initially planned to use his time listening to an audio recording of *Ulysses*. The humanist themes in Joyce's novel, and the way that coercive forces and prejudice are counterweighted within it by an imbuing of the everyday with aspects of the miraculous, are echoed insistently throughout the artist's *oeuvre*. (The book's title has, finally and fittingly, recently made its way into his art.) Wallinger also knows the value, in temporarily releasing us from heavy, earthly cares, of a good joke; or, even better, a good bad joke. Indeed, the prevalence of humour here might infer something about the magnitude of the problems.

In 2009, Wallinger's art was a question category on the long-running British television quiz programme *University Challenge*. If it is telling that an English contemporary artist's work has become common enough currency to warrant such an inclusion, it is equally notable that the projects referenced – *State Britain*, *Sleeper* and *Ecce Homo* – were radically diverse, public or at least high-profile affairs, and made after Wallinger turned 40, by which point artists are often assumed to have done their best work. Wallinger, conversely, seems to be in his prime, and one question his story so far asks and continues mercurially to answer is this: How do you fashion a compassionate and ethical yet not preachy art, one that can potentially touch large audiences, in an age ever more devoted to crowd-pleasing spectacle and the severance of art from a dimension of social conscience?

Another, of course, is this: How do you get from Chigwell to here?

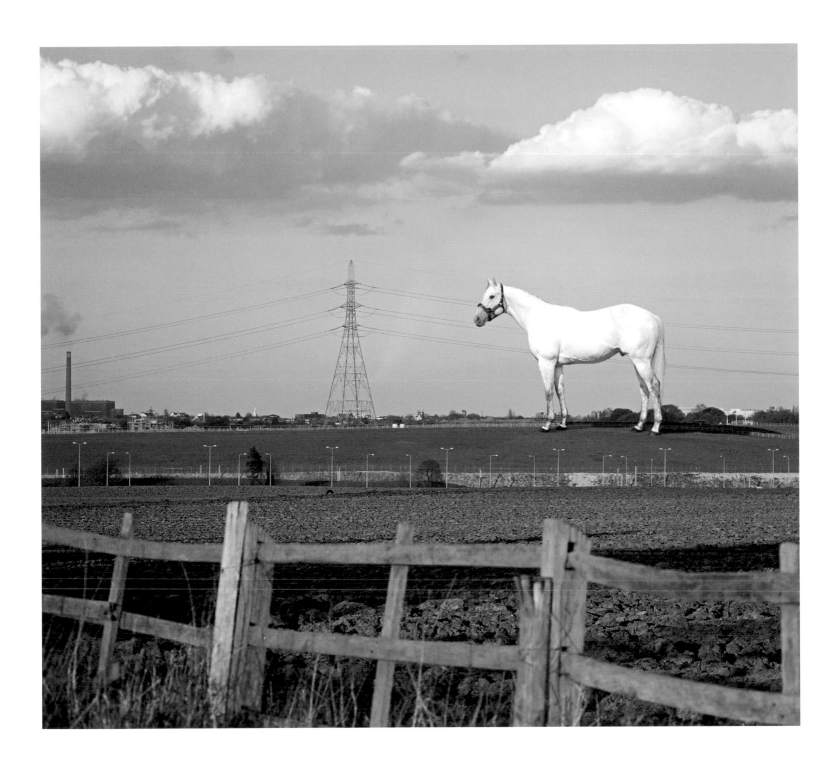

The White Horse
Photo montage, artwork proposal for
the Ebbsfleet Landmark Project, 2008

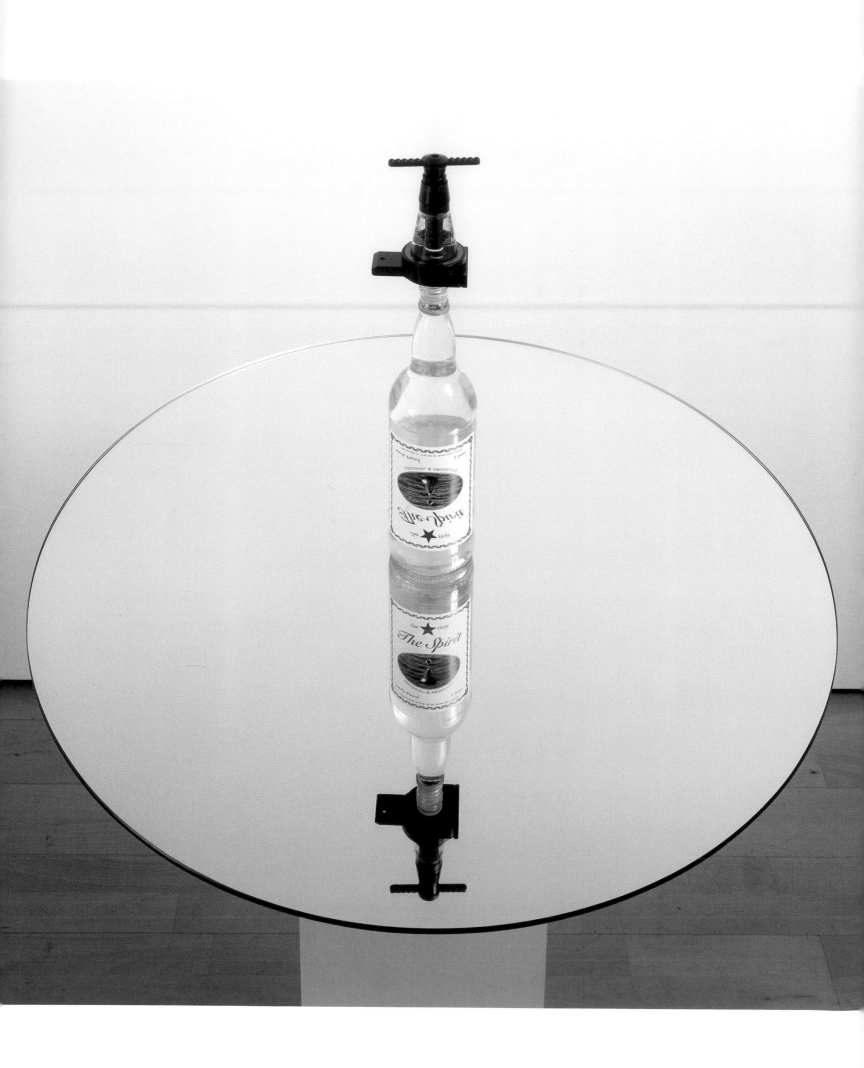

ONE

Battling for Britain (1985–1989)

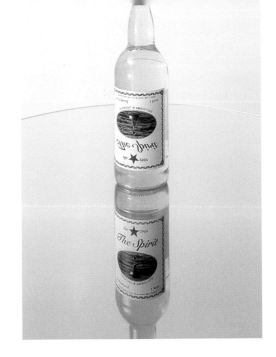

Est. 1959

Most of us, when we are standing at a bar, waiting for service and gazing idly at the hostelry's row of inverted spirits bottles, do not tend to envision the cosmic and the commonplace united by wordplay. One evening in the mid-1990s, Mark Wallinger did so: the thought process led back to his birthplace. The physical result, a sculpture entitled *Upside Down and Back to Front, the Spirit Meets the Optic in Illusion* (1997), consists of a clear spirits bottle filled with colourless liquid, fitted with a barman's optic and placed upright on a circular mirror. Upon it is a custom-made label, printed back to front and (as it would be on a bar bottle) affixed upside-down, decipherable only in reflection. In fact, this is a self-portrait of sorts, albeit of the elliptical, punning, representation refusing sort you would expect from an artist who, when he began producing a series of paintings collectively titled *Self Portrait* ten years later, did so by depicting the letter 'I' in various fonts.

'What's visible in the mirror, and readable, is the public face that you show to the world,' says Wallinger. 'What's in the bottle itself is the indefinable thing that expires with all of us.' (When he came to reinstall the work for his retrospective in 2007, a notable proportion of the liquid in the bottle had evaporated.) And what *is* visible and readable in the mirror? Inverted and reversed, the label – signed verso by the artist, printed in the green, violet and white of Wallinger's horseracing colours and bordered by a scrolling DNA pattern – reads 'Est. 1959', Wallinger's birth date, followed by the brand name THE SPIRIT and the assurance that THE SPIRIT IS DISTILLED AND BOTTLED AT SOURCE. Below is a map, and beside it a text identifying the location at its centre: a house on Fontayne Avenue, Wallinger's first address in Chigwell, Essex.

To talk of Wallinger's formative influences, then, to unravel his 'I', is to read something of the public face while accepting that the knowable conditions do not account fully for what is in the bottle. Hindsight is 20/20; nevertheless, Wallinger's art does invite a degree of interpretation through the emphases of its maker's life. It is a system of unpredictably repeating concerns in which nothing ever really goes away, and its architect is the first to note that the subjects he studied for A level – Art, English, History and Geography – are the keystones of what he does today. Wallinger's diverse flow of artworks since 1985 can be seen to synthesize his extramural fascinations to the admirably streamlined point that little in his life *is* wholly external to his creative activity. Indeed, he appears to have drawn upon it, and particularly upon a strand of experiences from his Essex days, since the outset.

Opposite
Upside Down and Back to Front, the Spirit Meets the Optic in Illusion, 1997
Glass, clear liquid, plastic, paper, mirror on plinth
148 x 80 x 80 cm
(58¼ x 31½ x 31½ in.)

Above
Detail

Acorns and Oaks

In January 1986, aged 26, Wallinger held his first London solo exhibition, 'Hearts of Oak', at Anthony Reynolds Gallery. One work from this show, *Where There's Muck* (1985), characteristic of the exhibition as a whole in melding righteous anger with cool control and rhetorical precision, consists of appropriated art-historical imagery executed in charcoal in skilful freehand on ten sheets of packing plywood and one sheet of galvanized corrugated iron. Wall-mounted at hectic angles like an exploded jigsaw and vigorously scorched in places, the ply sheets had come from Collet's, the Soviet-funded leftist bookshop on London's Charing Cross Road where Wallinger had been working evenings and weekends since 1981. Upon them is a fragmented rendering of Thomas Gainsborough's *c.* 1750 double portrait of landed gentry, *Mr and Mrs Andrews*, a portrayal as much of prosperous ownership, private possession of oak-rich, game-laden English land, as of the estate-owning young sitters themselves.

The title of Wallinger's painting, meanwhile, refers to the old Yorkshire saying 'where there's muck, there's brass', i.e. there is money to be made from dirty jobs. (Coal mining, for example; in the UK, the Miners' Strike had taken place the previous year.) Appositely, and presented on the unlovely ridged metal at the centre of the pictorial array, in diametrical opposition to the ease and prosperity being dismantled elsewhere, is a pitiful image of dispossession that the artist found in an agricultural history book: a man employed in the 19th century to act as a human scarecrow. Spray-painted over the sheets in deep Conservative Party blue, tying the work together formally and ironically referencing both a mythical past and football's unruly supporters, is the word ALBION.

If a cultural history is encoded into this work (several are, in fact), so too is a personal one. Wallinger had grown up in semi-rural Essex not only aware of the work of Gainsborough, John Constable and George Stubbs, but also cognizant of an almost magical connection between art and the real world. On school holidays, his parents would take him to the National Gallery and the Tate. Back home, says Wallinger, 'Where we lived in Chigwell, in one direction it's London and in the other it's fields all the way. Walking through those fields, it wasn't a great leap to Constable. That got me inside.' A gifted draughtsman from an early age, Wallinger cannot remember wanting to be anything other than an artist (although that did not prevent him from having other immersive interests, from horse racing and football to ornithology and literature, all of which are referenced in his work). His father, a frustrated writer who had inherited the family fishmongers', sold it, and was on his way to running a string of life-insurance branches, bought him his first set of oils and taught him how to use them. The fact that by 1985 Wallinger's art would feature Gainsborough's imagery of tranquil, class-driven opulence trembling beneath yobbish graffiti, however, reflected another parental bequest: an early exposure to politics.

Wallinger's mother and father were both, as their son would also be, strongly and actively leftist Labour supporters. In 1936, Wallinger's father was in London's Cable Street, among the protestors against Oswald Mosley's plans to march the British Union of Fascists through the Jewish areas of the East End; in later life, Wallinger recalls both parents in dispute with a retired RAF man who had complained about the CND and Greenpeace stickers in the windows of their house. Meanwhile, the artist recalls, 'Certain issues of class were evident to me at an early age. People who might be inclined to correct the way I spoke, for example.' By 1979, the year that the Conservatives were swept to power, Wallinger was attending Chelsea School of Art in London alongside 'probably the most unpoliticized bunch of students in the history of the world. And

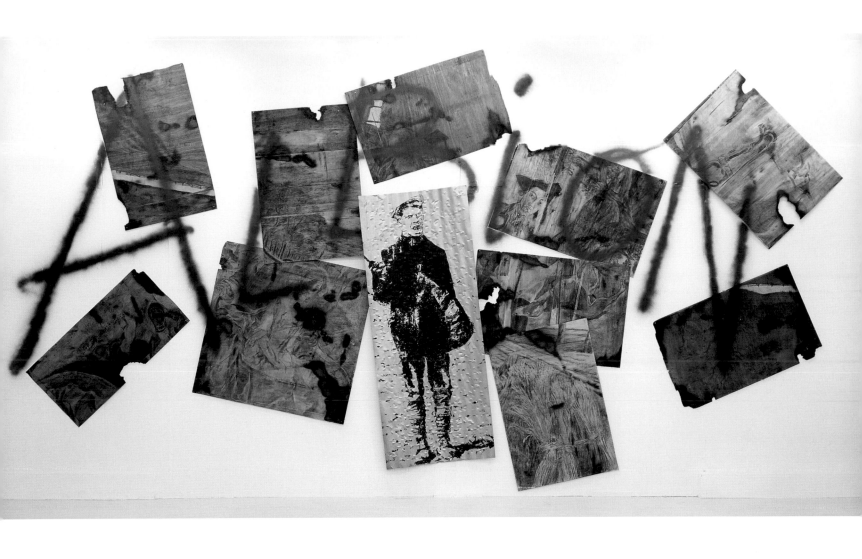

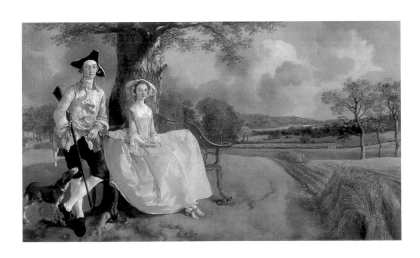

Above
Where There's Muck, 1985
Plywood, charcoal, corrugated
iron, cellulose paint
335 x 700 cm
(131 x 275½ in.)

Left
Thomas Gainsborough
Mr and Mrs Andrews, c. 1750
Oil on canvas
69.8 x 119.4 cm
(27½ x 47 in.)

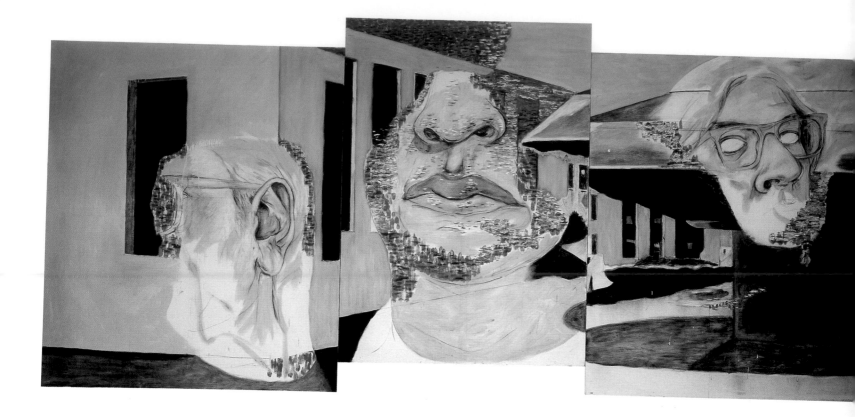

some were saying, "Oh, give Maggie a chance." And then there was the Falklands War and the Miners' Strike, the SDP and [then Labour leader] Michael Foot: it was a terrible time. And this bogus notion of England that was being peddled, that really got my goat.'

Considering this 'bogus notion' as a battleground of representations is precisely what *Where There's Muck* and its cousins do so cogently, and it would be the making of Wallinger as an artist. This would not happen at Chelsea, however, where he struggled against reactionary teaching and his painting stalled. The main thing Wallinger did there, aside from picking up a lifelong sense that he had fallen behind (which would consequently drive his fierce work ethic), was to discover James Joyce's *Ulysses*. That 1922 novel, with its emphases on tolerance, ubiquitous division, and the compensatory wonder of the everyday, would profoundly modulate Wallinger's thinking. It is also postmodernism *avant la lettre*. 'It shows its seams,' he says. 'The writing's so beautiful, but at the same time, it's telling you how it's doing it. I actually wrote my BA thesis on *Ulysses* after a first proposal on horse racing was rejected; I got Joyce in on the second ballot.' As such, *Ulysses* would be an oddly useful primer for the intellectual milieu at Goldsmiths' College, where Wallinger arrived in 1983, and where he would quickly find his feet.

At Goldsmiths', 'showing the seams' was in the air. In the freshly translated post-structuralist theory of Jean Baudrillard, Jacques Derrida, et al., then appearing in Semiotext(e)'s pocket-sized paperbacks, the process was called deconstruction and lionized American painters such as David Salle and Peter Halley were making work reflecting its authority, their own influence percolating in turn through the more advanced English art schools. This intellectual climate gave Wallinger a self-reflexive method and, consequently, the first paintings he was happy with. Anthony Reynolds, Wallinger's gallerist, who saw them at the time, recalls that these were self-portraits of a sort, including one entitled *Self Portrait as an Alien* (1985). 'They were very bold and ugly in many ways, but also fascinating … this combination of his giant features emerging from bucolic English landscape settings or obscure sci-fi film stills.' Goldsmiths', says Wallinger, 'helped me construct a framework which I could then undercut or ironize. It taught me about images as currency.' The content he had chosen to deconstruct, however, reflected other, crucial influences.

Above
Self Portrait as an Alien, 1984
Oil on canvas
Triptych, overall installation
dimensions 175 x 420 cm
(69 x 165¼ in.)

Opposite above
John Barleycorn, 1984
Oil on canvas
213 x 152 cm
(84 x 60 in.)

Opposite below
Common Grain 3, 1985
Mixed media on plywood
107 x 63 cm
(42 x 24¾ in.)

FIGHTING WORDS

In this period, Wallinger came across three books that would have pivotal effects on his thinking and art making. The first was E. P. Thompson's *The Making of the English Working Class* (1963). A thousand-page labour of love that reconstructs the history of dissent and working-class organization before and during the Industrial Revolution, it is an affirmation, stirring and depressing by turns, of the potential power of the toiling masses – a narrative which, given that history tends to be written by the victors, had previously been almost wholly unknown. The second book, which Wallinger remembers pulling out of a delivery box at Collet's, was Patrick Wright's *On Living in an Old Country* (1985). Dissecting the recent 'invention' of the heritage industry in Great Britain, it considers how appeals to a mythical past served the re-energized Conservative Party; how, because what survives of the past is mostly the art and architecture of the landed classes, our understanding of history is one that reifies the class system and the eternal rule of the rich (which is why the working class had no written history until 1963); and how the Left lacks a repertoire of images to counter this.

If this was a manifest cue for an artist as angry as Wallinger has always instinctively been at social injustice – one who notes that 'I don't get along well with authority; that's an instinctive thing I've always had' – it took a third book to give him the visual foundation for organizing this intellectual input. John Barrell's *The Dark Side of the Landscape: The Rural Poor in English Painting 1730–1840* (1980) references Thompson's opus and performs a similar task of reconstruction and rebalancing with regard to 'official' history. Constructed as a triptych of iconographic studies – Gainsborough, Constable, George Morland – it explores the changing notion of the pastoral. The rapprochement with the sylvan scene that one finds in Virgil's bucolic poetry still felt tenable in the art of Gainsborough; by the time of Constable, however, it was not: here, Barrell writes, 'the *ideal* of the close rural community has replaced the *experience* of it … Constable reduces all labourers to serfs, but in the same act he presents them as involved in an enviable world', which encourages us 'to ignore the fact that the basis of his social harmony is social division.' Barrell, furthermore, often zooms in on a detail of a larger canvas, pressing a case for its disproportionate significance. This is precisely what Wallinger would do when deconstructing art history as an image repertoire – one which at the time was virtually a subset of English Heritage – and making it a term in an acerbic equation.

Accompanying the degree show and exhibition was a collection of quotations asserting the continuity of the radical tradition from William Blake to William Morris, together with coverage from *The Times* of the trials arising from the Miners' Strike of 1984. Slogans Wallinger spray-painted over the *Common Grain* series include the phrase 'John Barleycorn Must Die' taken from the English folk song 'John Barleycorn' in which barley is personified as a figure that goes through various sufferings in order to make beer. In *Common Grain 3* the phrase appears over a boy with a hound, taken from a Stubbs painting, and in *Hearts of Oak* it occurs over a blasted oak tree. The song itself, he recalls, 'seemed a celebration of the inevitable cycling of the seasons, but also an embodiment of a permanent state of dissent or rebellion. There is an implicit violence in separating that phrase out as a slogan – but if you know the song, that unites you as a body of people that have such an understanding.' A representation of Barleycorn himself, meanwhile, had appeared in an earlier painting, *John Barleycorn* (1984), where he figures, says Wallinger, as 'something fabulous but workaday'.

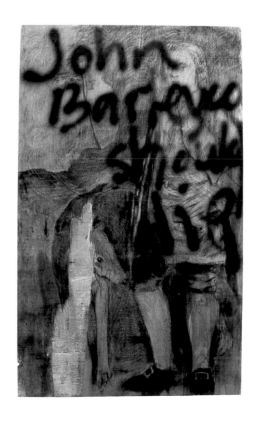

The spray paint was not the only defilement of the cherishable past. Both the contemporary and historical working class insinuate their way into *National Trust* (1985),

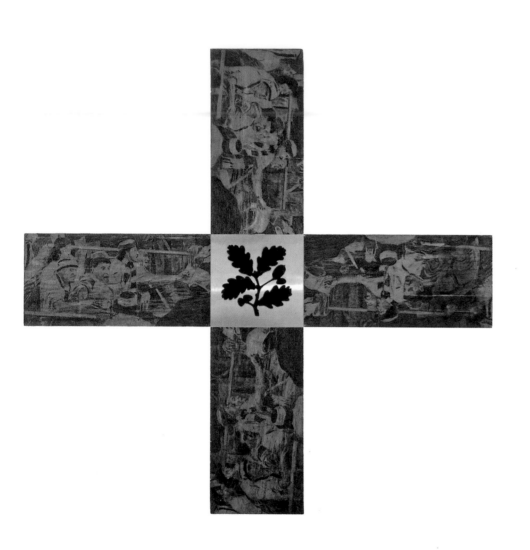

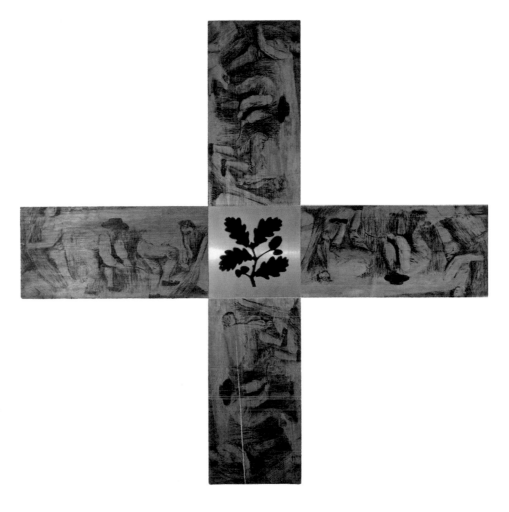

National Trust, 1985
Oil, cellulose and charcoal
on plywood and aluminium
305 x 1,036 cm
(120 x 408 in.)

Above
Common Grain 5, 1985
Mixed media on plywood
72 x 94 cm
(28½ x 37 in.)

Opposite
Battling for Britain, 1985
Oil on canvas
213 x 152.4 cm
(84 x 60 in.)

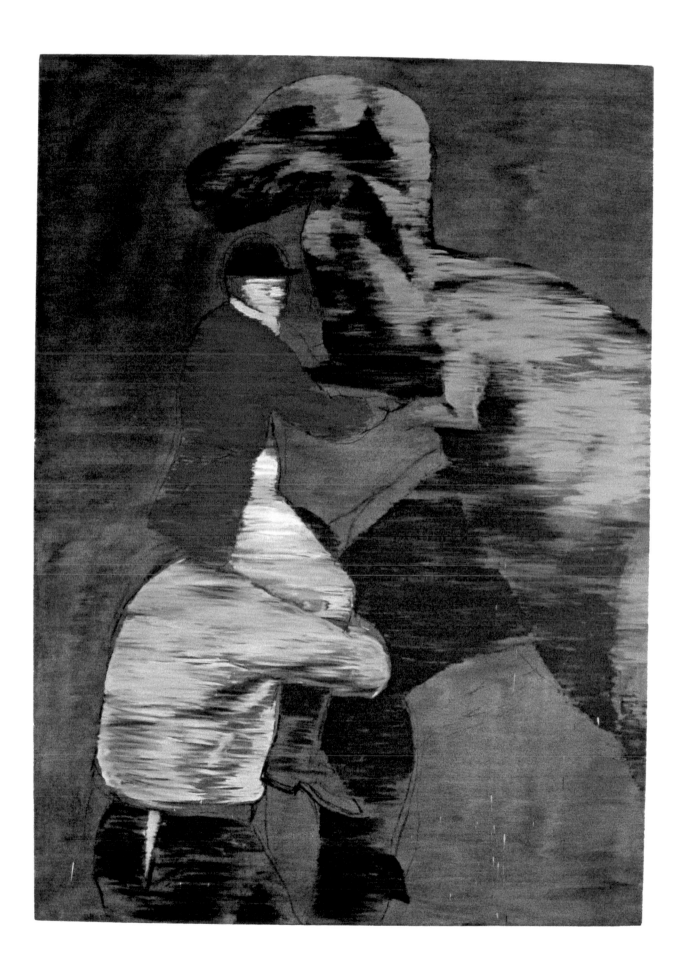

a triptych of cruciforms. The central cross has a plaque marked 'Jerusalem'; the outer crosses are centred upon oak leaves (the recognizable logo of the heritage institution). The cross on the right is overlaid with toiling workers from Stubbs's *Reapers* (1785) and that on the left with an image of violence from the final of the 1985 European Cup. In the centre, 'the gaffer' from the *Reapers* looks down from his horse at the workers. *Common Grain 5* (1985) again features the word 'Jerusalem', here sprayed over a blown-up detail of a labourer in Stubbs's *Haymakers* (1785).

In the realm of image making, these works served to undercut a monolithic narrative, asserting that the past was far less settled than history books and political interests might make it appear, and had a role to play in the present. The title of another work, *Battling for Britain* (1985) – featuring a huntsman in pink on the shoulders of a peasant, doing battle with a Tyrannosaurus rex – attested as much. As argued by a work like *Where There's Muck,* the sour truth underpinning the elysian English past being gestured towards is that for every easeful man of property, members of the working class were reduced to acting as human scarecrows as a result of the steady erosion of common rights to work the land: a process exemplified by the private enclosure of land from 1760 onwards, which Thompson calls 'a plain enough case of class robbery'.[1]

This body of work is a reminder, too, that while the newly elected government had been making its dreamy overtures – and, Wallinger perceived, stoking a jingoistic mood for the Falklands War while simultaneously planning to handicap the working classes by disempowering the country's unions – the artist saw things from the perspective of Brixton. 'You had to block out my bit of South London for any of those National Trust properties, that theme park that the country had become, to have any meaning.' Here, near the scene of the 1981 riots, there were boarded-up houses aplenty – to which Wallinger's graffitied packing boards were a reference – and an increasingly obvious context of ugly nationalism and growing social unrest personified partly by hooligan football fans. For all that the English government in power at the time might be trying to promote one idea of England, a sector of the populace was hell-bent on undoing it.

Under such circumstances, a politicized mind might see contemporary art as equivalent to fiddling while Rome burns. Wallinger thought otherwise. Since the role of representations was evidently increasingly decisive in politics, art – as somewhere to analyse and mirror what images *do* – might be a fruitful place to set to work. Imported from the USSR, sandwiched between the packing ply that Wallinger had obtained from Collet's, were Bolshevik revolutionary posters by Alexander Rodchenko, V. V. Mayakovsky and others. A popular seller in the shop, meanwhile, was a somewhat toothless satirical parody of a film poster for *Gone with the Wind,* and featured Margaret Thatcher in the arms of Ronald Reagan amid nuclear apocalypse. That, Wallinger thought, was not very effective.

Still, he was going to use humour from the start. (Wallinger is nothing if not tactical about his art's engaging qualities. As Anthony Reynolds notes, 'with all of his work, there's always something that seduces you. Sometimes it's the humour, sometimes it's the surface virtuosity, and sometimes it's an obvious punch of some kind.') Consider *Stately Home* (1985), an engraving of an image of an Essex country pile belonging to one 'John Arnold Wallenger [*sic*] Esq' which Wallinger's father, presumably knowing that his family line goes back to what the son calls 'illiterate Bermondsey costermongers', had picked up at an Ideal Home Exhibition and hung, jokily, in his hallway. In Wallinger's outsized, rambunctious remake on cardboard, one of his 'ancestors' does St George-like battle with, again, a dinosaur (the rapacious, ancient upper classes embodied) in the boating lake. If the wit and absurdity lures a viewer welcomingly inward, then the real combativeness beneath the sociable surface

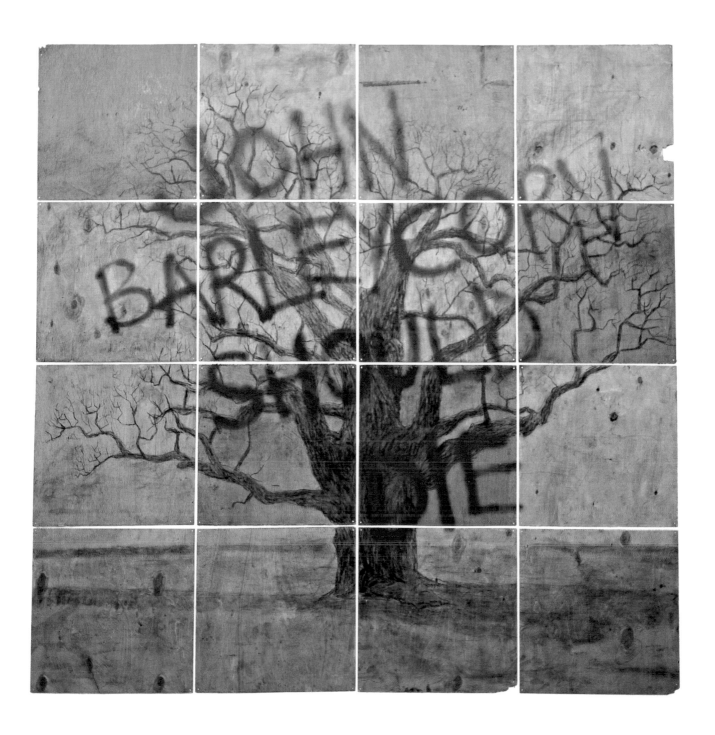

Above
Hearts of Oak, 1985
Oil, cellulose and charcoal on plywood
16 parts
250 x 250 cm
(98 x 98 in.)

Overleaf
Stately Home, 1985
Watercolour and charcoal on cardboard
8 panels
315 x 508 cm
(124 x 200 in.)

Thomas Day *pinx*

Hare Hall in Essex the Seat

f John Arnold Wall_inger Efq.^r W. Angus sculpt P.V.6

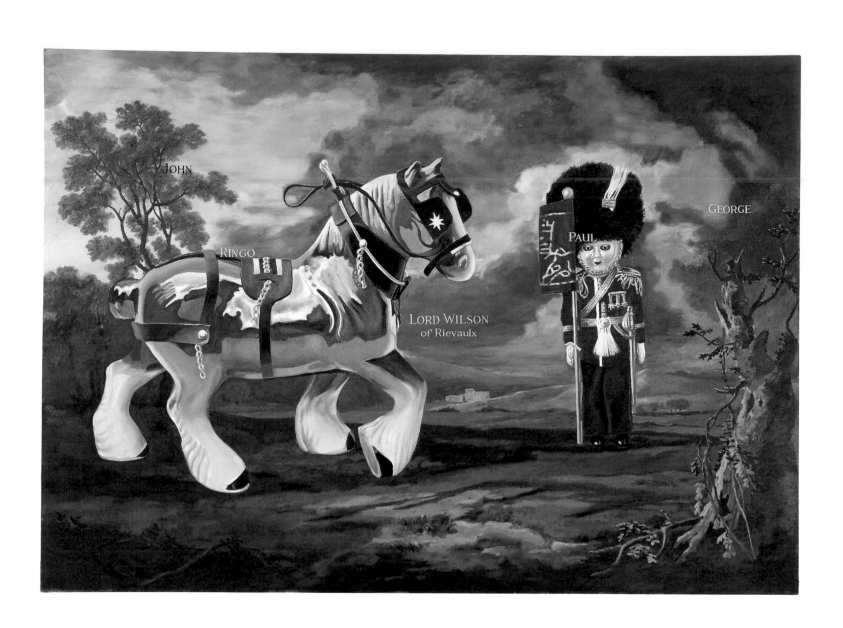

Lost Horizon, 1986
Oil on canvas
152.4 x 213 cm
(60 x 84 in.)

surprises by stealth. 'I wanted to get under the skin of how certain images or narratives, people's idea of nationhood, are so pervasive,' says Wallinger. 'Why do we keep getting returned to Elgar and Constable? It was a *fight* for the image, in a way.'

Up and Away

Given all this, it might seem unlikely that his earliest and most longstanding champion, who would sign Wallinger to his gallery even before his degree show, would be a privately educated, softly spoken, urbane gentleman. Then again, says Anthony Reynolds, 'Mark is deeply and charmingly contradictory at times. I'm part of his contradictions. I'm part of that group that he thinks had it all. I went to public school.' (As we will see, Wallinger's own simultaneous attraction to and ambivalence about the products of class, religion and breeding are a powerful engine of his own production.)

By 1985 Reynolds had left a job at the Arts Council, spent some time dealing privately, set up a gallery and was taking tips from Gerard Hemsworth, a tutor at Goldsmiths' whose work he was exhibiting. As a result, in 1984 he had first seen Wallinger's work in 'an exhibition in a shared house in Herne Hill, South London. And I had a sense of him as a potentially important artist straightaway. No question. All those issues of class and possession were there, and I understood where he was coming from.' Significantly for Wallinger's future work, the pair also shared an absurdist sense of humour. Reynolds included Wallinger, then still a student, in a group show at his gallery in May 1985. 'And when he did his final MA show later that year it was fantastic, so ambitious, a real leap. I had a huge gallery space then [in Cowper Street, EC2], and I basically took the whole show. I was bowled over. And so were a lot of other people.'

'Hearts of Oak', its title smartly referencing a folk lyric while suggesting an unfeeling ruling class, received uniformly strong reviews in the broadsheets and art periodicals. Marjorie Allthorpe-Guyton in *Artscribe* presciently saw that Wallinger's artworks 'feed on ambiguity, while their ideological allegiance is clear but unblinkered'. John Russell Taylor in *The Times* approved of Wallinger's indignation and 'bitterly ironic' tone (while outing his rhetorical debt to John Barrell). And Waldemar Januszczak in the *Guardian* reckoned that the display 'undoubtedly announces a powerful new presence in our contemporary art'. Wallinger, via this body of work, had unveiled what would be an enduring fascination with the illusions that are foisted upon us, that we cling to, and that shape our value judgments and our attitude to others. His next move would also foreshadow a permanent refusal to explore his given territory in anything approaching a signature style. Or, rather, it would herald both that and a sizeable streak of ambition, since Wallinger had now elected to take on an entire historical genre: history painting, the traditional, allegorical, epic mode whose best-known example might be Théodore Géricault's *The Raft of the Medusa* (1819).

From working on exploded found supports, Wallinger had moved back onto canvas. The paintings, though, were still emphatically constructs, being palimpsests that pointedly juxtaposed eras: pasts haloed by unearned nostalgia, and the invidious present. 'The first one was *Lost Horizon* (1986),' says Wallinger, 'and it has three layers. The background is from a Stubbs painting, the horse on top of it and the bearskin-wearing guardsman next to it were from a souvenir shop near Leicester Square. These floating names on top of that, John, Paul, George and Ringo and Lord Wilson of Rievaulx, refer to a famous photograph of Harold Wilson presenting the Beatles with the UK Variety Club award in 1964, when he'd just assumed power; later, he became a peer. To have Wilson represented by his noble title and the Beatles subsumed into the background of a Stubbs painting is to suggest that there's a line of radicalism and

Above
William Hogarth
Self-Portrait, c. 1757
Oil on canvas
45.1 x 42.5 cm
(17¾ x 16¾ in.)

Overleaf
Satire Sat Here, 1986
Oil on canvas
Diptych, 213 x 305 cm
(84 x 120 in.)

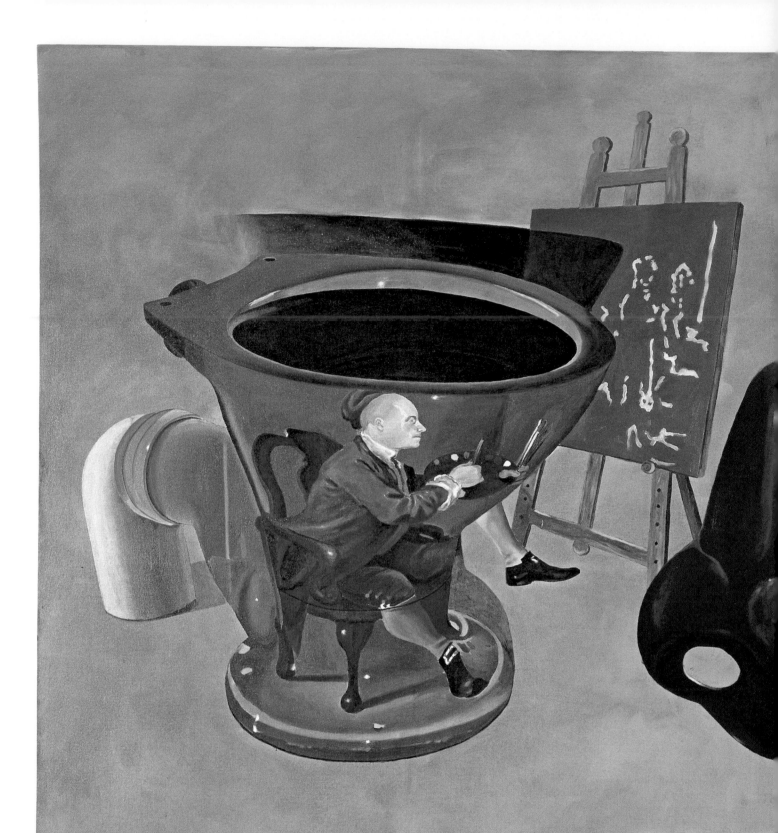

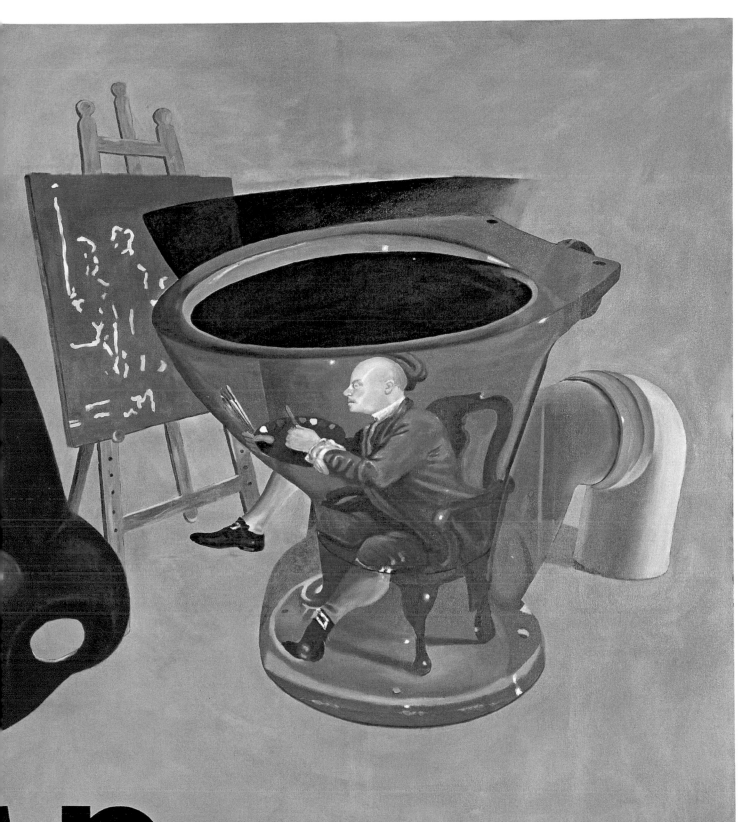

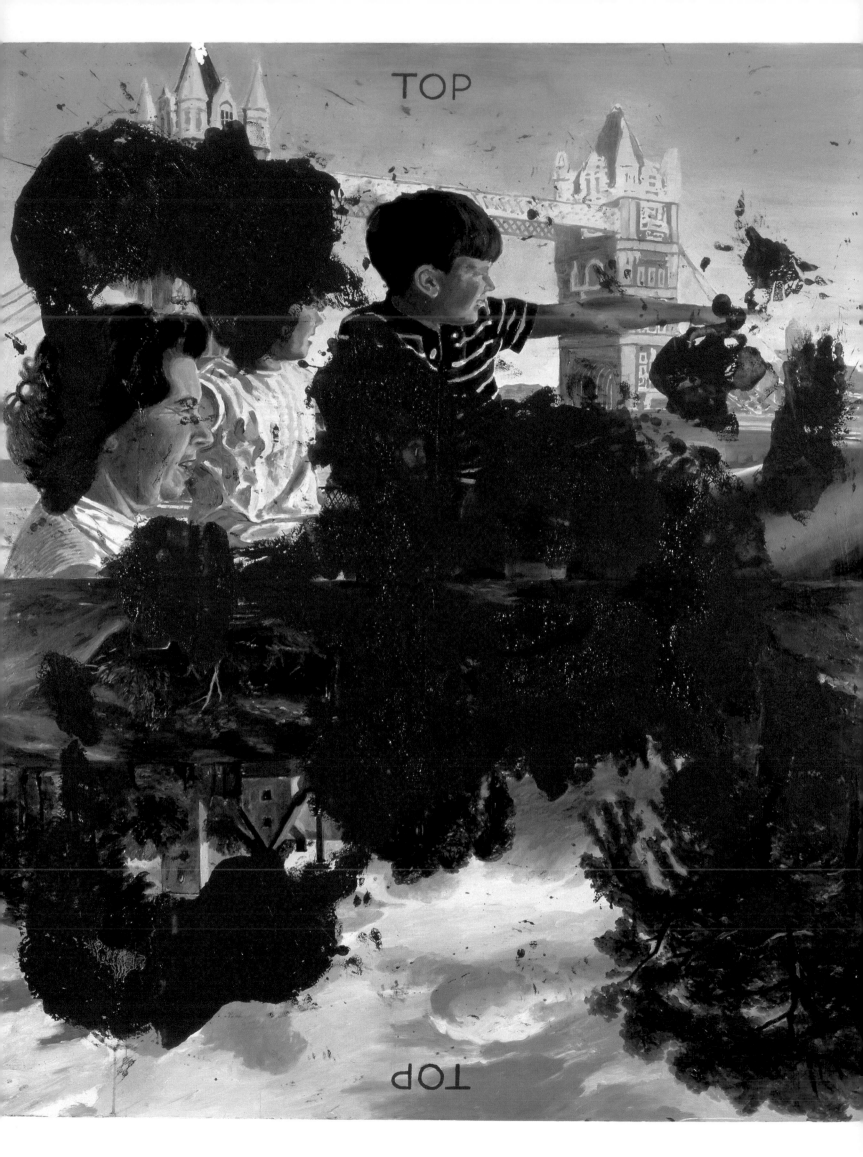

dissent that always gets ameliorated, and we're back to trees and hedgerows and a bucolic vision of England, rather than the urban reality. It says you've been sold a pup.'

That this tendency towards absorption into the establishment included mockeries of the status quo was clarified by *Satire Sat Here* (1986). For this work, Wallinger projected onto a toilet bowl William Hogarth's *Self-Portrait* of *c.* 1757, in which he shows himself painting Thalia, the Muse of Comedy, photographed *that*, and then by projecting the front and back of the resultant slide in turn onto canvas – created a painting in which this composite was seen mirrored. In Wallinger's sardonic assessment of how 'a certain tradition of British satire is toothless and always ends up a creature of the Establishment, and revered for being so-called subversive', the foreshortened ellipse of the bowl becomes an eye, and the intricately mirrored composition – also involving a red nose and the palindrome and double entendre 'GAG' functioning as a mouth – adds up to a dead-eyed clown face. In this recasting of a tradition of pictorial illusion stretching from Giuseppe Arcimboldo to Salvador Dalí, the twin Hogarth heads might be two symmetrical tears.

Wallinger had moved from diagnosing a problem to considering, with some asperity, the existing means of dissent. Surveying the state of satire in a country where toilet humour is dominant, he found it lacking; the doubling in this particular artwork reflected its satirizing of satire. 'It wasn't really good enough,' he summarizes. 'There's a certain kind of self-satisfaction with the satirical position in Britain: it tends to be more about pointing out that people have broken the rules. It doesn't have any revolutionary intent, it's just catching people with their trousers down.' At the same time, Wallinger did not simply want to find another way of preaching to a small audience of the already converted. His procedure, which he had begun putting into action at Goldsmiths', was to make the viewer's interpretative process central to the work: to present an artwork as a construction, to actively engage his addressees and make them run through the work's implications.[2] It is no accident that the toilet in *Satire Sat Here,* and the shape of the false nose, nods to Marcel Duchamp's 1917 urinal-as-readymade, *Fountain* (nor would this be the last time Wallinger alluded to that once-notorious piece). Here, Duchamp's axiom that 'the viewer completes the work', was put tactically in the services of Wallinger's grievances with representation in the socio-political sphere.

For Wallinger, then, whose instinctive sense of equality extends to the process of receiving art, there was little point in substituting one diktat for another. What was necessary was for the viewer to be treated as an equal interpreter: to be presented with a readable dialectic, or an illusion that might be seen to dissolve in the process of viewing and thinking, opening onto multiple possible readings. Another painting in this series, *The Bottom Line* (1986), is explicit about this. It pairs a photo-derived image of a young Wallinger with his mother and sister standing next to Tower Bridge – 'people often think my mother looks like the Queen here,' he says – with an inverted copy of a Constable oil study, unites the two with a red Rorschach blot for projective purposes, and emphasizes that there are different ways of reading the image by printing the word 'TOP' at the top and, inverted, at the base of the image. The shape of the blot also suggests the painting might read better on its side.

This body of work eventually ran to a half-dozen ripe, beautifully painted, time-consuming canvases. 'I stopped doing these paintings because they were getting too arch and basically playing around with the same elements,' he remembers, 'but it was an important process for me, to find a way beyond collage and montage.' Now, Wallinger began experimenting in the studio: *Booty* (1986), for example – one of the first works that he allowed himself to call a sculpture – found him creating a poetic assemblage, a fractured evocation of aspects of English colonialism involving, grotesquely,

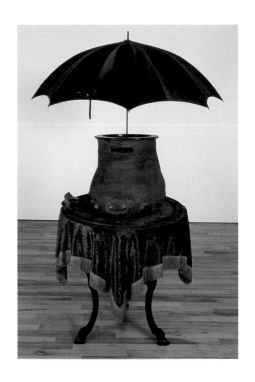

Opposite
The Bottom Line, 1986
Oil on board
122 x 99.5 cm
(48 x 39 in.)

Above
Booty, 1986
Elephant foot's umbrella stand, umbrella, clockwork train, velvet tablecloth, Victorian pub table
171.5 x 109.2 x 109.2 cm
(67½ x 43 x 43 in.)

an elephant's foot umbrella stand and an open umbrella, a Victorian pub table and a clockwork railway from the 1930s, its train pointedly going round and round in mindless circles. Suddenly Wallinger had widened his horizons concerning the forms his art could take. Having put down his brushes, he was now ready to pick up a brick.

MEDIA/MEDIUMS

From the beginning of his career, as titles like *Common Grain* and *National Trust* make explicit, Wallinger has been vocally passionate about the idea of what belongs to *us*, the people: our rights, our land. In 1987, shortly after the 18th century's high-handed negation of the right to work the land had been virtually replayed in the Miners' Strike, he saw the same pattern being played out in another, heavily ironic register.

'Each year, in the news, you'd see that druids were gathering for the summer solstice at Stonehenge, and the police were trying to keep them off it. I thought that was hilarious. The druids, the only community for which that place has a purpose or a meaning, are the only ones excluded!' At the same time, Wallinger saw a drawing by Inigo Jones, the architect's projection of what the completed stone circle in Wiltshire could have looked like, and a bell rang in his head. Shortly after, he found himself in a builder's yard in East Dulwich, South London, buying up house bricks, since, as he points out, 'Stonehenge is essentially two bricks with another on top'.

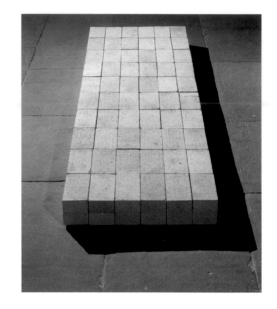

But the public supposedly cherishes it. And so, at the same time that the resultant *A Model History* (1987) concerned itself with the right to the land, it also addressed the seemingly ineradicable nostalgia, the rosy-tinted love for the old simply *because* it is old, that continually afflicts the British. 'What is left out of most museums – the background of social struggle, the politics of repression behind all these pristine arte-facts – is far more important,' said Wallinger at the time. He was talking to the *London Evening Standard,* and was doing so because *A Model History* had hit several nerves at once. Not only did it thumb its nose at Britain's cosy take on tradition by bathetically demonstrating that Stonehenge was essentially nothing but a pile of over-sized bricks, but it also teasingly invited philistinism by recalling the furore over American minimalist Carl Andre's *Equivalent VIII* (1966), a floor-based sculpture better known as the 'Tate Bricks', which the Tate purchased in 1972 (supposedly for a large sum), and which became a subject of controversy when exhibited in 1976.

When the *Standard* heard that *A Model History* had sold to a collector for £3,500, it 'commissioned two apprentice brickies in Hackney to create an identical work on their building site, asking price, £20.' Wallinger, invited to respond, wryly noted that 'it's not as if I'm getting public money, as in the case of the famous Carl Andre bricks ... mind you, when one considers the publicity, and the number of extra people who must have gone to the gallery to see them, I reckon they were quite a bargain.' He, like Andre, had his public profile elevated somewhat by notoriety. Neatly closing a circle of influence, later editions of Patrick Wright's *On Living in an Old Country* feature on their covers a drawing of a Stonehenge made from bricks.

Prior to this, Wallinger had made only a few tentative sculptures in his teens, 'in a kind of formal, playful way' on his (pre-degree) foundation art course. By now, though, he felt essentially like a conceptual artist, released from the constrictions of a single medium. Says Reynolds: 'I always felt, with Mark, that whatever he did was going to be in whatever medium suited the idea.' In 1987, even something as déclassé as a garden gnome was fair game, as demonstrated by *Gnomic Verse*, a frieze of industrious, anvil-banging gnomes on greengrocers' artificial grass, stencilled with a repeating phrase – 'Who controls the past controls the future; who controls the

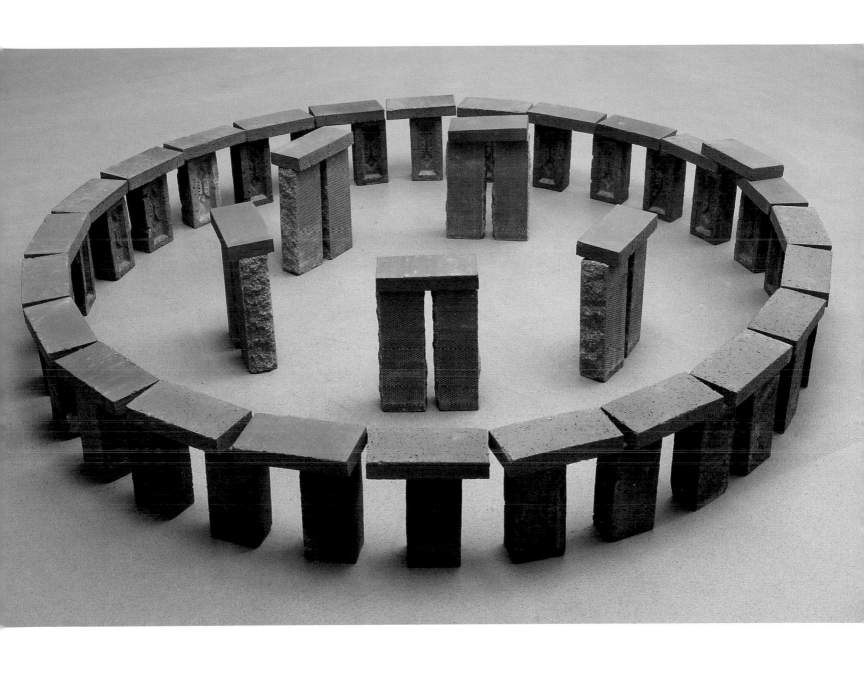

A Model History, 1987
Bricks
33.7 x 191 x 191 cm
(13¼ x 75¼ x 75¼ in.)

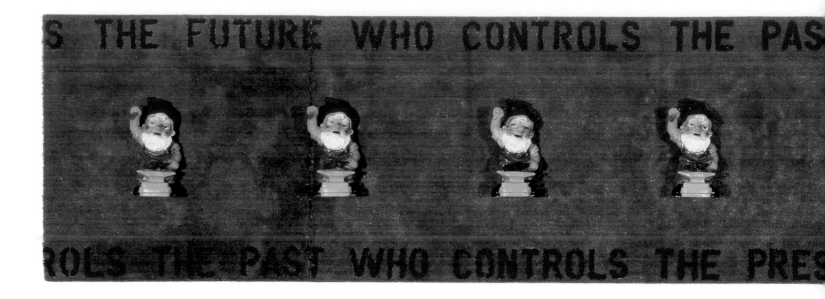

present controls the past' – from George Orwell's *Nineteen Eighty-Four* (1949). 'I was thinking of the gnomes of Zurich at the time,' says the artist, referencing Harold Wilson's derogatory term for Swiss bankers; Orwell's phrase, of course, while summarizing Conservative attitudes to heritage, carries more sinister totalitarian undertones.

Wallinger felt that he had paid his dues; he also recognized a potential pitfall. 'I'd spent a lot of time practising being skilful, and I think some people do get trapped by their facility in a medium. Difficult decisions about where my work has gone were made in order to turn my back on that. I also think I realized early on, to a certain extent strategically but also temperamentally, that I wouldn't ever be able to find the one thing that I'd carry on doing for the rest of my life. *A Model History* started me down a way of thinking outside of getting on to the next canvas, clocking on, clocking off. And I started getting better at hanging on to one half of a notion until, like music and lyrics, it had found its other half.'

The outcome of this self-determined shift in method, one of several punctuation points during Wallinger's career wherein he has essentially pulled a dangerously comfortable rug out from under himself, was an extraordinarily freewheeling three-year stretch: a high-wire display of inventiveness in which he essayed a mode of working where no two works looked remotely alike. (Not long afterward, this would become Wallinger's habitual approach, though the canvas has continued to exert a pull on him.) *Burgess Park* (1988), for instance, found him synthesizing his aptitude for painting with his newly liberated approach to material, producing his first installation.

'Burgess Park, in South London, was the first park since Victorian times to be created in the capital,' Wallinger recalls. 'It was paradigmatic of wrong-headed planning. These so-called slum houses were pulled down, all the council tenants were put in the Aylesbury Estate, which became the worst place in Europe for crime, and then there was insufficient money to develop the park. So it felt more like scrubland, and then they created an adventure playground but didn't have the money to supervise it, so it became this scary-looking fenced-off zone...' His ironical response was to paint twenty-four watercolours of this dismal area, as if it were something picturesque, then colour-Xerox them – gifting them with the corporate tenor of artist's impressions in an architect's office – and to place in the centre of this display a playground model constructed out of broken bits of picture framing, 'violating the integrity that the surrounding images pretended to contain'. Here was the reality behind governmental spin.

A variety of future concerns, too, would be introduced between 1987 and 1989. Freedom in medium and freedom in ostensible subject appeared to go hand in hand,

Gnomic Verse, 1987
Plastic gnomes, greengrocers' grass, paint, chipboard
91.4 x 548.6 x 20.3 cm
(36 x 216 x 8 in.)

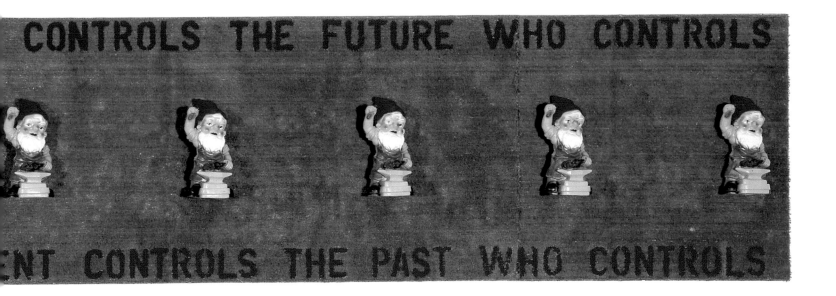

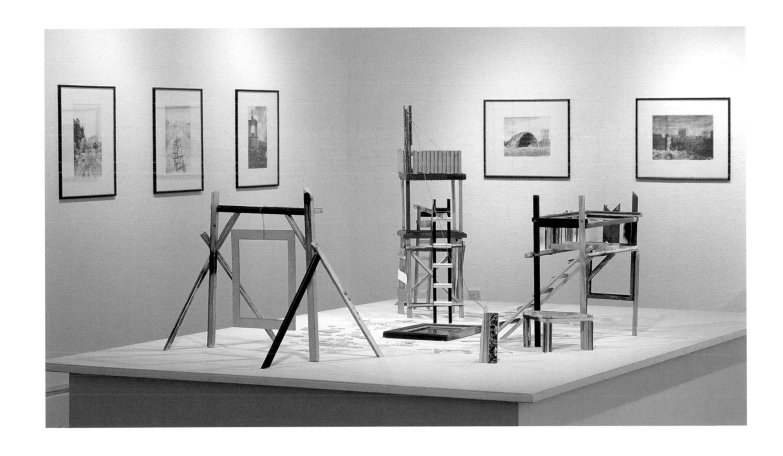

Burgess Park, 1988
24 unique colour photocopies
of original watercolours,
framed, wood, glass, metal
Dimensions variable
Installation view at Nottingham
Castle Museum, 1988

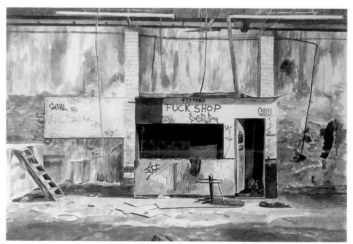

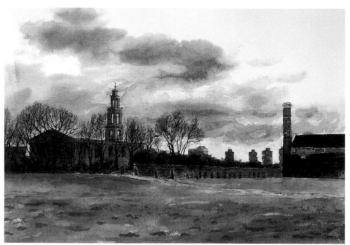

Burgess Park, 1988
Details

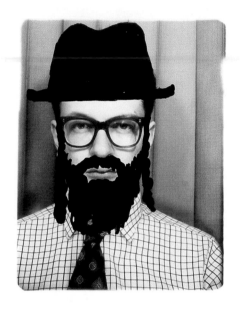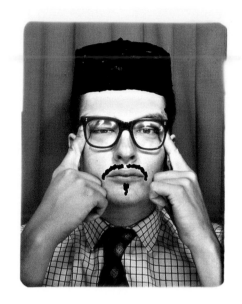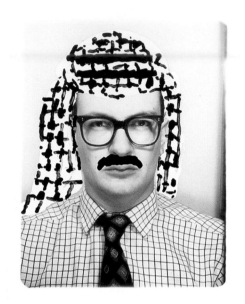

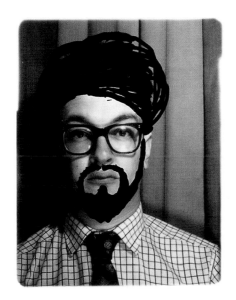 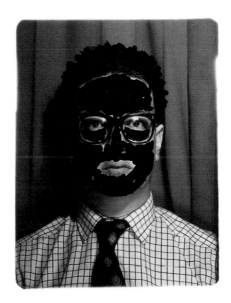 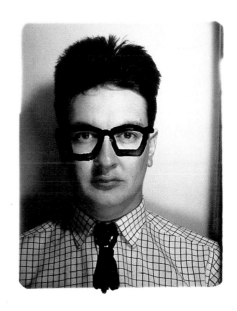

Passport Control, 1988
6 C-prints mounted on aluminium
Each 132 x 101.6 cm
(52 x 40 in.)

though the developments remained underwritten by Wallinger's larger concerns with belief systems, illusions and representation. The chance events of life would also play their part. 'In 1986 there was a Sinn Fein march in Islington,' writes Wallinger in the course of the illuminatingly personal, fugue-like text he produced for *The Russian Linesman*, the catalogue in the form of an artist's book that accompanied his 2008 self-curated exhibition of the same name. 'This attracted a strong counter presence from the British National Party, which had strong links to loyalist paramilitary groups in Northern Ireland. Afterwards, the BNP attacked the Gay's the Word bookshop in King's Cross before descending on Collet's. To cut a long story short, I got my head kicked in on a traffic island in the middle of Charing Cross Road.'

Out of this vicious incident came more than one work. For *Passport Control* (1988), Wallinger stepped into a passport photo booth and had himself photographed six times in a nondescript check shirt and tie. He then drew over his own face with a marker pen, to reduce his appearance to that of a blunt ethnic stereotype: a moustached Arab in a keffiyeh, a bearded and turbaned Sikh, a heavily bearded and ringleted, Homburg-sporting Hasidic Jew, etc., and finally had the defaced images blown up to a provocatively large scale. Given developments in geopolitics in recent times and increased paranoia at international borders, this was highly prescient. As, indeed, is Wallinger's whole focus on the signatures of ugly nationalism in this period. Not for the first or last time, the illusion in *Passport Control* has a quality of deliberate, faux-dumb transparency. It collapses, with grim humour, before the viewer's eyes. That it mirrors the reductive thinking of racism is the artwork's discernable subtext.[3]

An earlier response, *Tattoo* (1987), comprises a trio of mutated Union Jack flags painted in cellulose on PVC army surplus groundsheets, each overlaid with the word 'MUM', and muses darkly on the disturbing extremes of nationalist identification and projection. In the left-hand ensign the crosses quiver blotchily like – again – a Rorschach blot, swiftly and ominously suggesting that nationhood is a projection screen. The middle flag features at its centre a blotted form resembling an animal skull, while the white of the St George cross has vanished. The third is clear and precise, entirely in black, with MUM inscribed in the sort of gothic script that carries the taint of National Socialism. For Wallinger, *Tattoo* and *Passport Control* allude both to the appropriation of the British flag at this time by the British Nationalist Party with its anti-immigration agenda and the then-government's jingoist campaigns.

What Wallinger had homed in on was a conflict of representations, which exposed the way things he loved were being corrupted by association and misused. This also applied to his longstanding fondness for the paintings of England's Golden Age, which had been tempered by an awareness of their mobilization as part of a questionable heritage industry. Similar fault lines could be found in sport, another of Wallinger's personal passions, and one where the face of the nation was too often seen disfigured.

Aftermath and Afterlife

Wallinger grew up in a family that supported West Ham United, and he remains a keen supporter of the East London football team. West Ham players Bobby Moore and Geoff Hurst played for England, too – and they lived in Chigwell, giving the future artist another sense of proximity to greatness to add to the Constable-echoing fields and wide dramatic skies to the east. When Hurst scored a hat-trick in the controversial 1966 England vs. Germany World Cup Final, Wallinger, as a 7-year-old, was watching the match in a hotel television room in Freshwater Bay on the Isle of Wight. He now identifies it as being 'the last time that patriotism was an innocent feeling'. Forty-two

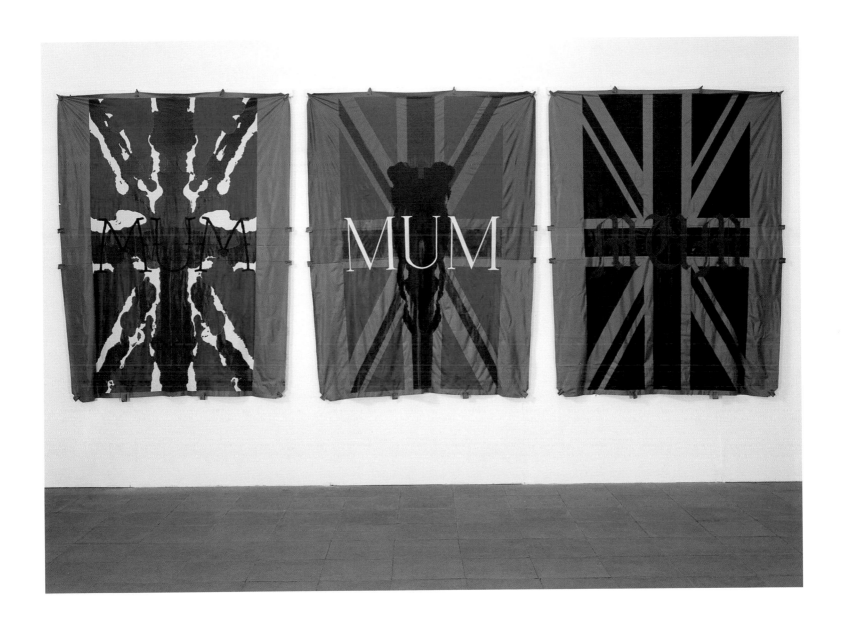

Tattoo, 1987
Cellulose paint on PVC
3 parts, each 274 x 213 cm
(108 x 84 in.)

years after the match, Wallinger's curatorial project and book, *The Russian Linesman*, subtitled *Frontiers, Borders and Thresholds*, would be consciously misnamed after the Azerbaijani touchline official who, to the enduring dissatisfaction of Germans, called a disputed goal in England's favour. At some uncertain point after 1966, a dark threshold out of innocence would be crossed.

By the time of the Heysel Stadium disaster at the 1985 European Cup Final in Brussels, wherein rampaging Liverpool fans charging a barricade precipitated 39 deaths and 600 injuries, Wallinger surely had complexly mixed feelings about his beloved sport and its attractiveness to the worst kind of nationalist thugs – feelings that were evidently filtered through, and perhaps accommodated by, his keen sense of irony. The contextually sardonic phrase ALBION sprayed over *Where There's Muck* and the presence of imagery from Heysel in *National Trust* had brought hooliganism into ironic and explicit counterpoint with class struggle. Here were the working class expending their energies in fighting each other, rather than concertedly troubling the privileged. Here, perhaps, was internecine fighting as the inarticulate venting of frustration at social inequality. (Broaching his own stained enthusiasm, Wallinger can still come across as quite the patriot, if a clear-eyed one.) He addressed the sport in a more reflective, though no less mordant tenor, in *They think it's all over… it is now* (1988).

This large marbled tomb is 'somewhere between a sarcophagus and an executive toy', with, on top of it, a Subbuteo table-football game laid out in a formation as close as Wallinger could get to the arrangement of English and German players at the final goal in 1966. 'It was a memorializing of my own memory,' he says, and a kind of capsulated requiem for national decline. It was also, notably, a working model of cultural difference, cultural division. 'I showed that work in Hamburg, in 1989, at the time

They think it's all over… it is now, 1988
Paint, MDF, Subbuteo football game
131.5 x 148.5 x 109.5 cm
(51¾ x 58½ x 43 in.)

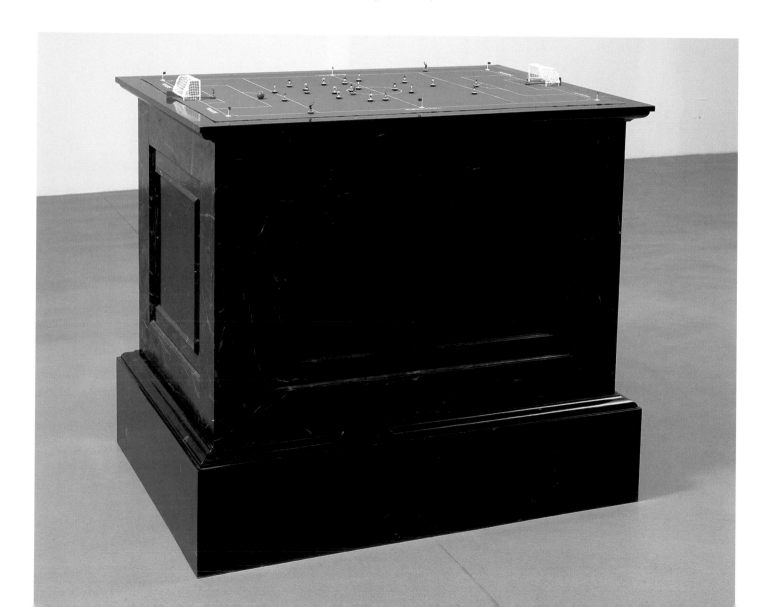

when the Berlin Wall came down,' Wallinger remembers. By now he was being invited to participate in major international group shows: this one, entitled '*Einleuchten*' or 'Enlightenment', at Hamburg's Deichtorhallen, was organized by revered curator Harald Szeemann. 'And there were Germans there who would say, "Is this the 2–1 goal?" [The earlier, disputed goal is widely seen as the match's turning point.] It was obviously a live issue. People started stealing the Subbuteo figures. I didn't want to glue them down, and I didn't want a glass case, so we had to send out reserve teams.'

Wallinger evidently felt able to balance nostalgia with a critical take on the emotion, for this was not the only marbled elegy for Albion that he made in this period. In 1987 he had produced *English and Welcome to It,* a gravestone covered in greengrocers' grass upon which is printed, in elegant italics, four lines from 18th-century English poet John Clare's 'Pastoral Poesy':

> A language that is ever green
> That feelings unto all impart
> As hawthorn blossoms soon as seen
> Give May to every heart.

The fake, 'evergreen' grass, meanwhile, is strewn with British Legion poppies. Again Wallinger juxtaposes eras to evoke both a diminished nation and the paradox of national feeling. 'That's quite a complex piece, looking back,' he says. 'The Clare poem, and that verse in particular, suggest such a rootedness in the landscape, an understanding of and embodiment of nature: which is a wonderful idea, but can then be used to slaughter people. At the same time, making it with artificial grass, there's

English and Welcome to It, 1987
MDF, paint, greengrocers' grass,
British Legion poppies
5.5 x 1177 x 207.5 cm
(2 x 46¼ x 81¾ in.)

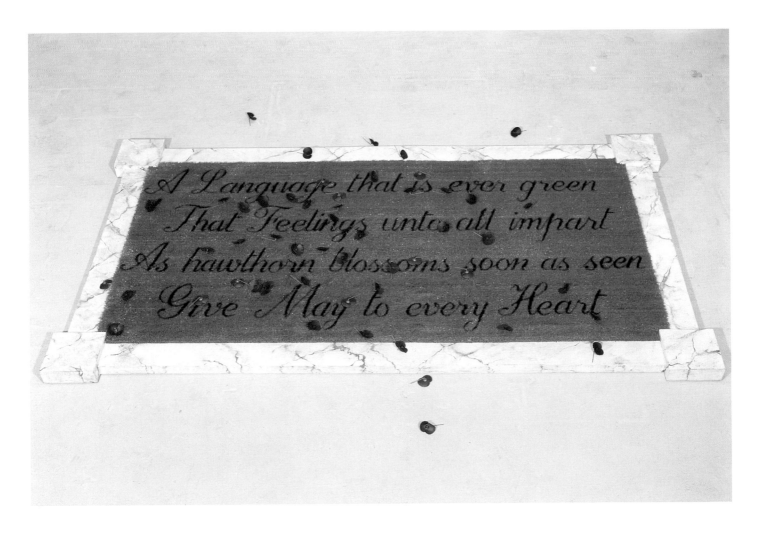

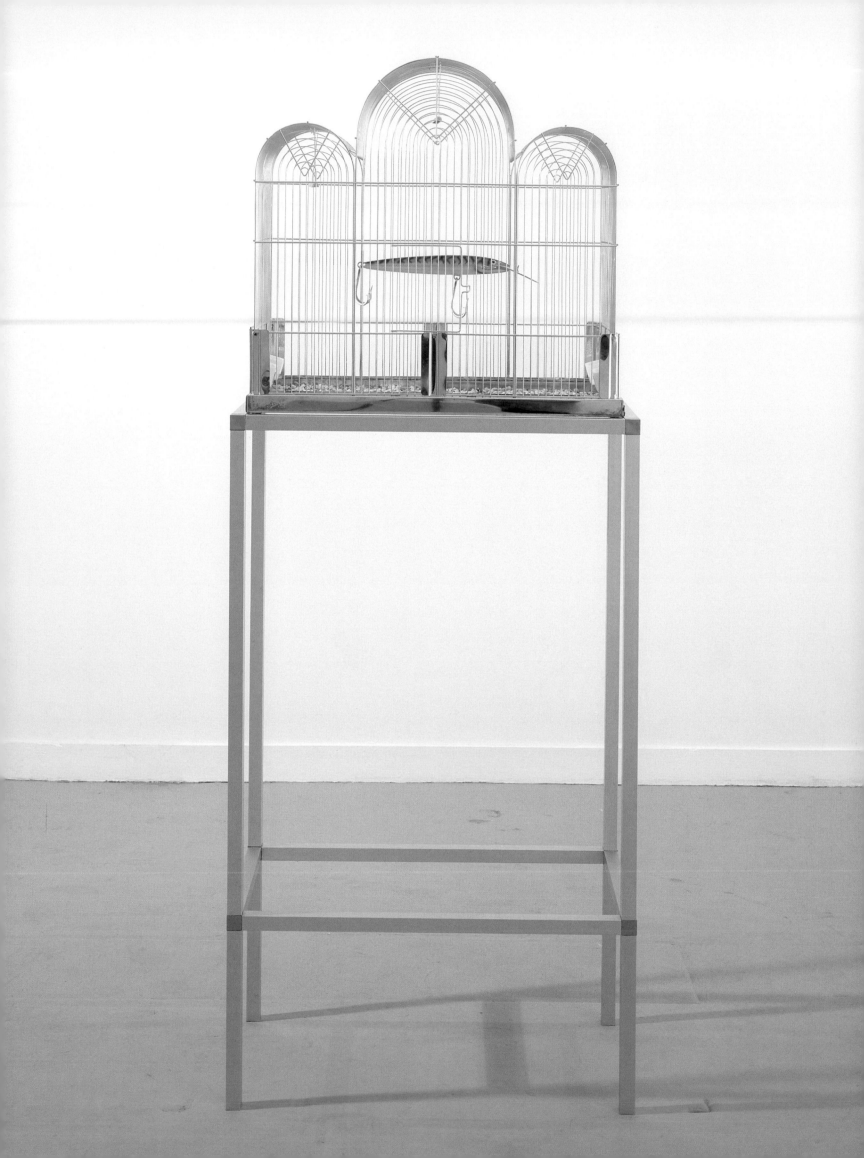

a sense that we've moved – terminally – away from any sense of being able to have such an authentic relationship. So it's a kind of mourning for what that can lead to, and that one can't have that innocent, unmediated connection.'

Even here, Wallinger was still drawing on his studies in class conflict. It was through reading E. P. Thompson, he remembers, that he discovered Clare; the poet's damaged mindset (in 1837 he was committed to an Essex asylum, and would claim to have previously been Byron and Shakespeare) partly resulted, it is thought, from the mental torment of the enclosures and the estrangement of working men from the land. Clare's stanza would recur in Wallinger's projects, and references to one critical result of powerfully mobilized national feeling, the First World War – and the rueful contradiction of beauty emerging from that specific suffering – were appearing elsewhere already.

If the parade of endings and deaths in these works loosely foreshadows Wallinger's emphatic turn towards matters religious in the mid-1990s, the blazingly melancholy *Heaven* (1988) is his first evocation of the afterlife. Suspending an iridescent, fish-shaped angler's lure above gravel inside a gilded birdcage, it references the 1913 poem of the same title by Rupert Brooke, which reads in part:

> Fish say, they have their Stream and Pond;
> But is there anything Beyond?
> This life cannot be All, they swear,
> For how unpleasant, if it were!
> One may not doubt that, somehow, Good
> Shall come of Water and of Mud

When Wallinger would later consider religious feeling in depth, he would not adopt an antipathetic position but would view the phenomenon quizzically, open-handedly, in the round: as something that acts, movingly if sometimes destructively, on human desires. Approaching these yearnings in the context of a catastrophic historical war, *Heaven* demonstrates how far Wallinger had already travelled in the services of elegant and allusive concision since the *bricolage* of his early work. As the critic Adrian Searle astutely summarized in a 1993 article in *frieze*, recalling the artist's 1988 show at Anthony Reynolds (a richly various exploration of national feeling that included *Heaven*, *They think it's all over ... it is now*, *Passport Control*, and numerous other works), 'Wallinger was capable, as an object-poet, of using objects not as cryptograms, so much as tart epigrams and metaphors for the most complex issues.'

He was, additionally, still determined to make works that inveigled his audience into an active relationship with them, putting viewers on an equal footing with the artist. *Natural Selection* (1988), for instance, is a working demonstration of how thoughts concerning pervasive social issues might precipitate in the unlikeliest places. Having found a number of swatches of Avon car-tyre rubber while walking along a railway line in Clapton, East London, Wallinger noticed that they contained serial numbers, a couple of which were identical. Back in the studio, he arranged these into a 6 × 4 grid and painted particular species of birds upon them. 'Darwin's finches played a key part in the theory of evolution', he says. 'I'd learned about this in one of those self-educating moments, going to the British Museum and getting hold of an illustrated first edition of *Origin of Species*: on the Galapagos Islands, Darwin noticed that while the birds were all recognizably akin to South American finches, depending on which island they'd thrived on, their bills had grown adaptive to the specific environment.' In *Natural Selection*, the two swatches with matching serial numbers feature the same bird; the bird on the bottom right-hand corner, meanwhile, appears tarred and feathered. If the work is read like a page, one works through it to reach a point at

Heaven, 1988
Brass, painted metal, gravel, aluminium
175.5 × 68 × 37 cm
(69 × 26¾ × 14½ in.)

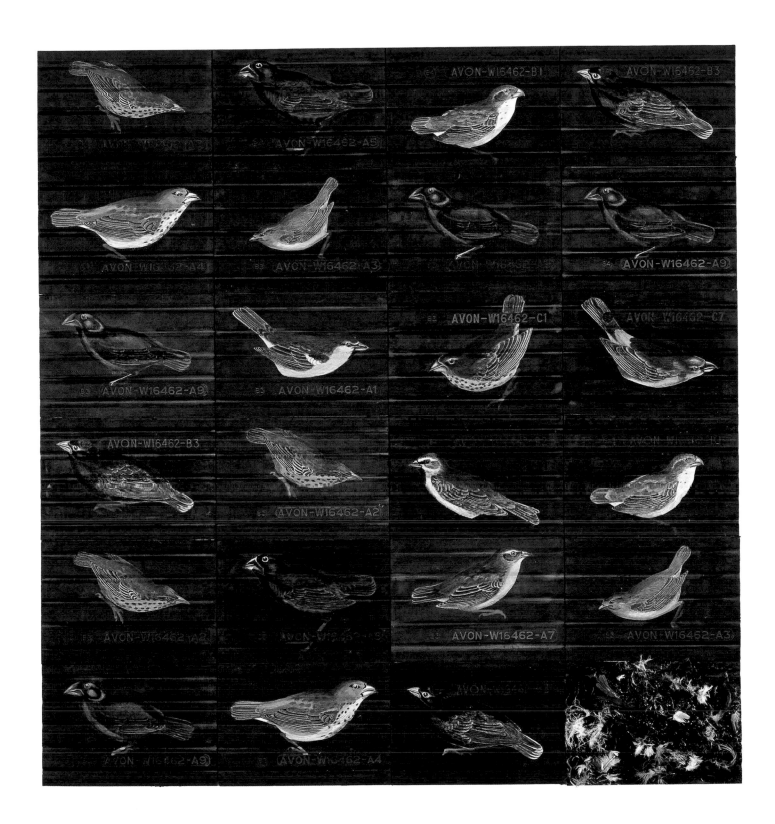

Above
Natural Selection, 1988
Acrylic, tar and feathers on rubber
50.8 x 76.2 cm
(20 x 30 in.)

Opposite
Detail

the end that retroactively invites a rereading of what precedes it: the work becomes
an interpretable commentary on prejudice, since the birds could stand not only as
endangered species but also as racial types.

In 1989 Wallinger began tracking back from such specific value-shaping forces as
nationalism to explore not just the extenuations but also the origins of the attitudes
we have as adults. *Desk* (1989) literally deconstructs a school desk and displays the
stacked wood in a vitrine; if one can almost imagine a bored schoolchild fantasizing
about such an outcome, a related work (of which Wallinger made more than one
version), *Object Lesson* (1989), fast-forwards the desk-bound sitter into the world of
work, where their jadedness continues. Here, as if the phantasmal product of an office
reverie, one desk is stacked upon another, the two divided with a mirror in which the
reflection of the upper desk, showing its underside, doubles the inverted desk below.

School (1989), meanwhile, is a series of seven chalk-on-blackboard drawings,
each in single-point perspective and inset with a light bulb shining out from the van-
ishing point: the light plays on 'enlightenment', while 'perspective' here takes on an
implicit double meaning, signifying both the construction of illusory space and mental
outlook. Based on those of his own school, the schematic gymnasium, assembly hall,
playgrounds, classrooms, etc. that Wallinger portrayed are calculatedly stereotypical,
a move that not only underlines the factory-like homogeneity of institutions of learn-
ing, but allows a viewer to superimpose their own experience onto them. 'I still dream
of these spaces years later,' Wallinger says. 'I wanted to make something about my
own memory, my own unconscious and about collective memory. I was interested in
using a language as uninflected as the delineation of single-point perspective. I remem-
ber being taught technical drawing and still can't shake the idea that the vanishing
point is the radiating source of meaning.'

Desk, 1989
Wood, glass, metal, paint
Overall dimensions
114.5 x 158.5 x 25.4 cm
(45 x 62½ x 10 in.)

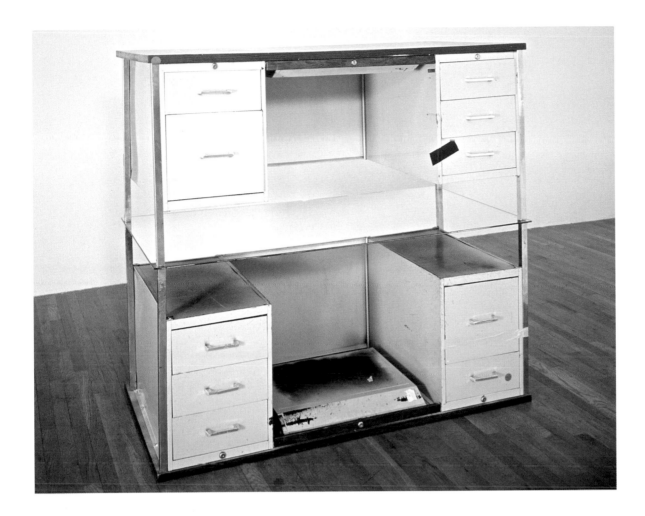

School, for all its minimalist restraint, graphic grace and comical repurposing of the aesthetics of education, is a quietly disgruntled assessment of the consequences of narrow learning. Wallinger points out that he had had to read E. P. Thompson as an adult to discover anything of the historical details of English class struggle, and quotes from Cicero, 'He who does not know history is destined to remain a child'. Fierceness was fuel, however. Asked to account for this period's frenetic and diverse bursts of activity, Wallinger recalls that 'I was still quite an angry young man.' His next project, *Capital* (1990), a labour-intensive tour de force that became Wallinger's first solo exhibition in a major institution, would make that abundantly clear.

1. Wallinger, here, was also working consciously in a tradition. In a *Times* article on Stubbs in 2001, he wrote that 'it was impossible not to see within the intricate compositions of *The Reapers* and *The Haymakers* that it is only the gaffer on his horse who is not working. Nor in *Hambletonian, Rubbing Down* to miss Stubbs's subversive empathy with an animal flogged to the point of exhaustion by its owner, the commissioner of the portrait.' The lesson that art can contain clandestine arguments would not be lost on him.

2. In 1995, writing in the catalogue of Wallinger's first survey exhibition, Wallinger's former Goldsmiths' tutor Jon Thompson brilliantly analysed his method in this regard. It is worth quoting at length: 'Wallinger took on the responsibility for revealing his sources and showing how he was coding and contextualizing them; he had to run the critical risk involved in allowing the conceptual seams to show. The principle that underlies this type of working procedure, then, is fairly easy to sum up: "what can be seen to have been joined together by the artist, can just as easily be taken apart and examined for its meanings, by the viewer". Thus through the act of reading, the viewer is critically empowered. While the artist might continue to work with a pre-ferred reading or readings, at the cutting edge of reception, the responsibility for making specific meaning – specific, that is, to that time and place – is given in trust to each member of the viewing public.'

3. Wallinger on the function of artworks, from the introduction to *Fool Britannia*, a 1998 book of critical essays he coedited with Mary Warnock: 'Artistic practice is the most critical practice. Artworks should engage, articulate, problematize, open new ways of seeing, place the viewer in jeopardy of their received opinions, move the artists to the limits of what they know or believe, excite, incite, entertain, annoy, get under the skin and when you've done with them, nag at your mind to go take another look.'

Object Lesson, 1990
Two office desks, mirror
144 x 150 x 75cm
(56¾ x 59 x 29½ in.)

School, 1989
7 works
Chalk on blackboard, matt varnish,
electric light
Each 122 x 244 cm
(48 x 96 in.)

Above
School (Classroom)

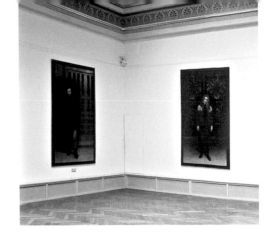

TWO

Entrances and Exits
(1990–1996)

BANK STATEMENTS

One night towards the end of the 1980s, Wallinger was passing the steps of the Bank of England on London's Threadneedle Street when he noticed a homeless person sleeping in the entrance. It is the sort of scenario his irony-attuned eyes would naturally latch onto, and it was also a symbol of the times. Homelessness had ratcheted up in the period, Wallinger remembers, due in no small part to 'a shocking bit of legislation that didn't allow people between sixteen and eighteen to claim any benefit if they weren't living at home. So anyone from a broken home, or who'd been kicked out, was on the street.' The spectacle of dispossession at the capitalist citadel's threshold might accordingly serve to indict an economic policy and its relation to the country's polarized groups of haves and have-nots, and this was the starting point for *Capital*. More than this, Wallinger saw, the destitute were also swept up in that battle of representations – the visual arena of politics – where he had positioned himself for the past half-decade.

'I'd noticed that there was a kind of journalese and a type of photography accorded to homelessness. The homeless only ever have a first name, like a dog or something, and they're always photographed in grainy black and white.' Diminish the idea that the homeless person *is* a person, by confiscating their identity and blurring their individualism through reportage aesthetics, and you potentially diminish sympathy and empathy towards them on a human-to-human basis. You undermine, too, the idea that instruments of power have effects on living, feeling people. When Wallinger accordingly set out symbolically to reverse this mendacious process by restoring some humanity to the homeless on the level of image-making, the result was *Capital*: seven fastidiously realist 'swagger portraits' in oil on canvas, of the sort historically made of the great and the good, each depicting a down-at-heel individual outside the imposing entrance of a notable city bank.

Or, at least, appearing to do so. Wallinger, in a move that paralleled the tilting of veracity in 'official' representation of the homeless, was here using visual dissimulation himself. The seven individuals were not actually homeless, not least because Wallinger thought it potentially patronizing and demeaning to have genuinely itinerant people endure sitting for him. Instead, he asked friends from college, housemates and studio partners to pose in apposite dishevelment (giving the paintings their real first names). This artifice was not hidden from viewers in the textual materials accompanying the work, and accordingly asked them to look past the deceptions of

Capital, 1990
7 parts
Oil on canvas, framed
Each 266.7 x 144.7 cm
(105 x 57 in.)

Above
Installation view at Manchester
City Art Gallery, 1991

Opposite
Detail, *Matthew*
Overleaf
p. 56
Detail, *Jo*
p. 57
Detail, *John*

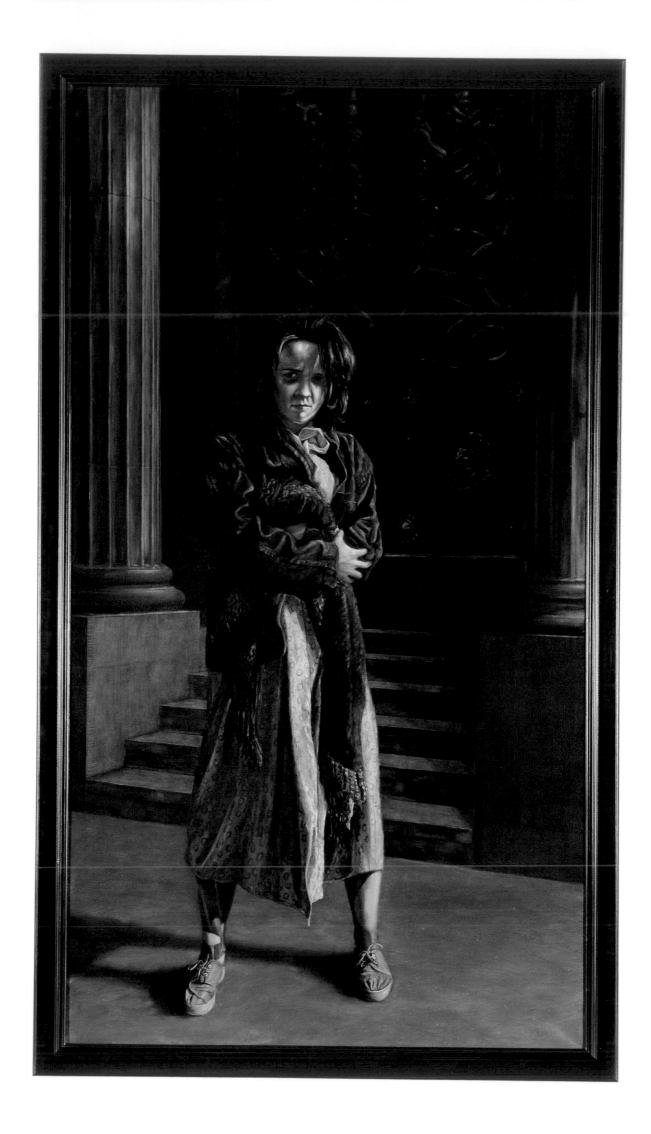

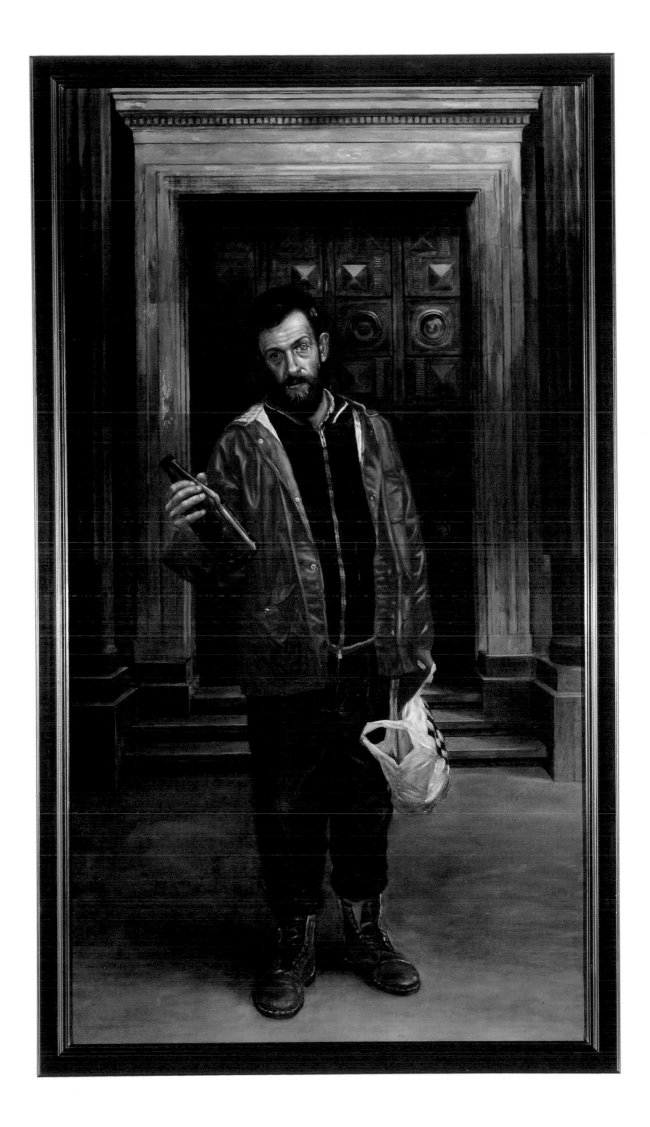

appearance – the work thus becoming a metaphor for the shiny surface of capitalism itself, and its manner of neutralizing images that go against its flow.[1]

Wallinger had begun this exhaustive series without a potential venue in mind. Sarah Lucas and Gary Hume approached him about exhibiting it unfinished in their 'East Country Yard Show' in 1990, but he was reluctant to show the series until it was completed. Then Emma Dexter from the ICA (Institute of Contemporary Arts) in London paid a visit to Wallinger's studio and an ideal venue emerged. *Capital* was first shown at the ICA gallery in 1991 – it had taken Wallinger well over a year to paint. Indeed, he had begun working on *School* almost as light relief from this gruelling project, though it turned out to be demanding in its own way.

That same year, *Capital* was shown in another recession-struck country. Wallinger's first New York solo show was held concurrently at the Grey Art Gallery, affiliated with New York University, and the Daniel Newburg Gallery, where the series was reprised as Scanachrome photographs on a 1:1 scale. In a development at once ironic and apt, the *Capital* paintings were bought by Charles Saatchi, whose advertising firm, Saatchi & Saatchi, had by this point contributed to three successive Conservative Party victories. *Capital* would be part of the second 'Young British Artists' exhibition that was mounted in Saatchi's Boundary Road gallery in 1993 – Wallinger's profile rising with the high level of publicity that accompanied the show. In the eyes of many, Wallinger thus became closely associated with the YBAs – and, indeed, had close friends and colleagues in their number. But he was older – he had, in fact, taught many artists of this generation after returning to Goldsmiths' in 1986 as a part-time lecturer. And the political ideas that underpinned his art were in sharp contrast to the indifference to politics generally expressed by that group. Hardline Thatcherism was now coming to an end (as it officially did in November 1990, when the prime minister was ousted by her own party.) *Capital* was a valediction of sorts to youthful anger, to picking up cudgels[2] – a last kick against a fading system and, crucially for Wallinger, against the rhetoric of representation that underpinned it.

Yet Wallinger was not done with considering the complexities of prima facie judgment, which received a phenomenological spin in *Stranger*[2] (1990), a series of work that also revisited Wallinger's fascination with the illusions of visual perception. Here, in each case, we see a 'stranger' twice: in mirrorings of photographic portraits attached to the underside of the two uppermost tiers of modest, three-level constructions. 'I found a whole load of discarded passport photographs,' Wallinger recalls, 'which were then laser copied and fixed to the underside of the mirrors. I was trying to get to grips with [the French psychoanalyst Jacques] Lacan at the time – the apparent splitting of the subject, the mirror phase, the Other. And looking at those unidentified photographs raised similar thoughts to those in *Passport Control*: who are the people you would regard with suspicion or not, prejudice or not, native British or not? That shifted, though, to an interest in what this created, reflected space does. Seeing the face repeated, the mind's eye quickly draws comparisons together, and then there's that sense that, oh, it's him. Your brain has got there quicker than your eyes and compared these two images of the same person. And as one circled them they seemed to circle you – both held in each other's gaze. It makes a stranger familiar.'

Soon after this, Wallinger quietly began work on another large and ambitious project: an endeavour which, in diversifying forms including suites of paintings, videos, photographs and a 'readymade' in the form of a live racehorse, would keep him occupied until 1995. Yet the first fruits of this would not emerge from his studio until 1992, so in the meantime Wallinger continued adding to his destabilizing constellation of differing individual works. *Genius of Venice* (1991) wrings unlikely

Opposite
Capital, 1990
Details
Above, left to right
Pete, Jemima
Below, left to right
Andy, Kate

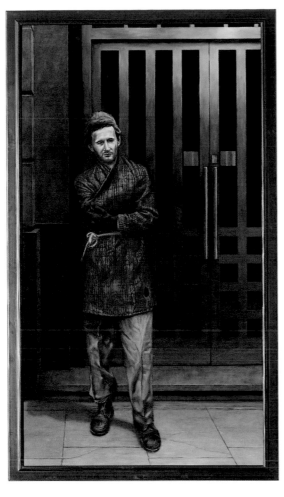
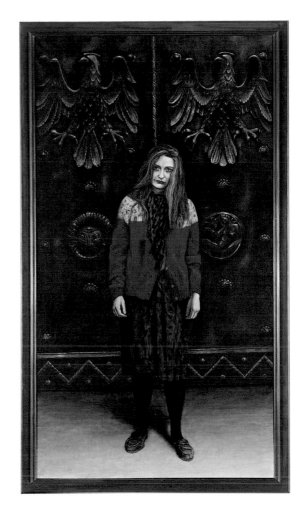
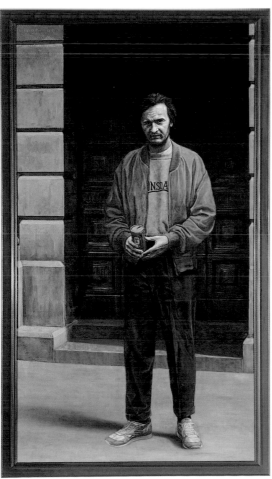
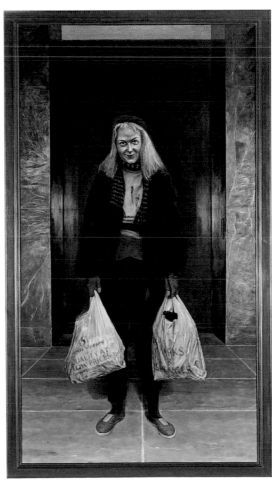

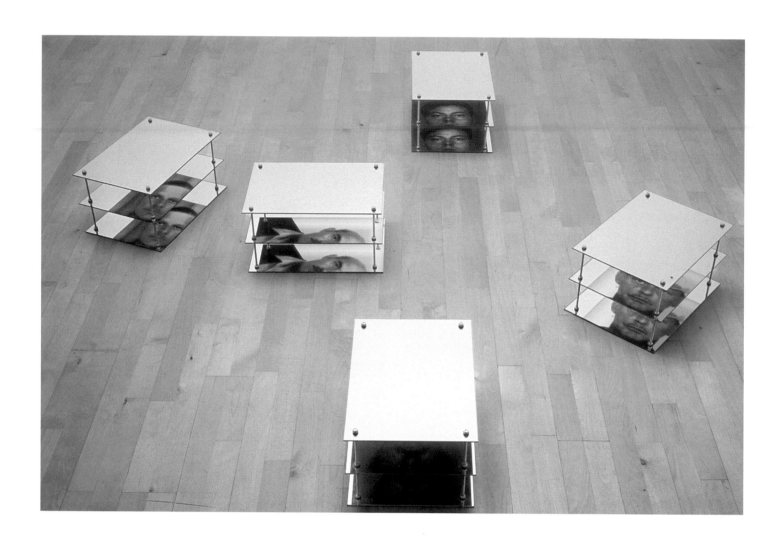

Stranger², 1990
Mirror glass, colour photocopies,
steel screws
Each unit 21 x 30 x 41 cm
(8½ x 12¼ x 16 in.)
Installation views at Anthony
Reynolds Gallery, London, 1990

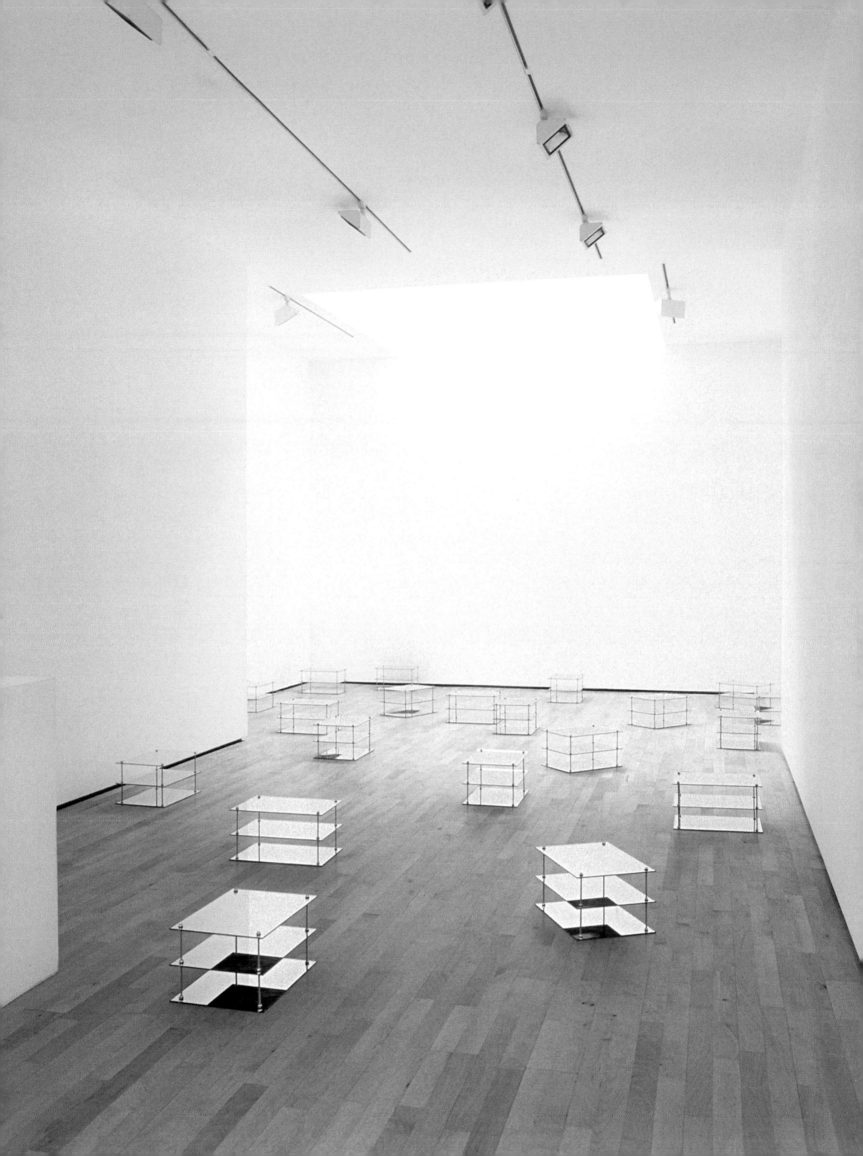

dimensions of affect out of a simple procedure: taking eight reproductions of catalogue pages from the 1983–84 Royal Academy exhibition 'The Genius of Venice, 1500–1600', sandwiching them between glass plates, and lighting each from behind with a flickering candle. As a wavering image of different parts of the reproduction on the reverse filters through in ghostly fashion to the scene on the front, depending on the movement of air currents, the piece's meanings literally shift in the wind and according to the proclivities and knowledge of the viewer. (Wallinger, for his part, notes that this work is inhabited by a mixture of the sacred and profane; the candle may or may not be a symbol of devotion.)

To the Racecourse, Via the Fountain

Wallinger's irritation with the facileness of the readymade format, already signposted a couple of years earlier by his own broken-down, vitrine-encased school desk, was superbly redirected in *Fountain* (1992). 'Duchamp has been hugely influential, but in quite a baleful way. I'd become fed up with all these shows in which something from the real world was co-opted into the gallery and, gee whiz, is it art? Rather than the readymade being utterly revolutionary and questioning the institution in which it is displayed, it's the other way around. All the work is done by the institution to sanctify the object as a work of art; by co-opting the vitrines and the rhetoric of museum galleries for their aura of authority, artists were reaffirming the power of these bodies. So I thought I'd try and make something that actually dealt with the meniscus between the gallery and the real world.'

The outcome was an object lesson in economy and inference. *Fountain*, and indeed the exhibition of the same name, consisted solely of a garden hose running

from a tap in the gallery, the hose's spout inserted into a new shop-front window – drilling would have been impossible – installed at the Anthony Reynolds Gallery in Dering Street, London. ('The hole is still there,' Reynolds would recall two decades later.) For the duration of the exhibition this hose pissed water onto the street, the readymade figuratively and actively entering the sphere of the real world. The piece 'was in the tradition of rather bad jokes that seem to constitute the best of conceptual art,' says Wallinger – and one that moved its maker's profile up several notches. ('There were six good, strong reviews in different magazines. It's a piece that's remembered by everybody,' says Reynolds.)

After catching the viewer's attention, however, *Fountain* revealed itself as layered, polyvalent. It holds diverse, even contradictory, meanings in improbable counterpoise. On an art-historical level *Fountain* can be viewed as an earthy dialogue with Duchamp's work. Its urination-related phallic boisterousness leads one back to the Frenchman's 1917 urinal of the same name; its pointed emergence into social space argues that the readymade needs to move onward and outward to have any effect.[3]

'I wanted to address the specificity of the object to make a rhyme with the original and on its function and relationship with the real quotidian world,' Wallinger says, 'to move the debate on value into a different realm.' So *Fountain* engages on a social level, activating public, civic space in a manner that prefigures later works ranging from *Angel* (1997) to *The Unconscious* (2010). That it works at all is because it accesses what Wallinger calls 'the invisible social contract we have with things like public services'. He recalls: 'It was a very liberating feeling playing fast and loose with the public water supply – and it was this co-opting of the public services that brought richness and complexity to the work, not the special place of the gallery.' Looking more broadly, the fact that the water continually cycles round the system (through the

Genius of Venice, 1991
8 parts
Glass, catalogue pages, nightlights,
metal brackets
Each 38 x 32 x 6 cm
(15 x 12½ x 2¼ in.)
Details

drains, etc.) insinuates forces of release and containment that lend themselves to metaphoric readings. Later, when Wallinger owned and raced a stallion in the name of art, he would look back at *Fountain* as paving the way for this singular readymade that not only probed the membrane between the art world and the outside world, but galloped deeply into reality.

ON HOME TURF

'I'd always loved racing and horses, and I'd always hoped to keep them separate from my work. I thought I could compartmentalize my life so that I could have this thing that was purely my own, this passion, and lose myself in it. But, like comedians say, you use everything in the end, don't you?'

By the early 1990s Wallinger's career was strongly in the ascendant. And yet, due in no small part to a tenacious formal diversity which, as Andrew Wilson pointed out in his *Artforum* review of *Fountain*, is uncommonly Duchampian in its own right, he remained something of an unknown quantity. His next move, he recalls, was thoroughly self-conscious and pragmatic: a sustained shift into a single subject matter, explored across multiple formal angles, which would serve as a useful crib for and summation of his core themes. 'I went into it with a sense that I'd reach an endpoint, in some way. And then, having cleared the decks, I could move on.' In order to do this, Wallinger delivered a subject close to his heart.

Horse racing had been in his blood for many years (and intermittently in his art since at least 1985's *Common Grain 5*). Wallinger had found horses beautiful as a child, he recalls, and would watch racing on television or go to fixtures at Newmarket and elsewhere with his Uncle Dick. Crucial for the body of work connected with racing that he would make over the next three years, however, was the fact that he had also long appreciated the intricacy and layered complexity of racing; that, and its compressing of a world. 'While I was revising for my A levels,' he recalls, 'I had a birthday, and my uncle bought me the form book. It's 1,700 pages long, it documents every race run in Britain the previous year with ratings and weights and comments for all the horses, and it's what professional punters use; it's the bible. Between revising, as a kind of therapeutic tool, I used to study a couple of races using the book, and this was a much more complex series of mental procedures than anything I was revising. So I knew that kind of richness in racing. And I put a frame around it.'

The first and perhaps most literal 'framing' occurred in *Race, Class, Sex* (1992), four large-scale and technically superb oil paintings that each features a racehorse, all of which are descended from the same foundation line of thoroughbreds as Eclipse, the greatest of all George Stubbs's equine models. Isolated on a white background, each horse is seen side-on, a bridle's strap leading off to an invisible owner. This is the pose familiar from the paintings of Stubbs, through the history of equine portraiture, and continued to this day in *Weatherbys Stallion Book*: the stud record and guide for bloodstock agents and trainers.

The title, and the passive posture, set up the racing stallion as symbolic of elite breeding, distinction and submission, all issues reflective of the artist's take on English society in particular and concepts of social division more generally. Again, though, these paintings are sites for active reading, and Wallinger here is once more setting up a complex model that will connote in various ways. The social order alluded to, for instance, plays against the fact that all these horses come from the Darley horse-breeding operation, owned by the ruler of Dubai, Sheikh Mohammed bin Rashid Al Maktoum. 'The Darley Arabian was the horse brought over from Arabia in 1704,' says Wallinger, 'and in 95 per cent of modern thoroughbred racehorses, the

Above and opposite
Fountain, 1992
Hosepipe, water, gallery
Dimensions variable
Installation views at Anthony
Reynolds Gallery, London, 1992

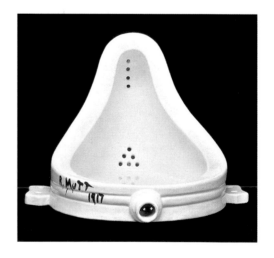

Above
Marcel Duchamp
Fountain, 1917 lost, replica 1963
Porcelain
h. 33.5 cm (13¼ in.)

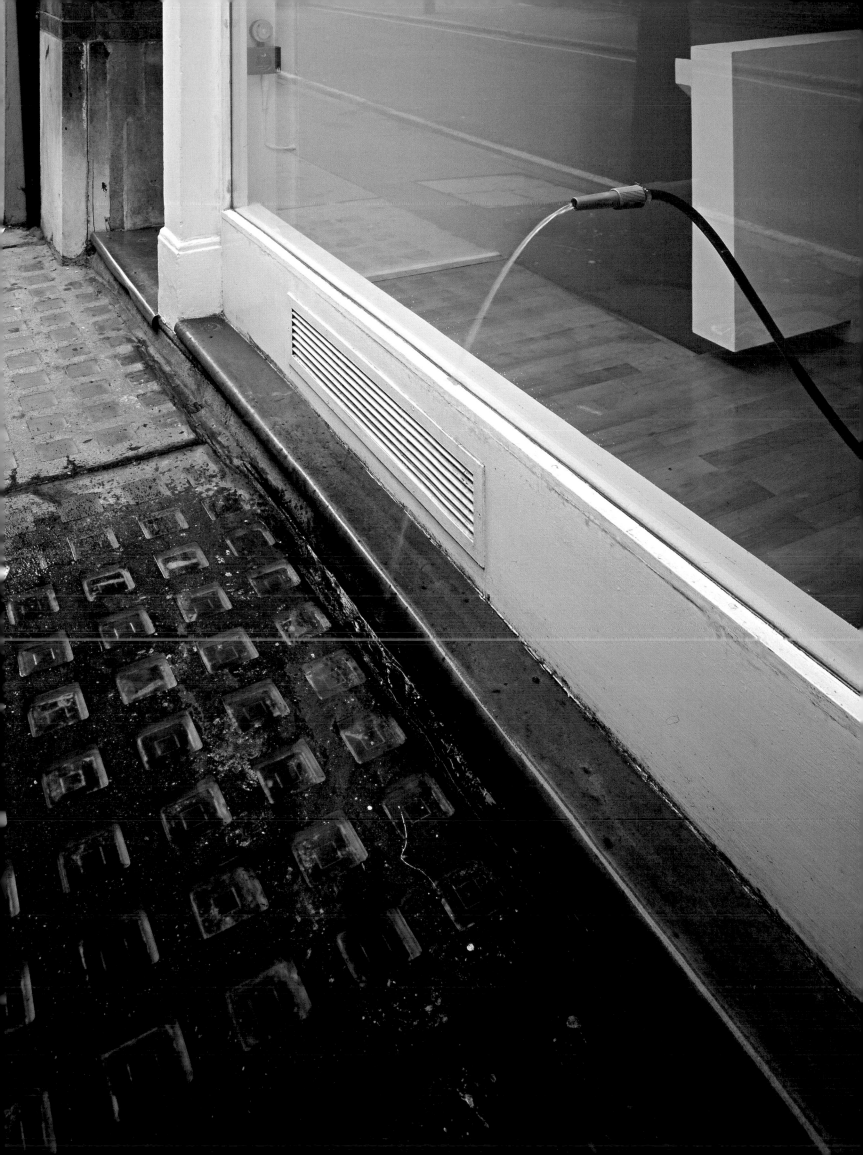

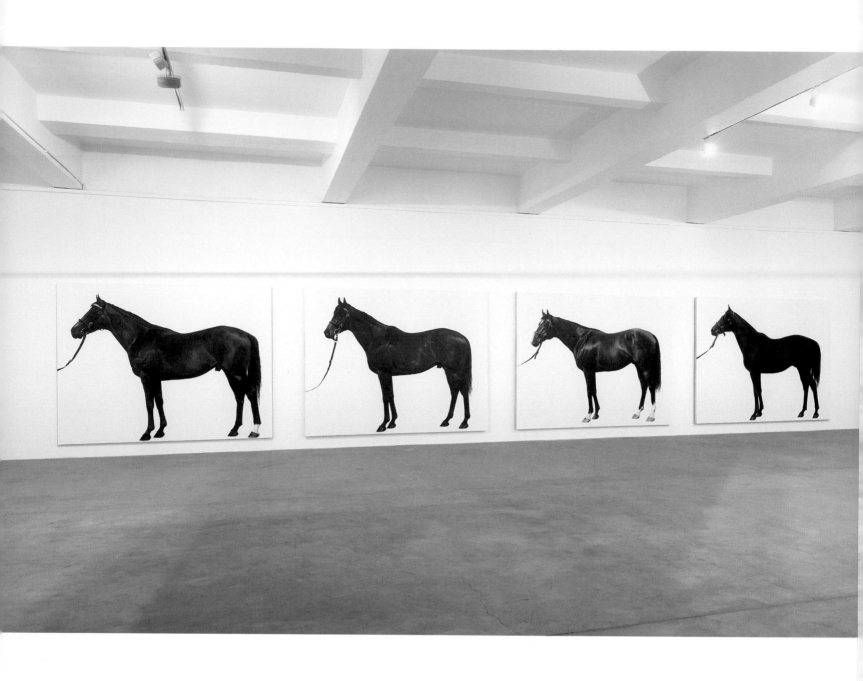

Left
George Stubbs
*Eclipse at Newmarket with
a Groom and a Jockey*, 1770
Oil on canvas
100.3 cm x 131.5 cm
(39½ x 52 in.)

Above
Race, Class, Sex, 1992
4 parts
Oil on canvas
Each 230 x 300 cm
(90½ x 118 in.)

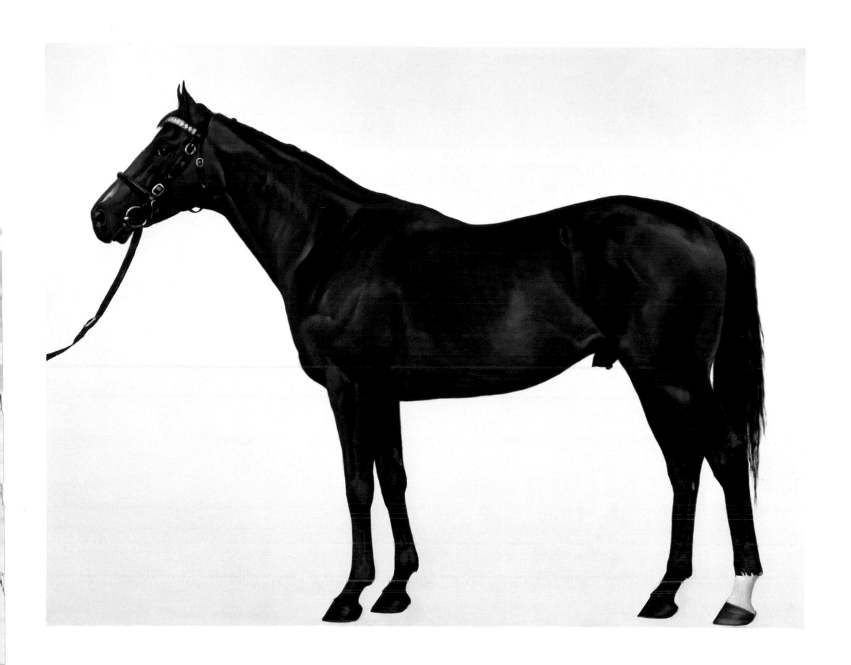

Race, Class, Sex, 1992
Detail, *Dancing Brave*

Y chromosome can be traced back to this single stallion. So, Sheikh Mohammed, in an interesting postcolonial move, is in a sense buying or claiming back the breed.' The colonial adventure and its aftermath, we shall see, have come to ghost much of the artist's work using horses.

But Wallinger was not just looking to isolate one historical irony. He wanted to immerse himself in the world of horse racing, with all its inbuilt metaphors, its contradictions, its satisfying density, while at the same time standing outside it. There was a degree of anti-hierarchical sentiment involved here in the exposure of unthinking snobbery. 'It pains me,' he says, 'that some people in the art world dismiss sport entirely. They don't understand that people get as much, if not more, from it in terms of complexities of meanings. First there's aesthetics, the beauty that most people find in the horse more than any other animal. Why do we have this affinity, this appreciation? The thoroughbred looks like that because we've been in the business of trying to breed them to run faster than their forebears: they have no notion of winning but *their* nature is the result of *our* pursuit. And the aesthetics are so varied, from a very formal apprehension of the colours to the unbelievable physicality and speed of the horses. Then there's betting, which is probably the purest form of capitalism. The fact that you invest something of yourself in the race, beyond just the money, and if your horse wins, you were right. You predicted the future. That's a rather wonderful feeling: I knew this was going to happen, and I'm *richer*. Plus, it's a world within a world, a microcosm, and the class relations still apply there, but horse racing stretches them. There's an upper class and a lower class, but really no middle class. Then the whole business of ownership, being able to register your unique colours, which is very satisfying ground.'

Registering his colours with the Jockey Club, 'the last non-elected oligarchy of British male aristocracy' and the administrators of racing at the time, was something

Self Portrait as Emily Davison, 1993
Photographic print on aluminium
89 x 137 cm
(35 x 54 in.)

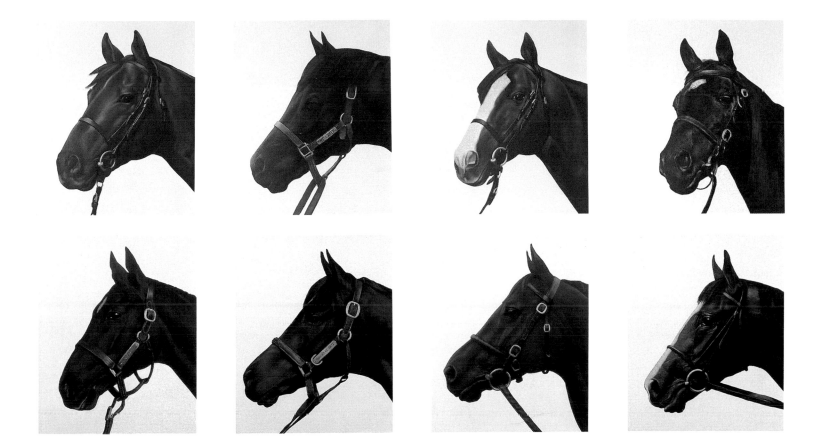

Wallinger had already done prior to making the paintings. His choice of colours speaks volumes about his sense of the contradictions inherent in the sport, and his wish to use racing to articulate issues of division and inequality and illuminate the unlikely spaces where class issues disintegrate. Wallinger chose the green, violet and white of the suffragette movement, in tribute to Emily Davison, the suffragette who was killed when she ran in front of King George V's horse at the Epsom Derby in 1913. 'I thought they'd be the most subversive colours to get in there,' says Wallinger. His 1993 photograph *Self Portrait as Emily Davison* would feature the smiling artist, in racing colours and cap and lipstick, arms folded determinedly, standing at Epsom at Tattenham Corner, at the very point where Davison ran onto the course.

After *Race, Class, Sex,* Wallinger painted four pairs of horses' heads, a series entitled *Fathers and Sons* (1993), which bathetically applied the mode of traditional portraiture to animals. Then, in 1994–95, he underscored his continuing concern with bloodlines by painting four works in the series *Half-Brother* in which the front and back of two horses who share the same broodmare were joined together, like a pantomime horse. (In 1993 Wallinger would exhibit *Behind You,* a sculpture suggesting sodomy transpiring inside a pantomime horse costume. The related *The Full English,* from the same year, is a monochrome photograph in which the act appears to be taking place at night, in a patch of urban greenery. If one imagines the whole of Wallinger's horse-racing-related work as an expansive, Hogarthian, panoramic burlesque of society as a whole, these might be its bawdiest details, suggesting the classes rubbing up against each other in the most intimate way and touching on a national comic spirit that is both innuendo-laden and coy.) The canvases are weighted with inner discord, as is Wallinger's racing-related art as a whole. While racing is seen as a pastime of the rich, the racecourse is actually one place where the classes mingle,

Above
Fathers and Sons, 1993
Oil on canvas
Each 81.3 x 66 cm
(32 x 26 in.)
In pairs, with father above
and son below, left to right
Blushing Groom and *Nashwan*
Mill Reef and *Shirley Heights*
Sharpen Up and *Kris*
Great Nephew and *Shergar*

Overleaf
Half-Brother, 1994–95
Oil on canvas
Diptychs, each part 230 x 150 cm
(90½ x 59 in.)
p. 70
Unfuwain – Nashwan
Exit to Nowhere – Machiavellian
p. 71
Jupiter Island – Precocious
Diesis – Keen

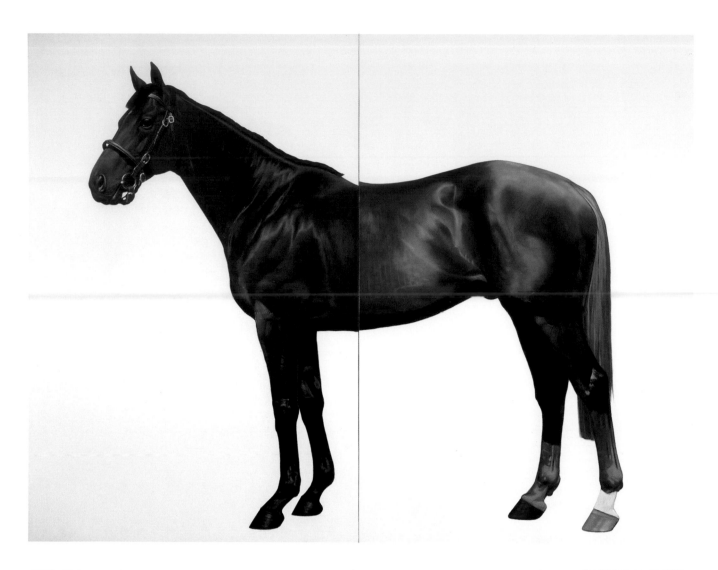

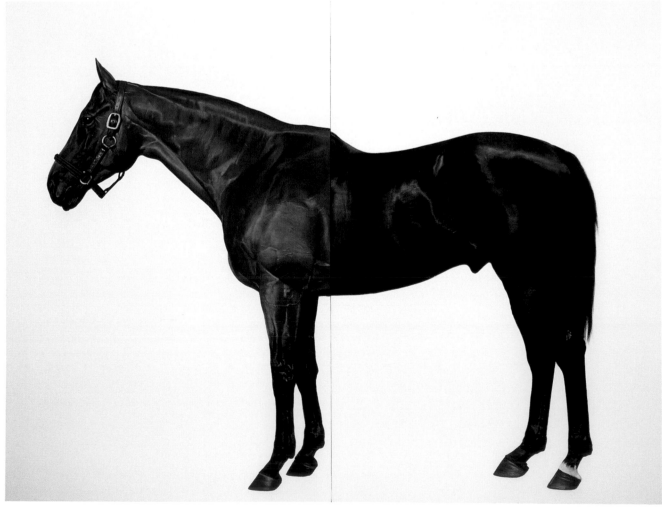

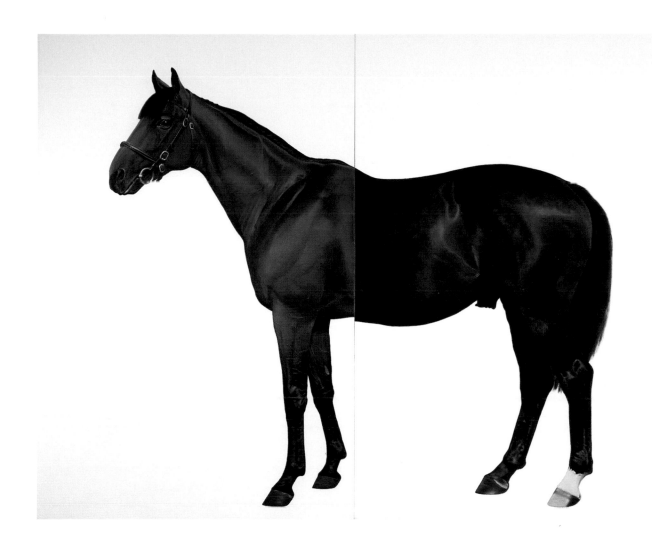
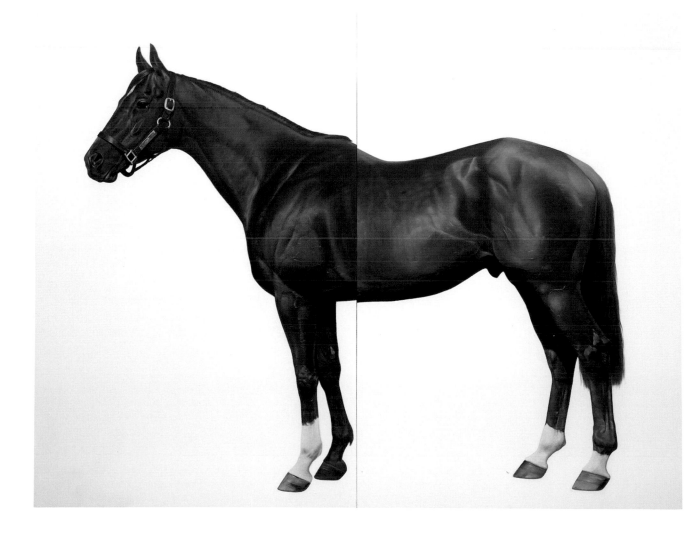

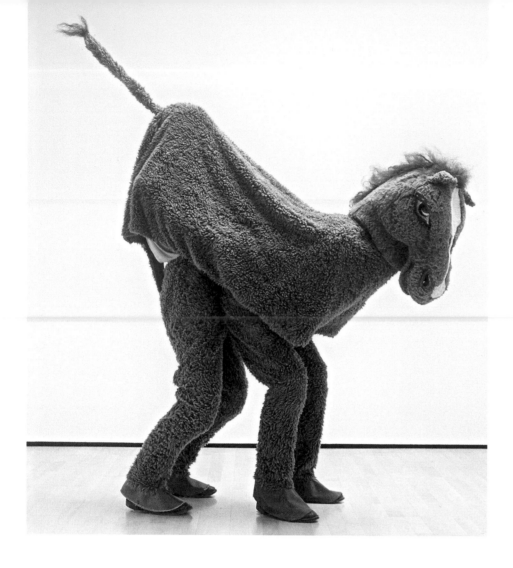

Left
Behind You, 1993
Pantomime horse costume,
two fibreglass resin figures
177.8 x 132 x 58.5 cm
(70 x 52 x 23 in.)

Below
The Full English, 1993
Black and white photograph
20.3 x 25.4 cm
(8 x 10 in.)

and the pecking order is sometimes reversed. In the Royal Enclosure at Ascot, which is accessible by invitation only, it is the rich who are made to wear nametags, as if they were supermarket cashiers.

The paintings reflect the kinds of mixed emotions one might have in appreciating the beauty of Stubbs's art and its subjects while recognizing the unequal society they advertise. Aesthetics and hierarchies are not divisible in them. These works, says Wallinger, were 'my tribute to the beauty of the animals. I enjoyed the fact I was painting an animal whose progenitor, twenty generations back, was Eclipse, who was painted by Stubbs. I chose to depict these stallions isolated on primed canvases to honour them as trophies and allude to the fact that Stubbs would leave an assistant to do the contextualizing work of painting the background.'

Furthermore, the work sets up a storeyed structure of looking, offering levels of access keyed to types of knowledge, not all of them artistic. Since this particular side-on view is the pose in which the bloodstock agent, the connoisseur of conformation, can size up a horse at a glance, anyone versed in horses would access a dimension of the work that a mere 'art lover' would not. Meanwhile, an aficionado of traditional painting might appreciate aspects in Wallinger's work unavailable to those who prefer to assess art in terms of conceptual gravity, and vice versa. The *Race, Class, Sex* paintings were again bought by Saatchi, quite fittingly since racehorses are trophies of the wealthy, and they were present (as well as *Capital*) in the collector's 'Young British Artists II' exhibition at the Saatchi Gallery in 1993. When the paintings were shown in 'Sensation!' at the Royal Academy in 1997, they were hung around the vitrine containing Damien Hirst's shark.

Wallinger's racing-related work moved in many other directions. *Monkey* (1992), too, had concerned itself both with racing and with art, specifically the question

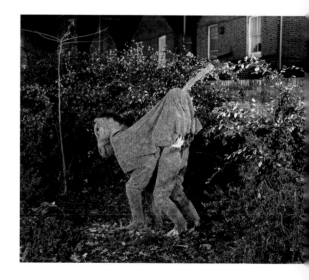

Opposite
Monkey, 1992
100 banknotes on canvas
70 x 135 cm
(27½ x 53 in.)

of value in art. '"Monkey" is punter's parlance for £500,' says Wallinger, 'so this is a canvas covered with £500 in successive numbered bills. Obviously, the market in terms of art is another situation where you're placing a bet.' Here, emphasizing the discursive, expansive nature of his horse-racing project as a whole, Wallinger managed to make reference to existing art – the arrangement of £5 banknotes makes for a Warholian grid of the Queen's face – while calling the monarch a monkey, and conflating the highest and lowest orders in the fashion that, as we have seen, horse racing naturally does. 'It's the sport of kings and queens, but much of the argot is old London or prison slang.'

The *Brown's* series of paintings (1993), with their Pop-style jockey silks – shirts and caps – on brown linen, was based on the colours registered by people named Brown, the third most common name in the country after Smith and Jones. (Reflecting the dressing-up implications of these floating, waiting costumes and suggesting that the racing world is a kind of escape from the everyday, the varied hues make apparent that most of the Browns avoided the colour brown.) As well as exemplifying the participatory, relatively classless aspect of racing (since anyone can register their colours), the sport's emphatic aesthetic facet, and the uniqueness of each participant's identity, Wallinger adds that this work 'was a nice joke on painting, that if you mix all the colours on your palette you get brown'.

Race Class Sex II (1994), a three-screen video in which we watch the reactions to a race of three sections of the crowd, would return to the idea of the social microcosm. Shot at Glorious Goodwood in Sussex, 'the second classiest race meeting of the summer after Royal Ascot', each of its screens looks onto the different viewing areas. 'You've got the Silver Ring, which is furthest from the winning post. You've got Tattersalls, which is middle income. And you've got the members,' says Wallinger.

Overleaf
Brown's, 1993
Oil on linen
Each 110 x 110 cm
(43¼ x 43¼ in.)

p. 74	p. 75
Top row, left to right	Top row, left to right
Mr W. H. Brown	*Mrs David Brown*
Mr D. B. Brown	*Mr R. W. Brown*
Mr Eric W. Brown	*Mr H. (Harry) Brown*
Second row, left to right	Second row, left to right
Mr C. W. Brown	*Mr R. L. Brown*
Mrs M. (L. H.) Brown	*Miss C. E. Brown*
Mr J. A. Craig Brown	*Mr A. N. P. Brown*
Third row, left to right	Third row, left to right
Mr R. P. Brown	*Mr J. R. Brown*
Mr A. A. Brown	*Mrs H. Brown*
Mrs P. J. Houghton Brown	*Mrs K. F. (R.) Brown*
Fourth row, left to right	Fourth row, left to right
Mr David Brown	*Mr Ronald Brown*
Dr P. P. Brown	*Mr A. Brown*
Mrs P. P. (M.) Brown	*Mr W. Brown*

The video, testing one's class antennae, tabulates the different ways in which the sport serves its audience, from the seasoned punter having given up the race already and consulting the paper, to the rah-rah excitement of a spectator in the Members' Enclosure.

Royal Ascot (1994), meanwhile, burrowed deeper into the realms of fascination and unease with pageantry and the trappings of privilege that underpin the horse paintings. Four video monitors play the BBC's opening footage from the four successive days of the race meeting, in which the Royal Family parade in carriages from Windsor Castle across the Great Park to Ascot, where each day a different regiment (the Coldstream, Welsh, Scots and Life Guards) strikes up the national anthem. What Wallinger's synchronized footage reveals is the rigidity of the class system in tangible form: the event is surreally identical every day, 'Except that the Queen is wearing a different dress or hat. The Duke of Edinburgh rather unnervingly doffs his hat at the same point, every day. So they become like marionettes, almost.'

Royal Ascot's rich colour and redoubling of camera cuts is a powerful aesthetic experience. That a viewer has to separate out critique from ravishment – or at least do some thinking about how the problems and pleasures of hidebound convention are bundled together, and indeed how the pleasures function to sustain inequality – is clearly part of Wallinger's intention. '*Royal Ascot* was as much celebration as ridicule. Only these things come together then, only a fawning BBC could cover the precision of the parade so lavishly. So all those things, and the way conventions of dress, etc. are strictly obeyed, are the result of tradition, both ludicrous and wonderful at the same time.' *National Stud* (1995), a video of a stallion impregnating a broodmare at the nation's own stud farm, serves a parallel deconstructive purpose in emphasizing the conflux of instinct and money at the heart of horse racing – and the head of state's imperative to breed.

Yet the culmination of his equine art in this period was neither a painting nor a video. In 1993 Wallinger began contacting trainers at Newmarket, subsequently met up with the esteemed trainer Sir Mark Prescott – 'one of the world's great raconteurs, who gave me a ninety-minute dissertation on everything he knew about racing. I wish I'd had a tape recorder,' he remembers – and began the process of buying a racehorse. After putting together a syndicate of a dozen investors including Anthony Reynolds, Wallinger's father Jim, and several other collectors and dealers, each paying in £1,750, and with further monies raised by the sale of an editioned model of a horse and jockey, Wallinger bought a two-year-old thoroughbred chestnut filly in Ireland for 6,600 Irish guineas, engaged Prescott to train her, and named her *A Real Work of Art*.

Art, under the auspices of nomination, is what she was. Here, moving on from probing the division between the real world and the art world in *Fountain*, Wallinger took the readymade to the extreme point of designating a living, breathing creature as cultural collateral. More, he created a symbolic structure in which all the activity around the racehorse, the complicated wider world of racing, would be part of the art, too: an artwork that was pointedly democratic. 'What I hoped would happen was that she would have run twelve or fifteen times that season, and each race would have been accessible to anyone in the country – there are bookmakers everywhere – and you'd bet. After each race she'd be given a rating. The horse would have form. And she would reproduce…'

But it was not to be. Or not as Wallinger would have hoped: 'She got injured in the spring, and then she finally got to run in September in Bath, on one of those foggy days when the sky seems like a white bowl, and she got injured coming out of the stalls. That was one of my grimmer days, career-wise. She ran the next year, still in my colours, and she won a race in Reim, and was then retired to be a broodmare.' But the

Race, Class, Sex II, 1994
Video installation for 3 monitors,
audio
2 minutes
Video stills

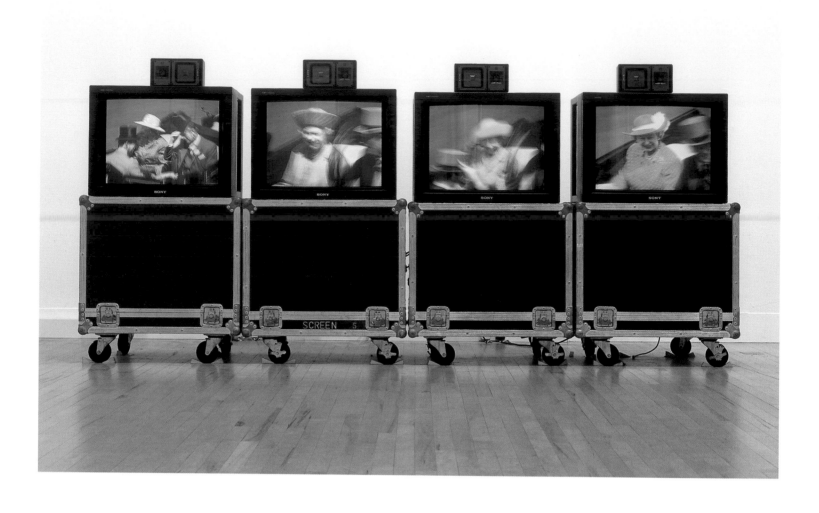

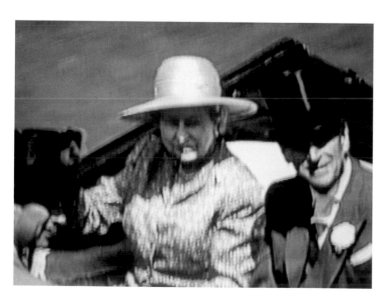

Opposite
Royal Ascot, 1994
4 video monitors on flight cases, audio
7 minutes 30 seconds
Installation view at Tate Britain, 1995

Below
Video stills

points – the delimiting of an artwork, the use of art to lasso a world that speaks volumes about the way a country organizes itself, overtly and covertly – had been well made. Decisively, it is with his racing works, and perhaps with *A Real Work of Art* in particular, that Wallinger broaches a theme that will recur, in diverse ways, through-out his art: that, despite the cordons that seemingly divide individuals, we are more alike than we are different. The mingling of classes, united in love of the racetrack (even within Wallinger's syndicate, and ideally in the invisible nimbus of punters that would surround his horse), is a working demonstration of this.

Desire is the motor, as Jon Thompson writes in *Mark Wallinger* (1995), 'which powers it [horse racing] at every level. The breeder wishes to find the perfect breeding line in order to produce the most efficient racing animal. More than anything else, the owner wishes to possess such an animal; the trainer to train one and the jockey to ride one. On the other side of the institutional equation, the race-going public wish to see such an animal run and win; and not just for monetary gain although this can greatly enhance the experience of pleasure. Ultimately, all of these involved are made part of a process through the psychological mechanism that Freud called "cathexis" – fixation upon an object of desire – and the resolution of this process occurs when their chosen horse either wins or loses. This is the moment when reality overtakes representation.'

A Real Work of Art also, as Roger Bevan noted in the *Art Newspaper* in 1994, sketched mordant parallels between the racing world and the art world. 'The artist belongs to a stable and is represented by a dealer who trains him for a successful career of mounting exhibitions, entering him into competition and finding works of art, or trophies, to satisfy the expectations of his collectors or investors. His silks, the colours which distinguish him from his competitors, are his styles. At regular intervals, cata-logues, or form books, are published, documenting his lineage (out of Velázquez by way of Manet) and achievements...' For all that the racing works may have incorpor-ated a cocked eyebrow at the art world, they also gave the art-viewing public a useful shorthand for who Wallinger was, what he was doing.

National Stud, 1995
DVD transfer from Umatic
master, colour, sound
Continuous loop
15 minutes 25 seconds
Video still

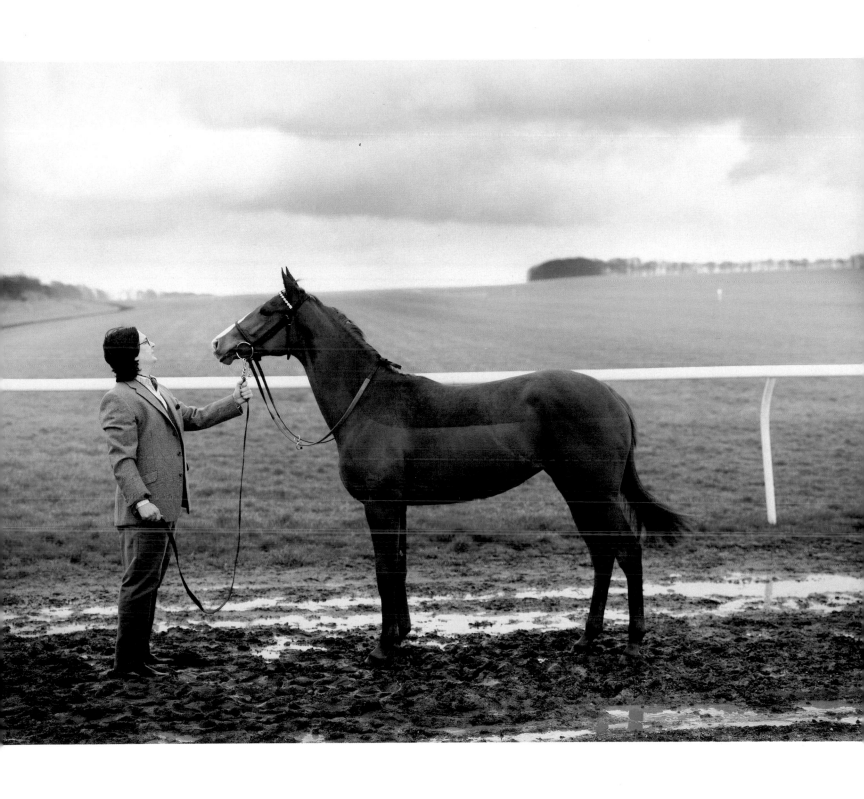

Mark Wallinger with *A Real Work of Art*,
1994, photographed by Cindy Palmano

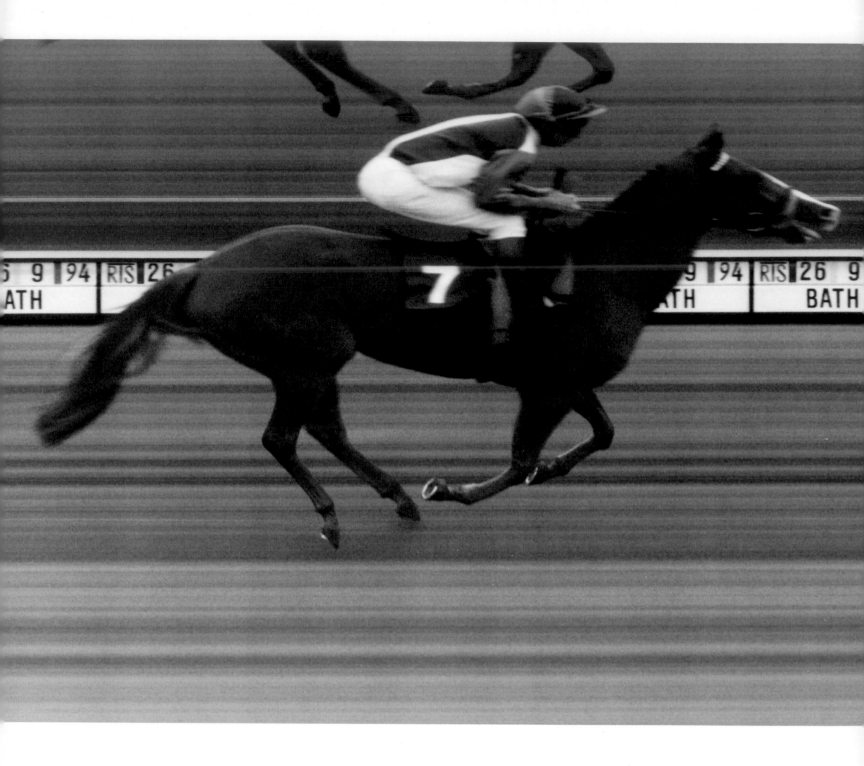

Above
A Real Work of Art: 26 September 1994
Colour photograph
20 x 25.5 cm
(8 x 10 in.)

Opposite, above left
Bookmaker

Opposite, above right
A Real Work of Art, 1994
Painted die-cast statuette
on wooden base
13 x 13 x 7.5 cm
(5 x 5 x 3 in.)

Opposite below
A Real Work of Art winning in Riem,
Germany, in 1995

A REAL WORK OF ART

Mark Wallinger Project's " A Real Work of Art "
Sieger im Radl Gigant-Rennen, 1500m, Riem 19.8.95
Trainer: Horst Weber Jockey: J.P.Carvalho

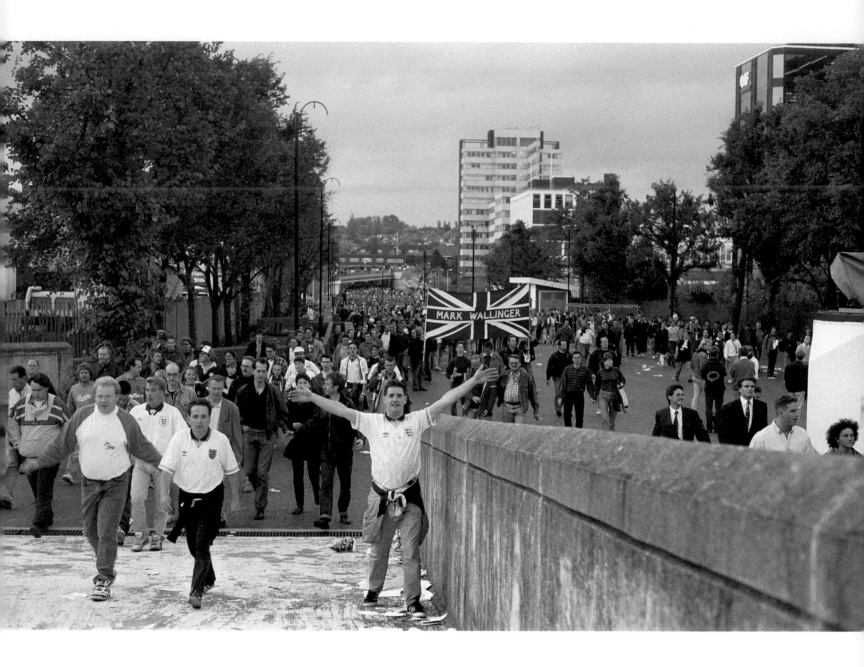

Mark Wallinger
31 Hayes Court
Camberwell New Road
Camberwell
London
England
Great Britain
Europe
The World
The Solar System
The Galaxy
The Universe,
1994
Colour photograph
mounted on aluminium
320 x 480 cm
(126 x 189 in.)

CROSS-FADE

While horse racing was the thematic spine of his work in this period, it was not Wallinger's sole focus. In 1994 he produced *Mark Wallinger, 31 Hayes Court, Camberwell New Road, Camberwell, London, England, Great Britain, Europe, the World, the Solar System, the Galaxy, the Universe*, a large colour photograph taken on Wembley Way prior to a football international between England and Poland, and featuring the artist and a friend holding up a Union Jack with 'MARK WALLINGER' written across it. The issue at hand here was identity, and its cultural construction through a range of forces from the very specific (the street where you live) to the middling (the nationalism at work in your country), to the cosmically immaterial. The point, as asserted by Wallinger's photograph, was to question and be aware of the energies at work.

Here, unexpectedly, one might see the artist's Joycean side coming through. James Joyce, though in exile for much of his writing career, always wrote about Ireland; for Wallinger, too, there is a necessity to admit the cultural specificity of one's psychic makeup. And, once again, to resist any temptation to exempt oneself: by holding up the flag, Wallinger effectively said 'this is my problem too'. With this work he was, furthermore, making a deliberate Joycean reference, directly citing what Stephen Dedalus has written on 'the flyleaf of the geography' in *A Portrait of the Artist as a Young Man*:

> *Stephen Dedalus*
> *Class of Elements*
> *Clongowes Wood College*
> *Sallins*
> *County Kildare*
> *Ireland*
> *Europe*
> *The World*
> *The Universe*

At the same time, the response to this particularity of focus was a source of frustration to Wallinger. While it was acceptable for, say, Anselm Kiefer or Jasper Johns to make work that reflected their national heritage, an English artist doing so was necessarily seen as parochial: England being both where the work begins and where it ends, allegorical readings being *verboten*. ('As if,' says Reynolds, 'ideas of class and identity didn't operate everywhere else.')

So it is notable that some of the other works Wallinger made at this time point towards an exit strategy from being typecast as magnetized to national character. In 1993, for an exhibition at the London gallery City Racing – an alternative space run, fittingly enough, in a former bookmakers' by a group of artists including Matthew Hale and Pete Owen, both of whom posed for *Capital* – Wallinger had exhibited his first video work. Predating *Royal Ascot* and *Race Class Sex II*, *Regard a Mere Mad Rager* also repurposed television footage, in this case starring the comedian and magician Tommy Cooper. (Cooper on horse racing: 'I backed a horse today, twenty to one. Came in at twenty past four.')

Wallinger had been a big admirer of Cooper, who had died in 1984 while on stage and, perhaps significantly for this piece, in front of the camera. Here, a video of the comedian performing was played backwards on a monitor while also being visible in reflection on a mirror-glass window in the space. There it was viewable reversed, with

Cooper's voice rendered backwards – suggesting, says Wallinger, 'an alien language of the departed, or the odd feeling that you might just be able to unravel the sense, in the same way we can read mirror images'. Here, what he calls a 'notional other space' assumed symbolic dimensions. Underscored by the use of a palindrome in its title,[4] this was a piece marshalling concepts of reversal, mirroring, doubling, with death as the constant shadow of life. Wallinger had used mirroring before: in *Satire Sat Here*, for example, where the symmetry undermined any idea of a meaningful dialectic. Here the import was more slippery. Wallinger was seemingly transitioning, feeling his way towards a shift in emphasis and articulation.

Untitled (1994) similarly touched on matters mortal, and in fact Wallinger felt able to take on this work about loss because he had made the Cooper piece. The painter and filmmaker Derek Jarman had recently died of an AIDS-related illness, and Wallinger was invited by the Richard Salmon Gallery in West London, housed in an elegant building where Jarman had maintained a painting studio, to make a piece of work specific to his stilled workspace. Alongside what he discovered there (a primed canvas, paint pots, the artist's overalls, an open casement window), Wallinger also found, in the dealer's office, a baby grand piano. He moved it into the studio. 'I hired a piano tuner to tune the piano, and recorded the sound. This seemed to be achieved by playing a succession of descending thirds, so it has a mournful quality. And then there's the cranking noise of loosening or tightening the strings. This was then played back on four speakers, so that the sound appeared to be coming from the piano, but with the lid of the keyboard shut.'

Untitled, then, augmented illusionism with dark tones: physical pain, departure, absence, austerely and understatedly addressed. The photograph of the installation published in the catalogue of his 1995 Ikon/Serpentine Gallery solo show was accompanied by W. H. Auden's 1938 poem 'Musée des Beaux Arts'.[5] It reads, in part:

Opposite
Regard a Mere Mad Rager, 1993
Video on monitor, mirror
Dimensions variable
Installation view at City Racing,
London, 1993

Above
Video stills

About suffering they were never wrong,
The Old Masters; how well they understood
Its human position; how it takes place
While someone else is eating or opening a window or just walking
 dully along

These works, exposing Wallinger's own reflexive attitude to his practice and fail-safe awareness of when it is running over familiar ground, presaged a phase of culminations and new beginnings for the artist himself. In 1994 and 1995 he made eight 'question' paintings entitled *Q1, Q2, Q3,* etc., which he describes as 'a valediction to painting'.[6] He had become increasingly conscious that 'paintings are the most transferable, exchangeable tokens in the art world.' The *Q* canvases, in this smooth commodity context, bristled grumpily. They spoke back, the object interrogating the subject, asking what their maker calls 'the sort of bad-tempered questions you'd have at the end of a relationship. And then,' he continues, 'it was quite a nice task to try and frame those questions within the means I had available to me.'

Reflecting Wallinger's interest in word games and satisfyingly natty formal solutions, this meant fitting a 25-letter question into a 5 × 5 grid of squares in each case, an overt play on Jasper Johns's grids of letters and numbers (and featuring faux-expressive dribbles). 'Do I have to spell it out for you', read the first one. 'What have I done to deserve you', lamented the last. Intended to be even more final, and again reversing the terms of the gaze and the notional passivity of the artwork, was *My Little Eye* (1995), which marked a continuation of Wallinger's preoccupation with perspective. Positioned at the very centre of this academic gilt-framed self-portrait was its subject's left eye, which was replaced – as in the device of putting a spy hole in the eyes of a portrait – with, as the title suggests, a glass eye. ('It's almost sad that painting is best viewed with one eye; it denies something about our nature,' adds Wallinger.)

The solo exhibitions held during 1995 at Birmingham's Ikon Gallery and the Serpentine Gallery in London were a marker that Wallinger had, so to speak, 'arrived'; another was his inclusion in the British Art Show, which every five years aims to freeze-frame cultural production in Britain. A third, later the same year, was his nomination for the Turner Prize. After this string of acknowledgments, the next year was a time for change and Wallinger moved out of the studio he had worked in for the preceding ten years. 'I moved to [South London studio complex] Delfina, shifted a lot of stuff into storage rather than cluttering up a new space, and I thought, OK, let's start from this point.'

Up until then, and particularly in the years of *Capital* and the horse-racing work, Wallinger had regularly satisfied his work ethic by setting up projects that would require him to put in a day's labour. Now he changed his methods. 'It was a new beginning. Whatever habits or comforts the work ethic confers, it can't wait idly by for an idea that may never arrive … I had to break that mindset. Just as a facility or talent can be a trap, so too with the need to feel productive – to have something to show for a day's work. I would still come in every day and put in the hours, and, if at the end of the day I had half a notion that I thought might last more than a week or so, I wrote it down and stuck it on the wall. After a while, I was getting a new, or different, kind of momentum. I didn't feel any tremendous urgency to produce a body of work. I was more interested to see where I was going at that point.'

Freed from the inner imperative to work with his hands, Wallinger began out-sourcing production. *Man United* (1996), made during this period, is a giant scarf in the colours of the football team Manchester United, titled after the familiar diminutive of the team's name and produced by the fabric department of Central

Untitled, 1994
Installation with piano and recorded
sound in Derek Jarman's studio,
53 South Edwardes Square, London

Overleaf and following pages
Q, 1994–95
Acrylic on canvas
Each 218 × 218 cm
(86 × 86 in.)
p. 90 (top to bottom)
Q1, Q2
p. 91
Q3, Q4
p. 92
Q5, Q6
p. 93
Q7, Q8

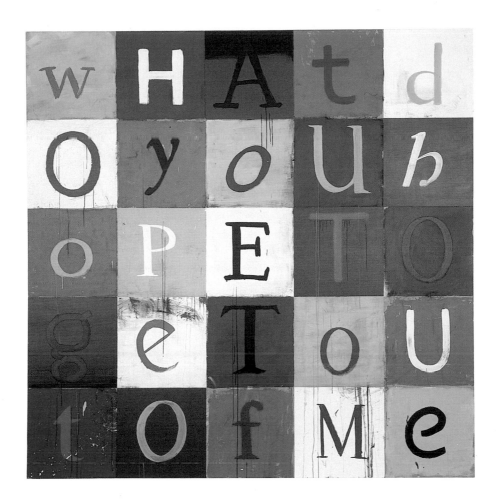

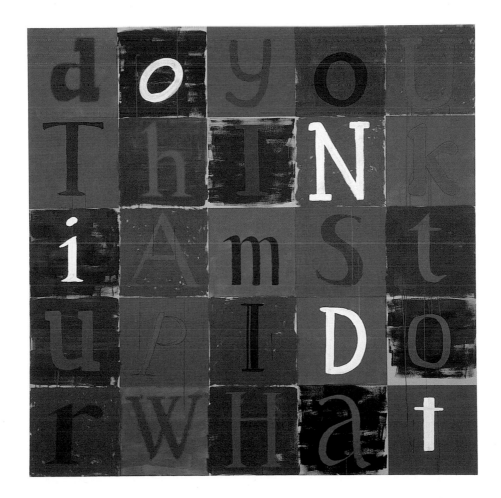

Why Did These Things For You

What One Heart Do You Take Me For

WhY SH
OULd i
giVEy
OUaNy
tHIng

wHat h
VE iD
ONTO
deseR
Veyou

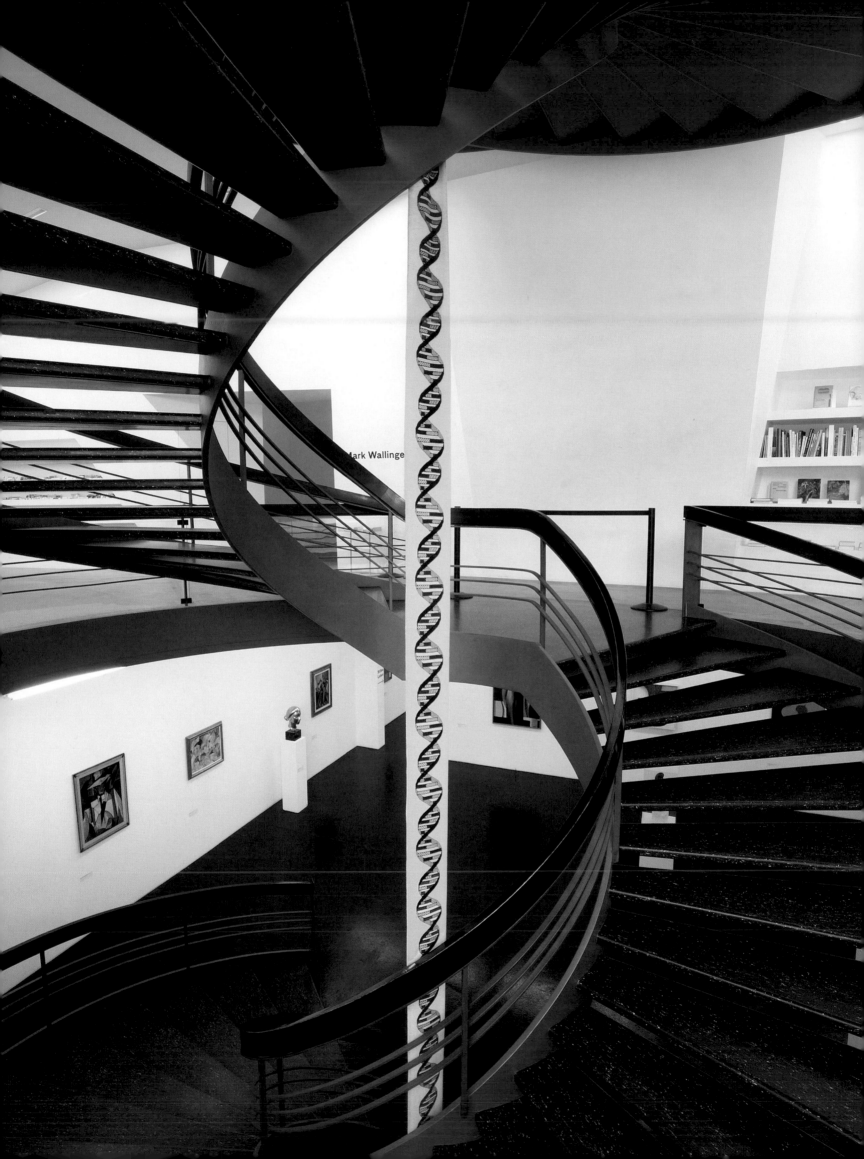

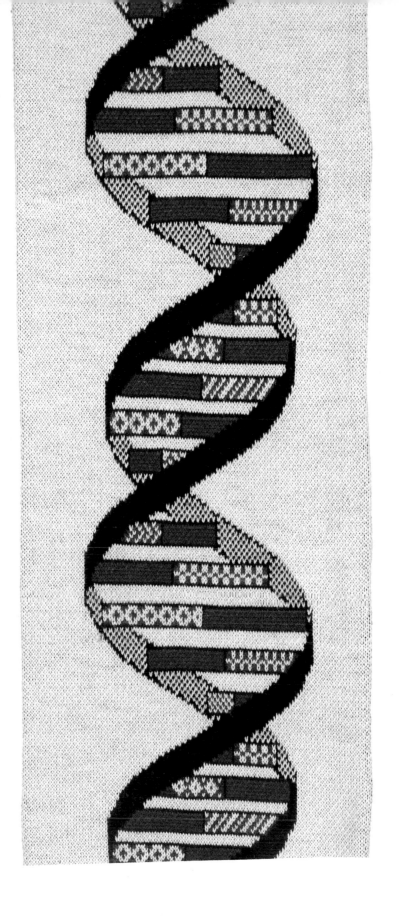

Opposite
Man United, 1996
Knitted acrylic scarf
22.9 x 1,524 cm
(9 x 600 in.)
Installation view at Aargauer
Kunsthaus, Aarau, Switzerland, 2008

Above
Detail

St Martins College of Art and Design in London. Featuring the double helix woven into its fabric – the pattern is a model of simultaneous separation and connection, being composed of two long polymers running in different directions to each other, joined by ester bonds – the work is, says Wallinger, 'a terrible pun: *Man United*. DNA is the stuff we're all made out of, but we can't all support the same human race.' But it was a hands-on production that spoke more definitely to where Wallinger was headed next.

Autopsy (1996) is something of a visual conundrum – though one ripe with cues – and also, characteristically, an airtight formal system. It is a second-hand table, three of whose legs have been sawn down. But the table still stands, propped up as it is by differently sized stacks of scriptural commentaries. Its three sawn-off sections stand upright on the tabletop in an ersatz crucifixion scene or schematic altarpiece, with the largest in the middle. In a sense this is another evocation of absence, and of a threshold experience. One might have all the interpretative knowledge in the world regarding the scriptures, *Autopsy* suggests, but the vital and unquantifiable ingredient, that which blindsides the intellect, is religious faith. Assessed from many angles, this fundamental facet of the value systems that shape, unite and divide cultures and individuals would be the defining focus of Wallinger's art for the next four years – highlighted by one of the most remarkable, and most emphatically public, artworks of his career so far.

My Little Eye, 1995
Oil on canvas, glass eye, frame
75 x 75 cm
(29½ x 29½ in.)

1. Further, as Jon Thompson argues, 'there is a curious and palpable ambiguity about these figures, a feeling that they are acting out their role for us, the audience, at the behest of an invisible control.'

2. Although *State Britain* (2007) would later suggest that after he put those cudgels down, Wallinger remembered where he'd left them.

3. This notion has proved to be a golden thread in Wallinger's career, and *Fountain* could be classed as his first public artwork.

4. After attempting to make up a phrase that reads the same backward and forward himself, the artist resorted to a compendium.

5. The poem was inspired in part by the painting *Landscape with the Fall of Icarus* in the Musées Royaux des Beaux-Arts in Brussels. This painting (long thought to be by Pieter Brueghel, though now that attribution is seen as doubtful) would be referenced by Wallinger again (see p. 190).

6. It was hardly to be the last of these; Wallinger has perpetuated his extended endgame up until the time of writing.

Autopsy, 1996
Wood, books
115 x 122 x 61 cm
(45¼ x 48 x 24 in.)

THREE

Questions of Faith
(1997–2002)

'After the Cold War it seemed to me that religion would define the new world order. In a way, the bigger revolution wasn't the Berlin Wall coming down; it was the Ayatollah returning to Iran.[1] It was already looming, and I thought: let's have a look at Christianity. We sense it is where our ideals and morality come from: how far is that true? How far does it still influence our thinking, and what is this desire, still, for transcendent meaning?'

One might draw two intertwined conclusions from this statement. The first is that what looked, in the mid- to late 1990s, like a turn in Wallinger's thinking towards matters religious might better be framed as a modulation, a furtherance in disguise, even a honing. (And also, as geopolitical events in subsequent years have borne out, a demonstration of impressive foresight.) After a dozen years of focusing primarily upon what serves to configure mindsets in his home country – the ineluctable DNA of national character – he now considered its ostensible roots in Judaeo-Christianity. The second is that Wallinger's inquiry was to be predicated on expansive, secular terms, not on belligerent anticlericalism.

For those who had tracked his art closely, there had been auguries. The Ayatollah Khomeini had made a cameo appearance in his work in 1990, in *We Know What We Like*, a gathering of seven framed pencil drawings commissioned from a street artist, evoking domestic shrines and stressing the significance of personal investiture in a figurehead. (Among the other sketched subjects are Benazir Bhutto, who in 1988 became the first woman elected to lead a Muslim state, and Nelson Mandela, then still imprisoned.) In 1988, the artist had made *Heaven*. And earlier works had carried a residue of religion. The fact that *National Trust* (1985) was presented as a set of cruciform-shaped works reflected Wallinger's awareness of the key role of noncon-formist religion in shaping oppositional radicalism (for example, the Diggers' desire to seize the land and own it in common); the prominent presence of the word 'Jerusalem' here and as a spray-painted slogan in the early body of work alludes to the idea of a 'New Jerusalem' on Earth.

'It was inevitable,' says Reynolds of Wallinger's new emphasis. 'It was bound to be. Questions of the relationship between illusion and belief, and different definitions of faith, are there from the start in terms of his doubts, his mixed feelings about class and social structures.' But if this was accordingly a movement towards the core of his concerns – what one believes in and why – it was a conflict far from home that really

Opposite
We Know What We Like, 1990
7 framed drawings, plastic
shelves and brackets
198 x 220 x 37 cm
(78 x 87 x 14½ in.)

Above
Detail

reinforced his decision to stress religion, one that would inhere in *Ecce Homo* in 1999: the war in Bosnia and Herzegovina between 1992 and 1995, the euphemistic 'ethnic cleansing' of Croats and Muslims by (primarily) Serbian forces, and the West's belated intervention. 'Bosnia brought home how little we knew, and how hopeless we were in that situation,' says Wallinger. 'And it was almost as if Islam, there, was the secret ingredient that we couldn't factor or understand.'

Wallinger was raised by parents anxious not to impose any particular religious belief. His exposure to the interiors of churches, he recalls, had mostly been through being a Cub Scout. His most substantial exposure to Christianity per se had been via aesthetics, through a love of devotional art from Giotto and Donatello onwards – 'there's no way you can look at that work without some working knowledge of the scriptures' – and literature, particularly Graham Greene's Catholic convolutions and, of course, James Joyce. Indeed, Stephen Dedalus's characterization, in *Ulysses*, of Ireland as a servant of both England and the (Roman) Church, tidily summarizes Wallinger's twin models of cultural definition up to this point. Nevertheless, as the artist points out, to be raised in a Christian country where religious principles underwrite the system of laws and, accordingly, conceptions of morality, is inevitably to be conditioned. 'I'm an atheist,' he says, 'but I'm a *Christian* atheist. Yet that might still make my view of the world entirely different from that of a *Muslim* atheist. And from that, I think, followed disasters in Iraq and Afghanistan. It's not quite a failing of the imagination, but simply that there isn't a way that this world can see that world in any way that's useful to it.' In short, if Christianity latently determines what the British people are, here are the effects of that cultural composition writ painfully large.

Fittingly, the first major result of this thinking was realized via a kind of providence. The BBC invited Wallinger to make a short film, offering a small budget: the result was *Angel* (1997), the video in which he debuted the character who would reappear intermittently in his art during the following three years, 'Blind Faith'.[2] *Angel*, like *Autopsy*, on one level addresses the distinction between faith and intellectual knowledge. 'You can literally learn the scriptures backwards, and that's not necessarily going to make you believe,' says Wallinger, who has known true believers.[3] For *Angel* Wallinger learnt phonetically backwards the opening of the Gospel of St John. Using a tape recorder to play his recitation in reverse, increment by increment, he devised a phonetic notation, an 'un-language', which took three months to master. He planned to recite the text on an escalator at a Tube station, and, after negotiations with London Underground, was invited to spend a Monday afternoon filming at – of all perfect places – Angel, in Islington, which boasts the longest escalators in Western Europe.

Dressed in nondescript black trousers, white shirt and black tie, wearing dark glasses and sweeping the air before him with a white stick, Blind Faith appears at the base of the central escalator. He is on the bottom step, but as the stairs rise behind him he has continually to step forward to stay in place. As he does this, Blind Faith recites: 'In the beginning was the Word, and the Word was with God, and the Word was God …' – which Wallinger says he has always found 'fascinating and beautiful'. Meanwhile, on escalators flanking him, commuters travel up and down, but those going upwards are walking backwards, face out, and vice versa. If this was not enough to tip one off that the video is running backwards, Blind Faith's garbled speech – which, usefully, sounds something like speaking in tongues – surely is.[4] The triangular composition that the fixed camera angle records is structured like a Last Judgment or an Ascension. At the video's end, to the grandiose chorale of Handel's *Zadok the Priest*,[5] Blind Faith stops walking on the spot and is carried upward by bluntly mechanical means, facing us as he goes.

Anglicanism, Wallinger notes, is something of an apologetic religion, a polite one, particularly when compared to, say, the very public events of the Islamic revolution, which took place on the street, or when one travels around Europe and sees representations of saints on every corner. With this work and its successors, his procedure was to drag a nation's religion from periphery to centre, to show in all its incommensurable registers that which has so decisively patterned the people of these isles – its mysteriousness, its dogmatism, its succours, its practicality (as Wallinger notes, 'the pattern of life has its punctuation points, which religion does take care of pretty well'), and the cultural beauties it has brought forth: the great art, the classical music.

Blind Faith is a concatenation of discomfiting facets. He's part street preacher – the one situation where religious fervour erupts in public – and part motivational speaker, recalling what Wallinger describes as 'those frightening people who think they're being a bit more informal by removing their jacket, but they've still got the tie on'. In *Angel*, the sacred language he speaks is punctuated by religious music and unlikely echoes of ecclesiastical iconography found on the Underground; yet profound thought isoffset with antic wit. The video is the Wallinger artwork of choice for the artist's American dealer, Donald Young, for compounded reasons: 'The references, the site, and the sheer wackiness of the idea.' *Angel* takes the central credo of revealed religion (God's messenger delivering the Logos, the Word), and by mobilizing an illusion – the video's reversal – has it disintegrate as you watch, in stark contrast to the efforts religions make to discourage the unraveling of their illusions. Wallinger, as ever, will not be party to lasting deception. Is it any coincidence that he was such an admirer of Tommy Cooper, whose entire career was based on letting viewers see through his tricks?

HIGH PLACES

It is later in 1997, and Wallinger is again dressed as Blind Faith, standing on a milk crate on Primrose Hill, North London, sucking an 80/20 mix of helium and oxygen through a breathing apparatus attached to a canister, and singing in a resultantly high-pitched, queasily comical voice. Again, the seams are shown. The song is a Victorian hymn, 'There's a Friend for Little Children' by Albert Midlane and John Stainer, intended to console bereaved parents in that era of high infant mortality:

> There's a Friend for little children
> Above the bright blue sky,
> A Friend who never changes,
> Whose love will never die;
> Our earthly friends may fail us,
> And change with changing years,
> This Friend is always worthy
> Of that dear Name He bears.

As he sings, Blind Faith holds a helium balloon bearing the face of Wallinger as a child: in the circumstances, perhaps the only child's face that could have been used. When the song ends, he releases the balloon and it floats away. He does it almost derisorily, with a push, emphasizing the menace that this character exudes: such blatant attempts at communicating on a child's level, in a creepy pseudo-childish voice, engender an unavoidable subtext of abuse.[6] But as much as *Hymn* is veined with anxieties about the priesthood and its inculcation of the unknowing young, the song itself lifts it into more expansive territory. For the idea that there is a 'friend in the sky' for one's lost child must surely have been a comfort in Victorian times,

Above
Mark Wallinger's notebook for *Angel*

Overleaf
Angel, 1997
Installation for video projection, audio
7 minutes 30 seconds
Video stills

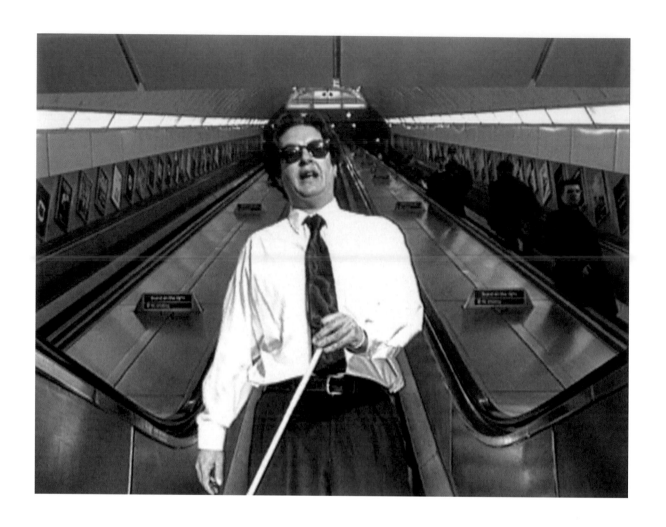

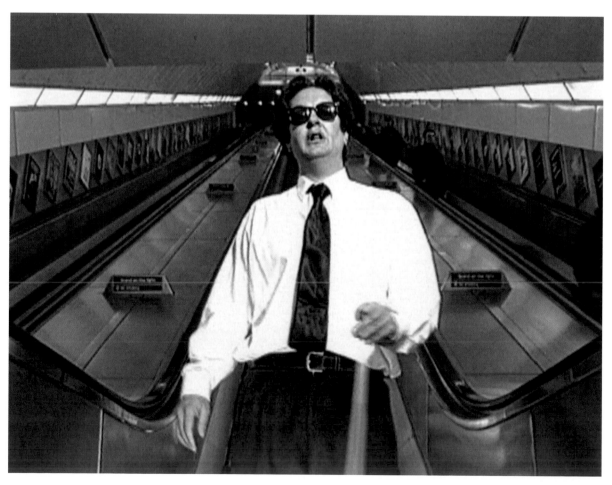

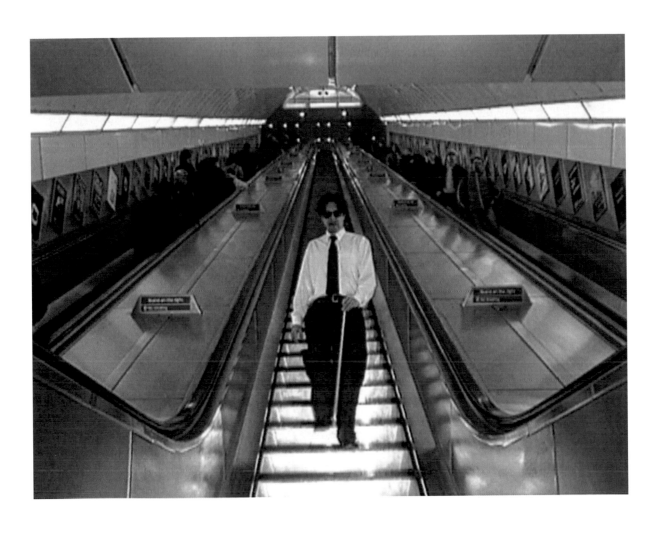

and religion remains a consolation to many. The discomfort created by the work is heightened by these unresolved contradictions.

It is also significant that, just as the urban subterranean milieu was the setting for *Angel*, London here spreads out behind Wallinger as he stands and sings at one of the city's most elevated points. He would return to the theme of spiritual questioning within this urban environment: the text *Mark Wallinger is Innocent* (1997), for example, filled the window of Anthony Reynolds Gallery for Wallinger's exhibition 'God', but was also fly-posted around London (see pp. 2 and 288). 'It harked back,' he says, 'to the "George Davis is Innocent" campaign of the mid-1970s in London, for the release of the convicted armed robber. These were often painted above bridges, and some of them you can still find. I liked this notion of innocence, and how localized, or final, or religious, or metaphysical it can be. If someone claims himself or herself to be innocent, does that debase the claim? I also liked the fact that it's a bit like leaving a sign on a shop saying "back in five minutes". We don't know when the five minutes started. Maybe you were innocent at the time, but not now.'[7]

In this conflation of the mystical and the metropolitan – something discoverable on the street that expands to cosmic levels of inquiry – we might observe the Joycean conception of worldly epiphany that permeates Wallinger's art. 'Even if you don't get the Christian uplift from the idea of the Word being made flesh, the Good News being given to people,' he says, 'there might be those kinds of little epiphanies available to people if they sharpened up their vision, or saw things in a broader light.'[8] Such pragmatic thinking, reflecting upon the fact that within the human organism is a fundamental desire for transcendent meaning, is at the heart of Wallinger's engagement with spirituality. That selfsame desire is the wellspring of faith, but it is non-denominational. For atheists it may be satisfied in the world, in marvellous flashes. For others it may be met by belief. Wallinger does not except himself from this: *Upside Down and Back to Front, the Spirit Meets the Optic in Illusion* (1997), the bottle of mysterious, soul-like essence discussed at the outset of this book, admits as much.

Note that Blind Faith has no need, or no ability, to see the 'real' world. Considering faith led Wallinger, with his propensity for punning, to further conflate vision with sight – which led him in turn, as the idea of a workaday ascension led him to an escalator, to the quotidian place where vision is 'corrected', the optician's. *Seeing is Believing* (1997) features a triptych of light boxes. In the centre is an eye chart of steadily shrinking letters which, when read, spells out the opening of St John's Gospel that Wallinger had recited in *Angel*. On either side are red and green squares inscribed with concentric black circles, as if the whole were testing for long- or short-sighted-ness,[9] colour-blindness and faith simultaneously. The same colours are used in 3D glasses to conjure space from a two-dimensional image, but the triptych form suggests a highly schematic version of a Last Judgment painting in which red and green represent hell and heaven.

As with *Autopsy* and *Angel*, *Seeing is Believing* situates the national religion in the everyday and traces a divide between those for whom the scriptures remain myster-ious, or only intellectually comprehensible, and those who understand them in their bones and act upon them. Religious division may be the root of much violence and unpleasantness, Wallinger suggests here, but it is each side's failure to grasp the other's perspective that sustains sectarian conflict – that, and the fact that individuals define themselves through their beliefs. He had addressed this point earlier, touching on religious dispute via nationalism, in *Oxymoron* (1996): an 'impossible' flag in which the red and blue of the Union Jack are replaced by their complementary colours, the green and orange of the Irish tricolour (see p. 129). 'That,' says Wallinger, 'seemed

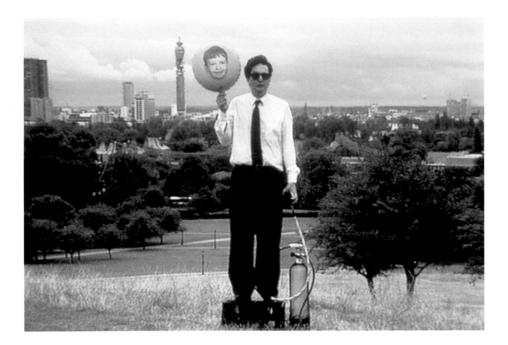

a nice optical way of describing how there is no common ground, no grey area, when your identity is predicated on being opposite to the other.'

The optician's chart in *Seeing is Believing* also seeded another project. For *On an Operating Table* (1998), Wallinger got permission to film in the brain-surgery theatre of King's College Hospital in Camberwell, South London. He elected to video the powerful lamp above the operating table, whose surrounding frame makes it look like an eye. Shooting as usual in a single take, Wallinger and his cameraman tinkered with the focus pull and the light dimmer, the resultant modulating light resembling what you might see while 'going under', or coming to. The dilating of the 'eye' is meanwhile underscored by the soundtrack, which consists of Wallinger's recordings of 'a nicely international mix of people' reading the lines of St John on his optician's chart. The sound was shaped into different timbres in postproduction, as if heard at the edge of consciousness.

This scenario, then, impishly conflates reading the Bible, 'seeing the light', having one's vision corrected, and being drugged.[10] Besides being a speculative site of passage between life and death, *On an Operating Table* is also, says Wallinger, a nod to the famous line in the Comte de Lautréamont's influential prose poem, *Les Chants de Maldoror* (1869): 'As beautiful as the chance encounter of a sewing machine and an umbrella on an operating table.' 'Maybe,' says the artist, 'it's all some terrible accident – or a happy accident – that we're here at all.'

THROUGH THE GATES

Such was Wallinger's fluency in video by this time that *On an Operating Table* was only one of three subsequently exhibited works he shot *on the same day*, although the other two would not be shown until 2000. That morning, he had gone early to London City Airport and made perhaps the most expansive of his transpositions of state religion onto an everyday milieu. *Threshold to the Kingdom* (2000), like *Angel*, hinges on two meanings of 'transport' (in the vehicular and spiritual senses) and two meanings of 'kingdom' (heavenly and terrestrial). Here, a fixed camera is trained upon what is literally the gateway to a kingdom, the United Kingdom: the electric double doorway through which travellers pass into the International Arrivals hall. The footage is slowed – *Threshold*, Wallinger admits, was in part a rebuke to the presumed

Hymn, 1997
Installation for video projection, audio
4 minutes 52 seconds
Video still

I

NT

HEB

EGIN

NINGW

ASTHEW

ORDANDTH

EWORDWAS

WITHGODA

NDTHEWOR

DWASGOD

Seeing is Believing, 1997
Screen printed light boxes
3 parts, each 127 x 127 x 20.3 cm
(50 x 50 x 8 in.)

On an Operating Table, 1998
Installation for video projection, audio
13 minutes
Video stills

Above
Threshold to the Kingdom, 2000
Installation for video projection, audio
11 minutes 20 seconds
Installation view at Milan Cathedral,
2004

Opposite
Video stills

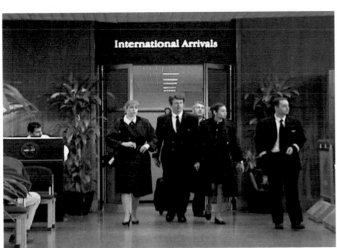

gravitas of Bill Viola's decelerated videos, 'the possibility of ordinary people's actions being transfigured rather than actors pulling faces' – and the soundtrack is Italian composer Gregorio Allegri's *Miserere,* a setting of Psalm 51 composed, it is thought, in the 1630s. The psalm is a plea for forgiveness and cleansing from a merciful God; in this worldly context, however, the meaning is reframed. While the music and the dreamy pacing suggest figures attaining some kind of heavenly afterlife, *Threshold*'s setting pointedly fuses the judgments of religious and state authority.

Wallinger, who had endured a lifelong fear of flying up to this point, had managed to identify that 'it was airports I was frightened of, not the plane. It was that incredible scrutiny, the state examining one, which you don't feel anywhere else. The powerful relief you feel when you finally reach home, or the state you're hoping to reach, seems rather like confession and absolution.' Such experiences, *Threshold* implies, reflect how far our daily experience is tinted by Judeo-Christian conceptions of judgment from above, by an abstract authority, and, perhaps, how a citizen's innate sense of existing under an omniscient gaze might reinforce the ambient power of the state. In this sense, CCTV, whose impersonal product this footage resembles, might be the eye of God (another link to *On an Operating Table*), and Wallinger's planting of a camera in the arrivals hall functioned as a kind of speaking back to power. Nevertheless, it is notable that here again Wallinger addresses the paradox that Christianity, which may be founded on untruth and has caused such conflict throughout history, has given us our richest and most enduring art. Allegri's ecclesiastical music, a closely guarded secret of the Vatican until a teenage Mozart notated it from memory, is staggeringly beautiful, and, says Wallinger, probably his ultimate Desert Island Disc.

Fly (2000) is the third film Wallinger shot that day. Eleven minutes long, it offers a static view through a window towards the blue skies, with a macabre corpse dead centre as its focal point. 'There was secondary glazing in our flat, and one or two flies spent their entire life cycle between these two window panes. This one had died and become atrophied, stuck to the glass. And we were under the flight paths of Heathrow and City Airport, so there are planes going past, and this dead fly: *Fly.* Terrible irony. The absurdity of this word that can apply to both that small creature and the plane … It's odd to think of tonnes of metal being more animate than this little fly. It's that

Above
Fly, 2000
Video on monitor, sound
11 minutes 34 seconds
Video still

Opposite
Credo I, 2000
Ink printed on paper
225 x 150 cm (framed)
(88½ x 59 in.)

Overleaf
Credo II, 2000
Ink printed on paper
225 x 150 cm (framed)
(88½ x 59 in.)

The eye is not satisfied with seeing, nor the ear filled with hearing

Ecclesiastes 1.8

He that eateth my flesh, and drinketh my blood, dwelleth in me, and I in him

John 6:56

stretch that I like.' The video condenses about six hours of footage so that distant planes routinely glide across the framed airspace; elsewhere, a baseline of action is provided by a live fly coming to investigate its dead cousin. The soundtrack further details what is 'on the air' at the time, in the form of radio and television waves: three or four radios tuned to different stations, and Wallinger's television, provide a babble of voices from the ether. Leavening potential solemnity with deadpan humour, *Fly* muses upon the impulse to look up and wonder: that unquenchable human curiosity about what, beyond radio signals and aeroplanes, is out there in the heavens.

Wallinger would revisit and finesse some of these works' themes. His thoughts about the intersect between faith, vision and language, for example, would find their most economical articulation in *Credo I* and *Credo II* (both 2000), in which biblical quotes from Ecclesiastes 1:8 ('The eye is not satisfied with seeing, nor the ear filled with hearing') and John 6:56 ('He that eateth my flesh, and drinketh my blood, dwelleth in me, and I in him') are printed in offset pink and blue ink on paper: put on the appropriate (i.e. stereoscopic) glasses, and the language jumps off the wall, becomes 'miraculous'. 'These works speak of a desire to become one with God that cannot be comprehended nor trusted fully through the senses,' Wallinger observes, 'and of a hunger that is only satisfied through transubstantiation.'

Wallinger would also return to his earlier preoccupation with sport in *Cave* (2000), made for his solo exhibition at Tate Liverpool. The title alludes to Plato's Allegory of the Cave in *The Republic*, in which prisoners perceive reality only from the shadows cast on the wall of a cave. The work plays back, at a quarter speed, footage of one round of a boxing match, shot from the four sides of the ring. Each projection is given one wall: the fourteen-minute result, visceral yet beautiful, is an exploded view, at once from the centre of the ring and outside of it. The contrived violence becomes mythic and the sound primeval. Meanwhile, from 1998, Wallinger had been planning a larger project, one wherein his main preoccupation would pointedly go public.

Cave, 2000
Installation for 4 video projections, audio
14 minutes
Each projection 300 x 600 cm
(118 x 236 in.)
Installation view at Tate Liverpool, 2000

ONE MAN IN A SQUARE, PART I

Standing in the northeast corner of London's Trafalgar Square, the Fourth Plinth was built in 1841 as a pedestal for an equestrian statue of William IV, who did not leave enough money in his will to pay for it. Arguments about what should go there ended in stalemate, and until 1999 it remained almost exclusively unoccupied. In the late 1990s, the Royal Society of Arts conceived a project wherein the plinth would be occupied, for months at a time, by a single contemporary artwork, the most popular proposal to become permanent. Of the initial three commissioned – by Wallinger, Bill Woodrow and Rachel Whiteread – Wallinger's was set to be first, in 1999, and to run over the millennium.

'Ecce Homo,' he recalls, 'was the most instant idea I've ever had. It had been obvious for quite a while that successive governments were uneasy with proclaiming or celebrating 2,000 years of Christianity, given that Britain is a multicultural society; the Millennium Dome was a huge diversionary tactic. And I did say at the time that my intention was to make Christ or Christianity as other, or threatening, or strange as Islam is to a lot of people in the West.' Indeed, such is the 'apologetic' nature of religion in Britain that there has been no public religious statuary since the Reformation, and so merely the presence of Christian iconography on the streets would have been a step into unfamiliar civic territory. But Wallinger had a larger dynamic in mind, and planned to make the work resonate in the present. He chose a subject that had been underplayed in Christian sculpture, perhaps because it is oddly undramatic: Christ placed in front of the people by Pontius Pilate for judgment, portrayed with his eyes closed, turned inward; the moment when he faces up to his destiny.

Ecce Homo, a body cast made from white marbleized resin, achieves a level of verisimilitude impossible via carving. It is a realistic Christ with bowed shaved head, hands tied behind his back, and a gold-plated crown of thorns made from barbed wire, and, as the title ('Behold the Man') reaffirms, a *human* Christ, a Christ of modern times. As such, it mobilizes the audience who stand in a Trafalgar Square, traditionally the site of large public assemblies, and makes them judges of a figure accused of religious zealotry, putting them in the place of those who would condemn Christ to death. This was the site of the original Charing Cross, the centre of London from which all distances were measured, and where public executions used to take place. Since 1675, the location has been occupied by the equestrian statue of Charles I; himself beheaded in Whitehall in 1649.

But Wallinger was minded of a more recent civil war. 'The work was conceived not that long after Srebrenica [where, in July 1995, some 8,000 Bosnian Muslims were killed in cold blood by the Serbian army; the ghastliest massacre on European soil since the end of the Second World War]. And that was entirely to do with nationalism, religion, bigotry: all the things that would have applied in Judea.' *Ecce Homo*, then, was at once Jesus Christ and a contemporary political prisoner, head shaving being habitually part of the humiliation. It dangled a question: are we going to condemn someone to death for religious differences? And it suggested, given how late the West acted on Bosnia, that in some ways we already had.

Despite his focus on religion, then, Wallinger had not ceased being concerned with 'the representation of politics and the politics of representation'. And yet *Ecce Homo* remained an intensely open work: one that, as he hoped, could resonate for Christians and non-Christians alike. 'I remember keeping away from the Square for a couple of months after,' he says, 'for fear of being spotted looking at my own handiwork, so to speak. The first time I went back, a Christian march that had come all the way from Iona [in the Scottish Hebrides] was winding up there. You could hear

Opposite and overleaf
Ecce Homo, 1999
White marbleized resin,
gold-plated barbed wire
Life size
Installation view in
Trafalgar Square, London

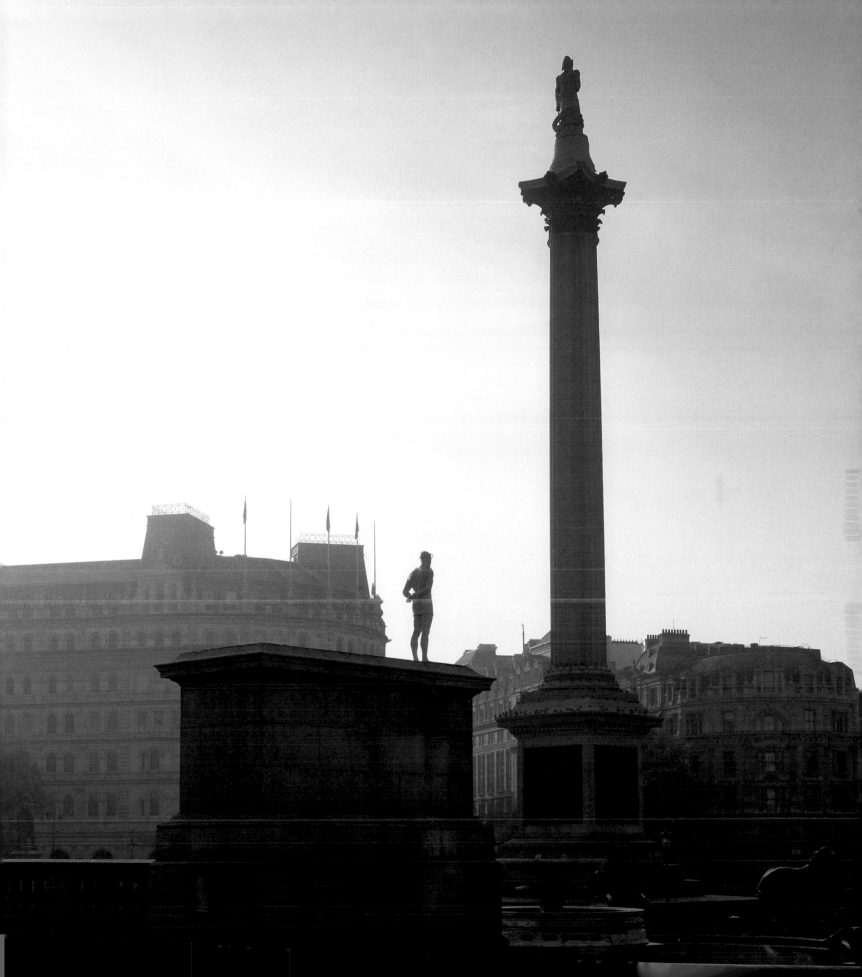

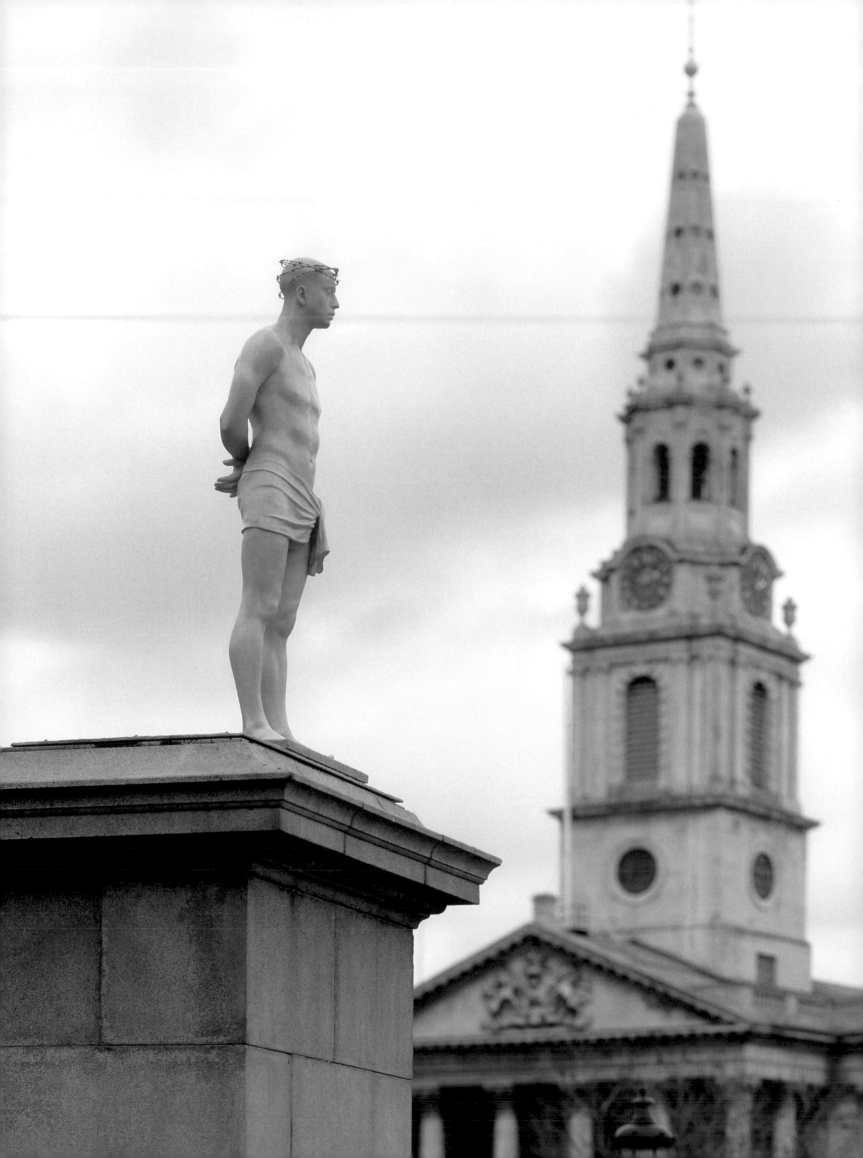

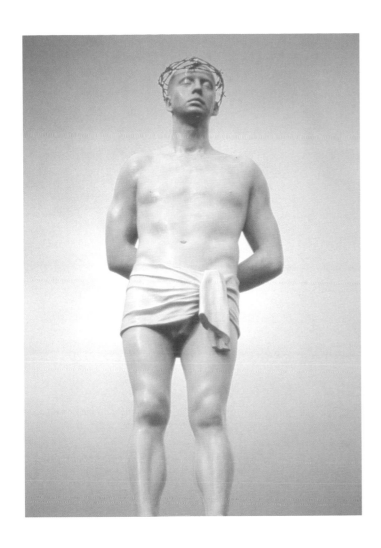

drums coming up Whitehall, and then three hundred Christians came into the Square, and went up to my statue and were given a sermon.'

Here, an artist who avowedly wanted his art to operate on viewers' subjectivities reached his largest audience yet, and met the challenge with a work that managed, brilliantly, to address the anniversary of Christ's birth without being a Christian work (and which, remarks Wallinger, marked the day of his birth by representing the day of his death). Moreover, *Ecce Homo* fulfilled his desire to make Britain's putative religion as public as possible, using the occasion additionally to comment on geo-politics, individual responsibility, and implacable cultural conditioning. If Wallinger had pursued belief in its religious mode only to make *Ecce Homo*, it would have been worthwhile.

KEEPING FAITH

As it was, he had more to say on the subject. In the consciously theatrical multipart installation *Prometheus* (1999), Blind Faith returns. On video, in the final part of what came to be designated the 'Speaking in Tongues' trilogy, he appears in his habitual costume but barefoot, strapped into an electric chair, singing Ariel's Song from *The Tempest*:

> Full fathom five thy father lies;
> Of his bones are coral made;
> Those are pearls that were his eyes:
> Nothing of him that doth fade,
> But doth suffer a sea-change
> Into something rich and strange.
> Sea-nymphs hourly ring his knell:
> Ding-dong.
> Hark! now I hear them – Ding-dong, bell.

Again, there is a blatant technical falsifying. Wallinger originally sang the words in falsetto, in the manner of English countertenor Alfred Deller, but then slowed the recording so that his voice becomes deep, gurgling, oddly aquatic. As he finishes the verse, however, the film is subjected to an accelerated rewind that turns his voice into a bloodcurdling screech, and the verse starts again. The endless video loop is aptly used. In Greek myth, Prometheus made a living human figure out of clay and stole fire from Zeus to give to mortals: he was punished by being chained to a rock and having his liver pecked out by an eagle for all eternity, the organ regenerating each day for further torture. Here, in a chain of associations, Wallinger links the Prometheus narrative – that of a character high-handedly assuming the right to bestow life – with the Frankenstein myth. The connection comes via Percy Bysshe Shelley, whose tombstone is engraved with lines from Ariel's Song and whose wife Mary wrote the gothic horror novel *Frankenstein: Or, The Modern Prometheus*, published in 1818. (Percy Shelley, Wallinger points out, was involved in 'Humphry Davy-type experiments[11] at university, sending kites up into thunderstorms'.)

The video segment of *Prometheus* was originally presented at the entrance to a mixed-media installation. Entering, one encountered a buzzing metal ring scaled to the Vitruvian proportions of Wallinger's own body. Screwed to the wall directly opposite and facing downwards, meanwhile, was the electric chair from the video. The room, one realized, had effectively been rotated through 90 degrees, the view through the metal hoop delivering a God's-eye view on a prospective punishment.

Opposite and overleaf
Prometheus, 1999
Video
Installation views at Portikus, Frankfurt am Main, 1999
Continuous loop video projection, audio, 2 photographs, metal, wood, leather, copper, foam, electrical equipment

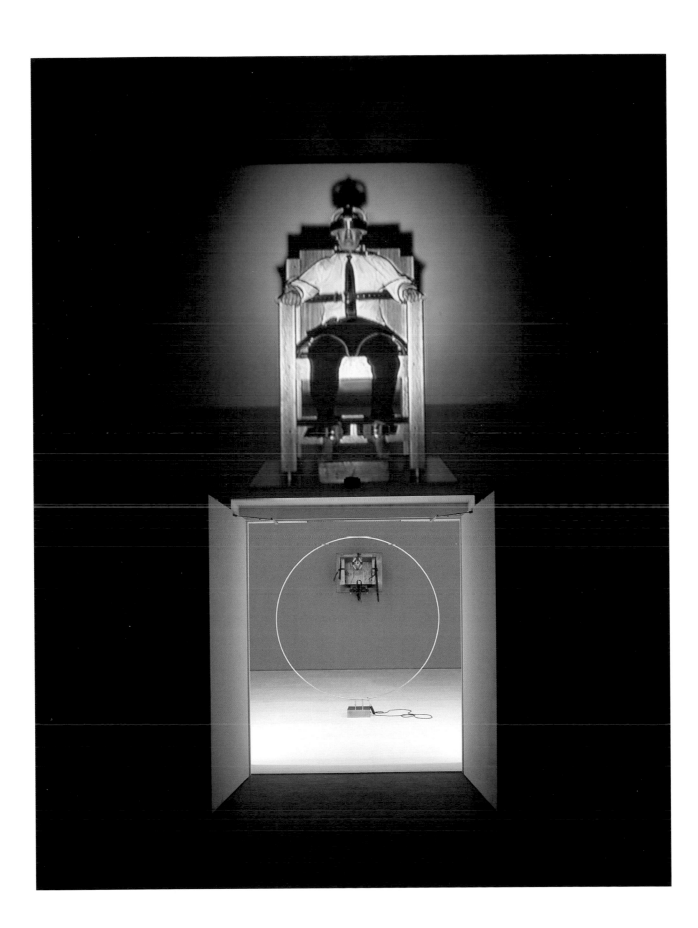

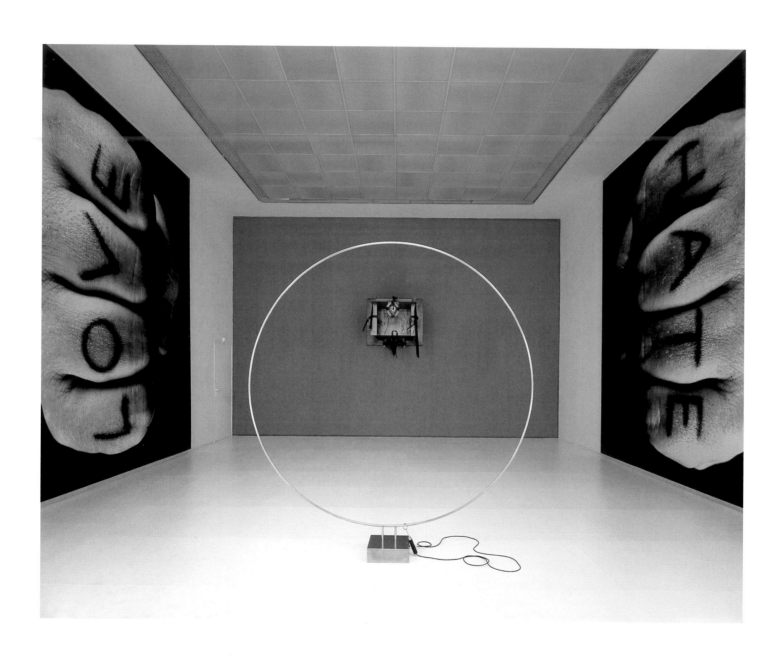

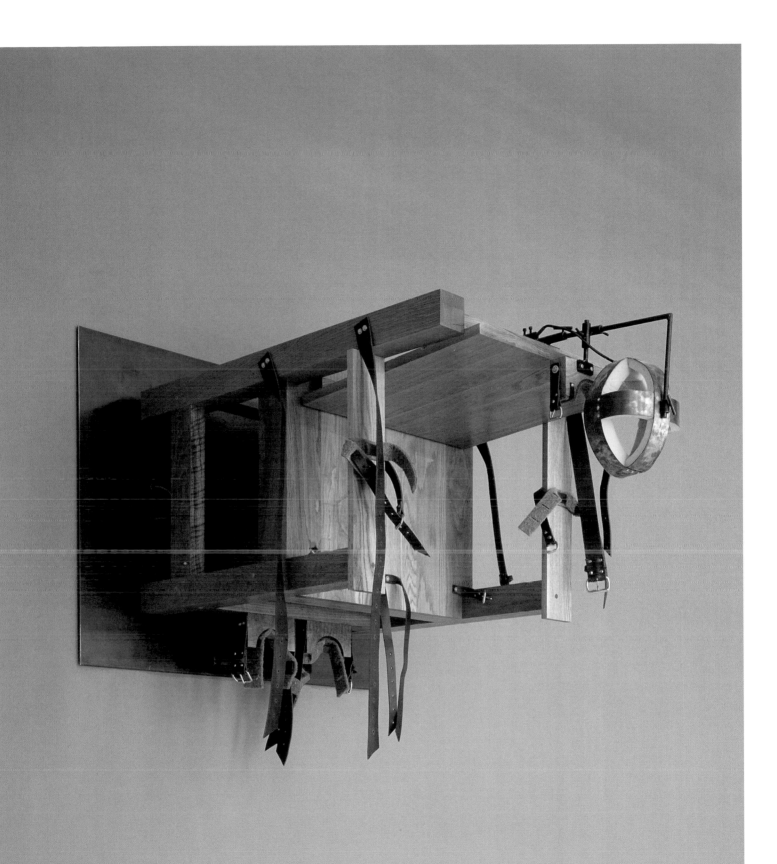

On the walls flanking the chair, and perpetuating the disorienting illusion, were two huge photographic close-ups of fists, one knuckle imprinted with the word 'LOVE', the other with 'HATE'. Those familiar with the 1955 film *Night of the Hunter* should recognize a reference to the tattooed hands of Robert Mitchum's serial-killer priest, Reverend Harry Powell, and *Prometheus* does concern itself with religion and retribution in America, home of both the Religious Right and the electric chair.

The chair in the installation was going to be a replica of Old Sparky, the Florida electric chair.[12] In the end it never arrived, so Wallinger commissioned Mike Smith Studio in London to make a replica of the Tennessee electric chair. By way of pointing out how fundamental is the American way of death, he mentions that 'Edison opposed capital punishment, but his desire to disparage the system of alternating current pioneered by Westinghouse led, ironically, to the invention of the electric chair – which he built for the state of New York to promote the idea that alternating current was deadlier than DC.' In *Prometheus*, then, Wallinger explores the paradoxical upshots of religious fervour: that religion might instil such an inflexible sense of right and wrong in a society that it would feel justified in determining whether humans should live or die. Playing God, in effect: precisely the usurping behaviour for which Prometheus and Dr Frankenstein were punished.

Prometheus, says Wallinger, is 'a rich stew'. Implicitly a commentary on the narrowing and arrogance that faith can occasion, it is in some ways not so far from *Ecce Homo*. Given the God's-eye view of a waiting throne of punishment, we are put in the role of arbiter, invited to interrogate the nature of belief and to consider how retributive justice is galvanized by the same force that gave life. *Prometheus* is also reflexive, the self-questioning that has pursued Wallinger throughout his career. Prometheus, in shaping man in clay, may have been the first sculptor, the first artist; *Frankenstein,* too, can be read in terms of the creative process. 'I guess every artist has to do their own version of that at some point or another,' Wallinger considers.

Is making art not, to some degree, playing God? He had, one should remember, just made a lifelike man, if not out of clay, then out of marbleized resin.

The figure of Blind Faith re-emerged for the five-part photographic series *The Word in the Desert* (2000), its title taken from T. S. Eliot's poem 'Burnt Norton' (1936): 'The Word in the desert / Is most attacked by voices of temptation'. In the opening two segments Blind Faith performs a couple of bluntly assisted 'miracles'. In the first, as he stands at Percy Shelley's tomb in the Protestant cemetery in Rome, the photograph is inverted so that Blind Faith appears to dangle like a vampire bat – and so that the lines from Ariel's Song on the poet's gravestone can be read. In the second, shot on a South London street, he appears to levitate in a star-shaped pose, standing with one leg out and being made symmetrical with the aid of a large mirror – a trick borrowed from the opening credits of English actor and comedian Harry Worth's self-titled 1960s television show. Wallinger, being Wallinger, had his photograph taken from a giveaway angle where his other real leg was still quite visible.

In the third photograph in the series, Blind Faith sits cross-legged, an ascetic or beggar, in front of the forbidding-looking entry to Camberwell's St John the Divine primary school. A piece of card in front of him reads 'Teach us to sit still': a quote from another Eliot work, 'Ash Wednesday' (1930), his first poem after his conversion to Anglicanism, which considers salvation in tentatively hopeful terms. In *The Word in the Desert V*, Wallinger's character walks up a road half-blocked by a painted *trompe-l'oeil* hoarding featuring an idealized perspective image of the rest of the street. It's as if the preacher has just walked out of paradise, via the open door at its centre (this time Wallinger did not even have to construct his own illusion-puncturing punch line), into the imperfect reality of South London. Inversion, mirroring, the enduring desire for transcendence amid the scruffily earthy: these dynamics were by now very much Wallinger's own. Yet still the goalposts keep shifting, for Blind Faith here is a character more rich and strange than ever before.

Opposite
The Word in the Desert II, 2000
Framed colour photograph
190 x 154 cm
(74¾ x 60¾ in.)

Above left
The Word in the Desert III, 2000
Framed colour photograph
190 x 154 cm
(74¾ x 60¾ in.)

Above
The Word in the Desert IV, 2000
Framed colour photograph
190 x 154 cm
(74¾ x 60¾ in.)

Above
The Word in the Desert I, 2000
Framed colour photograph
190 x 130 cm
(74¾ x 51 in.)

Opposite
The Word in the Desert V, 2000
Framed colour photograph
190 x 154 cm
(74¾ x 60¾ in.)

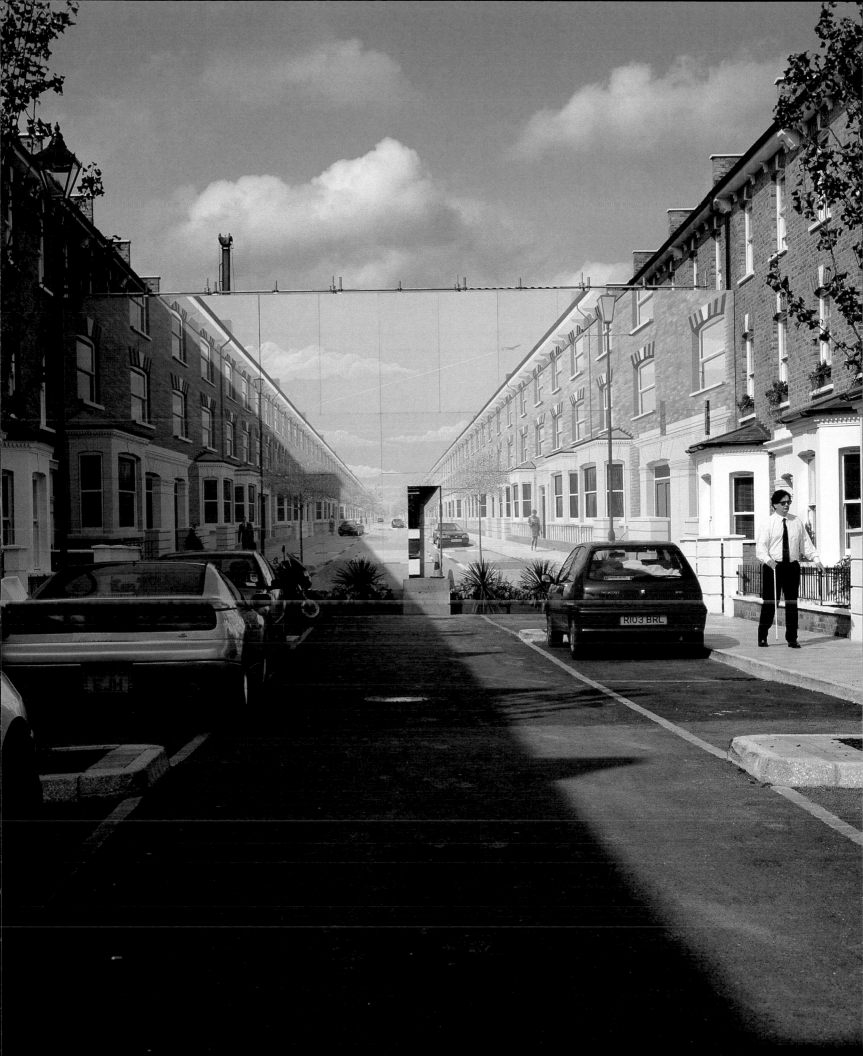

STRAIGHT LINES AND CORNERS

Throughout this time, and while his art emphasized one thematic line of inquiry, Wallinger continued to confound expectations. Between 1997 and 2002 he frequently operated contrapuntally, deviating consistently enough from matters ecclesiastical to remind audiences that religion, as subject matter, might be a symptom of something rather than a cause. What ties these works together is a gravitating towards interstitial sites and seams, towards notions of ambiguity and ambivalence. This is the point where what one might term Wallinger's *poetics* – his structural interest in what, in the subtitle to his 2008 curatorial project and book, *The Russian Linesman*, he would classify as *Frontiers, Borders and Thresholds* – begin to be focused. *Threshold to the Kingdom*, says Wallinger, marks the first time that this worldview had been so explicitly articulated in his work. From this point, while the religion-themed work continues, he accentuates pervasive patterns of division and liminality throughout what amounts to a school curriculum: geography, science, history, music, language …

In 1997, for the Jiri Svestka Gallery in Prague, Wallinger produced the installation *The Importance of Being Earnest in Esperanto*. 'That was a wonderful gift, really,' he remembers. 'I went to the Esperanto Centre, in [London's] Holland Park, which was run by some zealots for the cause. Alongside new but yellowing books for learning the language, they had a little section of VHS videos, and to celebrate the centenary of the publication of the language, they had a production of *The Importance of Being*

The Importance of Being Earnest in Esperanto, 1996
Installation for projected video, sound, found video, 100 chairs
2 hours 26 minutes
Dimensions variable
Installation view at Jiri Svestka Gallery, Prague, 1997

Earnest in Esperanto. I bought a copy. It was staged at the Bloomsbury Theatre, shot with two or three cameras, and wonderfully Brechtian. How many people could you get together who both speak Esperanto and have a taste for amateur dramatics? Gwendolen, who is supposed to be in the first bloom of youth, is played by someone who must be about 50.'

Wallinger screened this dramaturgical readymade in front of an idiosyncratic congregation of a hundred chairs, all different and roughly spanning the century. This signifier of an absent motley audience, in context, might naturally usher on stage ideas of vanished optimism about international unity; the language, invented in the 1880s by L. L. Zamenhof but never achieving its architect's dream of collapsing the language barriers between nations, is roughly contemporaneous with the idealist origins of modernism. (A rare Esperanto-speaking visitor to the show was Prague's Roman Catholic cardinal.) Here, then, the concept of division is broadened: Wilde, an Irish Catholic homosexual, and Zamenhof, a Polish Jew, understood all too well that how we are defined is how we are divided. Like the contemporaneous English/Irish flag *Oxymoron* (1996), this work addresses the deeply ingrained nature of cultural difference, itself rooted in a mixture of enveloping nationalism and the human desire to identify with something larger than oneself.

The Four Corners of the Earth (1998) engages with religion, but does so in a context of scientism: one reading of the title phrase being pressured by a later, more empirical one. This work was originally intended as a painting project, Wallinger

Oxymoron, 1996
Textile flag
228.6 x 457.2 cm
(90 x 180 in.)
Installation at Printworks,
Brixton, London

recalls, the sort of intensive, hands-on activity that he had become itchy to dive into again. Setting up the slide projector to begin work, however, he realized that the piece was effectively done. In its eventual form, in a darkened gallery space (initially Delfina in South London), four circular canvases were propped in the corners. Onto each was projected a photograph of the same cheap globe seen from particular angles, at the centre of each being one of the four points where, as scientists at Johns Hopkins Applied Physics Laboratory discovered in 1965, the surface of the Earth rises above the geodetic mean – in Ireland, south-east of the Cape of Good Hope, west of the coast of Peru, and between Japan and New Guinea – and gravitational pull rises too. While the Earth clasps us to it, though, human ingenuity lofted us into space, as these works' resemblance to photographs from the Apollo missions reaffirms.

The phrase 'the four corners of the earth' (originally in Isaiah 11:12, referring to the coming messiah's gathering of his scattered people, and notorious for suggesting that the Bible's supposedly divinely inspired writers thought the Earth was flat) thus is not exactly *wrong*. It's just mutable, overtaken by events, and the continuum of its changing meaning is what interests Wallinger here. Faith is figured as a practical tool in humanity's insatiable urge to understand the world, as is science. In 1968, via the photographs from the Apollo 8 mission, the God's-eye view became man's, and, avers Wallinger, 'human consciousness made a jump forward' via a specific shared viewpoint. ('Who'd have thought,' he adds, 'that we could go backwards again?') Of course, this kind of sweeping view, of us all as passengers on what Buckminster Fuller called 'Spaceship Earth', is not the one we tend to judge from, which does not help people override their seeming differences. Space, as *Star Trek* would have it, is additionally another kind of 'frontier'.

When Parallel Lines Meet at Infinity (1998/2001) also covertly sets a scientific standpoint alongside a spiritual one. Some time earlier, Wallinger had made a video on the Circle Line of the London Underground, filming the advancing rails from the driver's cab for the hour that it took to complete the circuit.[13] Three years later he worked out what to do with this film, finally completing it via a simple but effective move. As *School* and *Fly* signalled, Wallinger has long been fascinated by perspective in both senses of the word: as a device to structure space, and as a given mental viewpoint. Re-watching *Parallel Lines* in his Berlin apartment, he had an intuitive flash, stuck the lowest denomination 'mark' coin in the centre of the screen as a vanishing point, and became mesmerized. After a while, Wallinger discovered, one's eyes lock onto the rails, and the film modulates into the realm of illusion: what starts 'moving' is that which is fixed – the vanishing point (remade as a painted black spot on the wall for the work's projected exhibition). 'Visually,' he says, 'the lines converge and the spot hits its target quite a lot. But parallel lines stay parallel forever: if you were ever to reach the vanishing point – the end of the journey – then the black spot is death, extinction. Instead, we circle endlessly and never meet the object of our quest.'

Like *The Four Corners*, the work speaks of the partial and changing picture that we have of the world at any given time. 'I think of the Circle Line in this work as being the "Newtonian physics" line,' says Wallinger; in 2004, he would make *What Time is the Station Leaving the Train?*, a dual-screen work (of which more later) filmed on the S-Bahn in Berlin, which alludes to the concepts of Einsteinian relativity that supplanted Newton. Infinity may be to science as the afterlife is to religion, a generator of conflicting postulates.[14] The flipside of this, particularly when such ideas are situated in the everyday, as here, is that they open up a space for wonder regarding the invisible 'end of the line'.

Opposite
The Four Corners of the Earth, 1998
Slide projection on 4 circular canvases
Diameter of each canvas 230 cm
(90½ in.)

Overleaf
When Parallel Lines Meet at Infinity,
1998/2001
Installation for looped video projection,
silent, black spot painted on wall
60 minutes
Installation views

THE VENETIAN ASCENT

In career terms, Wallinger was being propelled further along the track: onwards and upwards. In 2001, at the invitation of the British Council, he had the honour of representing his country at the Venice Biennale. The floating city was a perfect staging ground for emphasizing a conception of nationhood pinned precisely to a larger picture of international relations and fascinated by the fault-lines within that picture. Established in 1895, this most venerable of international art expos arrays itself across the Giardini in pavilions that reflect what Wallinger describes as 'a sort of crazy golf course of different nations' aspirations from a hundred years ago'. Britain sits on top of Venice's only hill, flanked by Germany and France; Russia lies somewhere down the road; Africa did not get a dedicated pavilion until 2007. 'All the pavilions at the Biennale are like caricatures,' the artist said at the time. 'The German one looks like Albert Speer made it. The French one is neoclassical. The Hungarian one is Art Nouveau meets Hansel and Gretel. And the English one has pompous echoes of empire. It's not the sort of space that one can pretend is neutral, so I decided to use its position to undermine any residual sense of nationalism.'

Exploiting various types of illusion, this project began before viewers stepped inside the British pavilion. Passing *Oxymoron*, Wallinger's 'impossible' English/Irish flag planted outside, audiences realized that what they had taken at a distance for the front of the building was, in fact, *Façade* (2001), a life-size photograph of the building's frontage, mounted on scaffolding and pitched forward several feet. Inside, along with *Threshold to the Kingdom*, *Angel* and *Ecce Homo*, were three more pieces. *Life Class* (2001) existed only for this show. It featured a dozen easels, colloquially known as donkeys, set up to hold drawings of *Ecce Homo* (which was on the other

Above and opposite
Façade, 2001
Scanachrome print on vinyl
Life size
British Pavilion, Venice Biennale, 2001

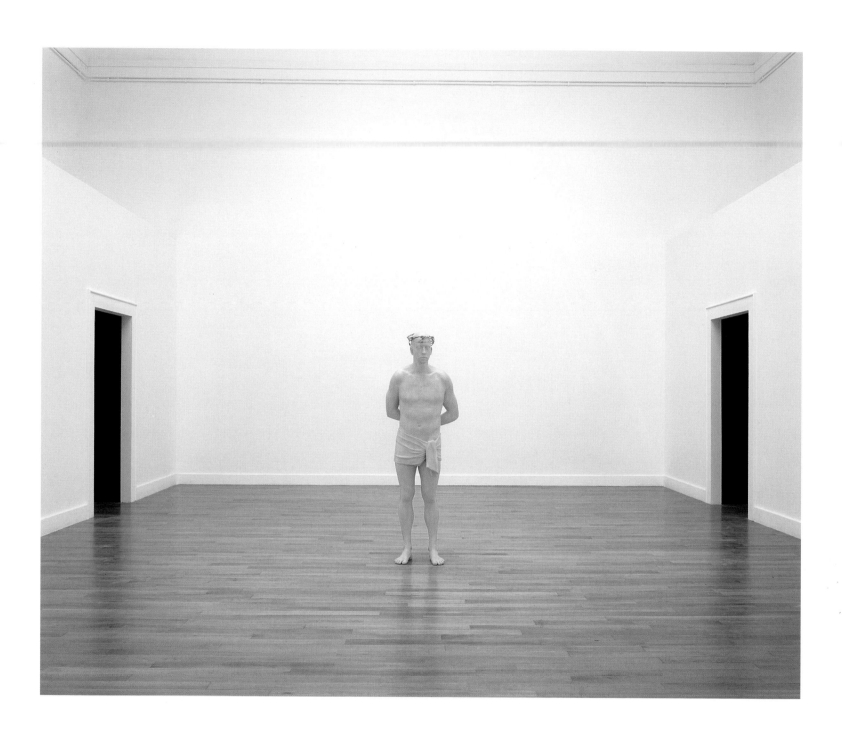

Installation view with *Ecce Homo*, 1999
British Pavilion, Venice Biennale, 2001

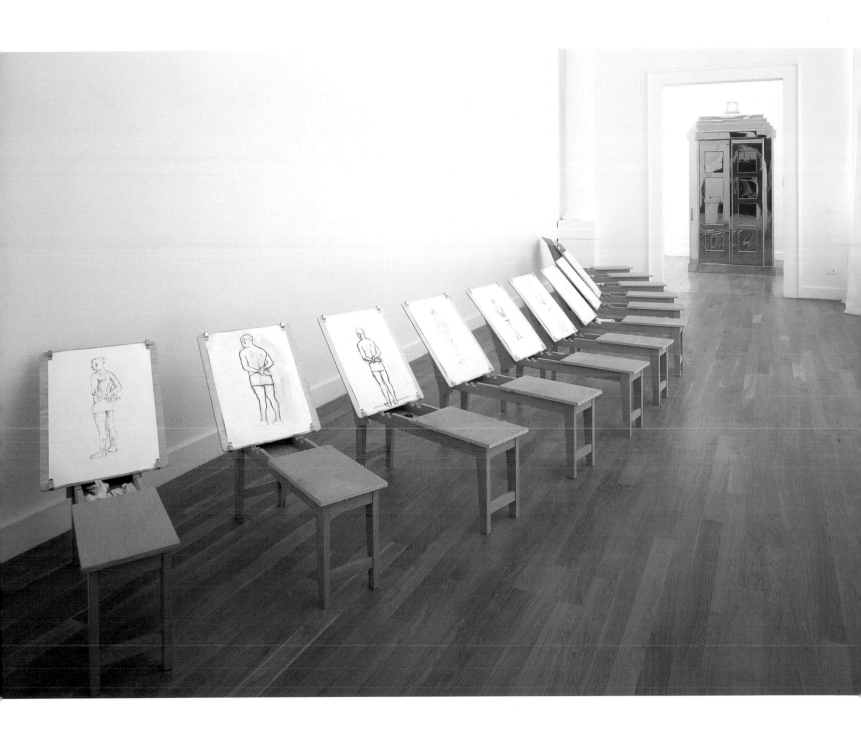

Installation view with *Life Class*, 2001,
and *Time And Relative Dimensions
In Space*, 2001
British Pavilion, Venice Biennale, 2001

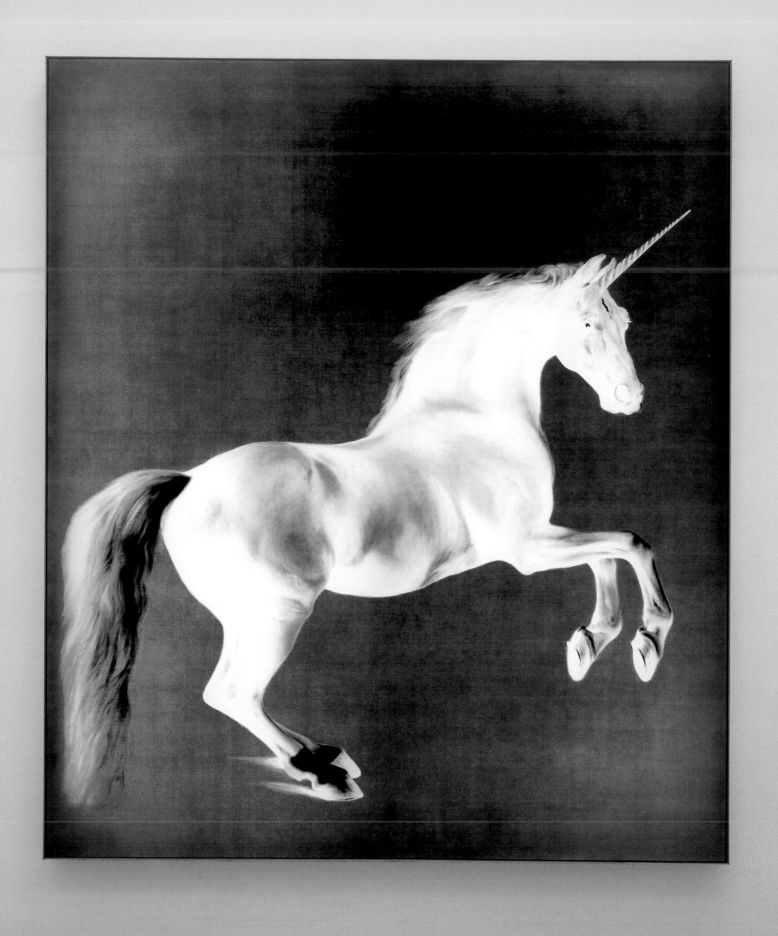

side of the wall) by Royal Academy students. The dozen different perspectives turn the makers into disciples. ('Life class is a discipline,' Wallinger points out.) Part of it would be destroyed among many of Wallinger's works that went up in flames at Momart's storage facility in 2004. *Ghost* (2001), on the other hand, emphasizes the role that *good* fortune plays in his art. A spectral, nearly 3m- (9ft-) high light-box photograph of a rearing white stallion with a unicorn's horn sprouting from its forehead, this was (like *The Four Corners of the Earth*) another example of his planning a consciously demanding oil-on-canvas endeavour before seeing the virtue in a shortcut.

'I might as well be honest about this,' he says. 'I'd planned to produce a painting of a white unicorn, and the image that became *Ghost* was going to be a tool to that end. I got my friend Bob Pain, who is my co-owner in [Wallinger's racehorse] Riviera Red, to make me some negatives of Stubbs's *Whistlejacket* – he runs a bespoke repro firm. The results looked like an X-ray, rather than a negative. And that, of course, brings up the notion of X-raying paintings, the secret life of paintings beyond the surface. So, in that instantaneous way, I had something that was a lot more interesting than anything I could labour away at.'[15] Leaving aside its suggestions of the endless interpretative play of art history, *Ghost* is marvellously allusive. Stubbs's *c.* 1762 painting was by some accounts an equestrian commission that fell through (as was the case with the Fourth Plinth), resulting in the artist leaving the rearing horse on a plain background (as in *Race, Class, Sex*). In negative, its plain pale background becomes deep space.

Ghost is an image of reversal and of tantalizing myth, presented in a building that dates from a point when the British Empire really was 'top of the hill' – and once again the illusion, and contrarily the ease with which we can come to believe our eyes, is made unavoidable. In imagistic terms it is an impressive piece of legerdemain, as Tom Lubbock of the *Independent* pointed out in 2007 when selecting it for the newspaper's 'Great Works' series: 'translating naturalism into supernaturalism, *Ghost* synchs the two dominant strains of English art: Stubbs' observational study is shown to hold within it a spiritual vision by Blake or Fuseli.' Additionally managing to remind Venetian viewers of Wallinger's equine work while departing from and establishing broader context for it, it is a minor miracle of poetic economy.

Ghost fittingly shared a venue with *Time And Relative Dimensions In Space* (2001): a work that again, and not without comic irony, suggested a melancholically vanished or vanishing form of the British questing spirit. To some degree, this work was in itself a marker of national difference. A good proportion of the international audience at Venice most probably thought the work was a mirror-surfaced replica of a British police box – if they even recognized it as that – rather than the TARDIS its name forms the acronym) used to travel through time and space by the eponymous hero of the long-running BBC television series *Doctor Who*.

The chief special effect in that show, a cheap and easy bit of video trickery, is the illusory disappearance of the TARDIS as it sets off for another dimension, gradually fading from the screen, accompanied by a resonant whoosh courtesy of the BBC Radiophonic Workshop. Wallinger's TARDIS, similarly, is here and not here. 'I understood enough about illusions to recognize that because it was square in plan, if you sat it in a square room – or at least equidistant to its corners – at a certain point the reflections would make it appear transparent.'[16] *Time And Relative Dimensions In Space*, in fact, had deeper roots, and ones that again reveal something of the chance processes and receptive authorial openness that, for all his self-awareness, serve to mould Wallinger's art.

Before embarking for Venice he had completed a year-long residency for the Oxford University Museum of Natural History. 'The place feels like a time machine in

Opposite
Ghost, 2001
Scanachrome on translucent PVC,
lightbox
295 x 249 x 18 cm
(116 x 98 x 7 in.)

Above
George Stubbs
Whistlejacket, c. 1762
Oil on canvas
292 x 246.4 cm
(115 x 97 in.)

*Time And Relative Dimensions
In Space*, 2001
Two Metropolitan Police box replicas,
mixed media
Each 281.5 x 135 x 135 cm
(111 x 53 x 53 in.)
Oxford University Museum
of Natural History
Exterior and interior views

Opposite
*Time And Relative Dimensions
In Space*, 2001
Stainless steel, MDF, electric light
281.5 x 135 x 135 cm
(111 x 53 x 53 in.)
Installation view at British Pavilion,
Venice Biennale, 2001

its own right, going back to Jurassic days and beyond, with its giant sequoia outside, its geological specimens from around the world, and its collection of beetles going down to the most microscopic specks. So I was thinking, it's square in plan and it sends your mind hither and thither through vast expanses of time. What does that remind me of? We got in touch with the people who'd made the TARDISes for the BBC, and got them to make two: these were blue ones. In Oxford, one sat in the museum collection, and one sat out on the front lawn, and as you couldn't see both of them simultaneously, the idea was that it might have dematerialized and moved.'

INTO THE DARK

In 2001 Wallinger and his partner, the artist Anna Barriball, relocated to Berlin on a year-long fellowship organized by the Deutscher Akademischer Austausch Dienst, or DAAD, after which they returned home for a while and then spent another year or so in the German capital. What eventually brought him home, Wallinger says, was primarily that he was not getting enough work done. Nevertheless, during this period he managed to make several major works. And while this moment hardly represents the conclusion of his concern with religion, *Via Dolorosa* (2002) might stand as Wallinger's most breathtakingly succinct statement on being and belief.

After spending time amid the classical and neoclassical architectures of Rome and Berlin, Wallinger had begun revisiting the 'sun and sandals' cinematic epics of his youth: *The Greatest Story Ever Told*, *Ben-Hur*,[17] and, decisively for *Via Dolorosa*, Franco Zeffirelli's six-hour television miniseries *Jesus of Nazareth*. Wallinger had seen this in 1977 on British television. There are parallels to be made with *Ecce Homo*, not least that Zeffirelli determinedly portrayed Christ as something close to an ordinary mortal man. What fascinated Wallinger on re-watching the film, however, were its formal qualities.

'I thought it got from Pilate to Christ giving up the ghost in an affecting way, but I was also interested in the different modes of cinematic language that Zeffirelli uses in that sequence: from Christ's view of the crowd in the square, then back to Christ and Pilate and how that's shot, and how the crucifixion is hand-held and jostling. I was interested in how we become attuned to cinematic language in a way that's probably akin to how people used to read devotional paintings.' The eighteen-minute *Via Dolorosa* would be a consideration of what we implicitly know, on the level of cinema and of religion. It would also function as a sequel to the arrested moment of *Ecce Homo* in following the result of the mob's verdict – that is, a road with death as the looming black finality at the end. Four years later, Wallinger would complete this trilogy of sorts with *The End* (2006), which functions as a credit sequence to the narrative. For *Via Dolorosa*, Wallinger digitally blacked out 90 per cent of the image, reversing the conventions of frame and image by leaving only a thin strip of peripheral action around the edge of a rectangular void. We cannot hear the film – there is no soundtrack – and we cannot really grasp it visibly. What we see, in glimpses, are blue skies and sand, blanked faces, the edge of a cross, a centurion's helmet, a scratched torso, an inch of beard, finally a darkening sky. But we *know* the story, because we are versed in cinematic convention (though we might not think so) and because even our culture's atheists are Christian atheists (though we might not think so either).

The most salient aspect of *Via Dolorosa* is that the blanking blows meaning wide open. It is a subtraction that is unexpectedly a gift. Caught up in its mechanism, one might not only recognize our deep affiliation to a specific religion but also have a melancholy sense of something blocked or inaccessible – the possibility, in an increasingly non-religious culture, of Christ's sacrifice being meaningful. One might see the

Opposite and overleaf
Via Dolorosa, 2002
Projected video installation (silent), continuous loop, black rectangle painted on wall
18 minutes 8 seconds
Views of permanent installation at Milan Cathedral

blackness in other, more humanistic terms, recognizing that the species inevitably yearns for some kind of higher and collective meaning against the prospect of the swallowing void. Or, given that the work has been deemed 'religious' enough to be installed permanently in the crypt of Milan's cathedral, the work's heavy foreclosure might speak rather of the private, incommunicable nature of faith – that which overflows reason as the imagery here exceeds the censoring black geometry, as Wallinger has suggested when discussing this work – and the resistance of the miraculous to representation.

For Anthony Reynolds, who thinks this may be his favourite of Wallinger's videos, 'it is very beautiful, very moving and challenging, very silent, and leaves you very alone with your thoughts.' *Via Dolorosa* is a black mirror, a question. By 2002, however, those gazing into it would not only see themselves, but a reflection of a world in which religious matters felt particularly urgent. Wallinger would continue to examine organized religion: the following year, when Tate Britain invited him to produce a Christmas tree to be installed in the gallery, he would present *Populus Tremula* (2003) a spindly aspen tree – the species whose wood, according to legend, was used to make Christ's cross – decorated with a thousand scented rosaries. ('It's a sort of perversion or reversal, replacing Christmas with Easter,' says Wallinger. 'Growing up, it always seemed bizarre to me that the birth of Jesus happens and then three months later he gets crucified; laterly it struck me that rather than a miraculous rebirth in three days we have a very human nine-month gestation period between death and life. So to decorate this tree with rosaries seemed to be fitting. On first sight they're festive, and then it becomes clear what they are. And there's no other story, is there, in which a character's death is so present at his birth, already foretold.')

In particular, it was fundamentalism that increasingly exercised Wallinger in this period. See, for example, *Forever and Ever* (2002), a giant aluminium Möbius strip in the red and white diagonals of hazard warning tape and overwritten with parts of the Agnus Dei in black gothic letters ('O Lamb of God, who takest away the sins of the world, have mercy upon us'). It is phrasing which, for all its beauty, signals, in this context, a species of thinking trapped in an inescapable loop, where no peace is granted. In the wake of 9/11, when the US and its allies had mobilized in Afghanistan and were gearing up to invade Iraq, few would question the logic of Wallinger's half-decade-old decision to foreground the subject. It stands, retrospectively, as emblematic of Ezra Pound's oft-quoted description of artists as not only thinkers but also feelers, 'the antennae of the race'.

In the wake of *Threshold to the Kingdom*, Wallinger had loosely planned some further work on flying. On 10 September 2001, he recalls in his book *The Russian Linesman*, which accompanied that exhibition, he was in the Aviation Centre in Berlin, which has 'an encyclopaedic collection of postcards of every conceivable type of airborne craft'. He bought four cards, took them home and, with a scalpel, excised the planes, leaving a white void in every case. He stuck one on each wall of his living room. 'The following afternoon,' he writes, 'Anna and I were sitting in the kitchen. The BBC World Service makes oppressive listening at the best of times, so we decided to walk to the Bauhaus home store for some inspiration. As we stood in line with our meagre purchases, I became aware that the German reporter on the radio was sounding more than usually animated. I caught the words "World Trade Center"...'

The postcards were swiftly taken down.

AWAKE IN THE NIGHTMARE OF HISTORY

Mark Wallinger, *Four postcards*, 2001

Above
Page from the book
The Russian Linesman, 2009

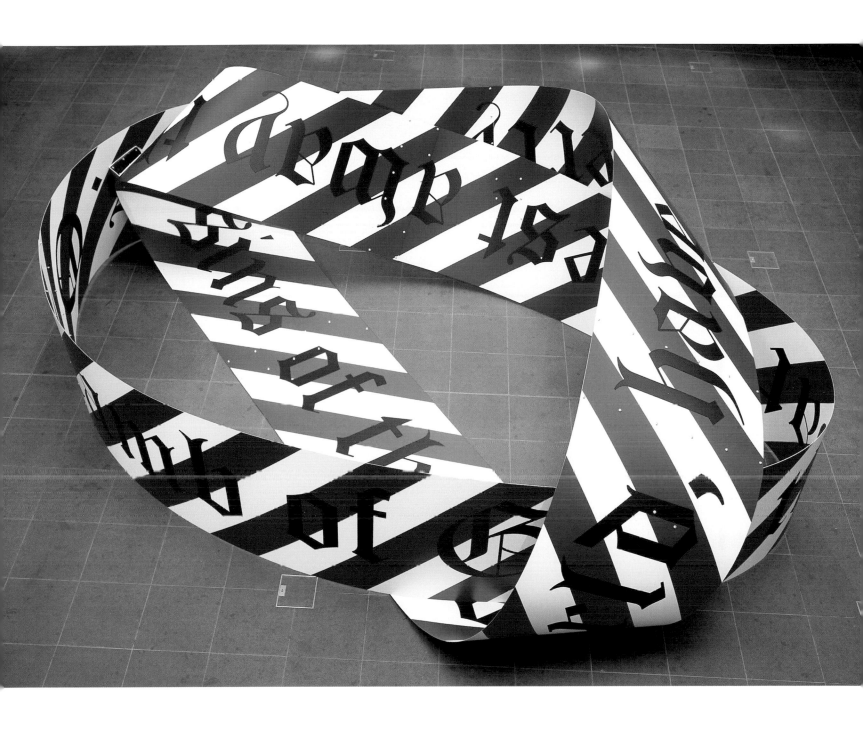

Forever and Ever, 2002
Aluminium, vinyl
200 x 700 x 500 cm
(78¾ x 275½ x 197 in.)
Installation views at 147 Bloomberg
Space, London, 2002

1. After fourteen years in exile, the Shia Muslim leader Ruhollah Khomeini had instigated an Islamic revolution in the country in 1979, overthrowing the Shah and becoming Supreme Leader of the country until his death in 1989; the event is considered the turning point in transforming Islamic fundamentalism into a political force.

2. 'In the beginning was the pun,' from Samuel Beckett's 1938 novel *Murphy*, is one of Wallinger's favourite quotes (used as an epigram in the catalogue for his 1998 show at Delfina in London and the Palais des Beaux-Arts in Brussels). With regard to the appellation Blind Faith, it is also perhaps worth noting that Wallinger was an admirer of the 1960s rock group of the same name.

3. When he later met the Queen's chaplain, he remembers, the latter described having an authentic vision: 'a shaft of light, the whole thing. He told me this in the Garrick Club…'

4. The dark glasses were pragmatic, says Wallinger. 'Practically, it meant I could read the phonetics off an 'idiot board' and people couldn't see my eyes flickering.'

5. 'The most climactic piece of music I could think of,' says Wallinger. *Zadok the Priest* was written for the coronation of George II, in 1727. Its lyric, from the Book of Kings, recounts the anointing of a king by a priest and a prophet.

6. The derisive shove of the balloon was actually a side-effect of the fact that, while the fifty helium-filled balloons Wallinger had bought to guarantee a successful take were lighter than air when he bought them, they weren't when he stuck a photograph on them. Hence the 'helping hand'.

7. Expanding on this idea, in 2008 Wallinger would return to the phrase, blazoning it on a billboard in Edinburgh near the Ingleby Gallery. 'The idea of innocence becomes more poignant the older you get,' he notes. 'And more cherishable, and ever more unlikely.'

8. Its Joycean overtones aside, the concept of worldly epiphany that will prove so important to Wallinger's work was first articulated to him, he says, when he witnessed the improbable grace of John McEnroe's tennis game.

9. Not for the first time, this was a work that converged with Wallinger's own life. He'd obtained a new prescription for his own spectacles: 'I was convinced that my previous prescription was more accurate, so I'd made the very thing to make me paranoid,' he recalls.

10. Wallinger had rehearsed faith's parallels with intoxication in *The Spirit Meets the Optic* and *Miracle*, a work from 1997 that features a dozen glasses of wine and a dozen empty, inverted glasses, separated by a mirror.

11. Davy (1778–1829) was an English chemist and inventor.

12. Made, grotesquely enough, by inmates on death row.

13. 'We had to go around three times,' remembers Wallinger; 'the first time the camera was misaligned, the second somebody emptied a bucket of water off a bridge, and it landed on the windscreen.'

14. In the twisty speculative precincts of non-Euclidean geometry, there is a theoretical point, 'infinity', where all lines do converge; the theory, however, cannot be proven.

15. The horn, belonging to a narwhal, was 'nerdled' in via Photoshop.

16. When this piece was shown, the cherished fragment of British cultural history that is *Doctor Who* was not on television, and there were no plans to bring it back. By the time the piece was re-shown in 'The Russian Linesman', the programme had been triumphantly rebooted.

17. 'I'd seen that at the Dominion Cinema in Tottenham Court Road when I was about 11, and it was singly the most epic experience I'd had at that age,' Wallinger recalls.

Populus Tremula, 2003
Rosaries, aspen tree
Dimensions variable
Detail

Opposite
Installation view at Tate Britain, 2003

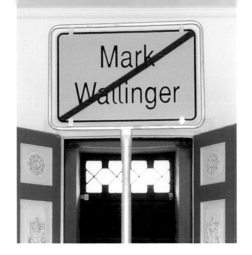

FOUR

New Frontiers
(2003–2007)

GHOSTS OF BERLIN

By 2003, Wallinger had been a professional artist for nearly twenty years. An appreciable number of the YBAs whom he had exhibited alongside in the 1990s had either stalled, or fallen off the map entirely; he, needless to say, had not. Instead, while moving forward in career terms, he had become progressively more difficult to pin down. 'Englishness' would not hold him, nor would 'religion', and yet this slipperiness had not undermined his profile. To explain why, one might point to the satisfying formal logic, bordering on compulsive problem solving, that courses through the majority of his work and offers ways around issues of neat categorization. When one takes the work as a whole, a cohesive picture is surely *there* – seen from a larger perspective, Wallinger's art offers a panorama of our imperfect accommodations to the world we find ourselves in, the representations and systems, and particularly, divisions that we create. (A picture whose darkness is, nevertheless, leavened by humour and the artist's attention to those exalting flashes of wonder available to us.) But even if one is not aware of such a cumulative scheme, Wallinger's art helpfully makes a case for its own integrity on a work by work basis. Towards the middle of the first decade of the 2000s, this fact became ever more apparent.

It is worth saying at this point that an artist does not necessarily create a grand design by consciously focusing on it; indeed, having a fixed sense of what one is doing might lead towards the dangerous waters of illustrating a big idea. While Wallinger says that he himself was not wholly mindful even of his predilection for 'frontiers, borders and thresholds' until he put 'The Russian Linesman' exhibition together, he also speaks of a kind of temporary fogginess around the meaning of his work. He will do things, he says, prior to knowing entirely why, following hunches; and the lag between making and rationalizing can be a matter of years. This is not a hard and fast rule: *State Britain,* as we will see, had very clear imperatives. But it bears mentioning in the context of a body of work that can feel dauntingly decisive and preconceived. An artist who has no use for intuition is disregarding perhaps the sharpest arrow in his or her quiver.

Besides all this, artists at midcareer have other issues to deal with: tending the flame of their own curiosity, warding off laziness and repetition and the temptation to produce for a market. (At this juncture, the contemporary art market was in the early stages of a boom that would last until the meltdown of late 2008.) In Wallinger's case, it might have helped that he had moved countries. Berlin is a living museum that wears

Spacetime, 2003
Installation views at Braunschweig
Kunstverein, 2007

its past on the façades of its buildings, and bears the weight of its absences. The house where Albert Einstein lived no longer exists, but Wallinger felt drawn to the location. (A month after Einstein left for America in 1932, Hitler came to power; he never returned.) This – and a very specific experience on the former border of East and West Germany – fed into *Spacetime* (2003), an installation that diagrammed the Einsteinian perspective on the indivisibility of time and space.

In the gallery, facing each other on opposite walls, were two photographs of passing cars. In each vehicle, someone is looking directly at the camera. And what they seem to be looking at is a sign placed in the middle of the gallery, imitative of those planted at the borders of German towns and cities. On entry one sees the name, on leaving one sees it with a diagonal strikethrough. Here the name is 'Mark Wallinger', a pun on the fact that 'Mark' in German can denote a region. This two-sided sign pointedly makes the gap between arriving somewhere and leaving vanishingly thin.

'I'd gone out to the Glienecke Bridge, the border with East Germany where the spy swaps used to happen during the Cold War,' Wallinger recalls, 'and I thought, well, where *is* the border? If we can have a notion of a border absolutely ending, or being precisely somewhere, it'd be the exact middle of this bridge. So I walked to the middle and started taking photographs from both sides. And when I got the contact sheets back, there were two photographs, one from either side, in which the passage of a car – one a Mercedes and the other a Volkswagen, so very German – was arrested at almost exactly the same moment and framed in the same way. And in each there was someone looking directly at the camera. The camera shutter is a thousandth of a second, so I thought, with a sort of Einsteinian sensibility at that point, that in standing there I stood in, as it were, for the spacetime event. And that where I was, or where this border was, would only have the substance of the sign that's annotated it. So I became "Mark". And I do have a German surname, it appears.'

Once again, there is a winning conceptual neatness to all this. Precision engineering, if you like. But, inbuilt allegories of modern physics aside, *Spacetime* also suggests a kind of poetics concerning thresholds, one in which the relativity of viewpoints comes to stand for the historical ideological distinction between East and West Germany, considered decades later in a city where past and present seem to coexist, and are contested in endless debates about what should be preserved or erased.

What Time is the Station Leaving the Train? (2004), meanwhile, was the second of Wallinger's videos shot on a circular railway, the Berliner Ringbahn, and the 'Einsteinian physics' successor to the teleological 'Newtonian' video *When Parallel Lines Meet at Infinity*. Berlin's S-Bahn is, for Wallinger, beautiful and one of his favourite things. 'It was only towards the end of our stay there,' he recalls, 'that they joined up the ring again, which had been broken when the Berlin Wall was built. So for the first time you could do this circuit again, which, just like London's Circle Line, takes an hour to complete.[1] We had two cameras shooting outside of opposite sides of the train simultaneously, so that when you played them back, screened side by side, you'd get this kind of palindrome in time and space. There are two vanishing points, and even though you're tracking past them the whole time, really and truly everything's disappearing down those two holes.'

The question 'What time is the station leaving the train?' is a droll quote from Einstein, a sort of haiku for the upending theorems of relativity. It's perhaps not surprising that an artist so interested in relative viewpoints should find his way to relativity. (*Time And Relative Dimensions In Space* of 2001 might have been the first inkling of this.) Wallinger, then, took up Einstein's 1905 theory of special relativity and its conjecture that all motion is relative, and time no longer unvarying or absolute. 'I just about got my head around that. The later General Theory, that's beyond me.'

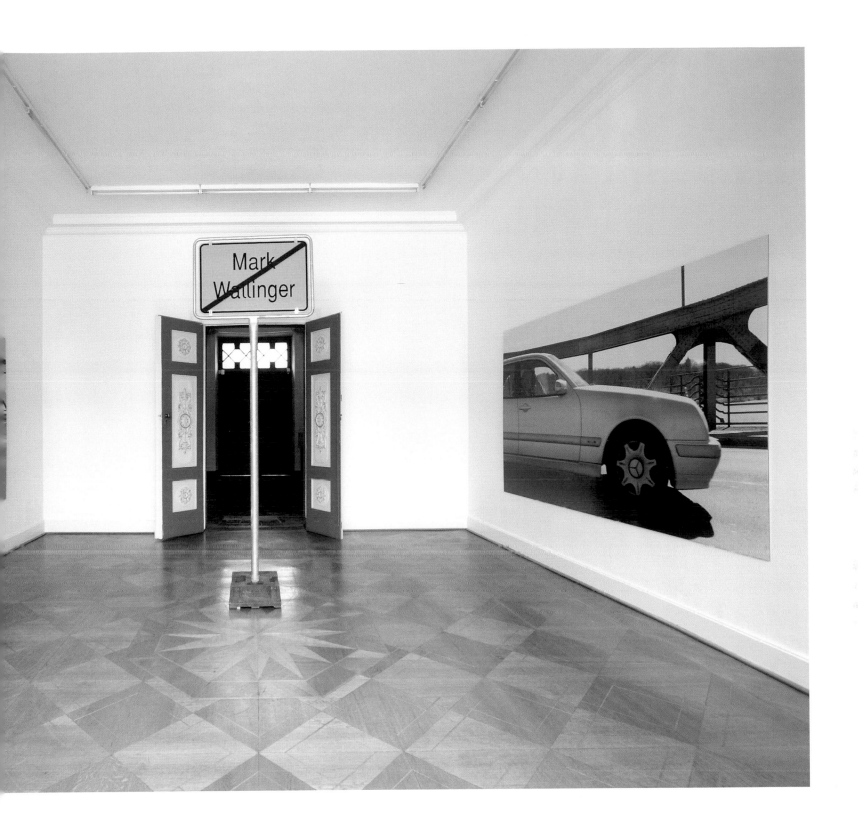

Spacetime, 2003
2 colour photographs on Dibond,
metal road sign on post
Each photo 180 x 300 x 4 cm
(71 x 118 x 1½ in.)
Sign 280 x 100 x 85 cm
(110 x 39 x 33½ in.)
Installation view at Braunschweig
Kunstverein, 2007

Another element in *What Time*, however, was Wallinger's memory of seeing Terry Johnson's play *Insignificance* at the Royal Court in 1982, whose plot finds Einstein, Marilyn Monroe and Joe DiMaggio in a hotel room, 'and there's a scene where Marilyn demonstrates to Einstein that she's understood relativity by using two toy trains'.[2] In any case, it is out of such confluences that art gets made.

One does not need the spectral presence of Einstein, though, to recognize Berlin's temporal strangeness. Time *feels* to be curving back on itself there, and that mood also suffuses *Third Generation* (2003), still another of those works that came about while Wallinger was considering doing something else. During his tenure in Berlin, the Daniel Libeskind-designed extension to the Jewish Museum had opened in the city. Wallinger, who had heard the American architect (born in Lodz in Poland, of Polish Jewish descent) lecture on his ideas in Rome, had issues with the project. 'It's really almost a kind of ghost train. There's one point where you get shut into this tower with odd angles so that you can, what, feel like a Jew at Auschwitz? And the building in plan supposedly looks like a fragmented Star of David – well, why not make it an *actual* Star of David? If you fragment it up so that it's unrecognizable, what's the point?' He had planned to film a kind of walkthrough of the museum. 'But then I got detained by the exhibits, thankfully.'

Three home movies, in particular, caught his attention; each looping silently and endlessly, among a gathering crescendo of horror. These were the survivors. One unmistakably shows New York harbour with the stars and stripes flying; a little girl on board a ship looks out from a life belt emblazoned with the vessel's name, *Manhattan* (the film glossing over the fact of American resistance to Jewish immigration). In another, Jews arrive off a ship in Shanghai, have their papers checked, are placed in a cattle truck and then taken to a camp where they line up at a soup kitchen. A man writes PLEASE and THANK YOU in English on a blackboard, as if for an audience. The third film was made by the Ascher family, who, like Einstein, were Jews who had fled Berlin. (They escaped to Palestine in 1938.) A wealthy family, fur clad in winter and waterskiing in summer, they are seen at play, larking for the camera. Trusting us. In each film is manifest the same innocent regard of the lens. But between the Aschers's seeming prelapsarian happiness and our moment is, of course, the measureless black chasm of the Holocaust. Emphasizing that fact in *Third Generation*, Wallinger delineates a division in absence. For while the phrase 'Third Generation' in the title might refer to a Jewish generation attempting to deal with the past, here it also applies literally to the film itself. Wallinger collapsed time into medium by videoing the films' transmission within the museum while visitors walked past – this second recording acting as an obscuring of a medium that already put the subject at one remove from the audience. He then re-filmed *that* footage, degrading the quality and bringing it closer to an unreachable abstraction.

In the context of the Jewish Museum, then, and against the supposed empathetic experience of being locked in a disorienting angular room, *Third Generation* admits the real difficulty of coming to terms with the past – leading to an amnesia that, militating against humanity learning from its mistakes, has all kinds of ramifications in the present. In the same year, Wallinger made *The Sleep of Reason*: here, he edited video footage of Margaret Thatcher's 1982 Conservative Party conference speech, running together every fragment where she blinks so that she appears disconcertingly to be talking in her sleep. If this – which also harked back to distant days of ideological polarization in British politics – was a reminder that Wallinger had begun his career by pitching his art against unhelpful or downright insidious forms of representation, works such as *Third Generation* assert that the wherewithal to do so clearly had not deserted him.

What Time is the Station Leaving the Train?, 2004
Installation for 2 looped video projections, 2 black spots painted on wall
60 minutes
Video stills

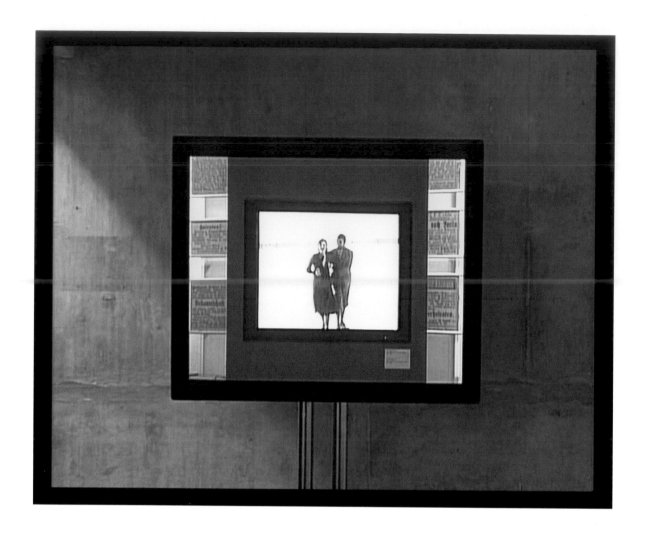

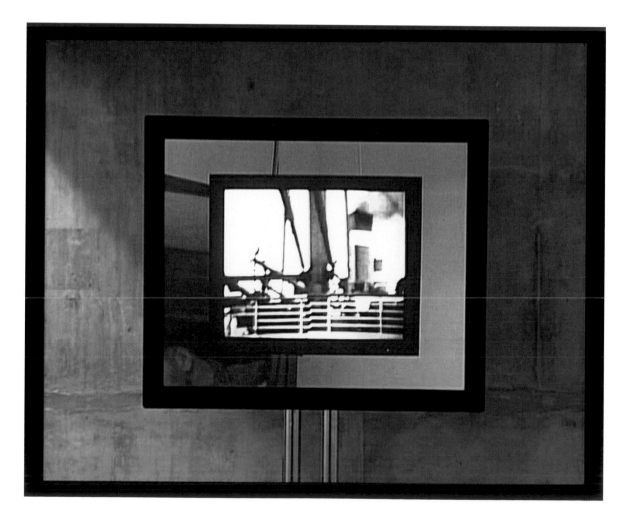

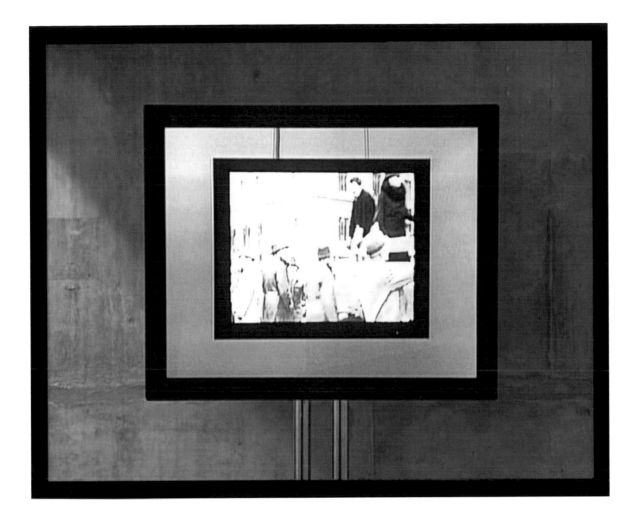

THE MOMART FIRE

On the night of 24 May 2004, a fire was started in the storage facilities of Momart, the British art shippers, handlers and packers, in Unit 47 on the Cromwell Industrial Estate in Leyton, East London. Investigations concluded that burglars began the fire in order to cover up the theft of consumer electronics from another business renting storage space in the building, a former factory. The fire blazed for almost a day, and by the end, hundreds of works by leading British artists were destroyed. Among them were more than thirty works by Wallinger.

'It was pretty awful,' he remembers. 'Anthony rang me up – it was my birthday – and said, "I've got terrible news". It was an incomplete picture at the time but he began detailing all the works that had been in storage and were almost certainly destroyed, and although this turned out not to be the case, we thought this included *Ecce Homo*. I remember I took myself off to the Peckham Premier cinema and just sat in the dark: that was my refuge for a while. It's the monumental stupidity of it that's hard to take, storing art near gas cylinders; and there are early works that I do feel bad about being gone. Some of *School* went up; I lost a lot of important pieces.'

'My mother was gravely ill at the time, and in a hospital that made the most unspeakable food, so me and my sister were busy trying to feed her, which put things in proper perspective. And once I found out that *Ecce Homo* was intact, I did feel slightly better. What was really disappointing, though, was the public response to the fire. There was a certain *schadenfreude*, glee, on the part of people who should have known better.' It was, perhaps, another good reason for Wallinger to be spending extended periods out of the country. Five months later, back in Germany, he would create one of the most enduring – and yet most fleeting – artworks of his career.

Opposite above
Third Generation (Ascher Family), 2003
Video installation
38 minutes 57 seconds
Video still

Opposite below
Third Generation (Manhattan), 2003
Video installation
15 minutes
Video still

Above
Third Generation (Shanghai), 2003
Video installation
9 minutes 38 seconds
Video still

NIGHTS IN THE MUSEUM

In January 2003 Wallinger had gone to Friedrich Meschede, head of the DAAD's visual arts department, and proposed the idea of *Sleeper*: a performance in which a man in a bear costume wanders around in Berlin's Neue Nationalgalerie after dark. Meschede burst out laughing, then called his secretary in: 'Listen to Mark's proposal!' And indeed *Sleeper* (2004) – made a year and three-quarters later since Wallinger had to wait for a moment when the building would be completely empty – is, on the face of it, a comically absurdist concept. It is also, however, a kind of TARDIS: bigger, not to mention darker, inside than it looks on the outside.

The piece originated with the Mies van der Rohe-designed museum itself, says Wallinger, and quickly escalated into multilayered symbolism. 'It's such an iconic building that it seemed criminally underused. I'd drive past it quite often, and particularly at night it seemed such a waste: this cold thing, a reservoir of darkness. Almost *anything* illuminated in there would have a presence. I'd been filming bears at the zoo and there were also all these fibreglass bears around Berlin, due to the current German vogue for branding cities.[3] But when you think about the Soviet bear – the Russian bear – it is not a cosy symbol (100,000 Berlin women were raped by the Red Army). And, of course, infamously, the Nazis kept bears in Buchenwald. You could say it was a rather over-determined symbol, but the key for me was a TV memory from my childhood, *The Singing Ringing Tree*: a programme that terrified and haunted a generation. I began to realize that this dramatized fairytale was known by my East German friends but not my West German ones and, in retrospect, it represented this psychic connection across the Iron Curtain...'

The Singing Ringing Tree was made as a film in the East German state-owned studios Deutsche Film-Aktiengesellschaft (DEFA) in 1957; it was serialized by the BBC and first broadcast in the UK in 1964. It tells the story of a prince searching for a magical tree, who is transformed into a bear by a malevolent dwarf. Part of the fascination for Wallinger was the cultural specificity of its limited screening. A man transformed into a bear, trapped in a kind of illuminated prison at night, would have a different set of resonances for Berliners depending on which side of the Wall they had grown up on. Here, if you like, was a model of how ideology shapes viewpoints. To reinforce the reference, an image from *The Singing Ringing Tree* was used on the posters advertising the ten-night performance, which Wallinger had pasted up on the S-Bahn and U-Bahn.[4]

But *Sleeper* yielded up multiple meanings, and it also narrates Wallinger's own experience, as a foreigner in Berlin, of trying to 'fit in' – in an absurd manner, by dressing as the city's emblem. 'I was an alien in disguise, in a German disguise; one that's so obvious that they might buy it. I remember, as a kid, reading lots of Richard Hannay-type, John Buchan books,[5] where the rule was "you always double-bluff the Germans". It was that, and also a sense of the poignancy of transplanted lives, and other cultures never being properly assimilated.' At the same time, the title refers to the history of spies and 'sleeper' agents and the intricate infiltrations of the Cold War, the paradox of someone being asked virtually to become a member of another society *because* those societies cannot see eye to eye. And, set in a once-split city, *Sleeper* was symbolic of the divisions and frontiers, the tireless carving-up of spatial and mental territory and fashioning of enmities that, in Wallinger's art, looks like the hallmark of humanity.

And all of this came wrapped in a supremely outlandish exterior. Each night at around 10 p.m., Wallinger-as-bear would appear in the glowing Neue Nationalgalerie and, visible through the glass walls, spend three or four hours improvising within

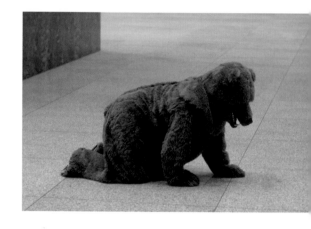

Top
Poster for *Sleeper*, 2004
Neue Nationalgalerie, Berlin

Above, opposite and overleaf
Sleeper, 2004
Performance, Neue Nationalgalerie,
Berlin

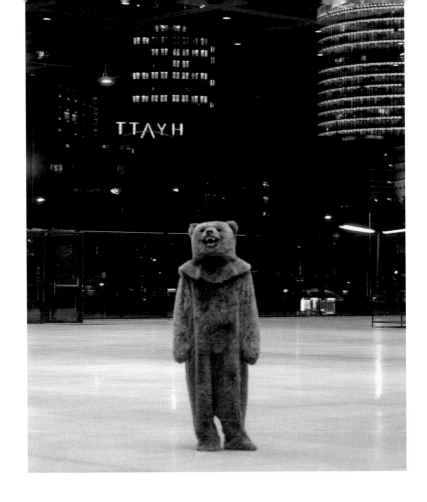

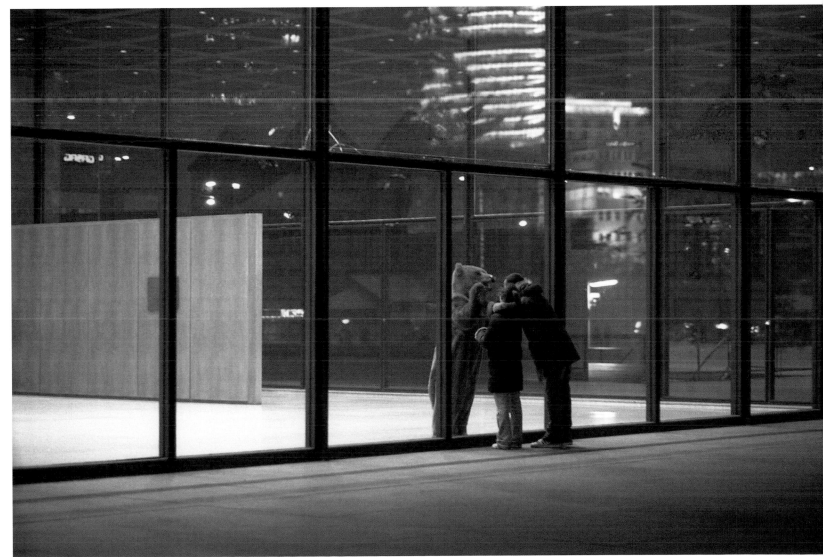

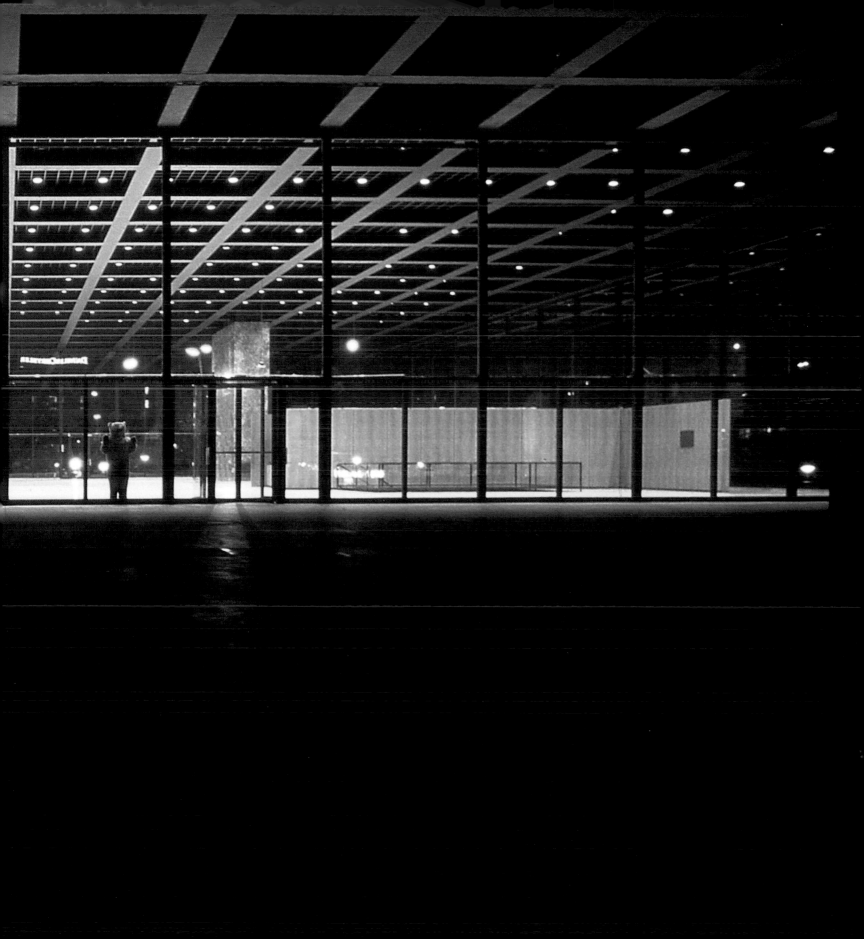

it while sweating inside a heavy furry costume that was, he says, 'like wearing a sofa'. (There are other ways of suffering for one's art than making meticulous paintings.) Here was a free, perpetually changing performance for anyone passing by, and also – crucially – a figuring of the marvellous: a strange and potentially epiphanic experience in the heart of the city. The beauty of *Sleeper*, accordingly, is that it manages to diagnose the downsides of the human condition, offer a dark history lesson, perform an implicit separation *and* offer some brightly incongruous compensation for all this, all at once. When Wallinger was awarded the Turner Prize three years later, albeit for *State Britain*, it is apt that his exhibition at Tate Liverpool consisted of the video version of *Sleeper* (a two-and-a-half hour stream of the original, on the second official night, had been broadcast by live link-up to the German ambassador's residence in London.) Its maker may have resisted a stylistic signature in the previous two decades, but in its lightly worn but profound concerns, this is conceptually a signature work.

Asked how *Sleeper* functions as a layered piece, balancing absurdity and darkness, Anthony Reynolds returns it to the largest scales of thinking and evocation in Wallinger's work. 'It needs those extra layers,' he says, 'to enrich and re-render it. Because it's one thing to – as countless artists do – present those issues in artistic form, but it's another to take you in and let you share an adventure of discovery. So much so-called political art is uninteresting, preaching what you know. In that piece, yes, there are all the issues, the bleak issues which are outside of the person, and all the issues that are *in* the person as well. The crushing loneliness of it: I don't mean he's crushingly lonely, because he's not in the slightest bit, but then we all are alone with our beliefs, our illusions, having to deal with them and wrestle with them.'

Sleeper also provided Wallinger with his own little epiphany, or at least a moment of apt strangeness. On the seventh night, at the end of the performance, a photographer waiting outside asked Wallinger if he had seen 'the other bear'. Wallinger had not. Around the back of the gallery, it transpired, was a figure in the exact same bear suit, pressed against the glass: a *doppelganger*. With Wallinger too tired and intimidated to approach it, the bear walked away, never to be seen again. In his book *The Russian Linesman*, shortly after describing the incident,[6] the artist writes: 'The two realms of Germany were like twins separated as children and raised in completely contrary ways. Having to cross irrevocably from one realm to the other, or be divided without appeal. This is what I have learnt and it seems very cruel. Germany invented the unconscious, which is not normally credited with respecting borders.'

Into the Light

The unconscious as the antonym of division: *Sleeper* would hardly represent the last instance of this in Wallinger's art. Meanwhile he continued to pursue a formal subtheme of his recent practice, the limiting or blocking of visibility that had begun with *Via Dolorosa* and continued with *Third Generation*. Whatever medium he uses, Wallinger tends to take account of its inherent properties – we have seen his paintings explore their own nature *as* paintings, perhaps most explicitly in the *Q* series – and his videos, too, have frequently turned self-reflexive. *The Lark Ascending* (2004) might be his most determinedly outré move in this regard. It was shown as a projection in a London cinema and technically it *is* a film, but it exists on the outer edge of what can be classified as a moving image.

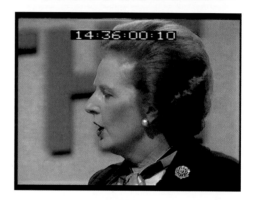

Characteristically, *The Lark Ascending*'s origins reside in an interlacing of longstanding concerns and fortuitous happenings. At one point during his second spell in Germany, Wallinger left Berlin, set up in a DAAD-owned studio deep in woodland and connected with something that, like *The Singing Ringing Tree*, spoke of distant cultural

specificity. 'It was quite an intense experience out there, and I'd brought with me
a bunch of new music and music I hadn't played for some time. Vaughan Williams's
The Lark Ascending struck me. It's based on George Meredith's poem about the
skylark, and I thought about the number of poets who'd written on that subject. And
then, talking to American friends, they don't really have larks, and I hadn't realized
how particular the lark was. And as a kid I was a member of the Young Ornithologists'
Club, and a couple of my happiest moments have been on the South Downs with
larksong...' Enter the pun upon which *The Lark Ascending* is predicated.

'I just conceived of this idea, of taking a recording of larksong and making the
sound itself ascend from somewhere just below human hearing, rising through the
octaves. My brother-in-law, who's a bit of a whiz with all these things, said he'd try
it out in his studio. And he was driving home from his studio, playing it, and the lower
frequencies cracked his windscreen.' By the time Wallinger was sitting in the Prince
Charles Cinema in London, waiting for the piece's premiere, he had had additional
concerns that the soundtrack's subsonic rumble might cause mass incontinence.
The visual component of the work, meanwhile, is an almost subliminal 'rise' in the
optical field. The screen at its outset is black. As the sonic aspect moves into audibility
and, finally, familiarity, it lightens to white, like a breaking dawn.

The Lark Ascending is not just a technical stunt. Like *Sleeper*, its outward simpli-
city encloses an elegiac meditation on history and trauma, and it particularly reflects
the influence on Wallinger's thinking of Paul Fussell's 1975 book *The Great War and
Modern Memory*, with its evocations of 'the troglodyte world' of the trenches.[7] 'I was
intrigued,' Wallinger says, 'by the fact that Vaughan Williams's *Lark Ascending* was
created just prior to the First World War, but not performed until after it. And, rather
like English poetry – and the soldiers all went to war with the *Oxford Book of English*

Opposite
The Sleep of Reason, 2003
Video installation
52 minutes
Video stills

Above
The Lark Ascending, 2004, screening
at Prince Charles Cinema, London

Verse, which was as ubiquitous a piece of kit as the King James Bible, and even became known as the atheist's bible – it came from a tradition that hit a catastrophic faultline with that war. After the trauma, a new language had to be made. And so it's imbued, again, with a sort of poignancy, an innocence that's gone for good.'

The bittersweet nostalgic dimensions of *The Lark Ascending* tempt one to bracket it with *English and Welcome to It* and *They think it's all over … it is now,* and to consider how nothing really goes away in Wallinger's art but only returns, revised and repurposed. What connects *The Lark Ascending* to this particular moment in Wallinger's production, however, is its use – or rather, radical reshaping into allusive abstraction – of music, a process that would be furthered by *The Underworld* (2004), *A ist für Alles* (2005) and *The End* (2006). In the process, the East/West motif that Wallinger had touched upon in his Berlin art would be expanded to global dimensions.

LOOPS AND LINES

'In all my work, if the video is looped then the loop is part of the work,' says Wallinger. *The Underworld* is a ring of twenty-one video monitors, each playing a 1982 TV performance of Verdi's *Requiem*, the Italian composer's 1874 setting of the Roman Catholic funeral mass. The piece has twenty-one sections, and running clockwise on each monitor the looped video of the entire performance shifts from successive starting points in the chain, turning the *Requiem* into an endless round – an atonal or perhaps microtonal one more reminiscent of György Ligeti's *Requiem,* famously used in Stanley Kubrick's *2001,* than of Verdi's. The vast hollow wailing that results suggests something like the massed cries of the damned, the obvious

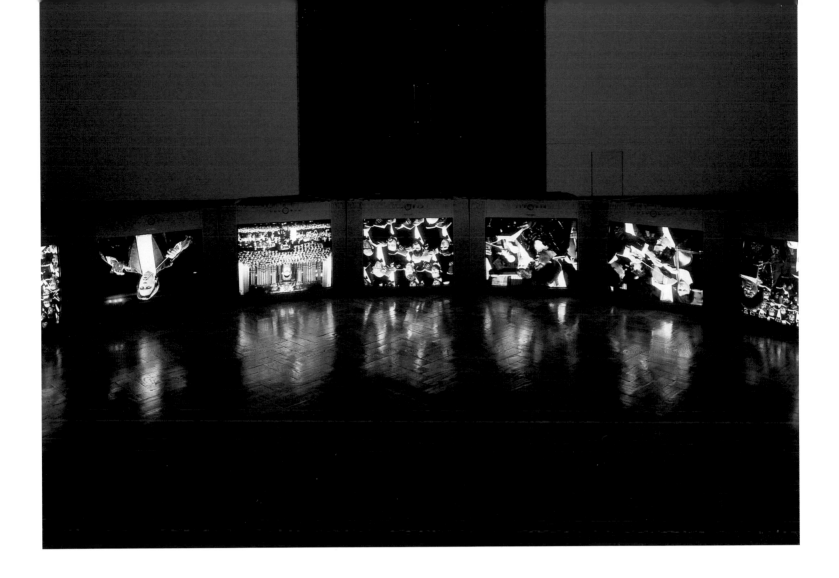

structural reference being Dante's circles of hell. (Wallinger's monitors are inverted, so that the conductor and every singer are upside-down. In the third ring of the eighth circle of the Italian poet's intricate structure of damnation, those who have committed simony, paying for sacraments or for holy office, are placed headfirst in holes.)

But *The Underworld* might be construed as being more about the *threat* of damnation that has historically sustained faith, and Roman Catholicism in particular. That, and – once again – the paradox that out of imposed fearfulness can come such beauty as Verdi's *Requiem*. Here, if you like, Wallinger restructures the music so that terrorizing and beauty, retribution and salvation, are conjoined. Taken another way, one might see Wallinger's procedure in *The Underworld* as blurring the sectarian specificity of the Mass, redeploying it so that it starts to evoke a more universal suffering, an evocation of the endlessness of pain here on Earth. In which case it would seem hardly coincidental that Wallinger had just spent an extended period in Germany and had made several works engaging with Jewish history and the Holocaust.

The following year's *A ist für Alles* could be seen as a counterweight, since it speaks to some degree of hope about the human spirit's ability to regenerate and renew itself. The starting point for this sparse installation (one piece of modernist furniture and an almost abstract soundtrack), as with *The Lark Ascending,* was the meeting of Wallinger's interests in classical music and poetry, and how music and poetry attempt to synthesize or reconcile differences: here, specifically, the poetry of Johann Wolfgang von Goethe, and the youth orchestra, the West-Eastern Divan.

Founded in 1999 by Argentine-Israeli conductor Daniel Barenboim and Palestinian-American academic Edward Said, the orchestra was named after (and intended to operate in the spirit of unity suggested by) a collection of Goethe's late poems. Written in 1814–18, inspired by Persian poetry, these were collated under

The Underworld, 2004
21 channel video installation for 21 monitors, sound, continuous loop
Dimensions variable
Installation views at Laing Art Gallery, Newcastle upon Tyne, 2004

the title 'The West-Eastern Divan' – 'divan'/'diwan' being an Arabic and Persian word meaning simultaneously a poetry collection and a council, assembly or meeting place in Muslim countries. The poems, Wallinger wrote in his book *The Russian Linesman*, might be considered 'a starting point in meditating on the West's idea of the East. A refuge for the imagination: an eroticized and fabulous land where one might meet one's reflection, or lose oneself through the looking glass. The West is not examined in return because its authority is not threatened. The analyst has no reflection. The land of dreams is therefore to be regarded as the analysand: Omar Khayyam cushioned and reclined. The Unconscious, the Muse, the Fountainhead. Poetry.' If the poems represented what Wallinger calls 'a rather idealistic notion of East and West joining in some way', *A ist für Alles* might suggest a more fruitful exchange. This space for analysis and for daydreams is the selfsame place: imagination is the unifying force and the overcoming of division is framed by the multiple meanings of 'divan'.

It comprises a black Mies van der Rohe divan installed in the gallery like a Freudian psychiatrist's couch, with a recorded soundtrack of the West-Eastern Divan's musicians tuning to 'A'. Doing so, in this context, suggests not only uniting in a shared project but also a new start, the beginning of the alphabet. The West-Eastern Divan orchestra played its first concerts in Weimar, in homage to Goethe who had lived there, and where, one hundred years after his death, the Bauhaus was to be founded. Mies van der Rohe's Barcelona daybed, or divan, one of the design icons of that movement, is a Western classic that owes its form and generic name to a relationship and fascination with the East, the '*other*' reality. Weimar, with its open creative spirit, stood for many as the zenith of German culture. And for that very reason, as Edward Said has noted, Buchenwald was deliberately positioned nearby. The line between

A ist für Alles, 2005
Barcelona daybed, sound
Dimensions variable
Installation view at Kunstmuseum
Thun, 2006

THE END

The End, 2006
35mm film, sound
11 minutes 40 seconds
Film still

culture and barbarism is perilously thin, and while the sound of the orchestra tuning up could presage harmony, the resultant drone itself is, as Wallinger says, 'just the preamble to whatever's going to happen'.

A ist für Alles premiered, fittingly, in Freud's hometown of Vienna at Ursula Krinzinger's gallery. And Vienna was to provide the thunderous soundtrack to a 35mm film, *The End*, which is like walking into a religious epic after all the action has passed and all that is left is a black void. *The End* is, in essence, the closing credit sequence to the greatest story ever told. On screen, beginning with the phrase THE END and accompanied by Johann Strauss's *The Blue Danube*, a vertical procession of white names scrolls upward against the blackness, as if ascending into heaven, beginning with God and Adam and Eve and ending some twelve minutes later with Joseph, Mary and Jesus. It is a list of the characters in the Old Testament and the New Testament up to the birth of Christ, in order of their appearance, leading up to 'THE END' in teleological terms. Along the way, one reads such names as Zipporah, Gershom, Igai, Shamer and Magplash. That central unfamiliarity and ethnicity of nomenclature is key to *The End*. As Gilda Williams wrote in an *Artforum* review of the exhibition, 'of unmistakably Jewish and Middle Eastern origins, these names plainly connect Christianity to the faraway cultures many Christians now feel so disconnected from – indeed, to the peoples we are at war with. Especially when we recall that Islam, too, claims its biblical lineage as descendants of Abraham, *The End* becomes a very complicated commentary – on the impossibility of fundamentalism, the dangers of forgetting, and the threads that unite mortal enemies.'

Via the choice of soundtrack over its flowing river of names, *The End* also becomes trans-historical, and speaks further of what conjoins as well as what divides. '*The Blue Danube* is now inextricably bound up with Kubrick's *2001*,' Wallinger notes. 'We are a jump cut away from savagery.'

SPLIT SCREEN

And, as Wallinger's geographical context broadens in this period – moving eastward across mainland Europe – it reflects fallouts from Empires, from the experience of the reunified Germany to the raw divisions of the Middle East. In the three-part *Painting the Divide* (2005), he focused on Jerusalem, Berlin and Famagusta in Cyprus, 'places I had lived or been invited to stay and then photographed, and three of the most divided places you can find anywhere'. Another mix of concept and happenstance was in play here. Having recently participated in a show at the Mori Art Museum in Tokyo, Wallinger had become fascinated by Japanese folding screens, which seemed to him the most elementary of separating devices (there is a hint of the English colonial adventure in there too, given the Victorian associations of dressing screens). For *Painting the Divide*, then, he enlarged photographs of the triumvirate of split – or formerly split – regions and affixed them to the concertinaed screens, as they exist on 'the flimsiest of dividing lines, the zigzag of a contested zone'.

One could argue that it took an extended period living away from England, and the sort of travelling now involved in a successful art career, for this internationalist purview to come to the fore in Wallinger's art. One could also call it characteristic of a mind that does not leap without looking. On the other hand, one could say that so much of Wallinger's background, particularly his upbringing in the powerfully class-bound country that took the colonial experiment the furthest, had fitted him uncommonly to view the globe holistically. (As had the fact that his father had spent much of the Second World War in the Middle East, and spoke to his son about it very even-handedly.) Talking about his widening scope in this period, Wallinger is

The End, 2006
Film stills

Overleaf
Painting the Divide, 2005
3 parts
Each comprising two 6-part folding screens, digital colour print on canvas, wooden stretchers
Each screen folded 240 x 60 x 14 cm
(94½ x 23½ x 5½ in.)
p. 170
Above
Jerusalem (detail)
Below
Berlin
p. 171
Above
Jerusalem (detail)
Below
Famagusta

GOD
ADAM
EVE
CAIN
ABEL
ENOCH
IRAD
MEHUJAEL
METHUSAEL
LAMECH
ADAH
ZILLAH
JABAL
JUBAL
TUBAL-CAIN
NAAMAH
SETH
ENOS
CAINAN
MAHALALEEL
JARED
ENOCH
METHUSELAH
LAMECH
NOAH

SAUL
BAAL-HANAN
ACHBOR
HADAR
MEHETABEL
MATRED
MEZAHAB
TIMNAH
ALVAH
JETHETH
ELAH
PINON
MIBZAR
MAGDIEL
IRAM
POTIPHAR
HIRAR
SHUAH
ER
ONAN
SHELAH
TAMAR
ZERAH
ZAPHNATH-PAANEAH
ASENATH
POTI-PHERAH
MANASSEH
EPHRAIM
HANOCH
PHALLU
HEZRON
CARMI
JEMUEL
JAMIN
OHAD
JACHIN

SHEREZER
REGEM-MELECH
MALACHI
ZARA
ESROM
ABIUD
ELIAKIM
AZOR
SADOC
ACHIM
ELIUD
ELEAZAR
MATTHAN
JACOB
JOSEPH
MARY
JESUS

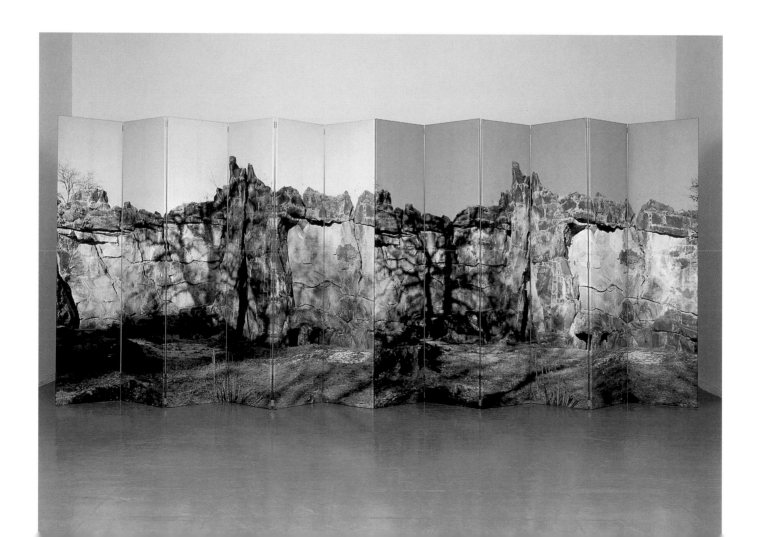

characteristically unassuming: 'I think I have learned a bit by experience. That sounds a bit crass, but I think my horizons have been broadened, that I've become cultured enough to address some of those things. I mean, one of my favourite cartoons of all time was in *Private Eye* – there's a publisher behind his desk and a hopeful writer, and the publisher says, "when I said write about what you know, I didn't expect this…" and there's a book on his desk called *Bugger All*. So I think that, as much as I like to make my case for the particular and the local, this doesn't excuse timidity. I was long resistant, though, to the arrogance of the globetrotting artist, with his frictionless vision.'

That said, one cannot wholly disregard changing external circumstances such as the transformation of the international art world after around 2001, underwritten by a long economic boom, the greater interconnectedness brought by globalization, the falling cost of air travel, and in the art world the spread of biennales from Dakar to East Kent. Artists in this period increasingly adopted a have-camcorder-will-travel mode, and it is to Wallinger's credit that he has never worked abroad without a powerful sense of self-consciousness. From 2006 he was beginning an ongoing series in which place is defined by geology and that allowed him to make work virtually anywhere. It was a process that had begun when he was living close to the river Thames and wandered the foreshore at low tide, picking up a rich variety of stones. Obeying a basic urge to make sense and order from this obdurate and ancient matter, he began enumerating them, until there were a thousand stones on the floor of his studio, meticulously numbered with a white paint marker. For *Okerstein* (2007) he dipped into the Oker river in Braunschweig and began counting at 1,001. For that work's immediate successors – *Oslo Steiner* (2010) and simply *Steine* (2010) in Berlin – Wallinger collected hundreds of stones from the sea or a local river. The process – the collecting and sorting of the local terrain and the mark of the artist's hand – was a moveable feast. However, by 2006, this newly globetrotting artist had found a project that would bring him home.

Above
Numbered stones in Mark Wallinger's studio, 2010

Above
Steine, 2010
1000 stones, paint
Dimensions variable
Installation view at Carlier
Gebauer, Berlin, 2010

ONE MAN IN A SQUARE, PART II

In April 2006, Wallinger received a phone call – a momentous one, it would turn out – from Judith Nesbitt at Tate Britain. The exhibition due to open in the Duveen Galleries the following January had fallen through: the Tate was therefore approaching artists who might be able to mount a show there at such short notice. 'I felt freed, in a way, by the urgency of the situation to run with immediate preoccupations,' Wallinger remembers. 'I had been nonplussed by how quiescent artists, writers and the press were about recent restrictions of freedom of speech and how supine everyone was about the continuing war in Iraq.' By 2006 Iraq was a bloody mess of sectarian violence. 'It seemed like Brian Haw was the last protester in England, and I was amazed how even the liberal press seemed embarrassed by him. Suddenly, I felt it should be Brian.'

Since June 2001, peace campaigner Brian Haw had been camping in Parliament Square, initially moved to do so by sanctions against Iraq. Wallinger had noticed and been affected by his camp; he was also, he says, 'conscious that SOCPA, the Serious Organised Crime Police Act of 2005, had been amended, ceding all power to the police to make up their own conditions regarding who can protest, and in how much space.

Left
State Britain, cover of Tate publication, 2007

Opposite
State Britain, 2007
Mixed media installation
5.7 x 43 x 1.9 m approximate
(19 x 141 x 6ft)
Detail, installation at Tate Britain, 2007

Overleaf
State Britain, 2007
Detail, installation at Tate Britain, 2007

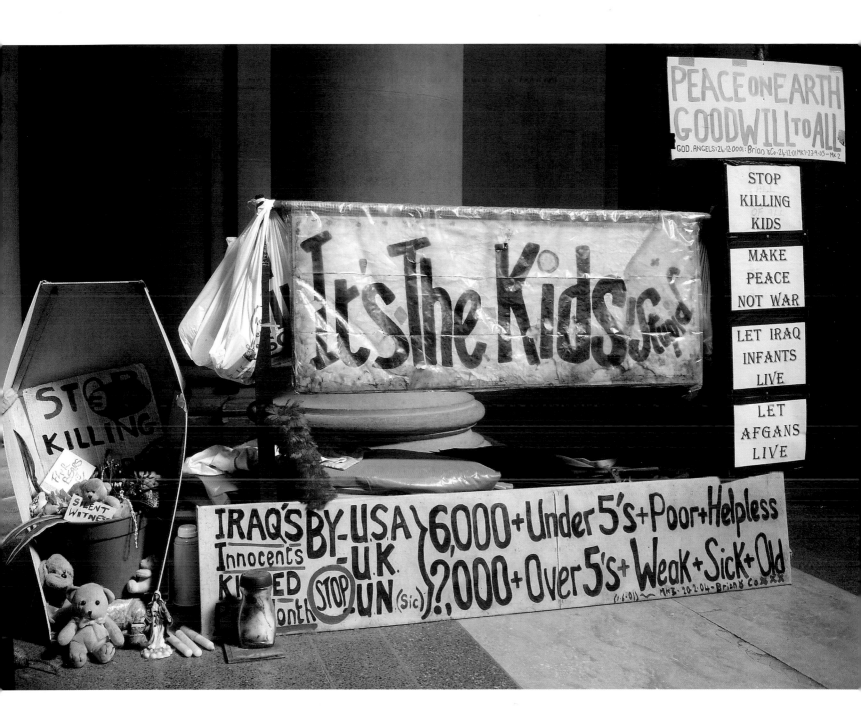

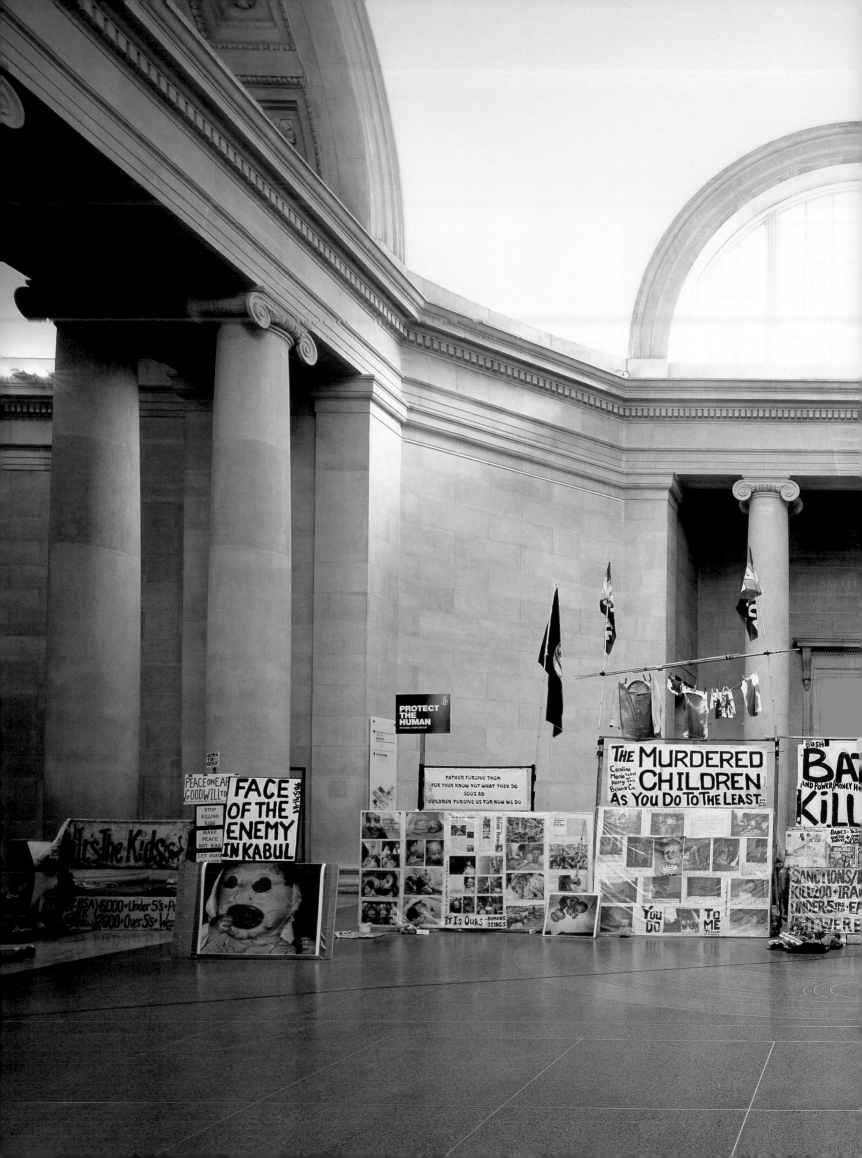

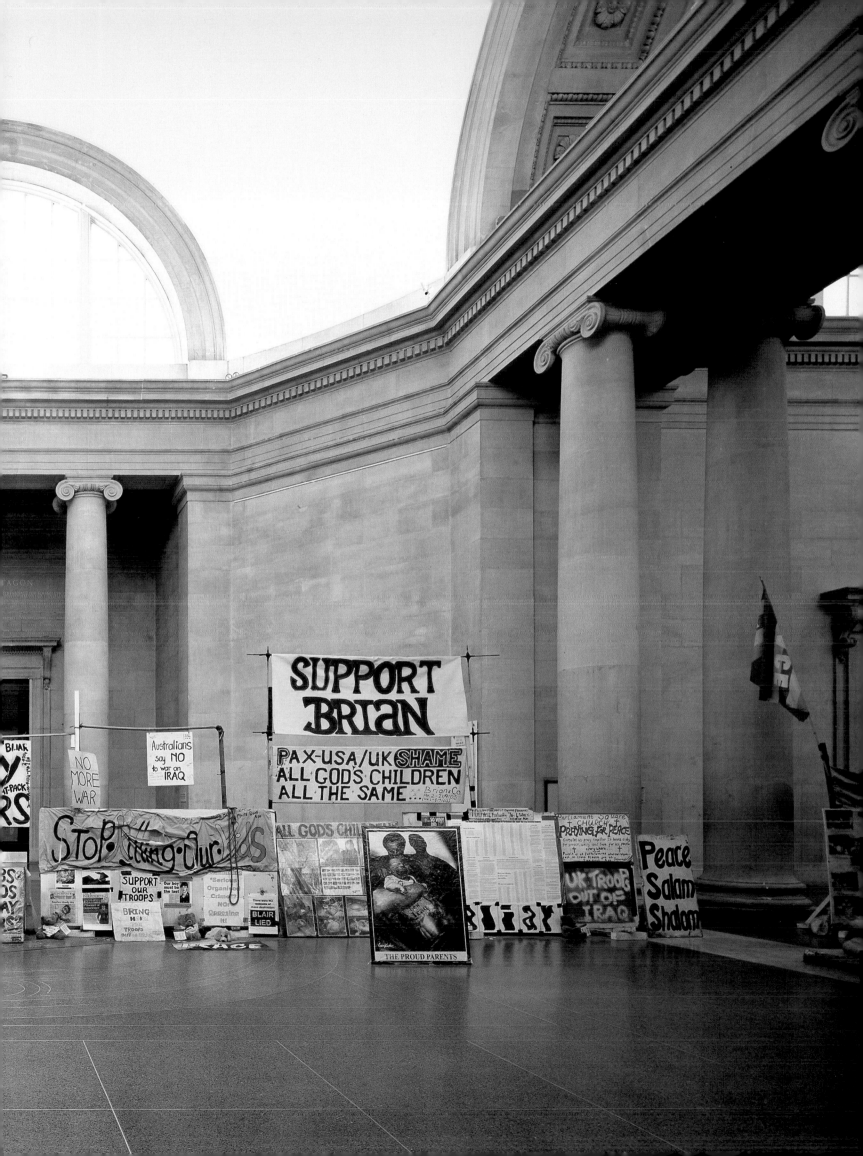

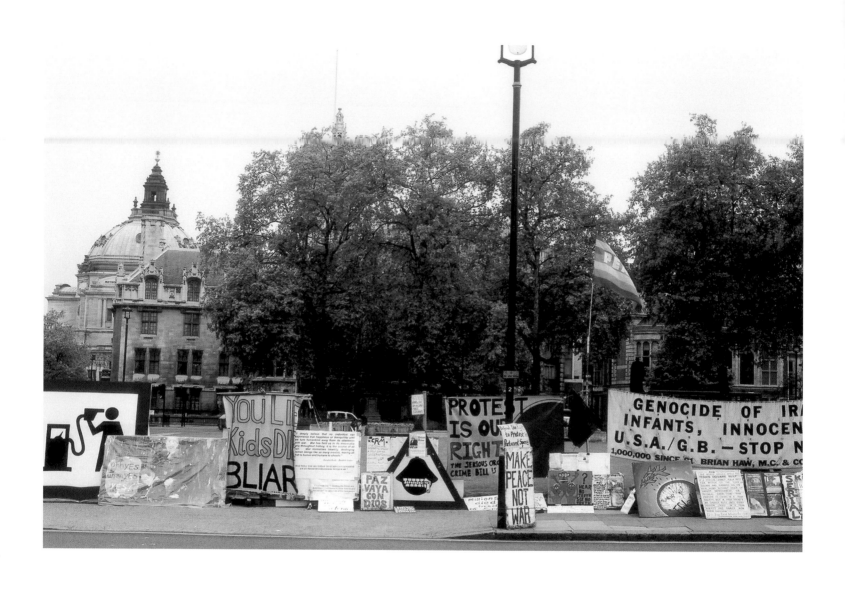

Brian Haw's protest, Parliament
Square, London, 2006

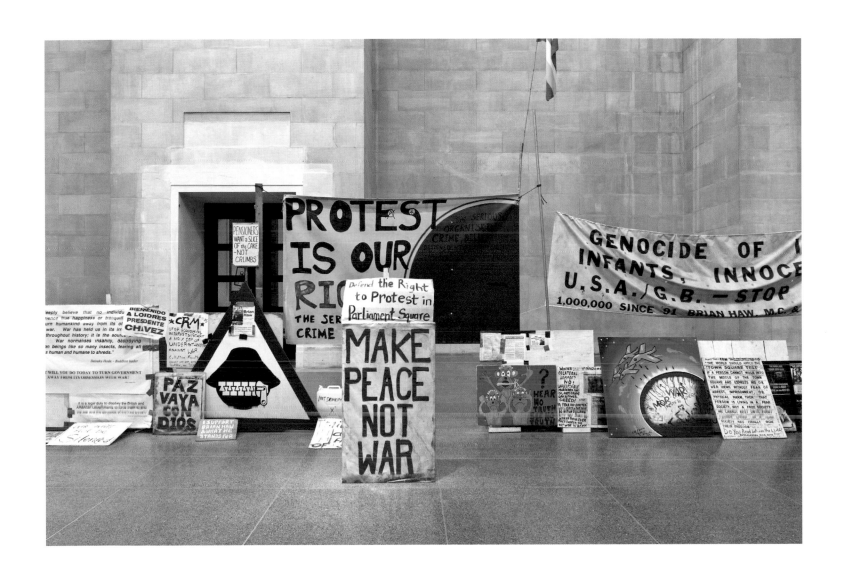

State Britain, 2007
Detail, installation at Tate Britain, 2007

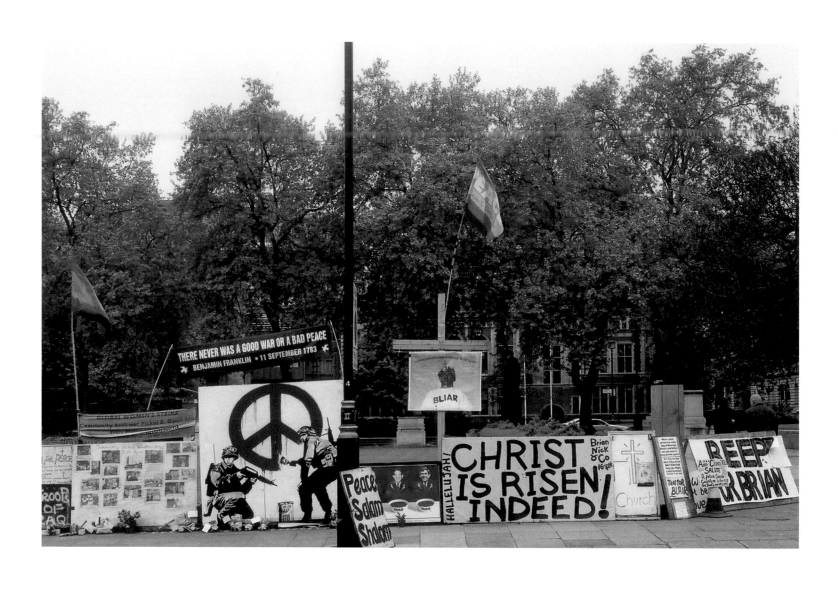

Brian Haw's protest, Parliament
Square, London, 2006

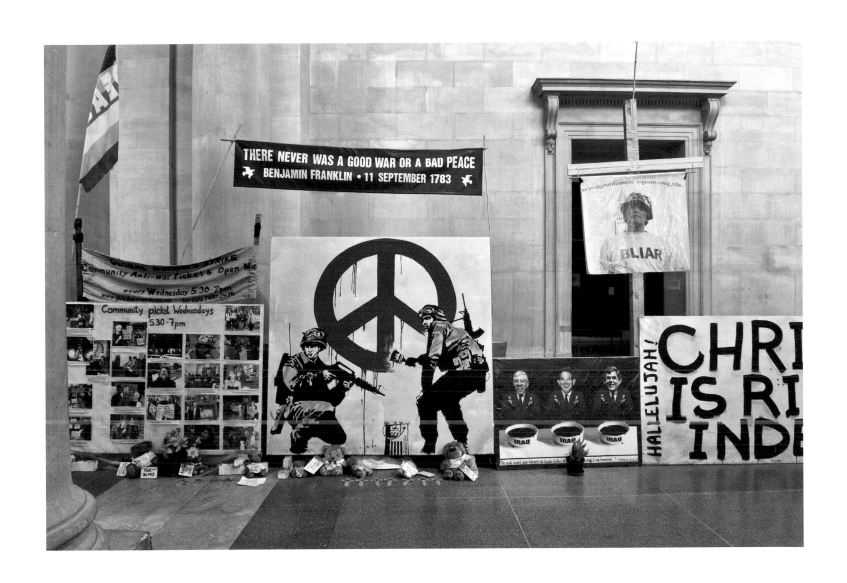

State Britain, 2007
Detail, installation at Tate Britain, 2007

So the clock was ticking, I thought, for Brian. I remember ringing Anna and saying, I'd better go and take some pictures just in case. And thankfully I did – seven or eight hundred, and a couple of days later I took Clarrie Wallis and Judith Nesbitt from the Tate down the road to the Square, saying, I'm thinking of reproducing this. And just twelve hours later, in the early hours of May 23rd, seventy-eight police descended to take it away.'[8]

State Britain (2007) was the result of Wallinger giving his exhaustive collection of photographs to London-based fabricators Mike Smith Studio and saying, in effect: make me a perfect copy of this. It took fifteen artisans six months to do so.[9] With this meticulous simulacrum of each of the six hundred parts of Haw's camp – placards, flags, teddies ('bears against bombs'), bloodied rags, photographs, defaced images of Tony Blair, etc. – Wallinger returns to the political arena of contesting representations, here explicitly the government's version of reality versus a lone dissenter. Meanwhile, it is still a religious work, even leaving aside the conflict of faiths that overarches the Iraq invasion, for Haw is a devout Christian and his written statements argue from a Christian viewpoint. As Wallinger observed, 'I often think of Brian's actions in terms of Christian witness and vigil.' And, like *Ecce Homo*, *State Britain* is in effect a portrait of one man in a square, standing alone, firm in his beliefs.

Part of the strategic gaming of *State Britain* in Tate Britain was that it effectively allowed Haw's protest to continue in something approaching a public place. And the fact that it was being presented as art likely served to draw *more* attention to it and simultaneously sanctioned the display being re-presented as a non-political act – for it is important that a publicly funded venue like Tate Britain not be seen as actively opposing government policy. Much of the interpretative literature that the institution produced served to frame the work in terms of appropriation. However, Clarrie Wallis's essay discussed it in terms of history painting. She concluded her essay by saying: 'In bringing a reconstruction of Haw's protest back into the public domain, *State Britain* does not just represent a historical event; nor is it simply a protest in itself. Rather, it raises questions about the right to protest and the limits and nature of art in its institutional context.'

The irony, however, was that *State Britain* did not *feel* simply like art. Its pre-aged verisimilitude made the gap between representation and original infinitely thin. The question of whether this was art or politics seemed inbuilt – though when Haw went to Tate Britain, tried to add things, and was rebuffed, it was made pretty clear what the answer was. Yet such was the aggrieved, no-holds-barred power of Haw's original display that from January to August of 2007 an anti-war viewpoint effectively infiltrated the ostensibly neutral building. 'There are different ways of enacting protest,' says Wallinger, 'and there are various platforms and media to do that. But really this museum was the only way of making this work. I think it neatly sidetracked any issues to do with authenticity, and also the "is it art?" thing, because there was an urgency for people to have a close look at *this*, and the only place they could do it was there.'

And there was another layer to the work to contend with. Running down the floor of the Duveens (and extending throughout the rest of Tate Britain) was a curving black line, marking the circumference of the one-kilometre (over a half mile) exclusion zone inside which, under SOCPA's new stipulations, protests against Parliament and its actions could not take place without police permission. *State Britain* straddled this boundary, raising the question of whether it constituted a lawbreaking act. Here is another way in which it returns us to Wallinger's formative concerns, for *State Britain* was once again about illusion; titled using a sardonic pun, it took the form of a 43m- (141ft-) long barrier; and, like works going back to *Common Grain*, it was concerned with our basic rights and liberties, specifically the right to protest. (For his part,

State Britain, 2007
Detail showing black line marking exclusion zone, installation at Tate Britain, 2007

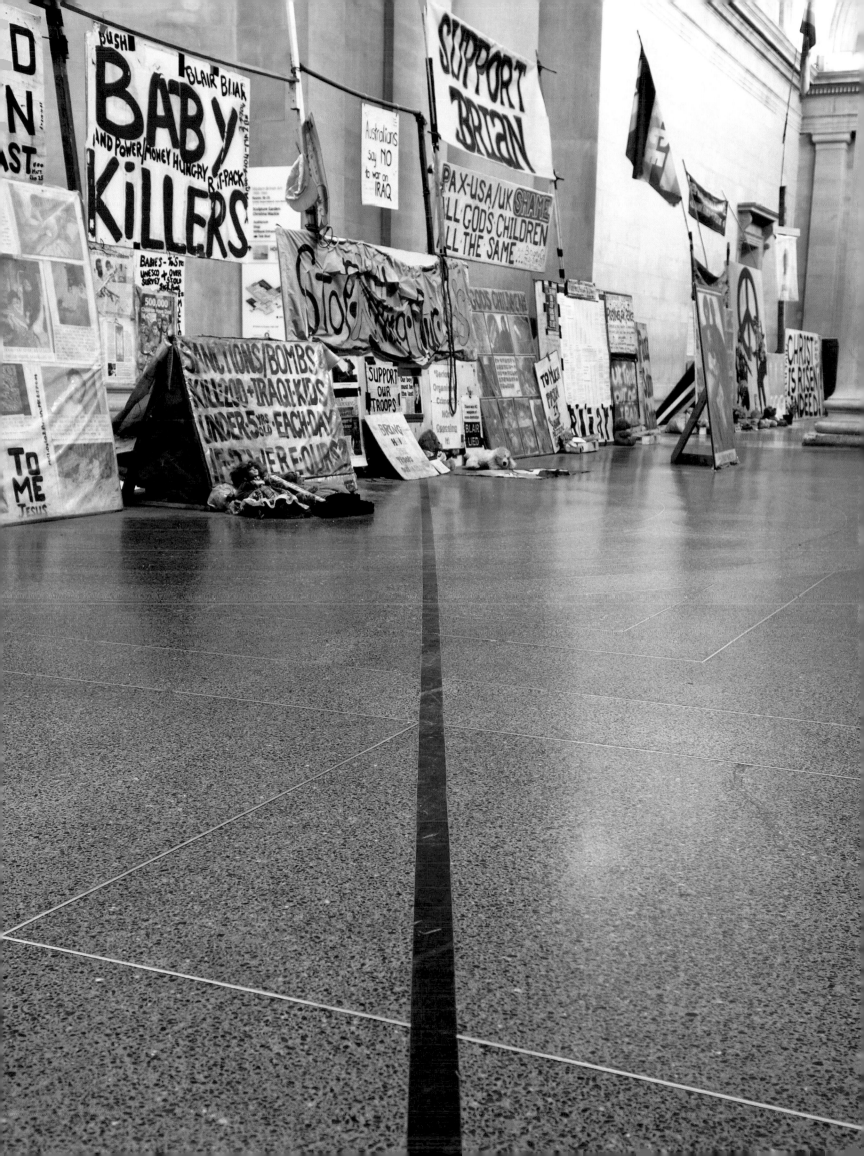

Wallinger had been appalled at the lack of outrage against the SOCPA law: 'Those rights go back to the Magna Carta.')

When Yve-Alain Bois described *State Britain* as 'one of the most remarkable political works of art ever' in *Artforum*, he was highlighting the fact that Wallinger had positioned something so potentially inflammatory in a publicly funded institution. Locating another subtext in the work's play with fact and falsity, he continued: 'the installation is in part so stunning because it provides a rich trove of vivid information at a time when information, precisely, is drastically screened and controlled ... In short, willingly or not, the beholders of Wallinger's piece learn that the war in Iraq is most certainly not virtual.'

Inclusion Zone

'Do you remember,' writes Wallinger in his book *The Russian Linesman*, 'playing a game of tag at school in which you could cross your fingers and declare "fay knights", a sort of street injunction that rendered you briefly immune to the normal rules of the game? Perhaps art exists in such an interregnum.'

State Britain suggested so. The context of this quote, though, was a discussion of *eruvs* – real or symbolic boundaries that encircle Jewish neighbourhoods, allowing those within to circumvent the strict limitations regarding public behaviour on the Sabbath. In the summer of 2007, Wallinger created an *eruv* in the German town of Münster, his contribution to the decennial art event Skulptur Projekte Münster. 'I was fascinated by how the prohibitions of the Jewish Sabbath are circumvented by a creative interpretation of the Law. This loophole allows for a designated public space to become domesticated by string stretched as "lintels" above "doorways" into

Skulptur Projekte Münster 07, map with *Zone*, 2007

a communal home – it's an assertion of religious communal identity, quite discreet to the outsider, which is the mirror of the ghetto in which Jews were banished into forced communality,' says Wallinger. 'At the same time, they also brought to mind the purity of form and the economy of means of [American minimalist artist] Fred Sandback's work with yarn. That sense of just how absurdly charged are the invisible planes they circumscribe, evoking children's stories of magical transformation: doorways into a heightened reality.'

An *eruv* is supposed to be near invisible, designated by an unobtrusive elevated thread. Wallinger used three miles of fishing line, and marked out his perimeter by taking a saucer, slapping it on a map of the Westphalian town, and drawing around it. *Zone* (2007) might be considered the inverse of *State Britain*. The boundary might become not a restriction but a permission, and the work speaks metaphorically of what art, as a roped-off space of freedom, might do. After several years of addressing prohibitive boundaries, here was a moment in which Wallinger gave in to his tendency towards dialectical thinking, and treated boundary-making as potentially unifying. However, as he recalls, there was some implicit pressure on those residences and businesses to which the line would need to be attached, emphasizing the authoritarian subtext of a work enfolding contradiction: 'I wanted to reverse roles and play God or authority or whoever is denoting this, without explanation.'

In the same year Wallinger made another work drawn in space using three miles of string, *The Human Figure in Space*. Here he set up an illusorily huge, geometric space by stretching the three miles of kite string into taut grids on frames over three of the walls of the gallery, with rows of back-to-front numbers stencilled at their bases. The reference is, first, to the 19th-century English photographer Eadweard Muybridge, who created his studies of figures in motion by photographing them

Above and overleaf
Zone, 2007
Dyneema fishing line, plastic
and metal clamps
Circumference approx. 4,800 m
(3 miles), 5m (16ft) above ground
Details of installation at Münster

Opposite and above
The Human Figure in Space, 2007
Approx. 4,800 m (3 miles) of kite string,
mirrors, stencilled numbers, nails, wood
Dimensions variable
Installation views at Donald Young
Gallery, Chicago, 2007

Left
Eadweard Muybridge
Animal Locomotion, c. 1887
Black and white film copy negative

in front of just such screens created with white thread, measuring and defining space, turning time *into* space; and, second, to Leon Battista Alberti's grid (of which Muybridge's was the negative), which has been used by painters since the 15th century to allow them to master perspective and present the illusion of three-dimensionality.

Here depth is represented differently. The fourth wall of the room is mirrored: in this otherworld, the numbers read the right way around[10] and the viewer's presence activates the otherwise austere and immobile piece. We become living motion studies, and also presences within a figuring of the plaintive history of pictorial attempts to make the depicted world seem real. *The Human Figure in Space* was shown in the Donald Young Gallery in Chicago, and it was in that city, at the 1893 World's Fair, that Muybridge demonstrated his zoopraxiscope – a device for running his serial images together – thereby creating the first motion-picture show. Muybridge has widely been considered the forerunner of filmmaking, and the subject of what is thought to be his first 'moving picture', made in 1882, was, pointedly, nothing less than a racehorse in motion.

In the same Chicago exhibition – alongside the video version of *Sleeper*, another lone figure seen against a grid – Wallinger also showed a further work concerned with human figures in space, *Landscape with the Fall of Icarus* (2007). The title, which Wallinger says is his favourite appellation for an artwork, comes from a painting long thought to be by Pieter Brueghel (but now considered a copy) that inspired the poem by W. H. Auden. As with *The Lark Ascending*, then, Wallinger uses layered cultural references, since Icarus's father was Daedalus, and Stephen Dedalus, the recurring character in James Joyce's novels, imagines himself in *A Portrait of the Artist as a Young Man* as 'a hawk-like man flying sunward above the sea, a prophecy of the end he had been born

Top and opposite
Landscape with the Fall of Icarus, 2007
5 monitor video installation, silent, continuous loop
Dimensions variable
Installation view at Donald Young Gallery, Chicago, 2007, and video stills

Above
Copy after Pieter Brueghel
Landscape with the Fall of Icarus, c. 1560
Oil on canvas
73.5 x 112 cm
(29 x 44 in.)

to serve'. In Wallinger's *Landscape*, a five-screen video work, the prospect of mortals hanging by a thread before crashing to earth is figured as tragicomically endless.

If *The Human Figure in Space* alludes to the earliest efforts to record moving bodies, *Landscape* spotlights what was then the newest: the camcorder. Scouring VHS copies of the television show *You've Been Framed*, for which viewers sent in videos of themselves or friends or family in embarrassing situations, Wallinger isolated five examples of humans defeated by gravity: trying to cross a river on two ropes, being tugged across a field by a pair of kites, zip-lining towards a pond to be doused in mud, being suddenly yanked upside down into the air, or losing control of a paraglider. What was originally lightly comic becomes, here, weightier (though still funny) and shaded with unlikely heroism. In another link back to Muybridge, Wallinger effectively turns the footage into slow-motion, stop-frame sequences, in tenths of seconds, and edits them so that, typically, once the action has ended – or failed to conclude, as with the rope-walker who sways continuously, perilously, above water – the footage reverses, returns to the beginning and starts inexorably again.

In terms of the contingent influences on Wallinger's work, consider that in the lead-up to making *Zone*, *The Human Figure in Space* and *Landscape with the Fall of Icarus*, he was preparing a talk on the work of Bruce Nauman for Dia Art Foundation: he had it delivered, by a hired actor, at the New York institution's Chelsea venue in May 2006. If any artist outside of Francis Bacon has made their territory the human body in a tightly defined space, it's Nauman, with his videos of himself in the studio – and Wallinger admits that the American's work may have inflected *Sleeper*, too. For Donald Young, the connective tissue between Wallinger and Nauman is simple: 'human behaviour and movement, with all its irrational quirkiness'.

CUE FANFARE

The year 2007 was a hectic one for Wallinger. As well as *State Britain*, *Zone*, the various works for Chicago and lecturing at Tate Britain, he began a new body of work. 'I remember coming out of my Tate talk, ringing Anthony [Reynolds], and saying, "has anybody done this?"' says Wallinger. 'This' would be his series of *Self Portraits*, effectively the first paintings he would make since saying farewell to the genre with the Q series a dozen years before.

The *Self Portraits* are a series of works in which the letter 'I' is painted in black on a white background, the first-person pronoun in a unique font (or, on occasion, loosely drawn). By 2009, Wallinger had made around thirty of these; or, in a sense, a large number of different Mark Wallingers had. If he had spent the last two decades exploring subjectivity, here he found perhaps the most essentialized form of the human subject – the 'I' – and fused it with a fundamental, and wholly contemporary, level of self-expression. Given that most of us write on computers, the font we choose to use says something about us. It is a form of dressing-up, a subliminal expression of personality.

'I'm fascinated by the fact that Helvetica does have unbelievable authority. I love Garamond, which was invented for the definitive text of the Bible – that's the *Word*. And this makes as much sense as me doing an ordinary self-portrait, because I know the truth and deceit of painting. There's something about the mystique of the self-portrait that I'm a bit resistant to. That kind of self-scrutiny has an elusive quality which, in the ever-expanding project of the *Self Portraits*, says something about how ill at ease anyone is with being defined.'

The *Self Portraits* appear in retrospect to be the first stirrings of a project investigating the artist's self – what he would come to summarize, getting his defence in first,

Self Portrait (Wallinger 1), 2007
Acrylic on canvas
76 x 46 cm
(30 x 18 in.)

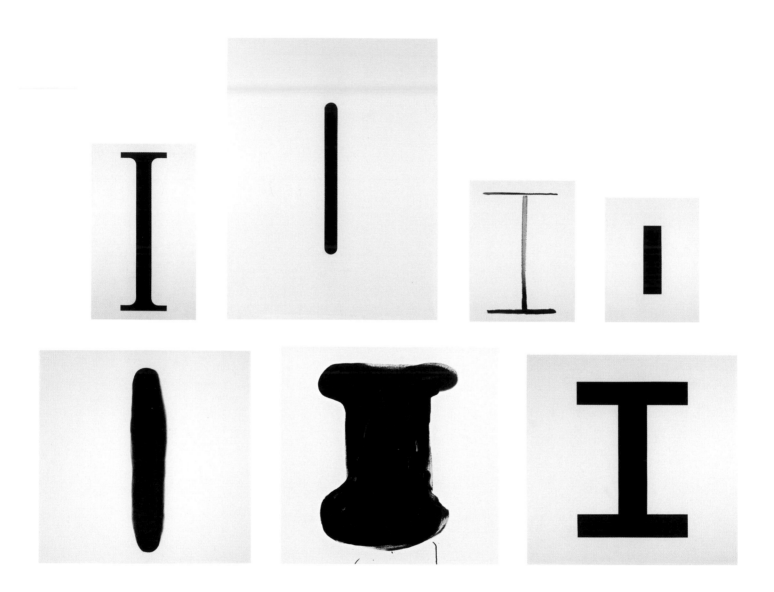

Top, left to right, all acrylic on canvas
Self Portrait (MSP Mincho), 2007
76 x 46 cm (29 x 18 in.)
Self Portrait (Gulim), 2007
122 x 91 cm (48 x 36 in.)
Self Portrait (Freehand 2), 2007
61 x 46 cm (24 x 18 in.)
Self Portrait (Franklin Gothic Demi),
2007
61 x 41 cm (24 x 16 in.)

Bottom, left to right, all acrylic
on canvas
Self Portrait (Freehand 3), 2007
92 x 92 cm (36 x 36 in.)
Self Portrait (Freehand 5), 2008
92 x 92 cm (36 x 36 in.)
*Self Portrait (Lucida Console Bold
Minor),* 2007
92 x 92 cm (36 x 36 in.)

Top, left to right, all acrylic on canvas
Self Portrait (Courier New), 2007
168 x 117 cm (66 x 46 in.)
Self Portrait (Braggadocio), 2008
183 x 112.5 cm (72 x 44 in.)
Self Portrait (Engravers MT), 2007
122 x 91.5 cm (48 x 36 in.)

Bottom, left to right, both acrylic
on canvas
Self Portrait (Lucida Console Bold),
2007
213 x 152 cm (84 x 60 in.)
Self Portrait (Runic MT Condensed),
2007
213 x 152 cm (84 x 60 in.)

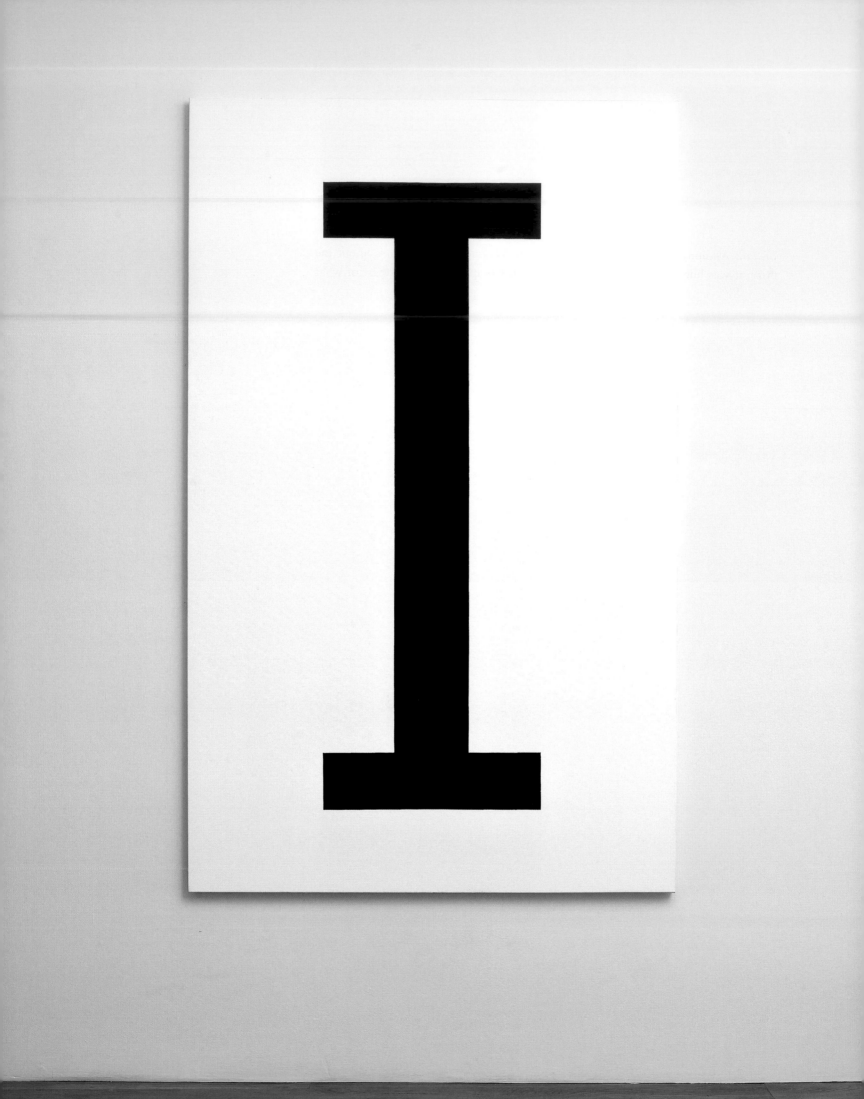

as 'megalomania' – which Wallinger honed over the next few years. They also might be, ironically, *true* self-portraits in that they depict Wallinger's artistic personality as a parade of shifting selves; resistant, as he says, to being pinned down. His practice is in effect a power game in which he retains the right to determine who he is, and a telling one in the context of a body of art that has been fundamentally about how our sense of self is modulated from outside. You could almost call Wallinger's entire conceptual focus an expression of character.

Later in 2007, Wallinger was nominated again for the Turner Prize, for *State Britain*. Anthony Reynolds thinks that despite Wallinger's reservations about the prize, it was hugely important to him to win it. Competitive spirit is part of what drives him – no one who owns a racehorse is going to be immune to the spur of competition. For his part, Wallinger wryly observes that 'after winning it the media gets to put "Turner Prize winner" before your name'. He was awarded the prize on 3 December 2007; his companion at the ceremony, spending his first night away from Parliament Square in a long time, was – who else? – Brian Haw.

1. As was the case in *When Parallel Lines Meet at Infinity*.

2. Wallinger's film might accordingly be construed as his playing the Marilyn role for his audience.

3. The bear has been the civic symbol of Berlin since the late 19th century. Wallinger says that the sign at the zoo where he was filming had a particular impact. The information label read, in part: 'This exhibit displays the European Brown Bear, the Heraldic animal of the city of Berlin ... During the coldest time of year they [the Brown Bears] undergo a "winter rest" in dens or under fallen tree trunks, but this should not be confused with the deep hibernation of other animals ... Unfortunately our visitors will have to forego seeing young Brown Bears for some time because we have instituted a breeding pause. Since this species of bear is maintained in many institutions, it is very difficult to find good homes for new generations. Reintroduction back into the wild for Brown Bears is not possible because of the lack of sufficiently large undisturbed land areas. Released animals would sooner or later inevitably come into conflict with man...'

4. 'I was also thinking about enchantment,' Wallinger recalls, 'and T. S. Eliot's 'East Coker'. The lines "And menaced by monsters, fancy lights, / Risking enchantment" remind me of my childhood fear of how far imagination might lead you, perhaps never to return. I thought of these lines often while working on *Sleeper* and *Time And Relative Dimensions In Space*. And there's also W. H. Auden's 'the power to enchant that comes from disillusion', from *The Sea and the Mirror* [his long poem on Shakespeare's *The Tempest*] which brings us back to Ariel's Song in *Prometheus*.'

5. Hannay was the novelist's fictional secret agent.

6. This section of *The Russian Linesman* draws on an article Wallinger wrote for *frieze* in 2005.

7. Considering Wallinger's work's abstract evocation of dawn, note that Fussell writes: 'It was a cruel reversal that sunrise and sunset, established by over a century of Romantic poetry and painting as the tokens of hope and peace and rural charm, should now be exactly the moments of heightened ritual anxiety.'

8. After the police officers removed and impounded the camp's contents, and after many days in court, in 2007 Haw's protest was allowed to continue, albeit on a vastly reduced scale.

9. Haw, for his part, had agreed willingly to Wallinger's proposal.

10. An echo of *Regard a Mere Mad Rager*: the world righting itself on the other side of a threshold.

Self Portrait (Tahoma), 2008
Acrylic on canvas
183 x 113 cm
(72 x 44½ in.)

FIVE

You, Me, Us
(2008–2010)

FIELD WORK

One of the quieter beauties of the landscape surrounding Oxford's Magdalen College is Bat Willow Meadow. Planted with a ring of willow trees, it is a water meadow, flooding every spring and blooming with chequered fritillary flowers. And, since 2008, it has additionally been home to Wallinger's sculpture, Y.[1] In essence, a career that began with angry expostulations about class and the English landscape had now led him to a bucolic meadow owned by one of the country's most elite universities – at that institution's invitation, to celebrate its 550th anniversary. Y is not one of the best-known works in the Wallinger canon, but it is exemplary of how he responds to a commission.

Y is a schematic metal structure that looks like a Y shape that has turned into a divining rod and then into a tree, replete with complexly branching forks. (In art-historical terms, it recalls the geometric trees that Piet Mondrian painted on his way to pure abstraction.) In the tradition of Wallinger's visual punning, all of these references are present. 'The water meadow makes seasons feel somehow exaggerated, and I was thinking of the willows and of divining rods and English paganism, and then of the architecture of the college, with its gothic traceries. And, also, since there's a deer park nearby, of antlers. And then, in terms of the branching, I was thinking that if we could go back maybe seventeen generations, that would get us back 550 years.' That, at least, was the idea: the finished work contains fewer branches. 'There's only so far you can go with branching; it gets too skinny. The golden ratio is built into the divides, too.'

That's a fairly good picture of how Wallinger's mind works, in terms of his ability to load potential multiplicity into an artwork and in terms of his taste for interlocking connections, coincidences, problem solving. But this work is of unexpectedly substantial conceptual dimensions. 'Y' itself, as a letter, is homophonically a question. It might be *the* question that has echoed down the 550 years of Magdalen's history, the desire to find something out. In those terms, and due to its flotilla of references, it satisfies the brief just as surely as *Ecce Homo* satisfied the brief to put up a statue around the time of the millennium. And yet it might also be seen to exemplify everything about Wallinger's art that pertains to subjectivity and the construction of meaning. Y can be read in various different ways – it is a willow, it is a divining rod, it is an architectural fragment – and its very form is a question; it accordingly becomes a piece that questions its own meaning, that asks the viewer to consider the fact of their subjective viewpoint.

While so much of Wallinger's work opens up layers of meaning by revealing ambiguities, it usually does so by finding purchase in an established representation: the Conservative view of the English landscape, for instance, or the iconography of religion. Y, however, has no overt 'other'. It simply asks the viewer to adopt a questioning attitude, and to accept that their answer to the question 'Why?' is going to be structured by all kinds of forces, among them where they come from. (The sylvan surroundings of Y, Wallinger notes, are 'terribly English'.) It is, if you like, a kind of discreet summa of his practice. And it was made, coincidentally, while he was preparing for a twenty-year survey of his art.[2]

One notable focus in the subsequent period is the relationship between objects and their designations: objects and language, objects and numbers, the links and the lacuna. This phase touches on the very human impulse to interpret reality via representations, a consistent concern of Wallinger's, here expressed through linguistic and numeric systems. It had been prefigured in works such as *Autopsy* and the 3D writing of *Credo*, which explore the infinite relationship between language and faith. But it really gains traction with the *Self Portraits*, which emphasize the limited or faltering connection between a representation and what it represents, signifier and signified.

Later in 2008 Wallinger created *Folk Stones*, a permanent work commissioned by the Folkstone Triennial, a newly inaugurated art event on the East Kent coast. *Folk Stones* consists of 19,240 numbered stones set into a 9m square of concrete on the town's cliff-top promenade, the Leas, overlooking the English Channel. On a clear day one can see France from here. Folkstone was the embarkation point for millions of soldiers going to fight on the battlefields of France and Flanders in the First World War. Each of these stones corresponds to a soldier who died on the first day of the Battle of the Somme, on 1 July 1916. *Folk Stones* is in this sense a memorial, but one that refuses the assumptions that go with memorializing. Rather, it questions its own efficacy on the level of representation: how can a stone ever equate to a life?

At the same time as it speaks of a kind of failure, *Folk Stones* also concerns itself with the common desire to make sense of the world we live in, to master it somehow through enumeration and representation. This intimation of struggle runs through Wallinger's work – think of the endlessly falling figures in *Landscape with the Fall of Icarus*, the relief of the travellers in *Threshold to the Kingdom*, the endless pursuit of harmony of the orchestra in *A ist für Alles*, Brian Haw's tenacity that underpins *State Britain*, the endlessly replenished capacity to ask 'Why?' It is at these points where his art is at its most affectingly compassionate, and where its feel for life's blemished beauty takes on Joycean contours. Towards the end of his BA thesis on the Irish writer, Wallinger notes that '[Leopold] Bloom will be able to teach Stephen to accept the world for better or worse.' It is, unknowingly, a prediction of the arc of Wallinger's own *oeuvre*.

LEFT AND RIGHT AND BACK AGAIN

Folk Stones is clearly a pun – though a clever one given its added reference to the First World War, since the root of 'folk' is the German *volk*. More understated is Wallinger's long-running layering of the meanings of 'transport': the divine, religious sense hitched to the mundane, vehicular one. It is there in *Angel* and *Threshold to the Kingdom*, in the two films set on underground railways in Berlin, and, morphing again, in *Ferry* (2009). Invited to make a site-specific work for Governors Island, off Manhattan, as part of public art event 'PLOT/09: This World & Nearer Ones', Wallinger moved through various ideas tied to its past functions. Not so surprisingly the historical timeline enfolds various strands: laws and ordinances were enacted on

Folk Stones, 2008
19,240 stones, paint, sand, cement, COR-TEN steel
900 x 900 cm
(354 x 354 in.)
Folkestone, Kent, UK

the isle relating to the tradition of religious tolerance on which the US was founded, while more recently it has served as a military base: the island was divided into two – one half for the officers, the other for the soldiers.

What he ended up doing was something that convoked religion, tolerance, division and state power in a nudging and mordantly economical way. Wallinger's favourite aspect of Governors Island, he decided, was the ferry that joins it to Manhattan, and he had noticed that the ferry was symmetrical, with no designated back or front. *Ferry* makes hay with the fact that the ship's two ends mirror each other by creating a mirroring that reverses itself: at each end, Wallinger put up a sign on port and starboard, the one on the right reading 'Sheep' and that on the left reading 'Goats' – the 'right-eous' and the 'sinister' (*sinistra* being Latin for 'left'), if you like, as according to Jesus's parable in Matthew 25 about the judging of mankind. ('And before him shall be gathered all nations: and he shall separate them one from another, as a shepherd divideth his sheep from the goats. And he shall set the sheep on his right hand, but the goats on the left … And these shall go away into eternal punishment; but the righteous into life eternal.')

The seriocomic symbolic reversal of *Ferry* was that if you got on the ferry as a sheep, if you kept to the same side, by the time you had walked through to the exit you were leaving as a goat, and vice versa. *Ferry,* then, is at least partly about the delicacy (or otherwise) of judgment: how we see ourselves, how we tend to define ourselves *against* others, and the usefulness of seeing ourselves as others do. No small issue in an America latterly consumed by the War on Terror. As Wallinger points out, only one chromosome separates sheep from goats in any case; the distinctions fundamentally are in our minds, enshrined in and cued by language. These are the largest of issues, but *Ferry* treats them with an admirably light touch. And, perhaps most importantly, it enacts itself in such a way that the viewer, after being amused and inveigled, is also implicated and led towards a moment of self-knowledge – a kind of transport.

BETWEEN, BETWIXT, BEWITCHED

Described as 'an artist's exploration of the frontiers and border zones through which and by which we come to be defined', Wallinger's curatorial project, 'The Russian Linesman', opened at London's Hayward Gallery in February 2009 and toured to institutions in Leeds and Swansea. The exhibition might be considered a kind of sweeping self-portrait by proxy, a constellation of Wallinger's own concerns through the art of others, or perhaps simply a marker of the scale of the thoughts that animate his own work. Roger Malbert, the Hayward's senior curator, in his afterword to the accompanying book, admirably linked Wallinger's artistic and curatorial practices: 'The exhibition's interrelated themes,' he wrote, 'reflect his concerns as an artist: ambiguities of perception and the unstable relation between knowledge and experience, fact and fiction, reality and illusion … the artist is fascinated by the ways in which the individual's subjective consciousness is immersed in – and participates in – the wider collective consciousness, how we negotiate the many levels of phenomena experienced in daily life, shifting between the personal, the practical, the social and the poetic.'

Here, diversely reflecting and stimulating such negotiations, were 19th-century crucifixes, apocalyptic Dürer prints, paintings and photographs of Jerusalem. Here were Ronald Searle's sketches of the Japanese secret police and of prisoners of war working on the Burma railway. Here were photographs of French high-wire artist Philippe Petit walking between the Twin Towers on a tightrope and a video from a helicopter circling the thread after his arrest; YouTube montage of tourist footage of

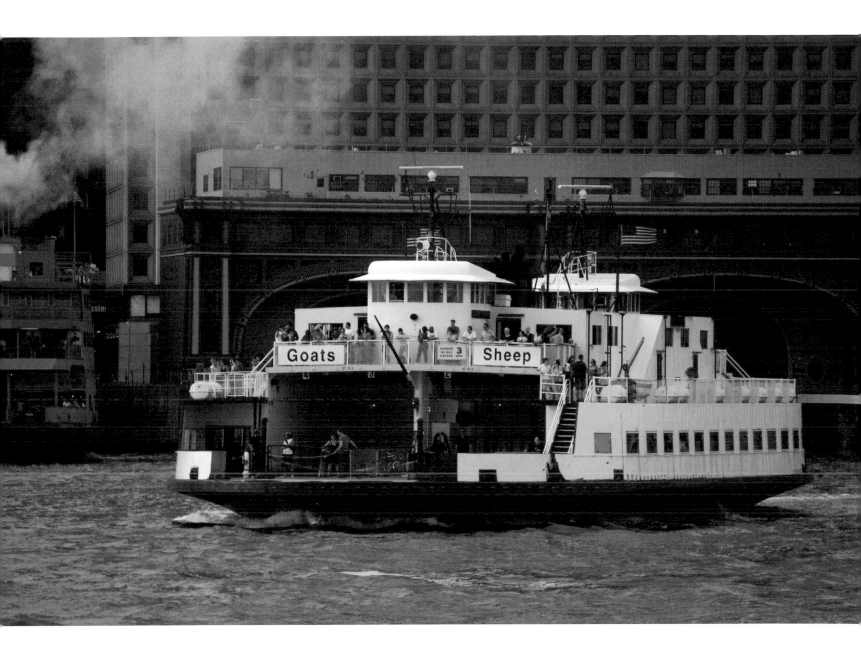

Ferry, 2009
Enamelled metal signs
Each 76 x 275 cm
(30 x 108 in.)
Installation on Governors Island Ferry,
New York

the surreal, high-stepping official ceremony performed daily on the India/Pakistan border; and a video of Bruce Nauman seemingly walking on a ceiling (its simple trick of inversion a reminder of Wallinger's own photograph of himself upside-down at Shelley's grave, and another example of 'showing the seams'). Here was a procession of illusionistic works and others using new means of representation and capturing reality, including a 17th-century drawing of a flea from Robert Hooke's *Micrographia* (the first book describing observations through a microscope), motion studies by Eadweard Muybridge, a photograph by Thomas Demand of a faked interior showing the site of the 2002 Florida electoral recount, and several works by Wallinger, old and new. *Time And Relative Dimensions In Space* (2001), a piece whose time-travelling mien made it latently symbolic of the show, was included: so too was *Double Still Life* (2009), at once a smart expansion of the tradition of the readymade and a consideration of threshold experiences in the everyday.

Researching for 'The Russian Linesman' in the Royal College of Surgeons' museum in London, The Hunterian, Wallinger was struck by a pair of extremely large and flamboyant flower displays in the lobby. 'I asked the receptionist where she got the flowers from and she said, "you do know they're fake?"' Wallinger, conscious of the contradictory feelings prompted by such knowledge, had a comparable pair of flower arrangements made, in silk and plastic, and installed them in his show. There, they created a cognitive line that the viewer crosses. Discovering the assiduous illusionism, we might feel what Wallinger felt: a complex response in which disappointment is diluted by pleasure at the skilful verisimilitude and the objects' potential to touch, impressively lightly, on the traditions of *vanitas* and *memento mori*.

Also on display was a series of fourteen stereoscopic photographs, entitled *The Nightmare of History* (2009), to be examined through Viewmaster eyepieces. Among them were images of Hitler, Queen Elizabeth II visiting a leper colony in Nigeria in 1956, and Wallinger's own stereoscopic photographs including *UN Post on the Green Line, Nicosia* (2006). In the book, Wallinger notes on the facing page that

The Nightmare of History, 2009
14 stereoscopes
Dimensions variable
Detail, *UN Post on the Green Line, Nicosia*

UN, 2010
Computer cut vinyl
396 x 336 cm
(156 x 132 in.)
Installation at Kunstnernes Hus,
Oslo, 2010

UNABASHED
UNABATED
UNABETTED
UNABLE
UNABOLISHED
UNABRIDGED
UNABSOLVED
UNACADEMIC
UNACCENTED
UNACCEPTABLE
UNACCEPTED
UNACCOMMODATED
UNACCOMPANIED
UNACCOMPLISHED
UNACCOUNTABLE
UNACCOUNTABLENESS
UNACCOUNTABLY
UNACCUSTOMED
UNACLIMATED
UNACLIMATIZED
UNACCOMODATING
UNACCOUNTED
UNACCREDITED
UNACKNOWLEDGED
UNACQUAINTED
UNACQUITTED
UNADAPTABLE
UNADJUSTABLE
UNADJUSTED
UNADORNED
UNADULTERATED
UNADVISED
UNADVISEDLY
UNADVISEDNESS
UNAESTHETIC
UNAFFECTED
UNAFFECTEDLY
UNAFFECTEDNESS
UNAFFILIATED
UNAFRAID
UNAGGRESSIVE
UNAGITATED
UNAIDED
UNAIMED
UNALIENABLE
UNALIKE
UNALLEVIATED
UNALLIED
UNALLOWABLE

'In the Green Zone you see the United Nations initials, black on white, painted on oil-cans. After a while I found I had started reading UN as UN- ...' (the hyphenated 'UN-' is printed in large letters). The presence of the United Nations anywhere, Wallinger would later say, tends to feel like a marker that something has gone wrong, come undone; the gap between UN and UN-, arguably, is that between what we would like to happen, a space of possibility, and that which actually transpires: what has been done cannot be undone.

When, in 2010, Wallinger held his most substantial exhibition of new and recent work for several years, at the Kunstnernes Hus in Oslo, 'UN' was emblazoned in huge black letters on the institution's façade. Inside, positioned directly behind the façade to serve as its flipside (in a show full of flipsides), was *UN-* (2010), a list of nouns, verbs, adjectives and adverbs from the American publisher Funk & Wagnalls's *Standard Dictionary of the English Language*, each beginning with the prefix 'un-'. This reciprocity between mind and matter would characterize the show.

Upstairs in the Norwegian gallery are two big, symmetrical rooms. Wallinger, of course, could not resist this. On the landing he mounted a print of *Ferry*, the boat coming broadly towards us, the main galleries leading off on either side of the photograph. The 'port' side (indicated on a boat by a red light; this would be the side you would have boarded if you wanted to be a 'sheep', though from the observer's perspective you are now a 'goat') neatly sat closest to a room at either end of which was a red traffic light, *Red* (2010). Leading off from the starboard side, meanwhile – which sports a green light on a boat – was another room containing a facing pair of traffic lights, *Green* (2010). The objects and items in these rooms corresponded loosely to a binary of 'fixed' and 'unfixed'. The red room was dominated by various methods of classifying and understanding, the green the province of the unconscious.

Opposite and above
UN-, 2010
Ink on paper
Dimensions variable
Detail and installation view at
Kunstnernes Hus, Oslo, 2010

Overleaf
Double Still Life, 2009
Silk, plastic urn, laquered MDF
and softwood
272 x 120 x 120 cm
(107 x 47 x 47 in.)

Above
Red, 2010
Pair of traffic lights
Detail

Opposite
According to Mark, 2010
100 chairs, string, marker pen, steel eye
Installation view at Kunstnernes Hus,
Oslo, 2010, with details of *Red*, 2010,
and *One Dimensional Sculpture*, 2010

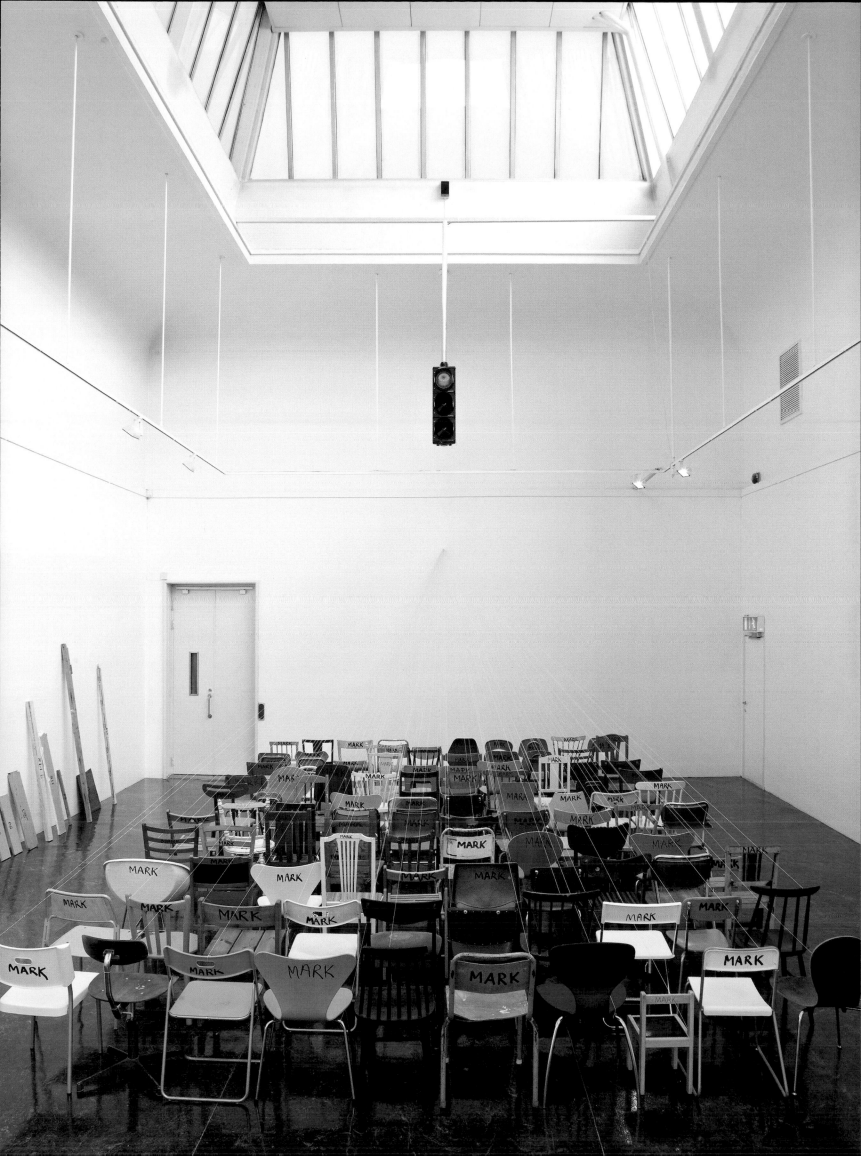

In an exhibition full of backward glimpses, the red room took up the issue of perspective that has been a leitmotif of Wallinger's career, hitching it to the 'megalomania' that seemingly began with the *Self Portraits*. In *According to Mark* (2010), a hundred diverse chairs (as in *The Importance of Being Earnest in Esperanto*), ranging from children's school chairs to design classics, stood in rows like a church congregation. Each faced forward, and each was attached to a string leading to a metal loop on the wall – an 'eye' – as if the whole was emanating from a single-point perspective, which in Wallinger's work has always represented a giving of shape to reality and (as in *School*) a deliverer of meaning and knowledge. In this case, every chair was marked – literally – with the word 'Mark'. The relevant pun, of course, is the Gospel According to Mark: here, the artist gets his own symbolic congregation, hooked to his viewpoint, as if he were a priest – a godhead, a determiner of meaning for a self-deluding congregation of the identically named.

This investigation of religious authority and the omniscient gaze was developed, in Oslo, by the work immediately behind *According to Mark*, entitled *I am Innocent* (2010). Here, a double-sided, ceiling-suspended photographic copy of Velázquez's portrait of the (red-clad) Pope, *Innocent X* (1665) – an image Wallinger would have known from his sojourn in Rome – spun around restlessly, one side correct and the other reversed: the eyes of God's emissary following you around the room. But religion, the show made clear, is just one way of imposing order onto the vexations of being alive in the world. Lined up bathetically against the far wall, *One Dimensional Sculpture* (2010) performed a symbolic act of mastery over the messy stuff of reality: what Wallinger describes as 'very basic procedures you'd perform to try and get to grips with things.' A miscellany of skinny objects leaning against the wall, from dowel to hardboard to plasterboard, were each 'marked' with their vertical

Above and opposite
I am Innocent, 2010
Digital archival prints on standard
fine art paper, mounted on aluminium,
laminated with ultrathin semi-matte
laminate, motor
139 x 117 x 2.5 cm
(54¾ x 46 x 1 in.)

dimension, while on the opposing wall a series of *Self Portraits* (2010) sought to give some fixity to the shifting nature of selfhood.

My Name is Legion (2010), meanwhile, mirrored *According to Mark* and sat at the far end of the room from it. Here, more strings emanating from a single 'eye' were attached, at the artist's eye level, in another working model of perspective, to a three-dimensional 'artist's studio' genre painting. Again, each was marked with the artist's 'Mark' (in marker pen): a case of beer, a fan, a clock stopped at 5.37 (just after knocking-off time, if you're the sort of artist who puts the hours in), a globe, a desk, an apple, white spirit, etc. *My Name is Legion* speaks to the fascination of seeing the world through the artist's eye, a conveyance of understanding: one human constructing a view of reality, others seeing it through them. However contingent the meaning he makes, the artist, in this symbolic economy, is not so far removed from the religious authority (as he was in *Zone*). If so, however, he is one who wants, once again, to 'show the seams': to stress and subvert his own power.

This set of readings was, in any case, destabilized by the 'green room'. Lining the walls was *The Unconscious* (2010), huge blowups of jpegs that Wallinger found on the Internet, each featuring someone asleep on public transport (transport/transport again). These, as the title suggests, are in part portraits of what cannot be seen or held onto: our inner lives, against whose unruly sprawl all the ordering and bordering and shaping devices that we have evolved as a species try to militate.[3] Is the inside of the mind a space of potential? Also here was *Word* (2010), in which what looks like a vast grey blur is in fact a version of the *Oxford Book of English Verse*: Arthur Quiller Couch's anthology, from which source all the titles and authors' names have been removed, together with all the line breaks, punctuation and spacing, leaving it as one word that embodies the history and advancement of the English

Above
One Dimensional Sculpture, 2010
Mixed media
Dimensions variable

Opposite
Self (Times New Roman), 2010
Glass reinforced polyester
on painted wooden base
Sculpture h. 180 cm (71 in.)
diam. 77.2 cm (30¼ in.)
base 47 x 77.4 x 77.4 cm
(18½ x 30½ x 30½ in.)

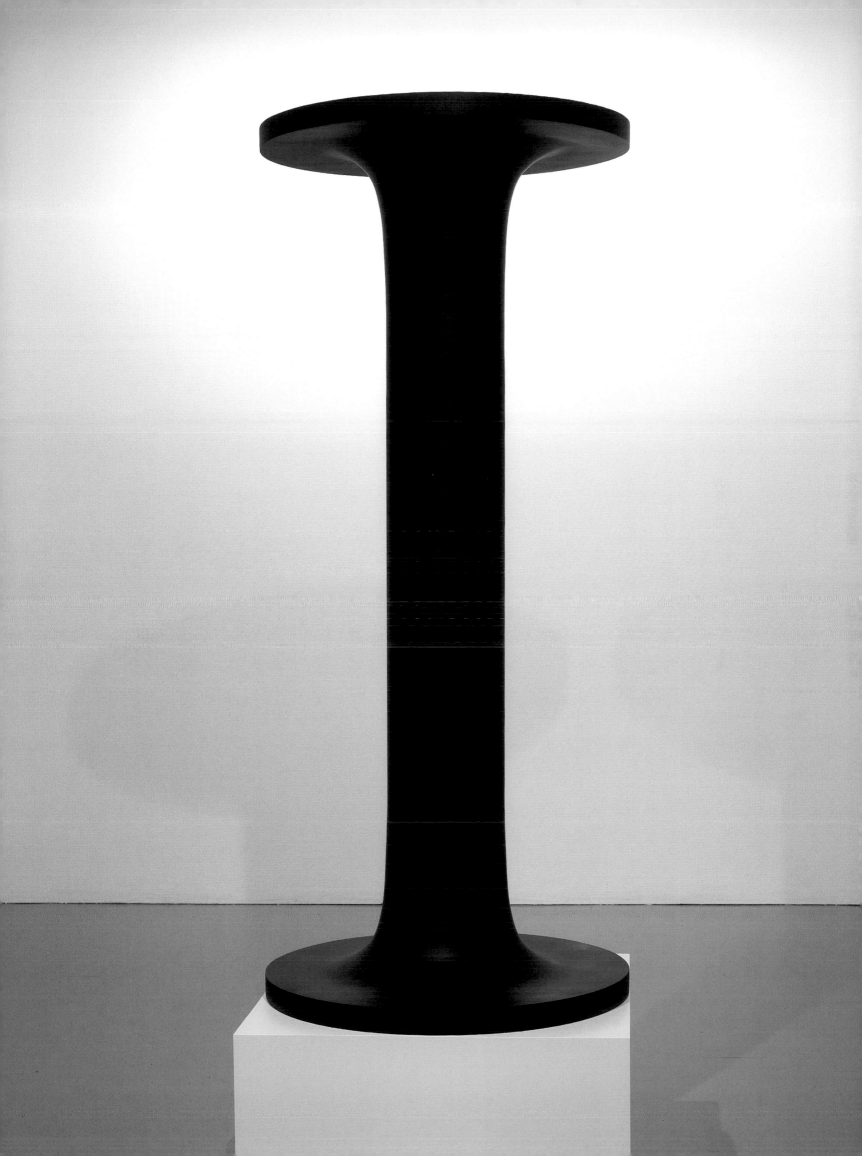

Above and opposite
My Name is Legion, 2010
Mixed Media
Dimensions variable
Installation views at Kunstnernes Hus,
Oslo, 2010

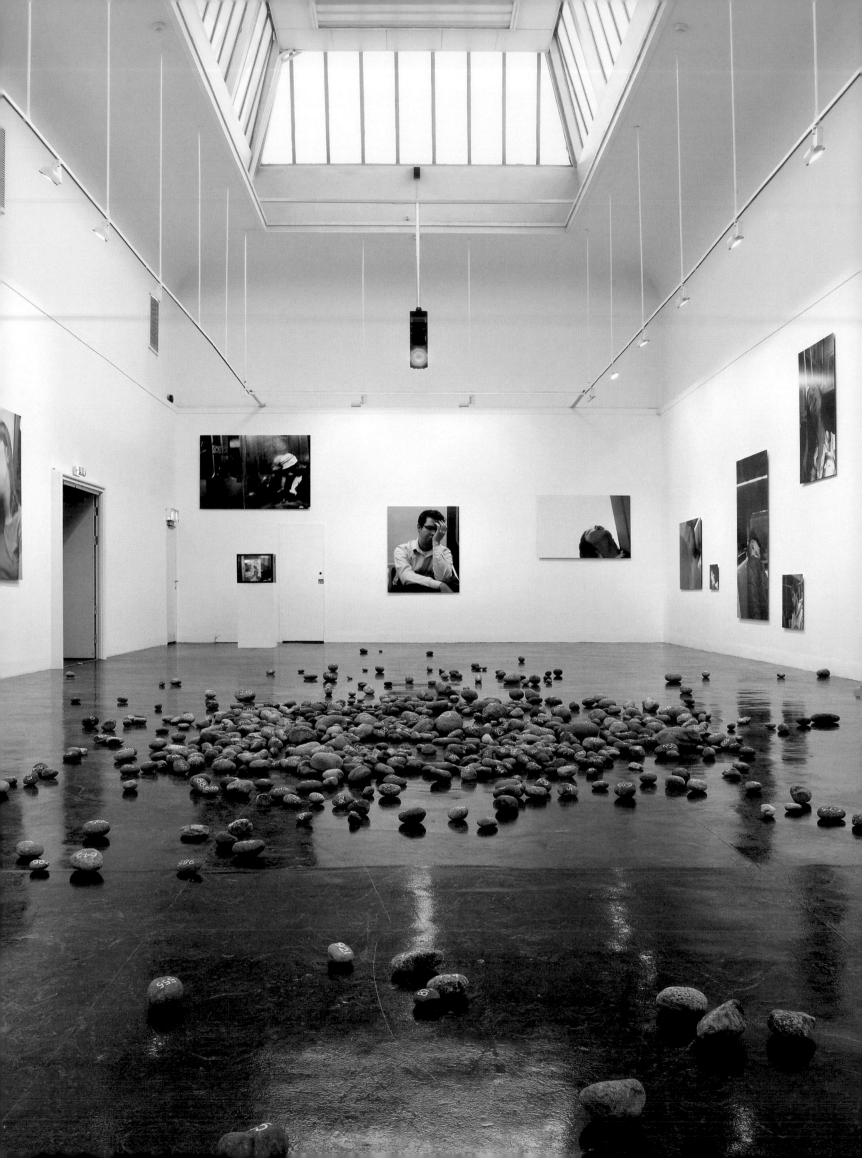

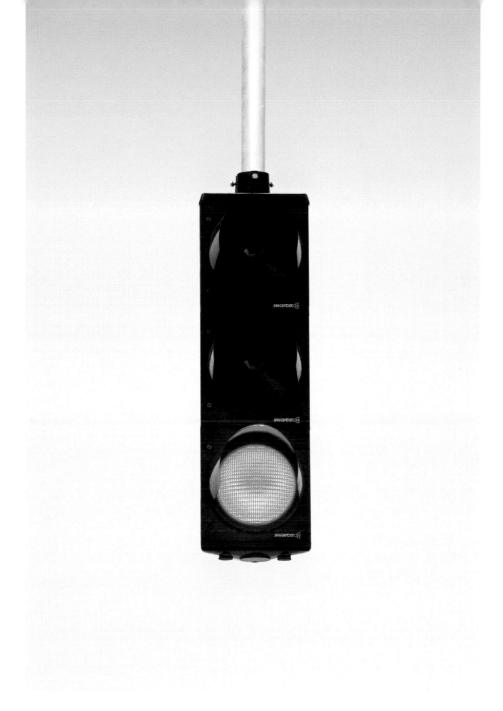

Above
Green, 2010
Pair of traffic lights
Detail

Opposite
Installation view at Kunstnernes Hus,
Oslo, 2010, with details of *Green*,
2010, *Oslo Steiner*, 2010, and *The
Unconscious*, 2010

Overleaf
The Unconscious, 2010
Digital archival prints on Dibond
24 parts, dimensions variable
Details

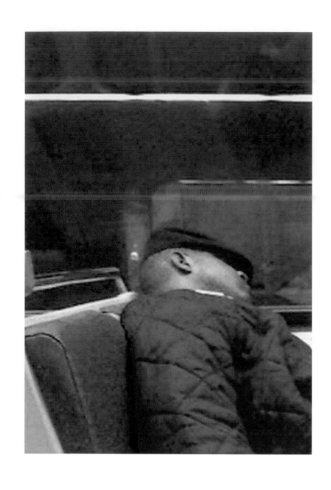
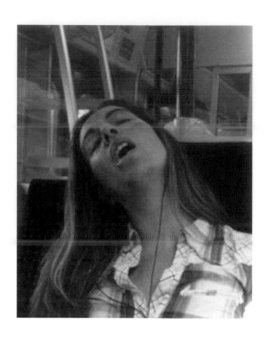

ouldthesphereloveitselfshallandneartherainbowsmywordsscatterdthesparksmywordsamongmankindthinktwillmurmurs...

longlaughingandlittlerillsofcrimsonwineimbruedhisplumpwhitespheroftime...

westhearyoungstrangerivebeenarangerinsearchofpleasurethroughouteveryclime...

seasonablemonthendowsthegrassthethicketandthefruittreewildwhitehawthorn...

appyboughsthatcannotshedyourleavesnoreverbidthespringadieuandhappymelodist...

ghthoursnovoicenolutenopipenoincensesweetfromchainswungcenserteeming...

meslikeagleanerthoudostkeepsteadythyladenheadacrossabrookorbyacidderpress...

shoulddieawaycontentastheirsrichinthesimpleworshipofadaybardsofpassion...

stillmysteriousstealthshewillmixthesepleasuresuplikethreefitwinesinacup...

healitnornumbedsensetostealitwasneversaidinrhymeowhatcanailtheeknightatarms...

livetotracetheirshadowswiththemagichandofchanceandwhenifeelfaircreature...

umantracesurrenderingupthineindividualbeingshalltthougotomixforeverwith...

chthygravelikeonewhowrapsthedraperyofhiscouchabouthimandliesdowntopleasant...

ksthatlurehimfromaboveothatintearsfrommyrockyprisonstreamingitoocouldglide...

soulwasoursonemindoneheartdevotedthatwiselydotingaskdnotwhyitdotedand...

fherhairshewearsacoronalofflowersfadeduponherforeheadandafaceofcare...

thedearestofthedearisawtheelovelyinesdescendalongtheshorewithbands...

oungandsofairlookathergarmentsclinginglikecerementswhilstthewaveconstantly...

wasteofseasyetstillthebloodisstrongtheheartishighlandandweindreamsbehold...

thewaefudevilickneistbutkindledagleamliketherosyeastthatsparkledfrae...

athwomesincenowbezidemydinnerbwoardyourvaicedoneversoundilleatthebitica...

ledthelorntravellerupthepaththroughcleanclipttrowsofboxandmyrtleanddon...

thewidowshomelierpottageathisapproachcomplaintgrewmildandwhenhishand...

beandpainpainandwoearemylotnightandnoontoseeyourbrightfaceclouded...

eathsawthingsthatmadehimwithgroansandtearslongforevendeathgoonto...

endingleaveallforloveyetthearmeyetonewordmorethyheartbehovedonepulse...

oxicatedandbythedraughtassimilatedmayfloatatpleasurethroughallyourpowers...

forfuturehoursadvancesparenotnorlookbehindploughdeepandstraightwith...

eetheresabellinmoscowwhileontowerandkioskoinsaintsophiatheturkmangets...

htouchitthemarbleeyelidsarenotwetifitcouldweepitcouldariseandgowhat...

theywillresumetherosesoftheirprimeandtheolddeadwillhearusandwakeup...

thesongandthesilenceintheheartarepartlyandinpartareprophecies...

henwritethinabooklikeanyclerkheisthepoetofthedawnwhowrotethecanterbury...

rcelytrustmycandidheartandofticatchthemsmilingastheypassbecausethey...

rosesfornowwhilesoquietlylyingitfanciesaholierodourabouttitofpansies...

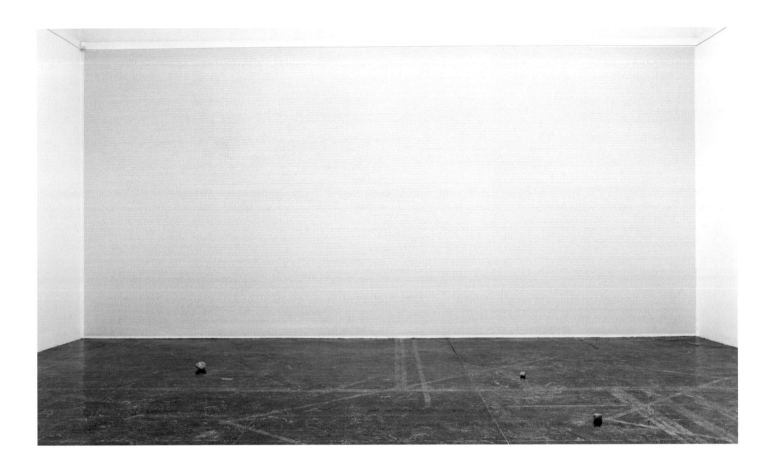

language; a single word that collapses time. (See p. 242 for this work's origins.) The book (and thus *Word*) begins with the ancient, anonymous 'Sumer is icumen in' and ends, in an evolved state, seven centuries later with 'In the hour of death, after this life's whim', which Wallinger describes as 'a deluded meditation on extinction'.

A poem, Wallinger quotes the Scottish poet Don Paterson as saying, is the only work of art that 'can be carried around in the brain perfectly intact. The poem, in a sense, is no more or less than a little machine for remembering itself.' What would it mean to memorize this epic poem? Could it be a force for good? The task stretches before us. It may be that the desire for it to be so is what counts, rather than the remote possibility of it happening. For substantial parts of this exhibition seemed to be about desire, whether it be the desire for something beyond workaday reality that animates *The Magic of Things* (2010), a similarly self-generating work in which every moment of hands-off prestidigitation in the television series *Bewitched* is run together, making a lengthy sequence of magical events in the domestic sphere; or the relentless Sisyphean determination that underscored the only older work here, 2007's *Landscape with the Fall of Icarus*.

Landscape, indeed, may have been the key work in this lyrical assembly, because it speaks of the gap between aspiration and reality, the indomitability of the former and the inevitability of the latter. The gap between flying and falling, here, is the gap between *UN* and *UN-*, between the dreaming figures of *The Unconscious* and the marshalling of the desire for transcendence by religion. Wallinger is not being censorious but saying rather that this, our being strung between these polarities, is just how it is: how we are and have probably always been.[4] In terms of relating empathetically to

Opposite and above
Word, 2010
Archival digital printed wallpaper
Dimensions variable
Installation views at Kunstnernes Hus,
Oslo, 2010

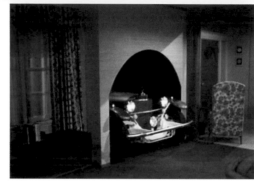

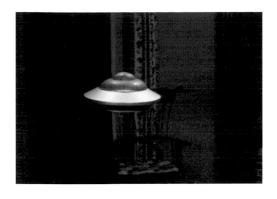

The Magic of Things, 2010
Video installation for monitor,
continuous loop
10 minutes 32 seconds
Video stills

others, seeing the larger picture – the timelessness of our hopes, our uncertainties, and our involuntary factionalism, the partiality of our viewpoints – is half the battle of being, of living decently and fully.

FULL CIRCLE

For years, Wallinger has kept two modest studios in Vauxhall, South London. One is for thinking: here reside the laptop and the books and the CDs, the globe used in *The Four Corners of the Earth*, the stovetop coffeemaker and the empty tins of ground espresso. The other, next door, is for making. It is quiet in these spaces, without assistants bustling around.[5] When I first went into the 'making' studio, in 2008, there were numbered stones scattered over the floor (taken from the Thames shoreline) and, on the walls, a small crowd of 'I's, the *Self Portrait* series. A couple of years later, the stones were still there. A rough version of *My Name is Legion* had come and almost

Amerika, 2010
Vinyl billboard
325 x 488 cm
(128 x 192 in.)

entirely gone, leaving a memory of Wallinger chuckling at the unlikely places his muse takes him. The strings were still hanging down one wall.

The idea of 'marking' objects with his own name would continue, and expand into the public realm. In *MARK*, produced over the summer of 2010, Wallinger's self-conscious performance of self-centredness would absorb vast swathes of London, the city that has so regularly been a backdrop for his art. Across the capital – from Clapham Junction to Mayfair to Camden Town, and many points between – he recorded his chalking of the word 'MARK' within the parameters of single standard-sized brick. The consistency of scale and the centring of this 'MARK' makes a deadpan vanishing point that sits still while, figuratively, the city changes about it. In a digitally rendered, photographic slideshow, 2,265 images appear, one every three seconds, over a span of nearly two hours. Within this comically affectless tagging was, once again, a performed attempt to 'get a grip on things' on small and large scales. Given that bricks are, as Wallinger says, 'as ubiquitous as people', those things might readily include oneself and one's position in a larger scheme of things. If, as he suggests, 'naming and numbering are in some kind of relationship at the limit of use or uselessness,' there is a fine line being walked here between controlling one's environment and accepting how insignificant one is within it.

Back in the studio, other visible drafts reflected the almost unconscious percolation of longstanding fascinations through his art. Poetry and history, for instance: a computer-generated image showed the words AMERIKA blazoned, in huge, Hollywood sign-style letters, on a verdant hillside. This would become *Amerika* (2010), a billboard project for the Aspen Art Museum, which replaced the abandoned *Mine* (see Unrealized Projects, p. 243). 'Aspen boomed briefly in the Silver Rush, then fell on hard times,' Wallinger explains, 'and after the war they decided to hold a bicentennial festival for Goethe, to put the place on the map in cultural terms. So on the reverse of this billboard there's Goethe's poem "Amerika, Du Hast es Besser": you've got it better than our old continent, Exult! You have no decaying castles, etc. That's the old world looking, in a rather utopian way, at the New World. It's a hope and aspiration that we bring to America, as much as anything that America actually has. And as for the "K" spelling: at one point, so the story goes, there was a vote in America as to whether English or German would be the standard language; if the latter had won, you'd get the K spelling. It's a future that never was.'

Another computer-generated image, meanwhile, featured a racehorse in a field, in the acquiescent pose derived from *Weatherbys Stallion Book*. The horse had returned to his art, and had done so via, first, his winning proposal for a huge public artwork in Ebbsfleet, Kent, and, second, a mix of wit and logic. The white horse is not only the symbol of Kent – the Jutland invaders who led the first Anglo-Saxon bands that settled England were named Hengist and Horsa – but also a longstanding staple of the English landscape in general (consider the prehistoric white horse carved into the chalk landscape at Uffington, Oxford), and so Wallinger's concept speaks of local and national pride. There's a deadpan logic to his deductive thinking here. A white horse *belongs* in an English field; it's what one would expect to find there – and perhaps, Wallinger has suggested, the most ordinary thing that might also make one pay attention, driving past in a car. (We pay attention because horses are beautiful, and embodying beauty is certainly part of Wallinger's intention here.) While one expects a horse in a field, however, one does not expect a horse that is 52m (170ft) high. The work at once belongs and does not, occasioning a double-take, and its invoking of illusion – and the relationship between what we perceive and what we believe – might be said to reflect more subtle aspects of the project. The A2 road from London to Dover from which Wallinger's horse will be visible follows Watling Street, the ancient

Overleaf
MARK, 2010
Digital photographic images transferred to Blu-ray
113 minutes 14 seconds
Video stills

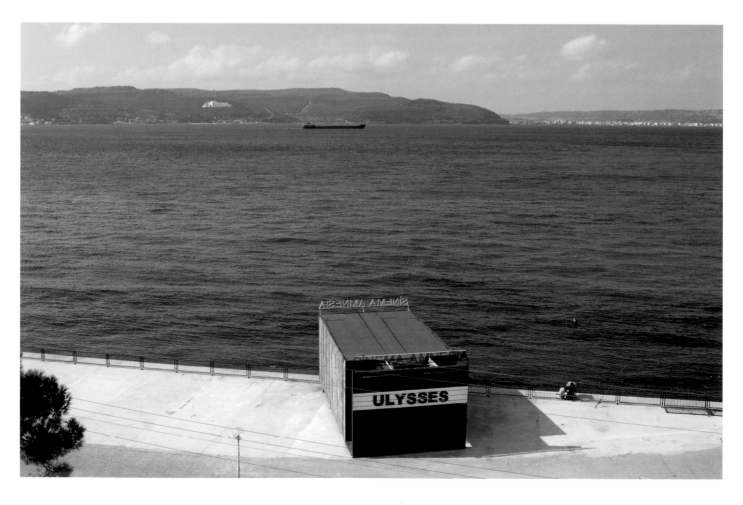

trackway that became the Roman road that was the historical trade route to the Continent: since thoroughbred racing, again, is largely underwritten in this country by Sheikh Mohammed, Wallinger's project points to a kind of reverse colonialism replete with historical ironies.

It seemed no coincidence that this proposal resembled a Trojan horse, hiding potential rogue meanings. Pinned up on the wall nearby was a plan for *Sinema Amnesia* (2010), a temporary movie house in Çanakkale, Turkey, situated at the narrowest point of the Dardanelles, one of the busiest sea lanes in the world, and the nearest town or city to the ancient site of Troy. The boxy structure with rusted sides that resembled a shipping container would be set up at the end of the promenade, by a tea garden and the mosque. Inside, what might be taken as a kind of camera obscura illusion was, in fact, a time-delayed image of the view across the straits, exactly twenty-four hours before, although the scene could almost be timeless: an endless yesterday, inspired by the ceaseless and seemingly immemorial movement of ships. While the name of this cinema manqué jutted from its roof, the film currently showing – named on the picture-house-style frontage – was apparently entitled *ULYSSES*. Here, snapping economically into sync, was a wealth of allusions: to the combative encounters of Homer's *Odyssey*, to Joyce's Dublin retelling of it, and to Turkey's more recent past and a continuum of conflict in the region.

Once again, Wallinger's fixed camera angle would position a specific vanishing point at its centre. The Dur Yolcu memorial, etched into the hillside on the Gallipoli peninsula, is the most visible monument to the 130,000 lives that were lost when allied troops were despatched in the ill-fated campaign to wrest control of the straits from the Ottoman empire; and is emblematic of the Turkish Republic that was born as a result of the conflict. Alongside an image of a soldier is a poem, which translates as:

> Stop passerby!
> This soil you thus tread unawares
> Is where an age sank.
> Bow and listen,
> This quiet mound is where the heart of a nation throbs.

As these layers converged without partisanship beside a watery divide that, in facilitating trade, also serves to connect, Wallinger here finally named in his work the book whose large-hearted take on humankind feels, looking back, like a lodestar for his art. (In a neat circularity, James Joyce created and oversaw in 1909 the first cinema in Ireland.)

Also on his studio walls were other kinds of loop: big printouts of zeroes, their centres cut away, work visually and verbally like Y. Zero is simultaneously something and nothing, depending on where you stand. 'The phrase Year Zero,' the artist writes in *The Russian Linesman*, 'may be used to describe any event considered so significant that it serves as a new base point in time.' Asked why he is so attracted to loops (and water cycles and rivers, which have figured repeatedly in his art from *Fountain* onwards), Wallinger returns again to Joyce and specifically the opening of *Finnegans Wake*, a book whose incomplete last line – 'A way a lone a last a loved a long the' – joins up with its first: 'riverrun, past Eve and Adam's, from swerve of shore to bend of bay, brings us by a commodius vicus of recirculation back to Howth Castle and Environs.' Beyond his own confessed attraction to the loop as a resolved aesthetic form, however (for Wallinger is an artist who, evidence suggests, has historically liked to hear his work's mechanisms clicking smoothly together), the idea of the eternal return touches on his art's deepest intimations and unvoiced ambitions.

Opposite and overleaf
Sinema Amnesia, 2010
Mixed media video installation
800 x 475 cm
(315 x 187 in.)
Installed on the waterfront
at Çanakkale, Turkey, 2010

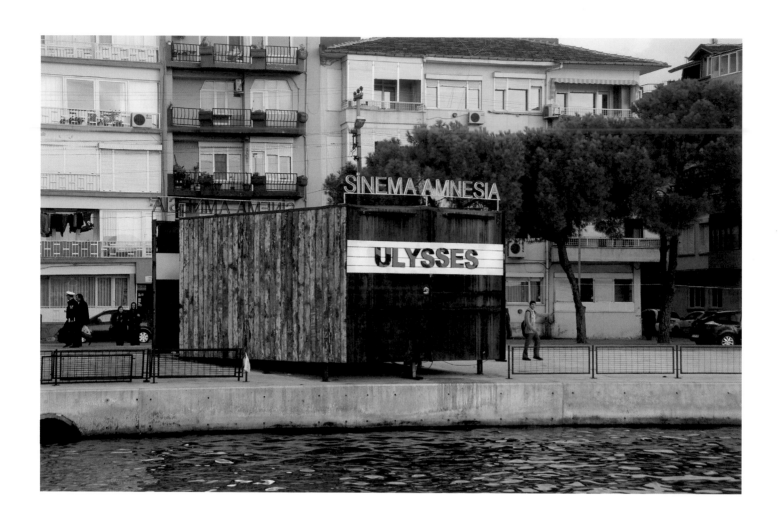

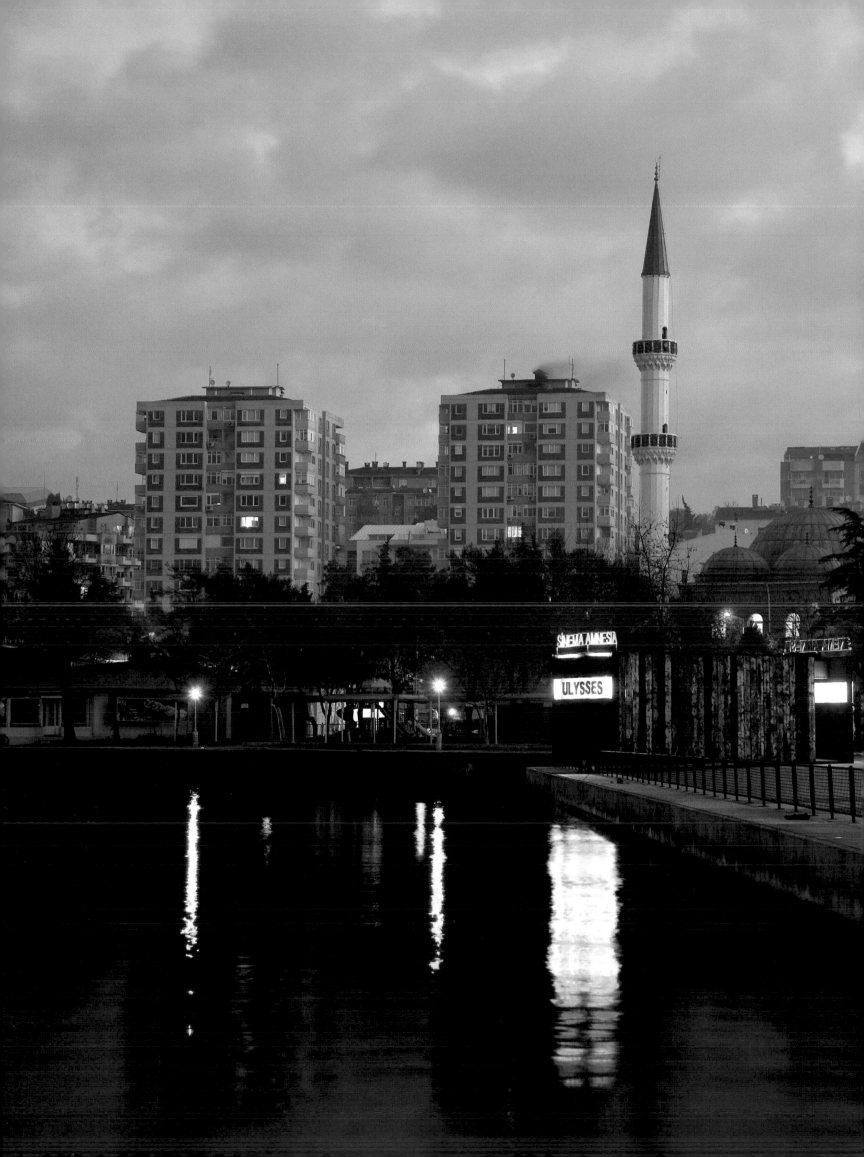

'The basis of most drama through the millennia is the consistency of human folly, isn't it? We're doomed to repeat. And so the thing that annoys me more than anything else is the notion of progress – and I think we all catch ourselves in it, because we confuse scientific progress with the progress of the race. We *never* learn, and that's why history inevitably returns as farce.' That sense of species-wide frailty runs deep in Wallinger's work. It is the wellspring of his generosity and his frustration – of his art's implicit, invariably engagingly voiced requests for tolerance towards those who we might see as 'other' – and his analysis of all the divides that we, as a race perplexed by the fact of being alive, endlessly set up.

His art, as should be apparent by now, is one of insistent counterpoint. It is a ceaseless looking, both with diagnostic intent and with a pun-lover's ardour, for the *other* of something: the verso, the secondary meaning, the other side of the border, the *doppelgänger*. This is the dialectical method, and it offers the audience the gift of reaching their own conclusions, albeit within proscribed limits. Yet Wallinger's richest opposition is that which he sets, time and again, in contrast to his holistic image of a world arrayed against itself, and that which his art, at best, makes tangible. It is the notion of epiphany, the human capacity for fleeting transcendence, for sensing ourselves as somehow TARDIS-like, more spacious within than without. The example that Wallinger returns to is an afternoon in Rome when, his stomach growling for lunch, he sidestepped into a church he had never visited, and – as another visitor slipped a coin into an illuminator – saw the radiant power of Caravaggio's St Matthew triptych bloom ineffably out of the shadows before him. In such moments of reception we *are* bigger, mysteriously so, than what divides us. Such moments are arguably the great reparation of being, yet so fleeting. Perhaps that is why we never learn.

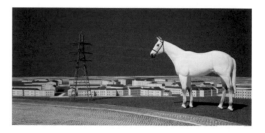

Conscious of the deep and unsolvable irrationalism in human behaviour, the merely analytical individual might throw up their hands at the possibility of anything changing. The compassionate one, though, may act, while faithless, as if they had faith. 'History,' Stephen Dedalus famously asserts in *Ulysses*, 'is a nightmare from which I am trying to awake.' But he is young. Wallinger, for his part, titled his long essay in *The Russian Linesman*, 'Awake in the Nightmare of History'. It is a locution that might point to a distance travelled in his own career: from making angry early canvases based on the idea that substantive change is possible, to a recognition that our good intentions and desires are continually undone. Such, played out in contrasting registers, is the burden of *UN* and *UN-* and *Landscape with the Fall of Icarus,* those condensations of thwarted optimism. Hope is absurd, and hope is inevitable. It isn't going to get better – the nightmare of history goes on day and night – yet one ought to *try* to make it so, if only to live in good conscience; and one ought to face this paradoxical world as it really is. There will, with any luck, be consolations along the way.

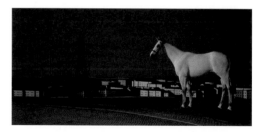

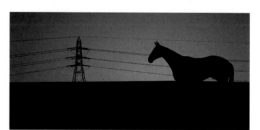

1. Wallinger prefers that the title isn't italicized; if it is, its ability to be at once letter and pictogram is lost.

2. Held in the Kunstverein Braunschweig and the Kunsthaus Arau, stretching from *Heaven* to *The Human Figure in Space.*

3. They are also studies in our evolving methods of representing the world to ourselves, being taken on mobile phones.

4. In an article for the *Guardian* in 1995, Wallinger wrote of characters in another Velázquez painting, *Triumph of Bacchus,* that 'the look they direct at the viewer slices clean through 350 years in the most disconcerting way. It is a look familiar to anyone who has enjoyed the glorious puerility of piling into a photo booth after a good session.' See p. 249 for the whole article.

5. 'I want to be an artist, not run a small business,' says Wallinger, though he does not work entirely alone.

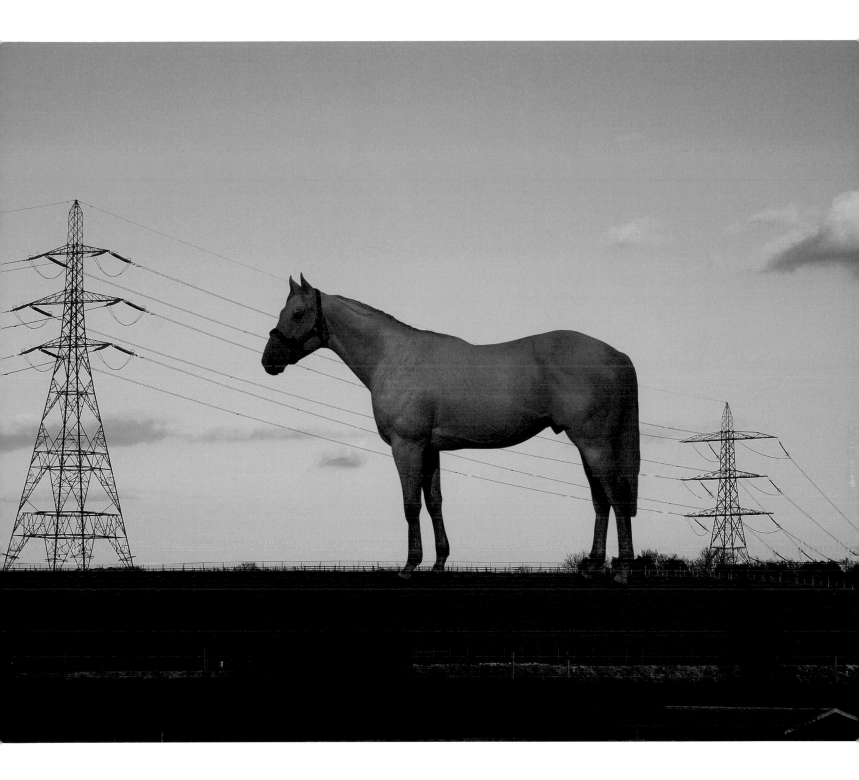

The **Sherman Silver Purchase Act** was enacted in July 14, 1890[1] as a United States federal law. While not authorizing the free and unlimited coinage of silver that the Free Silver supporters wanted, it increased the amount of silver the government was required to purchase every month. The Sherman Silver Purchase Act had been passed in response to the growing complaints of farmers and mining interests. Farmers had immense debts that could not be paid off due to a series of droughts, and they urged the government to pass the Sherman Silver Purchase Act in order to boost the economy and cause inflation, allowing them to pay their debts with cheaper dollars.[2] Mining companies, meanwhile, had extracted vast quantities of silver from western mines; the resulting oversupply drove down the price of their product, often to below the point where it was profitable to mine it. They hoped to enlist the government to artificially increase demand for, and thus the price of, silver.

Under the Act, the federal government purchased millions of ounces of silver (it became the second-largest buyer in the world, after the government of India); this eventually led to inflation and contributed to the Panic of 1893. In addition to the $2-4 million dollars that had been required by the Bland-Allison Act of 1878, the US government was now required to purchase an additional 4.5 million ounces of silver bullion every month. The law required the Treasury to buy the silver with a special issue of Treasury (Coin) Notes that could be redeemed for either silver or gold. That plan backfired, as people (mostly investors) turned in the new coin notes for gold dollars, thus depleting the government's gold reserves. After the Panic of 1893 broke, President Grover Cleveland oversaw the repeal of the Act in 1893 to prevent the depletion of the country's gold reserves. The repeal of the Act is sometimes blamed for the Panic, but the Panic was already well underway.[3]

ASPEN

$15,000 = 750,000

$7,500 in pennies = ~~————~~

$3,000 in quarters = 12,000

$3,000 in dimes = 30,000

$1,500 in nickels 30,000

822,000 coins

Project for Heathrow Airport, 1998

'The Heathrow Express was due to open in 1998 and there was a competition commission for an artwork that would provide a strongly directional cue to smooth arriving passengers' path from baggage reclaim towards the new railway terminus. The nature of the space – a staggered corridor, two sets of fire doors and a large vista to the wall facing into the new terminal – created problems in making a coherent statement. I proposed an extraordinarily long photograph of the finish of the Epsom Derby. (Quintessentially a London institution since before William Powell Frith's famous *Derby Day* painting of 1893–94.). Photo-finish cameras at tracks throughout the British Isles take high-quality photographs of time passing. The film runs by the "shutter" at the same speed as the horses. The shutter is in fact a 3/1000 inch slit constantly open. Years ago it was customary to reprint this lengthy photograph featuring all the runners in the Derby with, often as not, a furlong separating first from last. I won the commission but it didn't happen because, in a phrase that I've always treasured, they "had difficulty identifying the funding".'

Sections of the official photo-finish image showing the position of every runner at the end of the Epsom Derby, *Sporting Life*, 3 June 1965. Project for Heathrow Airport, 1998

Ark, c. 2000–02

'I had a residency with Grizedale Arts in the Lake District and came up with the idea of putting an ark – constructed according to the unusually detailed instructions in the Book of Genesis – on a high point in that area; we identified Beck Side Intake, which the eye is naturally drawn to when you're there, as the best spot. It's quite strange around Grizedale, with pine forests cultivated industrially and lots of loopy roads that go nowhere but are ergonomically designed for harvesting the trees. They have clearances where they chop the pines down and leave mutant ones that have grown up in a warped way. There was something post-apocalyptic about the place in general, and that might have set me thinking. There was also the fact that I was there during the foot-and-mouth crisis and the fuel blockades, and at one point I was driving to Grizedale and the gearbox went on the M6, so I had to travel the whole remaining way in fourth gear, and that was the end of the car, worth nothing more than the petrol we siphoned from it. Events like that made me think of elemental things. Apart from that, it's easy to imagine the whole Lake District landscape as having been underwater and drained away, as if there'd been a massive drop in sea level at some point.

There was intended to be a nice ambiguity as to whether the ark had appeared there in advance of the deluge or after it. If we are to imagine the Ark as pre-flood, then it would make the best sense to build it on the highest point nearest the habitations to be evacuated. I was also thinking about Werner Herzog's *Fitzcarraldo*, where he drags a boat over a mountain – the grandiloquence of a statement like that. And, really, I just wanted to see what it looked like. Various things curtailed it; one of the people who was really pushing for it moved, and I'd gone to see Isambard Kingdom Brunel's [passenger steamship] SS *Great Britain* in Bristol, which is also built to the proportions of Noah's Ark. Then that became a sort of found object in my mind; what would it say about our country to put *that* up there? And then I was busy with the run-up to the Venice Biennale and various other things, and the project petered out.'

A page of drawings from the notebook for *Ark* for the Lake District, *c.* 2000–02

Opposite
Notebook for *Mine*, Aspen, Colorado, 2009

Shadows We Are And Like Shadows Depart (Umbrae Ubrarum Vitu Soluimas), 2001

'I was invited to propose an artwork to stand in a square outside the Anglican cathedral in Liverpool, and I proposed an analemmatic sundial: you stand in a certain place, and it tells you the time with your own shadow. I still had *Ecce Homo* on my mind, and the idea of it – placing someone at a certain point so that their shadow would be cast – was to make a little theatre of people and their presence: to point up, in an everyday way, the evanescence of life. I was also inspired by a recent trip to the Observatory at Jaipur, the beauty and precision of measuring passing shadows. And this would have been in contrast to the cathedral, which is so extravagantly *bricky*. It's like an enormous Victorian toilet.'

Infinity Sculpture and Flag, 2002

'I started with the oval of an eight-lane athletics track and then applied two simple but significant mathematical figures in my proposal for the Manchester Commonwealth Games. The Möbius strip is a beguiling paradox – a two dimensional object that has only one side but exists in three dimensions. (Take a strip of paper; join one end to the other with a twist through 180 degrees.) This finds its most comfortable form as a figure-of-eight, which, when set on its side, is the mathematical symbol for infinity (or, if you like, the two adjoined noughts of 2002). This figure could then be incorporated in a flag – an emblem for the games and, in sky-blue and white, a symbol for the aspirations of a newly installed Manchester City. The scale is determined by the proportions of the running track (i.e. 400m long x 10.45 m wide).'

Scale drawing of an analemmatic sundial from the notebook for *Shadows We Are And Like Shadows Depart* for Liverpool, 2001

Tower Bridge is Upside Down, 2002

'As I remember, this was related to the More London development near Tower Bridge, which has gone on in the last decade or so and includes the mayoral building. My idea was for a darkened room somewhere near the latter, containing a camera obscura trained on Tower Bridge. I've long loved camera obscuras, and was rather impressed with David Hockney's argument (in *Secret Knowledge: Rediscovering the Lost Techniques of the Old Masters,* 2001), for their use in everything from Jan van Eyck's 1434 *Arnolfini Wedding* to Vermeer to Ingres. They were also popular during the Victorian era, and are seen as precursors to photography and cinema; in fact, though, they're at once more real and more surreal than either. There is something magical about them, because we're so used to the mediated moving image. I had recently visited the camera obscura outside Edinburgh Castle, and when you see the flags waving or you see a figure move, it doesn't seem possible that this can be reproduced just through a sheer phenomenon of light. So I wanted to take one of the half-dozen clichés of London's iconography and, using what is essentially a pinhole camera, turn it upside down, back to front and the wrong way around, and put it in the present tense. If you do that, it gives it back a bit of charisma, and allows you to examine it in its parts again. When you remove the gravity, it becomes – in a funny kind of way – either problematized or revelatory.'

Camera obscura image for *Tower Bridge is Upside Down*, 2002

Crib, 2004

'In 2003, the crib that St Martin-in-the-Fields had brought out into Trafalgar Square every Christmas was destroyed. I was shortlisted in a competition to create a replacement – to "consider the iconography and narrative of the traditional Christmas crib and propose a design that would stimulate debate and invite reflection". I proposed a Mothercare crib – a familiar object that betokens thousands of everyday miracles – and three security personnel to guard it, twenty-four hours a day, for the entirety of Advent. These are the three men from the East who wait in readiness for the arrival/return of the Messiah. They serve to remind us of the threat posed by Herod in the story, and childhood as reported in the newspapers today is menaced as never before. The vulnerability of the naked crib represents the fragility of hope and belief in the modern world. However, in this case we are aware of Christ's destiny, his ministry, the manner of his death, and if we believe, his resurrection. Of no other newborn child do we know the subsequent course of their life. The guards that protect also imprison.'

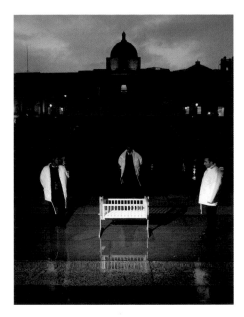

Photograph showing *Crib* for St Martin-in-the Fields, Trafalgar Square, London, 2004

London International, 2005

'This project was for Terminal 5 at London's Heathrow Airport. Identity is crucial at the interface of states, especially when it is the only checkpoint for potential security threats or for tracking the movements of people. We are being processed by the state. Tony Blair and Robert Mugabe have this much in common: they can be reduced to an image 36mm x 48mm. Even if your face is familiar around the world, you can go nowhere without a valid passport. Paradoxically the more one is scrutinized, the less individual, the more anonymous one feels. This is the most palpable intrusion the state makes into our little dreams of freedom. It is a small act of tyranny to which we acquiesce for the sake of the general good. Our image is simply a badge of identity, one more suspect to account for in the state's endless investigation. Now imagine your passport photo shown on an enormous screen at the airport...'

Photograph showing how proposed giant passport photos would be displayed for *London International* for Terminal 5, Heathrow Airport, 2005

The Four Winds, 2005–07

'The aviation research centre at Farnborough, UK, is where British Aerospace and the Royal Air Force do all their testing. It's where, in 1908, Colonel Samuel Franklin Cody undertook the first powered controlled flight in the UK. The site was being redeveloped but they were preserving a long, elegant 1930s building, which was the potential site for a work. My proposal was inspired by the three historic wind tunnels that are the heart of the site. In the past these machines generated wind to test the aerodynamics of aeroplanes. My idea was to reverse this relationship. Rather than the exceptionally large amount of power it took to drive the wind tunnels, I proposed four wind turbines, which turn the natural energy of the winds into power – more than enough power for the entire building in front of which they were to be placed. At the same time they were a silent allusion to aircraft of the past. The four propellers would be placed in two pairs either side of the entrance to the building in proportion to the invisible wings of the aircraft. The movement of the four propellers would have been in perfect unison, as if they were controlled and driven by some conscious design. *The Four Winds* was the most thorough experience I've had working with architects, agencies, landscapers, etc. – working on the project over two or three years.'

Architect's drawing of the 1930s building at Farnborough along which four wind turbines were proposed, 2005–07

 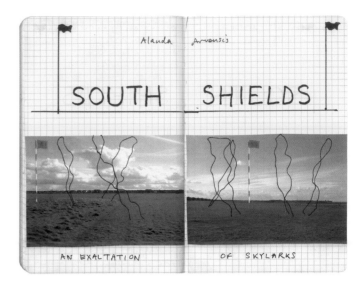

Pages from the notebook for the flag for the Great North Run and the South Shields seafront project, 2005–08

Flag, 2005–08

'I was approached by the Great North Run, which is the biggest participatory run in the world: seventy thousand people run a half-marathon that starts in Newcastle, goes through Gateshead, and winds up by the sea in South Shields. They have an accompanying cultural programme, commissioning an artwork each year, but Brendan Foster, the founder and chairman, invited me to create a permanent work to celebrate the event. The seafront at South Shields, the Leas, is rather beautiful and there were many skylarks when I was there. I liked the idea of making something that shaped the ascent of the lark and its pell-mell fall – so I was playing with that, and I went on to the idea of the repeating pattern of the heartbeat, which would have been a line drawn in metal along the Leas. But then I realized that (private health insurers) BUPA are sponsors of the run, and that's their logo...

And then I thought: what is needed is a finishing line, or something that you can see from a distance and that is your goal, your destination. I discovered that the accolade for tallest flagpole in the world is fought over in the Arab Emirates, and I thought that maybe South Shields could have the tallest flagpole in the world: and throughout the year they could have a blue flag, an abstract thing against the sky, and on the day of the race, there could be some little ceremony and a gold flag could be hoisted. And everyone went for that; but then some local elections took place and the newly elected people didn't like the idea. So that was the end of that.'

Project for Nicosia, Cyprus, 2006

'I was invited by Pavlina Paraskevaidou, who ran the Archimede Staffolini Gallery in Nicosia, to make a public work to coincide with Manifesta: the European biennial of contemporary art. Cyprus is a fascinating place, to land in the Mediterranean and drive on the left – that is an odd demonstration of the reach of British imperial power, but it is, of course, the more recent history of conflict and division that dominates the island. I met Pavlina's family and heard what they had lost in the Turkish invasion in 1974. Her father and uncle were both doctors and had houses on the northern shore of Cyprus, which were subsequently occupied, then reduced to rubble. Pavlina and her younger sister had crossed the Green Line – still a difficult

Photomontage for the project for Nicosia, Cyprus, 2006

decision for those who felt this would be giving credence or implicit approval to the Turkish authorities by recognizing it as a genuine border. (A partition established by the United Nations in 1964, dividing the country into a Greek Cypriot south and an increasingly Turkish Cypriot north, was made impassable in 1974 by a Turkish invasion that was followed by the Turkish Cypriots announcing their territory to be an independent republic, albeit one that the rest of the world doesn't recognize.) You cross the Green Line in Nicosia and you're walking back into the past because the sanctions against northern Cyprus mean that nothing new has been built in that half of Nicosia. So one half is like going down the A12 or the A13 in England – a kind of shapeless suburban development; and on the other side it's preserved in poverty.

I was struck by an article in the *Daily Telegraph* about a car dealer, which I quoted in *The Russian Linesman*. At the time of the Turkish invasion, the story reads, he "had just taken delivery of seventy new Toyota Corollas and Celicas at his showroom in the heart of old Nicosia. Each had plastic wrappers over the seats and 32 kilometres on the clock, the distance from the port at Famagusta. The fleet of cars sits there to this day, dulled with powdery dust, stuck in no man's land between the razor-wire of this divided city. As fate would have it, his building was right on the United Nations ceasefire line. Nothing has been touched since."

I wanted to place, just to the side of the main highway from the airport to Nicosia, two framing devices that were like wing mirrors, in proportion so that the road itself becomes a kind of car. Wing mirrors are quite contrary in that you're seeing the past rush away, but watching in case something moves up into the present. I was playing with the thought of that as memory. But while the platonic purity of the idea seems attractive, it turns out that Cyprus has more road signs and hoardings than most places, so it may have been lost. Then Manifesta was cancelled...'

Word, 2008

'This was a proposal for a text work on the ceiling of the Natural History Museum in London – the entire anthology of the *Oxford Book of English Verse 1250–1918* with all the punctuation and grammatical and syntactical signs removed. In his conclusion to *The Origin of Species,* part of which reads, "from so simple a beginning endless forms most beautiful and most wonderful have been, and are being, evolved", Darwin uses the consciously poetic motif of "an entangled bank" in the knowledge that nature is at the heart of English poetry. That final paragraph is, I think, what inspired *Word*: it's a marvellously poetic piece of writing, exciting and engaging in a way that understands poetry and metaphor and all those kinds of tropes in a way that is useful in terms of seeing interspecies and subspecies, and constructing an intellectual apparatus that can find room for these myriad creatures, life-forms, and how they might have evolved and changed and existed together. In what Darwin terms "deep time", *Word* is a stream of consciousness laid down in sediments of time, man's attempt to make sense of his brief tenure in the natural world over the space of 750 years.

I was thinking about how the original *Oxford Book of English Verse* was known, in the First World War, as the 'atheist's bible': soldiers went to the trenches with it. So in *Word* there's an acknowledgment of a debt of generations for this consolatory verse, something that speaks *through* the generations. And I was thinking about how, while the language has changed and evolved, at the same time poetry is kind of an oral tradition: all the tropes, the rhymes and rhythms are there to be learned off by heart. So that trace of memory is a very conscious thing that one generation hands on to the next: for want of a better word, it's evolution. The list stops at the end of the First World War; I wanted to mark that we had got to the point where we had managed, as a species, to invent industrial slaughter. Somehow, that seemed the appropriate place to end. *Word* eventually became a gallery work, a good example of how a work can develop further, away from the specific context that originally inspired it.'

Notebook for *Word* for the Natural History Museum, London, 2008

The Anatomy of Melancholy, 2008

'This was my first idea for the Folkestone Triennial. In the town, there's a statue of William Harvey, who in 1628 published his findings on how the human heart circulates blood around the body. It's a very arresting statue: he's standing with his right hand placed in a heartfelt gesture over his left breast, but with his left arm extended, the hand upturned; one sees with a shock, he is holding an eviscerated human heart. Robert Burton, the author of *The Anatomy of Melancholy* (1621), comes from the town as well. So, while these connections could feel a little shoehorned, I liked the fact that they were around at the same time and, while Harvey was writing about the heart from a scientific point of view, Burton was writing about it in a poetic sense: the humours and melancholy. I wanted a balloon to conjure two images of the heart; something reminiscent of a child walking out of a shop with a helium balloon shaped like a love heart – taking that image of carefree buoyancy, but creating an enormous balloon that would be very accurately shaped like a human heart, so that buoyancy becomes some overpowering life force.

We looked into various ways of achieving this – perhaps it could be tethered like the balloon that used to be raised above Vauxhall in London. H. G. Wells lived near Folkestone at one point, and I was thinking of something with a retro sci-fi feel: a slightly threatening presence up in the air. People got quite excited and on the case

Photomontage showing *The Anatomy of Melancholy,* Folkestone, 2008

about this; there was a lot of goodwill. Unfortunately, as it turned out, this was all rather impractical, because where the coast meets the land is a *windy* place. And soon the hot-air solution became impractical, as did the helium alternative, and the balloon got smaller and smaller, until we thought, you might as well have people carrying little helium balloons. So that's how that one foundered, and instead I made *Folk Stones* (2008).'

Mine, 2009

'This was a proposal for Aspen Art Museum, Colorado: it didn't happen for "environmental reasons" that were never fully explained. The city has quite unbelievable wealth today – just Google the names of the celebrities who have homes there – and it was once a silver-rush town, booming and crashing in quite short order. So there is that history, and the people there now and their mighty wealth, and then the ordinary people who service them, who commute in from miles away. My proposal began: "In these straitened times, what would be more provocative than throwing money away?" The budget available for a work was $15,000. I proposed converting this into small change and having it poured, scattered, dropped and flung into the Roaring Fork river, which passes the museum in question on its way through Aspen. I thought poetically this was apt, and also had another aspect: at what point would it be worth getting one's feet wet? After all, it's still thousands of dollars, even in small change. And the title, *Mine*, comes from a phrase I had stuck in my head: "It's mine, you understand? Mine, mine, all mine!" – which, it turns out, is Daffy Duck. So it's another punning title. But any film to do with a gold rush or mining always ends up having a moral to it, about greed and comeuppance, and that kind of fever seems to be there in that one word, really.'

sum, 2009

'Chichester Cathedral dates back over 900 years. In 2009 a competition was instituted to mark the centenary of Dean Walter Hussey who commissioned art for its interior – Marc Chagall's stained-glass windows, a John Piper tapestry, a Graham Sutherland painting, etc. The brief was very specific – the resurrected Christ. Towards the end of the 19th century, the spire, known to be fragile, collapsed. Precautions had been taken to remove the medieval screen that was underneath (later restored) but a depiction of the risen Christ, which hung above it, was destroyed. My proposal took the form of a poem followed by an explanatory paragraph. The idea, which fitted with the reductive strain in my work that led to the *Self Portrait* "I" paintings, was to have the phrase "I am", in lead letters, suspended from the ceiling. The letters would have been the height of a man – not least because the work alludes to Descartes' "*cogito ergo sum*" (I think, therefore I am) as well as "I am the resurrection and the life" (from John 11:25). The idea of what happens when someone reads it: it must be the shortest sentence in the English language, and you've read it almost before you realize, but very simply it is a communion and an affirmation of eternity.

At the same time, the ritual of communion is learned, and *sum* was intended to say something about how that is passed on. Consuming the body and blood of Christ is the extreme form of being "at one" with someone or something. And language, too, is at once opaque and the only vessel through which we can express ourselves.

sum

I am the resurrection, and the life
I am the shadows on the walls, the quire
and the congregation.
I am the present tense: pure being born aloft.
I am here now and
I am the life everlasting.
I am true for every reader, the endless altered people.
I am the resurrection, and the life: he that believeth
in me, though he were dead, yet shall he live.
I am the Word.
I am

I am To say it or think it is an act of communion.

Helvetica has become ubiquitous because of its
clarity and authority as a font.
Lead is the main element of type metal in the printing
process: the cast metal elements used to press ink
onto paper. It is the anchoring dark material that
frames the light of stained glass. Lead is the symbol
of heaviness and of impregnable individuality.
Here it floats free of gravity. Ascendant.

The proposal for *sum*, Chichester Cathedral, 2009

Photomontage showing O for the ten gateways of the Olympic Park, Stratford, 2011

The use of lead was intended to have overtones of lead type citing that history – the Gutenberg Bible. And with such an array of visual art competing for attention, it did seem to require something as clear as this, something readable, instantaneous when you entered the cathedral. "I am" is also like a trinity of letters.'

O, 2011

'This was in answer to a mapping project to mark the ten gateways to Olympic Park. I proposed ten spheres, each identical, ten metres in diameter. I began my presentation before the Olympic Delivery Authority (ODA) thus: "This has been a necessarily pragmatic, hardheaded Olympics, coming in on budget in a recession; a Games in which the main entrance will be through a shopping centre. The Olympic Park has many great and beautiful structures together with the more ancillary aspects of infrastructure and accommodation and the yet to be landscaped hinterlands. It seemed to me that to map the park, in line with the brief, it was essential to bring some unifying symbol, something to give the park and the area a distinct identity to take into the future. The history of the area has been given due consideration, but is there enough about the future? Talk of a legacy is like trying to imagine a new age with the benefit of clairvoyant hindsight. Let us rather embrace the future – give it the respect that is its due. The unborn, unknowing children should not want for ambition and they should be accorded a symbol that encourages them to dare, to dream. Because the future will start when the Games end, and the past will be over. This is the Olympics – nothing that existed previously will chime with the future, it would be like saying that Ephesus is all very well, but what was it before the amphitheatre and the Temple to Artemis?"'

Opposite
Photomontage showing *sum* in situ in Chichester Cathedral, 2009

Adam

I am monarch of all I survey
I arise from dreams of thee
I can imagine, in some otherworld
I dream'd that as I wander'd by the way
I dug, beneath the cypress shade
I fear thy kisses, gentle maiden
I had a little bird
I have been here before
I have come to the borders of sleep
I have had playmates, I have had companions
I have led her home, my love, my only friend
I have loved flowers that fade
I have seen old ships sail like swans asleep
I have walked a great while over the snow
I heard a bird at dawn
I heard a thousand blended notes
I looked into my heart to write
I lost the love of heaven above
I love the fitful gust that shakes
I love to rise in a summer morn
I met a traveller from an antique land
I remember, I remember
I saw the sunlit vale, and the pastoral fairy-tale
I saw where in the shroud did lurk
I set my heart to sing of leaves
I tell you, hopeless grief is passionless
I thought once how Theocritus had sung
I travell'd among unknown men
I wandered lonely as a cloud
I was thy neighbour once, thou rugged Pile
I wish I were where Helen lies
I woke from death and dreaming
I wonder do you feel to-day

'The brick is the message'
From 'Answer Back', *Evening Standard* Magazine,
6 November 1987

The *Evening Standard* had published an article questioning the value of Mark Wallinger's replica of Stonehenge made of bricks, *A Model History* (1987), following its purchase by a collector for £3,500. To highlight their point, they commissioned two apprentice bricklayers in Hackney, East London, to create a copy at their building site, asking price £20. Following some controversy, the *Standard* invited Wallinger to write the first article in an occasional series in which 'those who feel misjudged by the critical establishment' were given a platform to 'answer back'. Wallinger argues for the validity of his work (and defends the price paid).

When I saw the piece on me and *A Model History* in the *Standard*, my initial reaction was wry amusement. I knew something was up, because they'd come along to photograph me. But they didn't tell me they were going to get bricklayers to make a version. I was a little ambivalent about that. But in the end you think, what the hell? It's just another example of how modern art can be taken in isolation and misunderstood by the popular press.

It has mounted a sneer campaign on modern art for years. Basically the essence is that it may be appreciated by a few folk who inhabit a crackpot intellectual ghetto, but the rest of us recognise that someone somewhere is taking us for a ride.

There is almost a pride taken in not being able to understand it. Is it any wonder that modern artists are defensive? The prejudice is such that we repeatedly shuffle on stage to find that the warm-up man has armed the audience with rotten tomatoes. I am well aware that many people looking at *A Model History* will say, well *anyone* could do that. Well, they can do it if they want to. I don't see that as a problem, because the whole point of the work was its facile simplicity. What I am saying is, here is this great, traditional, national monument, of no use to anyone other than a few druids, say, or hippies (who are the very people kept away from it), and yet anyone could make a recognisable reconstruction of it out of something as numbingly banal as housebricks – or even Shredded Wheat.

It was part of a series of work I did addressing itself to – and challenging – this cosy 'mythology' of British tradition. I think what is left out of most museums – the background of social struggle, the politics of repression behind all those pristine artefacts – is far more important.

My Stonehenge is having a go at those people who cherish and perpetuate the cosy traditional legend; people who like to restore their Victorian terraces back to their supposed splendour.

In the main, my works are not so much pieces of art (I mean, I'm not arrogant enough to say I've just created a work of art) as statements.

Of course it matters to me what people think of them. I want them to have some reaction, even if it's hostile, but I also want them to put some effort into thinking what my work might actually be about. All this 'a child of five could make it' misses the point: the point is the message.

I take my work seriously, and put a great deal of thought into it. The press commented that Stonehenge was 'conceived in two days' and made out of £34 worth of materials from an East Dulwich builder's merchant. Well, it may have taken two days to construct, but it took two months to think out. And I have just spent three months on a painting which sold for just £800.

Some people might see the £3,500 price tag for Stonehenge as controversial. But it was determined by the going rate for my work – which is determined by buyers and the Anthony Reynolds Gallery, not me. I don't think I can speak on the actual *ethics* of what it's worth – you could relate it to Sir Ralph Halpern's salary or a new kidney machine. But I do feel that if I'd been, say, some famous pop star who'd just flogged his old shoes to somebody for £3,500, it would be taken on board by the press as just another wacky aside as they came to interview me about my lifestyle.

The emphasis on the money paid for Stonehenge also annoys me in that it gives people the wrong idea about what I must be earning. My aunt, for instance, estimated that I earned an annual fortune, when in truth I'll only make about six pieces a year.

I do make a living. Ninety-five per cent of my work is sold, generally to customers like museums, galleries, dealers and private collectors who actively encourage contemporary art. It is they who make my work *valid*, in a way.

And if other people don't think it's worth it, all I can say is, who's asking them to shell out?

It's not as if I'm getting public money, as in the case of the famous Carl Andre bricks, bought for some £1,000-odd by the Tate. Mind you, when one considers the publicity, and the number of extra people who must have gone to the gallery to see them, I reckon they were quite a bargain.

Opposite
Adam, 2003. Mark Wallinger's
found poem from *Palgrave's Golden Treasury*, 'Index of first lines',
comprising all those beginning
with 'I' in alphabetical order

<u>Letter to the editor</u>
From the *Guardian*, 28 April 1994

Wallinger responds to a negative exhibition review by art critic James Hall.

Having been variously described as a one brain celled, left wing, male intellectual, cultural crusader with a reluctance to politicise but the politically correct desire as a feminist to stable horses in galleries, forgive me if I am a little confused (*Guardian*, April 25). Add to this, the apparent insuperable misfortune of being born in Essex and 'the chances are', 'it goes without saying' that I have a 'stop-start relationship' with your reviewer.

Leaving aside his crass personal assumptions and the sublime pointlessness of his interrogation of my work, three things shine through his review: Firstly, his defensive mistrust of artists who may have read a book or two, and who are maybe versed in this century's 'fashionable' ideas about identity; ideas that may help him out of his pre-Freudian soup.

Secondly, his own patronising attitude to sport. When he talks about 'a primitive and mostly proletarian culture', which sports does he have in mind? Golf? Tennis? Cricket? Racing? Rugby? Ah, I know, football; that filthy game of the lower orders given patronage by the likes of Nick Hornby, Roddy Doyle and Silvio Berlusconi.

Thirdly, he might suppose that in the thirties 'male intellectuals of the left' were 'misty-eyed over the Olympics', but then what happened in Berlin in 1936 is obviously all ancient Greek to James, who knows nothing about History's propensity to return as tragedy, then farce. However, it is heart-warming to see the Corinthian spirit of the amateur – outdated as it is in sport – still thriving in your columns.

Mark Wallinger
London SE5

royal ascot

imagine a parade with perfect
horses drawing carriages bearing
dignified people in beautiful clothes
kings and queens and princes and princesses
acclaimed by an adoring public
the guardsman playing the national anthem

picture a procession with dignified
horses pulling coaches containing
famous people in wonderful costumes
kings and queens and princes and princesses
adored by a loving country
the bandsmen striking up the national anthem

envisage a pageant with fine
horses drawing coaches bearing
noble people in exquisite clothes
kings and queens and princes and princesses
applauded by a loving public
the soldiers playing the national anthem

imagine a cavalcade with noble
horses drawing carriages bearing
distinguished people in elegant clothes
kings and queens and princes and princesses
loved by a proud country
the cavalry playing the national anthem

royal ascot, 1994. Mark Wallinger's poem on the Royal Family's procession at the annual racing event (see pp. 78–79)

'A brush with genius: Mark Wallinger on Velázquez's
Triumph of Bacchus'
From the *Guardian*, 3 July 1995

Invited by the *Guardian* to inaugurate a series in which artists and art
historians choose the work of art they like best or which has had the
most influence on them, Wallinger writes about the Spanish painter's
masterpiece of 1628–29.

Velázquez is the greatest of all painters and this picture – prefigur-
ing *Las Meninas* by nearly 30 years – is a wonderful example of the
sophistication and modernity of his vision.

As in *Las Meninas*, Velázquez presents us with a complexity
of focal points. There are the figures paying sardonic homage to
Bacchus, including what appears to be one other deity. The late-
comer doffing his hat on the right I would guess was a latecomer to
the painting to break up the horizontal row of heads. Bacchus
himself, pudgily androgynous, appears illuminated by a different
kind of light. He gazes out of frame into a space from which we are
forever denied access. As a god, he is abstracted from the scene,
which only goes to place the two liggers on his left in even sharper
relief. The look they direct at the viewer slices clean through 350
years in the most disconcerting way. It is a look familiar to anyone
who has enjoyed the glorious puerility of piling into a photo booth
after a good session. We are welcome to join them for a drink as
long as we can stomach their blue jokes. However one might
describe them, we are made complicit in the meaning of the work.

This direct importuning of the viewer is one aspect of Velázquez's
modernity. The king looks at Diego and he (we) look back. He sees the
Hapsburg chin as a spade and paints it as a spade.

There is an extraordinary consistency to this gaze which can
find a king so ordinary. It can place the spiritual or mythological
amongst the everyday or make an old woman frying eggs seem a
matter of life or death. I think the key to this magic lies in
Velázquez's determination to reveal the materiality of the paint.
What we might now perceive as a sort of truth to materials was in a
religious age more akin to the transubstantiation of the bread
and wine in the Eucharist. Beyond verisimilitude, objects are not
so much described, as inscribed with meaning. (Or is that the
drink talking?)

Diego Velázquez, *Triumph
of Bacchus*, 1628–29
Oil on canvas
165 × 225 cm
(65¼ × 88½ in.)

'Is he the father of modern art?'
From the *Guardian*, 13 January 1996

In the lead-up to a major exhibition of Paul Cézanne's work at the Tate
in London, Wallinger questions modern art's debt to the French painter.

Cézanne, the father of modern art. I daresay this will be trotted out
before any appraisal of his work. Art, of course, is far too heteroge-
neous to be ascribed to a single parent. Indeed, modernity belongs
to and is a product of popular culture and this began (if we need
creation theories) with Daguerre and Fox Talbot.

But the camera's refractive objectivity and its sheer repro-
ducibility didn't (perhaps still doesn't) sit happily with a patrician
elite, whose role as dispensers and interpreters of cultural arte-
facts was threatened. Cézanne's interrogation of subjectivity was
advanced against the voracious grasp of the camera and its one
good eye.

Cézanne's early paintings reveal him to be free from any dis-
cernible talent or facility but possessed of a lurid imagination.
Junking the weird stuff, he reinvented painting as a journey without
end because just looking was an end in itself. Cézanne's unique
selling point was his vacillation: his way with paint simultaneously
tentative yet pedantic, making a hero of doubt.

So when Cézanne is called father of modern art, what progeny did
he spawn? Expressionism? Cubism? Futurism? Dada? Surrealism?
No, it was Cubism, the dullest movement of all. If we buy into the
kind of formal determinism I was taught as a student, this leads to
abstraction which leads ultimately to formalism's tautological
apogee: paint as paint.

In any case, the history of this century is far too messy for us
to follow untrammelled; this heritage trails back to Cézanne. The
claims for inheritance are a nostalgia for what might have been
if art could evade the taint of political reality. This is not his fault, of
course, but it seems to me that this century has needed witnesses
more than it has needed artists. The camera asserts what it has
seen. The artists are just looking.

Masaccio

Meeting parallel lines at infinity
Or the vanishing point of the Trinity,
From the apex or base
We might see our own face
Staring back as the Ghost of Divinity

Masaccio, 1998. Limerick written
during Wallinger's residency at the
British School in Rome to accompany
the drawing

'Fool Britannia: not new, not clever, not funny'
Delivered as a conference paper in 1998, and published in *Who's Afraid of Red, White and Blue?*, ARTicle Press, 1998, as well as in *Art for All?*, Peer, 2000, and in an edited version in the *Guardian*, 12 December 2000

In this frequently quoted essay, Wallinger writes about art and politics in Britain.

'He who does not know history is destined to remain a child.'
(Cicero)

'Two bald men fighting over a comb' was how Borges described Great Britain's war with Argentina. Sometimes the quarrel seems as distant and obscure as Jenkin's Ear. During the Miners' Strike (1984–85) men were incarcerated using any law on the statute-book, some dating back to the 17th century. A whole industry was dismantled to break union power in Britain. Hundreds of thousands of people marched against the trident missile and camped outside American airforce bases. Ronald Reagan's idea of a humourous aside was, 'let's bomb Russia'. These were the 80s as I recall.

During this time I worked in a bookshop. It had a big Russian and Soviet department. The directors were Communist Party members, frequently at odds with the staff, who were predominantly Trotskyist, although Arthur in the storeroom was definitely a Tankie.

In retrospect the factional disputes on the Left and changes in shop policy were an effective microcosm of the crisis of the Left in the world at large. Socialist Worker Party members were removed and replaced by Communist Party placemen. They turned out to be not very successful booksellers, so specialist booksellers and out of work actors began to take over as the business became more Thatcherite. In a bizarre presage of history, the shop started selling T-shirts and badges with Bolshevik slogans and pictures of Lenin. Retro-Russian-Revolutionary chic became a fashion sensation; so much so that it eventually constituted over half the takings of the shop. I left in 1988. The following year was to see momentous upheaval. Fourteen staff who walked out in protest at the manner that a sacked colleague was dismissed were themselves fired. The shop was firebombed for stocking *The Satanic Verses* and then closed altogether when the Soviet Union (which had payrolled it all along) collapsed.

Anyway, back in 1986 the National Front paid a visit and I got my head kicked in. Real things happened and sometimes I made work about them. *Tattoo* was made as a result of this attack. For all their violence, for some reason they struck me as a bunch of mother's boys scared of anything different, or 'other'. *Tattoo* was my attempt to come to terms with the passion of bigotry. Ironically, in the years to come, my work has been criticised for being too English. Middle-class squeamishness of self-analysis only allows Englishness as a term denoting parochialism and nostalgia. Remember how the National Front successfully annexed the Union Flag as a symbol of white supremacy? Those wistful for an older order might do better to imagine what it is to be too Irish, too Serbian. In 1986 Englishness *in extremis* was imprinting itself firmly upon my mind.

For those somewhat younger or with narrower hindsight, the 80s conjure something different. An age of opportunity, advantageous property deals, distressed jeans and Wham! The age of the entrepreneur, asset-stripping, privatisation, business built on hot air and recreational drugs. Advertising became hip. The exhibition 'Freeze' was paradigmatic of the 1980s and for artists caught in that moment they have never ended. They are the first generation of artists to demand a lifestyle, lofty ideals are for, well, ideal loft spaces in Clerkenwell. Man the barricades, I demand to be a restaurateur!

Charles Saatchi's gallery was the model for 'Freeze' and the warehouse and vacant building shows that followed. These ex-industrial spaces were much too big for the exhibitions and art works became stunts – a small explosion here, a revolving bow tie there. The spirit of PT Barnum infected the exhibitions, a sensibility that would persist into the 1990s. Empty buildings – or strictly speaking emptied buildings – were sought for a proliferation of artist-run shows. Buildings emptied of history and, by dint of the artworks, removed from the context of urban blight and redevelopment. But never mind. 'Freeze' was received in terms of its own hype – as an event that was bigger than its actual content, which has never been properly evaluated. Even so, spurious claims have been made about the new relationship of art to galleries and collectors. The most bogus claim was that of accessibility to a new audience. These were the most elitist of shows – a direct appeal to money, ladies who lunch, collectors and bigshots who were air-lifted into East London (*ich bin ein Londoner*).

Although much of the work was to leave locals as well as initiates nonplussed, contenders new to the field soon learnt the mantra, 'Great Space' and 'Who's curating that Show'. In a uniquely tautological arrangement, to be invited to one of these shows was to be included in the in-crowd, a trend which reached its nadir in what might be called Scottish Mailing List Art. Specific art world figures were targeted and asked for their contributions to an exhibition. Staggeringly, this obvious ruse sufficiently flattered the recipients that they were only too happy to oblige. What could be finer? They make the work for you and 'hey presto!', it has an instant Zeitgeist as well.

At this point one begins to sense that something was missing. What was missing was the audience. In hot wiring straight to the moneyed and the influential, the need for a discerning public was successfully avoided. In many ways this resembled the radical overhaul effected by Direct Line Car Insurance – except the latter appealed over the heads of brokers direct to the public, rather than the other way around. Similarly, the effacement of a building as a productive space made of that loss a paradoxical kind of value. Art objects were invigorated by their capacity to empty out history. A no space in no time where nothing can fail to signify.

The search for vacant space with maximum headroom was shared with the nascent rave scene. Despite the claims made for a shared youth culture, young British art, as promoted by Saatchi, displayed little of the rave sensibility, preferring instead the *coup de theatre* so beloved of stadium rock (Harvey Goldsmiths College perhaps). Youth culture, which is as omnipresent and significant as acne, should not be confused with popular culture. It is just a phase art is going through because artists stay younger longer. Popular culture is the same team supported by generations of the same family. It is the kerbstones painted in Belfast. It is essential to people's identity.

Whilst popular culture hadn't much to answer for in new British art it certainly influenced how art was received at a critical level. For a number of reasons art had given up the ghost under the weight of theory. The breakdown of distinctions between high and popular culture led to all manner of cultural produce and effluent being sifted and read as text. We were top-heavy with theorists (not to mention curators) who needed scant visual stimulus to write the work into the flat ergo of postmodernist irony: in short what we had was nominalism. Artworks merely had to ring the appropriate bell to set the Pavlovian critics slavering for interpretation.

If the artist has been reduced simply to repeating, appropriating, quoting or pointing a camera at a world awash with meaning and interpretation, the only meaningful position is to be a curator. Artists are too narrowly concerned to achieve any kind of adequate overview of contemporary culture. Only the curator can bring any kind of authoritative commentary. Unafflicted by complacency, nepotism, sycophancy or careerism, they alone can provide artists with those links with collectors or more often than not, taxpayers' money, in the quango-led non-meritocracy that constitutes the London art world.

Curators have the important advantage in that they need not take any responsibility for their actions. Any spin through the career of our most esteemed curators reveals how nimbly they can move from conceptualism to neo-expressionism; minimalism to mannequin abuse without being court-martialled for dereliction of duty. Artists, however, are required to perfect their schtick and stick to it. Its tough enough for a curator, what with coming up with a title for a show, ringing up your mates, rummaging through art magazines. What would they do if the artist stopped painting, say, and took to the stage? In this brave new superstore it is unacceptable that the same people that make baked beans start manufacturing lawnmowers. These modern day Sophists have worked in concert with a greedy market to ensure that artistic development is restricted to product placement and niche marketing.

The artists themselves are curiously mute about their practice, perhaps because there is little to say about works that specialise in stating the bleeding obvious. Art is a commodity in the marketplace, women have had a raw deal, children's sexuality is spooky, we are all going to die, etc. The more feral artists have gone even further and forged a career by loudly proclaiming they have nothing to say. However, they have learned one important lesson.

Context is all. What is lamentable on Jerry Springer is presentable in the gallery. The authority of the gallery creates a magical hiatus where pandering to the audience's appetite for sensation and vulgarity is seen in the guise of importance, However, nothing worthwhile can live long within inverted commas. The lazily adopted tag, 'Duchampian', that attaches to much current work is misleading. Far from being subversive, much of this work is subservient to the institution's validating power. But this 'radical' charade is of mutual benefit to the artists and galleries and the first step to success is to get yourself curated. ('They think it's funny, turning rebellion into money'.)

Artistic practice is the most critical practice. Art works should engage, articulate, problematise, open new ways of seeing, place the viewer in jeopardy of their received opinions, move the artists to the limits of what they know or believe, excite, incite, entertain, annoy, get under the skin and when you've done with them, nag at your mind to go take another look.

Instead, today we have nominal triggers for regurgitating arguments better rehearsed elsewhere, which are neither illuminated nor in any sense present within the work. This is work that is essentially literary; work that repels the senses and takes us off to the library. The press release is the pitch, is the interpretation, is the whole work, ready to be phoned around the world; art that, in deconstructive logic, is a footnote to the text which justifies its existence. Young men and women emerging from the Courtauld and Sotheby's are guided by more pushy types towards young artists, anxious for their *oeuvre* to be bookended with scholarly appraisal. Once the artist is afflicted by this desire to be curated, or his work is deemed curatable, he or she is gradually but inexorably freed from accountability – hereafter the work need retain only a semblance of authenticity.

Paradoxically, the growth in numbers of curators has been accomplished at the expense of art history, which could be a thing of the past. At many art colleges, art history has been replaced as a mandatory part of fine art courses by critical theory. An academy, an orthodoxy, a training scheme for artists has been created and, like mannerist paintings, gestures have lost their connectedness with meaning in the way that sentiment comes apart from emotion. Within this academy the student is best advised to choose between two basic strategies:

1. Be a swot and drop the right references in work that positively aches with its desire for approval.
2. Become a slag, an unholy innocent conduit of society's maladies and peccadilloes.

The first strategy gains Brownie points and is popular with curators who need the ballast of the dull and worthy to set against the raucous clamour of the second category.

Whichever the student chooses, they had better get on with it. I recently received a letter from a German museum:

'It is really unfortunate, that we could not consider your works for our project 'Urban Legends, London' – however, one of the main

Easter, 2005
16 fibreglass flagpoles, 16 polyester
Union Flags, 16 bases
Poles 3.5 m (c. 11 ft); flags 3 × 6 m
(*c.* 10 × 20 ft) overall; installed
dimensions variable
Installation view at Hangar Bicocca,
Milan, 2005

criteria of choosing the participants was not to exceed the age limit of 35. This is of course a very bad reason to have, but strangely enough, it is an important one.'

Apparently an artist's creative life-span is similar to that of a footballer's – once the knees start playing up the whole cerebral cortex shuts down. Myself, I've always preferred Piero to Ucello, he was so much younger.

Postmodernism, with its refutation of meta-narratives and ideology, has unfortunately served as a handy argument in favour of ignorance as an end-of-history stance. Andy Warhol, having already squeegeed history flat, left his successors nowhere to go, other than A to B (Anal to Banal). This nevertheless was the path chosen by the students of the 'Freeze' generation. 'Freeze' was the show in which student work broke through. Its greatest quality was its removal of expectations of depth and meaning, to be replaced by the society of the dilettante. In a world that begins and ends at one's fingertips, with an ineffectual past and a baseless future, all things are ever present and equivalent. Within this Fool's Paradise, if you look like an artist, live like an artist and behave like an artist, then you are indeed an artist.

NB. Some advice on deconstructing current critical terminology. Simply replace 'not' for 'post', so that post-modern, post-conceptual and post-ironic become not-new, not-clever and not-funny.

'The Pygmalion paradox: Mark Wallinger on the new Establishment'
From *Art Monthly*, issue 218, July–August 1998

In this feature for *Art Monthly*, Wallinger looks at the ways the British class system and the Establishment relate to contemporary art and artists.

'It is impossible for an Englishman to open his mouth without making some other Englishman hate or despise him.' G. B. Shaw, Preface to *Pygmalion*

Several years ago, in my capacity as boyfriend of the headmaster's daughter, I was invited to speech day at Greenwich Hospital School. Removed to Suffolk in the 1930s, it is a boarding school largely devoted to educating the sons of navy and military officers. My only previous experience of such an event had been the film *If...*

Prior to the serious business of speeches and prize-giving, boys from different school houses marched up and down the vast parade ground. The guest of honour was the then government minister for Northern Ireland in the House of Lords – this at a time when the IRA was pursuing a policy of targeting military and government institutions on the mainland while the wrong men, incarcerated for previous atrocities, were finally being released on appeal.

The first speech was given by the chairman of the board of governors. Speaking with the air of someone who was used to being listened to, the lengthy speech was memorable for the cadences telegraphing the approach of a joke, and for one joke in particular whose punchline I thought I knew. 'Have you heard about the Renault 4?' he asked. 'They were all guilty.'

The concept of the Establishment is not the product of a conspiracy theory. It is real. Its existence and continuance are testimony to a basic human craving to trust in the veracity of paternal authority, an authority that is its own guarantor and requires faith rather than imagination from believers. If it were a religion it would be fundamentalist. If we view it as a dystopia it would follow the Orwellian model (you would have to be educated at Eton to understand). It functions most simply where hierarchies are unquestioned. The racing world, with which I have been associated – my trainer was a baronet – is one such world. Here, a man can enter a room, be told by another 'you can't come in here', and exit without demur.

By the Pygmalion Paradox I mean the haplessness of the radical impulse in any art form faced with the implacable forces of the Establishment. How a work whose intent is subversive only further reinforces the status quo. The irony is compounded by the fact that when the coercive power of the Establishment is revealed by its own machinations, everyone is generally too polite to notice.

To take Shaw's satire as an exemplar: on the face of it we have here a work seeking to articulate the iniquities of the English Class System, in which an ill-speaking flower girl is equipped with the diction and manners necessary to pass as a Duchess at an Ambassador's Ball. The paradox being that down the years Eliza has been played by the kind of well-bred gals from RADA who have had every advantage in life and have struggled temporarily to dumb down their diction to the requisite cockney before resuming with their more natural elocution. This immediately places the work within patrician parentheses – what should empower the poor condescends to the street.

The film *If...*, mentioned earlier, is itself a good example. Once you know that Lindsay Anderson sought and received permission from his old public school to make the film on its premises, Malcolm McDowell's grenades have the potency of flour bombs in a St Trinian's farce. The fact that it is still viewed by some as a powerful satire is itself a testament to the evasions and euphemisms by which we tiptoe around class in this country. ('Don't mention the class war, I mentioned it once but I think I got away with it.') Manners are small morals, and generally speaking the moral is: behave yourself. It would be terribly rude to say Anderson's film is undermined by his need for approval from his alma mater.

'Who controls the past controls the future. Who controls the present controls the past.' Orwell would have taken a close interest in that late 20th-century phenomenon, the contemporary art museum. Museums are, by definition, ill-equipped to deal with the here and now and those charged with discriminating what should be Here and Now are in a particularly onerous position. The Tate Gallery, like all big pubic institutions funded by taxpayers' money,

works like any other branch of the civil service, and taking a punt at posterity is antipathetic to organisations in which decision-making is diffused through the system by bureaucratic osmosis. Perhaps in compensation, the Tate has its own quango, The Patrons of New Art, less accountable to the public and more conducive to old-fashioned patronage.

Faced with an inadequate budget, and an incoherent policy on contemporary practice that is its corollary, it is small wonder that the Tate's credibility rests so heavily on the annual speech day that is the Turner Prize. Although, true to Establishment instincts, it seems the appearance of authority is always more important than the substance. How else does one explain why decisions that will change the careers of this year's shortlisted artists are to be entrusted to a jury including a singer in a pop group.

The credulity of the general public has been sorely tested of late. The Royal Academy pre-empted Sensational reporting by cynically promoting the Myra Hindley portrait, then offered the families of the victims a viewing of the painting. Presumably the work said more about the nature of evil than anything their imaginations had managed to summon up in 30-odd years. Such enlightenment produced a double whammy – patronising and traumatising the families while guaranteeing Hindley's lifelong incarceration. For the Academy then to take a stand against censorship smacked of hypocrisy. It is at such moments that the Establishment reveals itself more devastatingly than any satire could do.

In many ways the Academy was an appropriate venue for the New Establishment. Thatcher had shown a new way for old money. The type of person whose creative needs had previously been fulfilled by sporting a cravat at the weekend now tried to get hip to the kids. Never mind that their vision of Bohemia was not far removed from Ruritania. Meanwhile, a new generation of artist wannabees helped turn the Hoxton Square fete into nothing less than the Berkeley Square Ball of the New Establishment Season. Sharing many of its characteristics, wannabeism is partly the result of Thatcherism. Commercialism and entrepreneurialism, unburdened by ethics, favour charlatans because, in the culture of selling, commodity value replaces all other values. For instance, curatorship is now a career option, like working in PR or TV. Institutions need them to complete a process that is much like money-laundering. All manner of dodgy deals and realpolitiking can be redeemed once you have got your artwork through the portals of the museum. This is not a difficult thing to achieve: the legions of exhibitions at home and abroad featuring the same personnel don't exactly testify to great independence of thought among the burgeoning ranks of curators.

I am writing as the Queen's Birthday Honours are announced and some weeks after a reception for the arts at Windsor Castle – which leads one to speculate on the bizarre nature of celebrity. Granted the usual quantity of luvvies got their gongs, but the guest list for Windsor Castle suggests, paradoxically, that fame is a great leveller. There was Shirley Bassey, Michael Caine, Ken Barlow, Ben

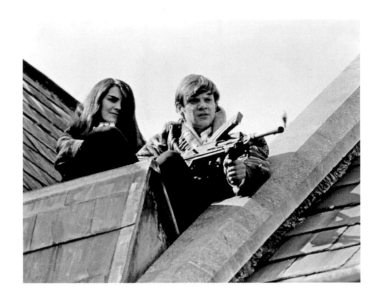

Okri and Mick out of Brookside. Mark Lawson has coined the expression Media Munchhausen Syndrome – the almost pathological need to have one's existence validated by celebrity. If this is the motor force behind a lot of contemporary artists then one can see why. Recognition is everything. In a hall full of 600 people, it matters little if you have written *The Caretaker* or played one in a TV soap, if no one can recognise you from Adam. The fact is that when the *über*-famous Queen failed to recognise Mick Hucknall it was deemed newsworthy, suggesting perhaps that fame is a currency, an economy, a possibility of escape from one's designated station in life. It certainly lacks the patronage inherent in the present honours system. Unfortunately, in the free market of celebrity the worthy are outmoded by the media-worthy. In a country steeped in deference, fame is never comfortably accounted for. No matter how wilfully it was sought nor how accidentally it was achieved, there is a hankering for something more authoritative, which might explain why we still have so many speech days.

'Here we are at the Tate Gallery for the announcement of the winner of the Beck's Turner Prize. The young people have settled down and the Chairman of the Governors has just introduced the four judges: they are Alice Band, a curator who has spent many years in the pockets of commercial galleries before landing a plum job at the Arts Council; Henry Courtauld who writes endless drivel about irrelevant exhibitions in publications no one reads; John E Foreigner, who finds London the most exciting place in the history of the world, and Mr Posh Spice himself, David Beckham. Let's return to the speech:

'My Lords, Ladies and Gentlemen. Have you heard the one about the new meritocracy? No, but seriously folks, it gives me great pleasure to present the award on behalf of the Tate, Channel 4 and everyone who knows me. And the winner is … us!'

Film still from *If…*, 1968, produced and directed by Lindsay Anderson

'*Art for All?* Introduction'

From *Art for All? Their Policies and Our Culture*, Peer, 2000

Wallinger coedited this anthology with Mary Warnock. In his introduction to the book, he considers the relationship between cultural policies and art-making in the UK.

What became clear in the course of our discussions whilst editing this publication was not only the range of arguments made, but also the breadth of tone, the sheer variety of language, with which the arguments are expressed. Since it would be difficult to introduce these essays in a tone that could encompass the magisterial, the peevish, the idealistic, the righteous, the absurd and the downright hacked off, this introduction is not intended as a measured overview, but as a similarly opinionated response from my point of view as an artist...

The need to commodify art, or the willingness of artists to see their practice reified, is essential for securing the money. Subsidised institutions within a mixed economy have inevitably struggled to find ways in which to confer value on art distinct from the market. The visibility and fashionableness of art, and the increasing media profile of some artists are an insistent siren call to loosen the public purse strings. So it is perhaps no surprise that initiatives wholly engendered by public institutions require *bona fide* credentials from artists as potential agents of moral improvements before they can get the money.

Funding for artists comes with long ideological and economic strings attached. As an artist, one has to use another language. The ideas, hunches and vacillations that accompany the creation of an artwork have to be banished so that a seamless project can be proposed that can guarantee a calculable return from the potential audience – regardless of race, creed, or colour.

Unable to codify artistic practice according to the artist's experience, the burgeoning ranks of plutocrats, bureaucrats and apparatchiks have evolved a vocabulary and practice of Swiftian inversion, imperturbably Soviet in its incontestable rectitude. The aims of the work have to be pitched like an application for planning permission in a parallel universe, in which the offence to neighbours is measured by the degree of irrelevance one can bring to their lives, or the hope that the response of an indifferent public can feed back as a dividend return on the project.

This is a fundamental vision of art in which it is hoped that the viewer will 'interact' with the work to arrive at a prescribed interpretation. Cause and effect must be measurable in order to gauge the success of the work and to justify the jobs of the commissioners – the great-and-the-good and the not-up-to-much.

Prejudices must be challenged, new audiences must be reached, something-or-other must be subverted. One has to deal in absolutes – a world of binary oppositions that are readily identified, diagnosed and neutered. The economics of arts patronage encourages a concomitant economy within the structures they create and deploy, expressing their desire to meet the audience halfway. The language of accessibility has led to an almost unconscious adoption of Reithian values – the mission to educated, entertain and instruct – which have permeated from outreach projects to the galleries and museums.

This itself was a reaction to the sanctification of greed and conspicuous consumption of the late 1980s, when, in the absence of any meaningful debate, a new apolitical orthodoxy gave the opportunity of power and influence to a swill of artist/curators who might previously have found employment in PR.

The subsequent rise of the curator has coincided with the decline of the artist. The continuing fall-out from the collapse of painting as the axiomatic site of the modernist avant garde, and the subsequent hegemony of conceptualism, has required a small army of interpreters, eagerly co-opted by institutions anxious to be identified with the new Zeitgeist. This clamour for explanation means that it is becoming increasingly hard to distinguish curators from what used to be called sociologists. Where once an artist's work was analysed in terms of the formal development of themes and subject matter, it is now corralled into the box marked 'Issues', a proper understanding of which is contingent and contextual and for which the individual artist would necessarily have only an imperfect or partial grasp.

The danger comes when the Lottery-funded superstructures – the museums and galleries – expect curators working within a management structure to make far-reaching and disproportionately influential decisions. The fact that they are essentially civil servants means that responsibility for these decisions can be all-too easily diffused through the system. The star curators, impatient for novelty, can dodge in-house and out-house like the hokey-cokey, whereas the artist, once curated, is either collusive with, or powerless to resist, the bowdlerisation of their poetry for inclusion in an anthology of prose.

When decisions and positions hard won and developed over a lifetime are reducible to indicators of cultural diversity, with no regard to individual development, the result is a trite and condescending anthropology of the modern age. Shrinking time into space, the here and now, the better to categorise, catalogue and compare, encourages a kind of historical amnesia where curators can pick and choose from a smorgasbord of narcotic sensations, a baseless landscape of outrage. Art is the new rock'n'roll. Art is for everyone. Art is the opium of the people.

'Private passions: Mark Wallinger on *Whistlejacket*'
From *The Times*, 3 October 2001

Invited by *The Times* to write on a subject he is passionate about, Wallinger describes his attraction to the work of George Stubbs and draws out a hidden subtext in Stubbs's equestrian masterpiece *Whistlejacket* (see p. 139).

George Stubbs's last work was to be 'A Comparative Anatomical Exposition of the Structure of the Human Body with that of a Tiger and a Common Fowl'. When set beside those of his fellow mortuary attendants, Leonardo and Géricault – the scientist and the romantic – it is impossible not to see this gloriously bathetic title as a fitting expression of doughty British pragmatism.

Indeed, according to the artist Ozias Humphrey, Stubbs was so convinced of the importance of observation that he visited Italy in 1754 only to reinforce his belief that nature is superior to art.

My initial attraction to Stubbs was in the 1980s when I used his bucolic scenes of an English Golden Age to represent the never-never land that Thatcher saw threatened. However it was impossible not to see within the intricate compositions of *The Reapers* and *The Haymakers* that it is only the gaffer on his horse who is not working. Nor in *Hambletonian, Rubbing Down* to miss Stubbs's subversive empathy with an animal flogged to the point of exhaustion by its owner, the commissioner of the portrait.

Just how radical *Whistlejacket* (1762) is depends upon which stories you believe – or, more accurately which stories you reject. The iconic status that the work has gained is achieved by absence – by what is missing or found wanting in the image.

We do know that the painting was made for the 2nd Marquess of Rockingham, Whistlejacket's owner. The horse had been retired to stud after his last famous victory at York in August 1759. Stubbs had sufficient prestige in his day to leave the contextual background to assistants, but that is not the only thing missing. According to some writers of the period, the original intention was to commission an equestrian portrait of George III.

Since this is art, not nature, imagining the absence of George III is no more fanciful than imagining St George on board. Stubbs surely must have learnt something in Italy. The paintings of Uccello and Carpaccio and countless others have a rearing horse bearing St George and his lance into battle with the dragon. The image of male potency is as obvious as the rearing horse on a Ferrari. Indeed, as part of the mythology of the work we have the story of the fractious stallion, Whistlejacket, obeying his nature and attacking his likeness in the painting.

If the subject is seen simply as a stallion, the absent party is the client mare, or in the absence of the mare the lack of the single most obvious signal of male potency. Thoroughbreds, like kings, are in the business of begetting. Rockingham would have seen the painting as both a glorification of the horse he owned and an advertisement for potential brood mares.

Stubbs was obsessional in his examination of equine anatomy – killing the horses himself and peeling away layers of flesh until the corpses were too rotten to be worked on any more. Perhaps, finally what we find mysterious about *Whistlejacket* is how Stubbs brings all his forensic knowledge to bear in making a rare painting, one that can be apprehended as one seamless gesture. A visceral understanding communicated with immediacy, like a small ray of enlightenment.

'Sleeper'
First published in *frieze*, issue 91, 31 May 2005

Wallinger writes about the ideas underpinning *Sleeper* (2004) and his
experiences of making the work.

As a bear I don't claim any special knowledge. Only that which I have
experienced and how it led me here. Growing up in the shadow of
the wall was not about proximity. Imagine casting a stone into
water and finding that the ripples, expanding in concentric rings,
never diminish. Berlin was part of my subconscious before I ever
set foot here.

A sleeper may be planted years in advance – of all the double
agents buried during the cold war, not all of them were sprung. The
secret of a successful hibernation is a matter of provisions and a
plausible disguise. At night I am examined for authenticity, during
the day I pass unnoticed. The bears in the zoo are the last of their
kind, as they are no longer allowed to breed. When the last one dies
will they raze the whole sorry zoo to the ground like they did with
Spandau prison after the death of that idiot Hess? Alone in the
centre of this vast space I gaze towards Potsdamer Platz like the
guilty conscience of the building. A bad sleeper. Sometimes I feel
adrift as if I have woken up in the middle of this story.

A transparent building is intimidating. It can only exist in a
society that doesn't fear its shattering. In the Neue Nationalgalerie
we are open, we have nothing to hide – art is for all to experience.
When the wall came down, there it was, naked. And looking at the
Fernsehturm, you can't help thinking, how appropriate; this is what
you get when a culture of surveillance and paranoia commissions a
representative national icon. One gigantic look-out tower.

The bear costume is an obvious disguise, I know. (Too much
effort would appear ingratiating, I thought.) It is both bear, and
clearly not bear. Children, for all their fear of the unknown, can play
with this fear. They switch from play to reality effortlessly, exist in
two realms simultaneously. (Tonight I have been trailed by two
small girls who tease me through the glass. I breathe a little cloud
on to the pane. They fan out a pack of playing cards and bid me pick
one. I point and they turn over a picture of Harry Houdini.) The portal
to the other side, the underworld or wonderland is the mirror as
represented in *Orphee* or *Alice*. You have to pass through your own
image to reach an imagined world. Risking enchantment.

As a child I was traumatized by a vision of the other side. *The
Singing Ringing Tree*, made in a fully imagined world in Babelsberg,
tells the story of a selfish princess who sends a long suffering
prince on a quest for a magical tree. He reaches the border of
another kingdom which is protected by a ravine and a sheer rock
face and guarded by a dwarf. The prince explains his quest for the
magical tree, and the dwarf offers it to him on one condition. If the
princess does not love him by sunset, he must return to live in the
magic kingdom. The prince is so confident that he jokes. He says
that if he fails he will be turned into a bear.

What does it dream? This empty building full of limpid darkness,
like the promise of a well, a reservoir of silent thought? How often
does one look at the moon and think that a man has walked there?
On the other side of the wall the Palast der Republik is choking
with asbestos.

In Babelsberg, tongue-tied over their short history and in grief at
their estranged brothers and sisters, they turned to the long past
for some unexpurgated truth. The two realms of Germany were like
twins separated as children and raised in completely contrary
ways. Having to cross irrevocably from one realm to another, or be
divided without appeal. This is what I have learnt and it seems very
cruel. Germany invented the unconscious, which is not normally
credited with respecting borders.

What if I died in here?

Being alone in a museum was a delicious recurring dream of
mine, to transgress among objects of such inestimable value. But
an empty museum, what would that be, exactly? I have met many
people who preferred the Jewish Museum empty of exhibits. Why?
Something to do with Freud and the return of the repressed, I
suppose. Because what do we dream until we know what we have
done? The characters in Fairy tales are hapless innocents – they do
not yet inhabit a moral universe.

Bauhaus is our house, Gretel.

What are we allowed to dream? The past rises up with all its
vivid detail to mock our progress at every turn. The long past of our
own fear. Inside the bear's head I am aware of my own breathing.
Looking out of the jaws at my narrow view, my progress from stim-
ulus to distraction gains some kind of animal momentum – to
watch and be watched as a foreign, alien, strange, endearing,
imprisoned animal.

Don't feed the bears.

Marx wrote that history weighed like a nightmare upon the
brains of the living. Without the notion of a God to console, history
may seem random and uncontrolled. Joyce talks about the night-
mare of history as the unbearable contingency of being: the
accident of birth that would take more than a lifetime to under-
stand. He chose exile from god and nationality. The rest, the past
which lies unrecorded, are what myth and folktales retain, the long
past where no details change; where things remain real and
answer to their names.

The Neue Nationalgalerie declares that the modern world, so
cruelly interrupted, will resume its business from such and such
a date.

Tonight, the moon shone brighter than the lights of the Sony
Centre.

Did I tell you about the other bear? On the seventh night a bear
appeared, identical in every detail, looking through the glass. The
security cameras picked it up.

My German brother. *Mein doppelgänger.*

'MAKE ME THINK ME'
Published in *Serpentine Gallery Manifesto Marathon*,
König Books, 2009

This lecture on Bruce Nauman was delivered by an actor on 1 May 2006 in the Artists on Artists series at DIA, New York; and by Wallinger himself on 18 October 2008 at the Serpentine Gallery, London, as part of 'Manifesto Marathon'.

Bruce Nauman was born the day before Pearl Harbor was attacked.

'Reports that say that something hasn't happened are always interesting to me, because as we know, there are known knowns; there are things we know we know. We also know there are known unknowns; that is to say we know there are some things we do not know. But there are also unknown unknowns – the ones we don't know we don't know.'

The day after Bruce Nauman was born, Pearl Harbor was attacked.

Some years ago, I was asked by an old friend from college to give a talk about my work at Hull School of Art. He was relatively new to teaching, and I was a reluctant speaker. He was nervous for me, and the feeling was contagious. The lecture theatre had a prodigious rake and a formal lectern. This was to be my first experience of stage fright. I would try to begin a sentence, personal pronoun followed by verb followed by a. . . by what? Each word became disconnected from myself and any ordering logic – it seemed to land on the floor and stare back at me, like those words that grow crazy if you think about them too much, seemed to be too densely packed to own to anything but itself. I remember the students were agog.

A panic attack is a meeting with the absolute. The here and now are catastrophically present, suffocating any attempts at reflection with existential dread. I recognise this aphasia as a quintessential Naumanesque experience. Do something, or I'll die. I can't do anything.

> SPEAK AND DIE SPEAK AND LIVE
> FAIL AND DIE FAIL AND LIVE
> RUN FROM FEAR FUN FROM REAR

There is a German term *ohrwurm* (earworm), which defines those insidious tunes, riffs, jingles, catchphrases that work their way into one's consciousness. They come unbeckoned.

> PLEASE PAY ATTENTION PLEASE
>
> MAKE ME THINK ME
>
> PETE AND REPEAT
>
> NO NO NO NO NO NO NO.

'I'm not into this detail stuff. I'm more concepty.' That is Donald Rumsfield again. Humpty Dumpty pleading to be liberated from the constraints of his story, from responsibility. What if there is no moral to the tale?

'When *I* use a word,' Humpty Dumpty said in a rather scornful tone, 'it means just what I choose it to mean – neither more nor less.'

'The question is,' said Alice Lydell, our embedded correspondent, 'whether you *can* make words mean so many different things.'

'The question is,' said Humpty Dumpty, 'which is to be master – that's all.'

My word is my bond. I give you my word. In the beginning was the pun. Words become intransigent or under pressure of great conflicts, untrustworthy, evasive, treacherous, like photographs. Time and space cannot be faked. Weight, gravity, stillness, movement. The laws of motion. An equal and opposite force. Newton. Newton, who gave us gravity but believed in alchemy.

THE TRUE ARTIST HELPS THE WORLD
BY REVEALING MYSTIC TRUTHS

Einstein is asleep.

'He's dreaming now,' said Gilbert: 'and what do you think he's dreaming about?'

Alice said 'Nobody can guess that.'

'Why, about *you*!' Gilbert exclaimed, clapping his hands triumphantly. 'And if he left off dreaming about you, where do you suppose you'd be?'

'Where I am now, of course,' said Alice.

'Not you!' Gilbert retorted contemptuously. 'You'd be nowhere. Why, you're only a sort of thing in his dream!'

'If he was to wake,' added George, 'you'd go out – bang! – just like a candle!'

I remember the cover to *Roget's Thesaurus*. On it was a photograph of a paper chain – on each coloured loop of paper was written a word, and the chain proceeded by synonym and nuance to gradually circle around the absent object of its definition. Looping the loop.

In religious ceremony, the repetitions, no matter what religion, are ruled by the loops around the sun, even before we knew we were aboard the moving body. Easter and Passover are alike in their repetition of sacrifice. Ramadan ends on the new moon. Our links with the past and our reassurance of our future require such ceremonies. The same thing repeated forever is a litany. Litany – words that mean something sacred. But we know that is only through a leap of faith, because the linguistic sign is arbitrary. Rhetoric is all. The aircraft towing an advertisement across the sky. Dollar signs in the middle of the desert. Dirty money. The beginnings of Howard Hughes's obsessive compulsive disorder – obsession with cleanliness, withdrawal from the world. Retreat. Ever washing, cleansing. When we bathe together, it is holy. Baptism. Dirty money. Shame, Guilt. Jesus wept, we are talking religion here. When we

speak together it becomes a chant. Plainsong. Dollar signs in the middle of the desert. Kerching. You can't take it with you. You will hang for this.

Not that the experience is circular – cyclical – but the quality. The circles in Dante's *Divine Comedy*, the inverted theories of capitalism expounded by Milo Minderbender, the Dick Cheney character in *Catch-22*. The white soldier in *Catch-22*, bandaged from head to foot, with an intravenous drip feeding into his arm and another tube draining him; when the liquid had passed through him, the two were swapped. *Catch-22* itself.

'From the earliest tapes that I did, coming from a certain sense from some of Andy Warhol's films. They just go on and on, you can watch them or you can not watch them. Maybe one's showing already and you come in and watch for a while and you can leave and come back and eight hours later it's still going on. I liked that idea very much. It also came from some of the music that I was interested in at the time. The early Phil Glass pieces and La Monte Young, whose idea was that music was something that was there. I liked that very much, that kind of way of structuring time. So part of it is not just an interest in the content, the image, but the way of filling a space and taking up time.' (Nauman, like Warhol before him, brings bad news for American dreamers.) Filling a space and taking up time. Starting where things generally end, in definition, is surely putting Descartes before the horse.

Art jokes are bad because they come retold by the likes of Freud or bloody Duchamp. All old Europeans, they never dreamt the American Dream. Architecture and sculpture are within America's domain post-war.

And looking west, that's a lot of new space to fill, but with what and for whom? Sculpture was released from its pedestal into the wide world of buildings, street signs, walk don't walk, the general public. Painting still requires connoisseurship, because it needs a roof over its head, and the concomitant values associated with the bourgeois collector. Alone in an old shop-front in San Francisco, Nauman junked the painting and self-consciously followed his every move. The first post-war artist, first existential artist, alone in a studio. Everything connects and everything alienates. Nothing connects and nothing alienates. All that we see is both particle and wave. Supple as seals in water, but the land … the land is a different matter. Matter meets gravity which is insistent and difficult like a page full of German nouns. I can't go on. I will go on. Present the work. No more, no less.

Film is famously the technology of representation (but these are not representations, they are records, moulds, pathways, corridors, digital information, sound) most closely associated with philosophical insight into the mutual and paradoxical constitution of time and the self. The self in time – past, present and future – in memory, attention and expectation. Video is sheer information, pure enumeration. Even its snowy nowhere is called static. Sometimes duration is nothing more than the wind through the trees. The tree in structure and detail does not change, though constantly moving. It does not tell us anything essential about the tree or the wind. It breathes. In cheap cartoons, sometimes the characters' only animation are the blinking eyes – see: it lives!

Plaster casts are made to objectify and interrogate their host body. The kernel removed, they insinuate that we are hollow, of unshapely pipes and cavernous depressions, with unlikely peaks and troughs. Then something manmade, a chair is dared into existence; lets see how it relates to everything else.

Where to start?
Everything cracks and shakes.
The air trembles with similes.
No one word's better than another;
The earth moans with metaphors…

In some languages, the question mark comes at the beginning of the sentence, which seems sensible because we are prepared for the right inflection. It is as if a primer in grammar thoroughly interrogated the efficacy of language, testing it to its breaking point. Ethical or philosophical questions raised are a by-product. We may think we know them by name, but let's see what they actually do.

Figures which change the typical meaning of a word or words.

Figures which move the letters or syllables of a word from their typical places.

Figures which omit something. For example, a word, words, phrases, or clause from a sentence.

Figures which repeat one or more words.

Figures which repeat a phrase, a clause or an idea.

Figures which alter the ordinary order of words or sentences.

A miscellaneous group of figures which deal with emotional appeals and techniques of arguing.

In AUDIO-VIDEO UNDERGROUND CHAMBER, with the figure in the ground, figuratively speaking, the camera and microphone become our proxy consciousness. The underground chamber is the space inside our heads. It represents the complete decapitation of mind from body.

'During my two decades of residence in Arabia as a royal adviser, I witnessed my share of judicial decapitations. A friend who was a surgeon told me that under medical conditions one can remain conscious for two or three minutes after the blood supply to the head has been cut off. This indicates that, unless rendered unconscious by hitting the ground, a person's severed head remains sentient after the sentence has been executed. A police officer who

presided at executions subsequently confirmed this. He told me that if the head is picked up too soon, it endeavours to use its only remaining defence mechanism – biting.'

The Queen had only one way of settling all difficulties, great or small. 'Off with his head!' she said. And all the king's horses and all the king's men couldn't put Humpty together again.

Having sacrificed it to power (the slave and the conscript) then to industrialisation (the blue-collar worker), the subject is now separated from his body.

GOOD BOY	BAD BOY
GOOD DOG	BAD DOG
GOOD GOD	BAD GOD

Consider the duration of the works. When you wait for so long at a stop sign you think it is stuck. Then it changes, and you forgot your frustration long enough that eventually it is only the horn of the guy behind that interrupts your reverie. What's your hurry? Consider the attention that is given to the work. Time, the fourth dimension, is implicit in the sculptures, where the viewer is manipulated through corridors around hoops inside cages before disappearing off-screen. 'I mistrust audience participation. That's why I try to make these works (words) as limiting as possible.'

Objects in a museum wait in the dark all night. They don't need to be switched on. Video is always on somewhere. You don't need a projectionist or any special premises, let alone a gallery.

THE TAPE RECORDER SET INSIDE
A CONCRETE BLOCK

The buried chamber and its watcher. 'My mind is the key that sets me free.'

Whatever we fear, Houdini knew about it. 'There is one reality, at least, which we all seize from within, by intuition and not by simple analysis. It is our personality and it's flowing through time – our self which endures.' Henri Bergson's idea of duration, like de Selby's disembodied travel plans: a trip from Bath to Folkestone by means of an exhaustive series of successive photographic images. A philosophy of the absurd, the footnotes of a thinker who never existed, in a book about eternity narrated by a dead man. I am talking *The Third Policeman* here, not the Old Testament.

It would be absolutely impossible to represent duration conceptually, because we would be talking about the memory of duration not the actual experience of duration. Intellect is the mould in which the richness, joy, and creativity of life is jellied into an inert motionless and static dead matter.

'Negative space for me is thinking about the underside and the backside of things. In casting, I always like the parting lines and the seams – things that help to locate the structure of an object, but in the finished sculpture usually get removed. These things help to determine the scale of the work and the weight of the material.

Both what's inside and what's outside determine our physical, physiological and psychological responses – how we look at an object.'

When looking at a static object, the phenomenon of time, of how we perceive something, can be separated from the 'what' we are looking at, which does not change.

Negative space, as against what? Positive space? The obverse of free will the artist is faced with existential crisis. To make or not to make, that is the question. Which bit of the world's negative space am I about to fill.

The underneath of the chair – hotel chair – any old chair in a room you landed in. When sat on, what is the least considered region in the entire universe? Perfect.

Abstract thoughts being lobbed back and forth, in a setting that is as metaphorical as it is mundanely commonplace. Abstract and concrete, allusive, reductive, particular and exemplary. It sets banality and originality on equal terms, because one cannot exist without the other.

Insomnia is a waking nightmare. Nauman doesn't blink. It is a long, hard stare. It affords no distance between desire, need, remedy, ill, conscious, unconscious; it is the whole animal. Nothing transcends the limits of language. The only casts are just so – casts, they fill the space not the chair or animal or head. The head casts are too full of their own matter to have any trace of voodoo. It is dead air like in the video. Darkness is dead light. Neon is the night advertising its dark side. It is a word announcing itself, neither verb nor noun; action or object. Our goal, like the burning bush is unconsumed by its own desire. Lust is endless. Neon is a sign.

The loop. The insomniac loop like Philip Guston's Painter rigid in bed ever-open eyeball. The loop is there in all his work, however ephemeral or concrete. It is as relentless as a jukebox full of country music:

'The only time I wish you weren't gone /
Is once a day, every day, all day long.'

Or as abrupt as a punchline:
What is brown and sticky? A stick.

GOING AROUND THE CORNER PIECE

RED RUM RED RUM RED
RUM RED RUM RED RUM

Round and round the corridors, a child's view of a dream or nightmare, the locked doors of empty rooms. The child's intuitive grasp of something momentous, something happening at or just beyond the limits of its child mind, behind locked doors. The little figures in the head in the Beano cartoon were a way of compartmentalising the conscious mind and the dream-work. Running the film backwards is a waste of precious time.

The work plays powerfully with play and playfully with playfulness. It finds the interstices, the synapses, the current leaping across the gap. It knows that values, meanings, weight and scale

exist in relation to their opposites: thesis and antithesis, love and death, the skull in the Nativity scene.

HANGMAN is a game for children. A race to meaning with the ultimate jeopardy and shame we discover in the post-asphyxiation erection. Executed by the state and exposed to the public. Sit down like a good boy or sit down to die. An eye for an eye forever.

VIOLENT INCIDENT. The logic of comedy is murderous. These are cruel toys. Cruel stories we are used to. We fear the end, but at least it is the end. There is space for a story in *Tom and Jerry*. But imagine a future unfolding in endless repetition, everything exactly as predicted. Itchy and Scratchy, the one in the other. Forever and ever. It is America staring down its other and finding what itself lacks. A poke in the eye with your own trigger finger. Abroad in the world is no place for a cowboy, a toy with a toy gun. The boy with the mutant toys next door. That is the imagination of Hieronymus Bosch. Make use of old Europe and learn the more creative elements of torture and their names. Rendering. That's me in the corner, losing my religion.

The Fall is godless and graceless. Gravity comes with an implacable formula – the momentum of falling bodies can be expressed as a number. At a given location on the earth and in the absence of air resistance, all objects fall with the same uniform acceleration. This acceleration is called the acceleration due to gravity and it is referred to commonly as g.

g = 9.8 m/s^2 (metric). Gravity exerts its pull everywhere. For human beings who walk and crawl and dance and rest, however graceful and awkward, it characterises our meetings with the ground. To deny gravity is to become disembodied, spectral, godlike, directing and starring, meddling with its power like the silent masters – Chaplin, Beckett and Keaton. Tramps and clowns, those stock figures that move us out of ourselves the better to examine our behaviour. And the ground threatens to rise up at any moment.

'Buzz Lightyear to Star Command.' This is the moment Buzz Lightyear realises he is not a superhero, he is just a toy. His existential moment as he flies, rather falls, is thrown through space. Martin Heidegger says we are thrown into existence. 'That's not flying: that's falling with style.'

Ludwig Wittgenstein characterises our compulsion to 'run against the boundaries of language. This running against the walls of our cage is perfectly, absolutely hopeless... What [any discourse on ethics] says does not add to our knowledge in any sense. But it is a document of a tendency of the human mind.' Metaphors are like clowns running at you with buckets of confetti. The slap to the back of the head is some clown manoeuvring a plank. Have some dignity. Oh God, here comes the clown with the bucket again.

DOUBLE STEEL CAGE PIECE. Just thinking about it is strangely liberating. Why is that? A cage within a cage is a double negative. Two wrongs don't make a right. Just as SOUTH AMERICAN TRIANGLE has the abuse of power implicit in the upturned chair and the historical memory of the triangular trade of slavery. These are the rules, but the rules are nonsense. It is a protection against

our own irrational desires, but at its heart it is empty. It is protection against ourselves, but that 'protection' is a useful fiction, a protection against the emptiness at the centre. By this double bluff, it reveals us to ourselves as hollow.

Guantanamo Bay. There is nothing to fear but fear itself.

We don't have answers, and we have the hostages to prove it.

To walk inside it is to be in No Man's Land, a space for no-one. It is the supreme work of nihilism.

What we cannot speak about, we must pass over in silence.

Famous last lines.

SHIT AND DIE SHIT AND LIVE

What is truth? asks Pontius Pilate.

Human and divine.

Particle and wave.

Opposite
Bruce Nauman, *MAPPING THE STUDIO II with color shift, flip, flop, & flip/flop (Fat Chance John Cage)*, 2001
7-screen video work
Installation view at Tate Modern, 2005–06

'Bruce Nauman diary'
Kept in 2006, recorded on a CD and played at DIA,
New York, 1 May 2006

Wallinger visited Tate Modern repeatedly over several days during 2006
spending extended periods of time in Bruce Nauman's 2001 seven-screen
video installation *MAPPING THE STUDIO II with color shift, flip, flop,
& flip/flop (Fat Chance John Cage)*, and kept a diary while he did so.

DAY 1. February 2, 2006, 11:00
actually the mice bring unwanted incidents to the strange and preg-
nant inversion of emptiness – the pixels seem to be moving around
the contours, both emphasising and losing substance
uncanny
Rothko
7 Screens
11:18 No-one stays – even for as long as it takes to cross
the room
The contours have shifted, one screen inverted...
Suddenly a new view appears
A boy stays, lingers, taking notes, i-pod
I think of nature-watch cameras trained on the swifts' nest in the
tower of the museum
The cat is alarming

DAY 2. February 3, 16:40
The cat's arse is looking at me upside down.
Bruce is about.
I instinctively look to the next screen as he moves out of shot
The images are constantly shifting like reflections that never settle
to stillness – perhaps there is a human instinct to bathe in such
reflection
Sometimes, as now the colour wash achieves some verisimilitude
as now when it approximates the buff colour of the removed lid and
crate marked fragile
Like spores or generating cells and yet never growing, the cease-
less activity within the image is disconcerting because it neither
grows nor lessens nor fixes on anything
I hear the cat again – is this the same as yesterday?

DAY 3. February 4, 13:50
I once shared a house with a friend who was a photographer
One day he installed a large refrigerator on the landing to store his
film stock.
At night the thing was either humming or not, my time was parcelled
out in the cycles and I always hoped I would sleep before the next
cycle.
I rarely did.
The cat is missing its tail.
The bird in the kitchen this morning brought with it everything from
outside

I cried out
The green screen next to the red screen has reached such an inten-
sity of colour that they have a relationship for about a minute
This even more of the case when two screens flip/flop. Then all
proportions seem calculated, canny.
It is like a bunker. It is not night it is describing
It is not necessary or healthy to be this vigilant
NASA/Home security
I wouldn't want a cat that vocal
They are going to close the London Planetarium
One view seems to have changed but it is only the colour fooling me,
I think

DAY 4. February 5, 11:40
There are double screen doors pictured in one image that I have
seen with one door and two doors open and I suspect that the
kitchen chair in the image with the bentwood armchair is also dif-
ferent at other times – Have also seen this back to front as well as
upside down.
The sound and sights are digital nerve endings willing to describe
everything
Ears and eyes open, never blinking unfaltering never disheartened
by the endless flow and flux of information
Always conscious, never unconscious
Unnerring
World without end
Completely unnecessary
Again I feel as if we are underground
Two men are cuddling on the bench in front of me
The teeming thousands pixels boil across the floors and walls
and chase around straight edges like soldier ants.
Like infinite unravelling of three dimensions into two
I don't know this space so I don't know this space so I don't know
how representative it is. That is not to say it is
Unrepresentative

DAY 5. February 6, 12:45

'Will it do it again?'

'What's it about?'

'Sir...'

Teenage schoolkids – two male teachers, one young, one grey-haired

It is a different chair, or else something has been placed on it that covers up to 2/3 of the struts up and down its back

The floor with fluorescent fittings and the two wax heads has flipped back to front

A studio is a conduit or it is a shrine. When the body has left the soul

My father left his body behind for disposal

Unreachable

The undiscovered country

This could be heaven or it could be hell.

A very loud silence

A seance with magic lanterns

The insubstantial here and now here and now and yet unrepeatable

A record of the past played out in to the future

Again and over and again

The boiling floor is skittish with static and the mice though undisturbed zip about magnetically tiny headlight eyes, and then every other point of light looks back

DAY 6. February 7, 11:10

Night with its terrors. The cat is spooky, but the artist's footsteps, the tread are sort of familiar – The weightier tread around the house when as a child in bed, awake.

Just what is light to an infra-red camera. The artist walks through with a flashlight

Hilda died. Strange how I thought of her at Lingfield in the cafe then Mum phones. I am at the station

The sound now is louder and fluctuating like a hundred thousand poplar leaves.

The chair that was empty now bears the weight of I know not

FRAGILE

PROJECT

The only words visible

There is a strange drawing with tape on the wall and at the bottom one looks down on what could be a foot in plaster. A dumb looking presence but a presence all the same.

Now the sound is falling like rain and allows the mind (finally) to wander beyond the screen door – to venture out of the open door into the corridor one has never been or close the eyes, acquiesce, relax, let it go. The wind blows a lower note and a gate squeaks.

These sounds are familiar

familial so we are not so afraid

DAY 6. February 7, 16:50

The chair is empty again

The cat on the windowsill turns its headlights towards the camera

The G-cramps and the scene with the stepladder is brightest and clearest with a green light.

I am in the surveillance truck in The Conversation.

The flipped chair bears objects again unfathomable

The swirling grey/green recalls Shelley Winters corpse seated in a Model T Ford submarine her hair becomes fronds

The Night of the Hunter

Miraculously a field mouse rushes to the centre of the image, stops and is struck upside down, then continues on his way

The lens, the camera is the light source like a flash exposure where space is condensed, the shadows shallow little halos that make a bas-relief that pixellate every quality of material

VCR porn

unrelieved

The punter

The unknown is it?

Or the untold

A Prisoner of Faith, the Imam was described – you could take that in two ways and they took him straight to prison

At night

DAY 7. February 8, 11:46

DOUBLE SILVER DISASTER

All is death now and Warhol. Why had it not connected before?

These are silkscreens, the colour and hue is even more arbitrary and the vision made particular or meant only by the awful duration

The two wax heads recall Mishima style suicide. How long does consciousness survive in the severed head?

The sound of the static the sound of an untuned radio between stations in the empty space is the remaining sound from the big bang still echoing across the universe. A long exposure, the shutter open forever all shadows running from this one point

The primitive game of appear and disappear that always amazes and amuses a child because a child cannot comprehend existences beyond its consciousness.

This space is absented by its author, we are scared kids

Are you looking for something?

Just what are you looking at?

RED STUDIO GREYBLUE STUDIO

BLUE STUDIO OCHRE STUDIO

GREY STUDIO UMBER STUDIO

GREYPURPLE STUDIO

STUDIO PORTRAIT

Raining static still confusion

DAY 8. February 9, 11:26

12 teenage schoolgirls black v-necks tartan pleated skirts.

Initiates

uninitiated

Each new visitor

The empty strutted chair flips and the leather cushioned chair has

been moved.

OMIGOD

The girls give the work serious attention

We are distributed over the 4 benches as on a boat trip

The jittery movement of the mice, tracing the edges of the floor is like the images themselves nerve endings the image crawling over itself consuming

unconsumed

Never to meet its object.

'You want to stay in here?'

'Yes,' a chorus

'I find the sound very difficult, disturbing, how about you?'

'What is the crime, is it murder?'

'Is it burglary, a break in?'

'Has it been deliberately messed up?'

There follows a discussion

Flies loop the loop

The discussion continues, mainly the teacher, who has done her homework

What does a camera do, left to its own devices?

Is it summer or winter? Could you see your breath, can it record vapour?

DAY 9. February 10, 10:10

WAIT UNTIL DARK

Is there a child part?

Undead unredeemed unholy

The sound of silence in the studio is an unholy row

There is enough of a draught for two threads to swing from the back of the bentwood armchair with shadows moving in tandem

NIGHT OF THE HUNTER!?

AMERICA – I have only made it halfway across

TO KILL A MOCKINGBIRD

TOM SAWYER HUCKLEBERRY FINN

The darkness brings back fear of the dark, which brings back childhood – a child looking at unaccountable adult things

MOON RIVER

MOCKINGBIRD-CAPOTE-MOON RIVER-MARK TWAIN

A rat sized (rat!) runs out from between the two wax heads

A shiver of repulsion

PANIC ROOM

I see again the creature running to the middle of the image which flips upside down but the creature continues right to left.

Black cat crossing my path

The brightest spots are surrounded by a penumbra, a halo of darkness similar to old b/w T.V. footage

My mother is now the last of her generation

This place is really getting me down today

DAY 10. February 13, 10:57

I see the artist in his cowboy boots and flashlight for the fourth

or fifth time

The bentwood chair is moved further into the shot so we no longer get a view of the seat of the armchair

I see the camera move right to left and back again (upside down) in the view of the screen door. Similarly the FRAGILE box is further into the frame

A dog barks

Try looking at nothing

Empty your thoughts

The depth the one eye of the camera infers is enough to give any arrangement in space a kind of order – perhaps with a moving camera fixed upon stillness that cannot be emulated in its reproduction

The trick of turning three dimensions into two – shifting garrulous portrayal of stillness

Again the chair in Sing Sing is somewhere in the pop and fizz.

In Florida the inmates themselves built Old Sparky

Particle and wave

FRAGILE is now spelt back to front and upside down

The reflecting chorus

Turning to the radio just as the minutes silence begins you think

MARCONI – WOW

DAY 11. February 15, 13:12

Missed Hilda's funeral. Abcess has swollen my face grotesquely and in a delirium of pain and panic about taking too many over the counter pain killers made myself throw up

This piece is less DOUBLE SILVER DISASTER, more BAADER MEINHOF – the facts of the matter like all things from the past infinitely strange, constantly familiar

Literally a dark place – How can this be the work?

'This is weird,' small boy

Has happened, about to happen

Four benches in the space, we are obliged by the context to give the work a different kind of attention. We wait for something to happen or console ourselves with nothing

THE DARK SIDE OF THE MOON

Michael Collins was the most isolated human being in human history passing behind the moon, alone in the return module

Incorporeal my relatives

Stop frame animation we jump from freeze frame to freeze frame

The artist's footsteps,

Like the Farmer in Peter the Rabbit

MAPPING THE STUDIO – there is a radar quality the studio as unfixed as the sky before any rules were established and coordinates found

DAY 12. February 16, 12:23

Sound is reproducible but its reception is irreducible, unmediated but its reception is

actual, real

Images are never real

The hiss one suspects is the effect of whacking the mics way up, but its sound is then immediate and un mediated

'The thing is, would it work without the sound?' – a girl of 10 or eleven, twelve says

'Something went across there like a lizard,' a woman with friend and children

The stop/start animated effect of the rendering makes the movement of the mice lizard like

I move from A to B then from B to C, then D like so,

The tank in the zoo marked human. It is night and the voyeurs having paid their money are eager for some action

No one speaks

The cat miaows

The dog barks – the man with the flashlight says nothing

FRAGILE and PROJECT are the only remains of readable language

'Behind the chair'

'There, on the blue one'

MAPPING THE STUDIO

'Ooh it scampered all along the back wall.'

'The other way up.'

DAY 13. February 18, 11:35

Had the piece of glass that was left in my hand after the accident of 4 Nov removed at St Thomas's.

The radiologist called me over to show me the digital x-rays

He couldn't remember seeing glass so clearly and he had done 'Hundreds of thousands of x-rays'

The doctor's incision I felt and he left the room to find more anaesthetic.

IN COLD BLOOD

The type of incision you might make in a lamb joint before pushing in a sprig of rosemary

The cat and the mice being ghosts are as we see them and possibly dead or more precisely the undead which is the condition of the recorded/moving image

Moving but unchanging

Truthful but illusory

The cat aswell as the walls has to be remade every fraction of every second

Exhausting, inexhaustible

Wave and particle

The whistle and hiss are today nothing more than the equipment pushed past the limit until a dog barks again but now this is a sound affect. I am tetchy and bored

the cat the cat the cat

the cat the cat the cat

the cat the cat the cat

DAY 14. February 20, 11:27

Shelley Winters. Last night the BAFTA film awards cut together

clips of film stars that had died in the previous year. Shelley was swimming underwater in the Poseidon Adventure as though alive and escaped from the Model T Ford at the bottom of the lake, but still subterranean.

The only cartoon strip that appealed to me as a child had tiny people inside the head of the central character assigned to different sensory and cognitive roles and functions.

I meet Sigmund Freud at a cocktail party. 'It's funny,' I say, 'I never remember my dreams'

The Nightwatch

Nocturne

The Sorcerer's Apprentice

A Séance.

Suicide watch

Surveillance

Unfathomable

Lacking gravity or presence

every object and its relation

to every other object

The same rainbow's end

Up around the bend

Shadows that have no substance

Light that has no object

Life is ebbing away, ebbing away

Clinging on clinging on

Explain to Friday, what can we build here to protect us, what signal could would we send out from here

DAY 15. February 21, 11:00

There are more CCTV cameras per capita in the UK than any other country.

An insect streaks across the screen like the land speed record across the desert. The flattest part of the desert.

Why do flies find corners in empty space?

Is that the wind or tape hiss?

It is evocative nevertheless

Another fly trails a series of pearls adumbrating the limits of its digital representation

Would the ever mutating colours find their aural equivalent with a pitch shifter?

Schoolchildren still behave like friends. Sit close together and move wordlessly on.

Nothing happens

Something happened

Depends on your point of view

It is an ON/OFF button

When we have nothing more to say, we say, the fact of the matter is

At the end of the day

All things considered

In the final analysis

When all is said and done

The giant's footsteps are heard again, the cat's miaow and the hiss is the wind through poplars. The giant is not in his nightgown
The schoolgirl smiles delightedly
 delightfully

DAY 16. February 22, 11:43
ELIGARF
'Ssshhh'
'Ssshhh'
Shut up
A man lies back in abandon to see the screens that are upside down.
I haven't done this
I now see FRAGILE and a W in the screen with the sink and the paint or plaster flecked bowl.
The idea of gravity as your own reflected self conjoined in magnetism, each footfall met on the surface of the earth each effort ballasted and rhymed by the Laws. In repose the body returns to the landscape, in motion an astronaut, the lunar bounce not visible to the naked eye.
Chairs are miracles of poise harnessing and modifying and elevating man into ritual positions poses
Who leaves the earth the longest? Is it the long jumper or the high jumper?
There are known knowns and known unknowns
Rumsfeld has the best definition of the uncanny
Nothing to fear but fear itself
another American politician defining the unrestricted play of the unconscious
This is a work of art and so one experiences it as such. If Armstrong continues to land on the moon he takes only the one step. It is not part of an edition.
But this is still a reproduction, a recording – it asks us at every instant to experience then as now or to have our own experience of its past. No-one is going to say it never happened. [The big plaster foot has gone]
We can feel weight with our eyes. Top light and shadow and density and volume we take in without thinking twice
Upside down all bets are off
A man running on the moon
Did Buster Keaton live to see the day?

DAY 17. February 23, 12:35
It is not public, nor is it private. Work has been accomplished here and we infer will be made in the future. This was 2001 and he is still a practising artist
So we presume that thoughts were thought and things were made. The law of averages is on our side: On this, my 20th visit to the work I find the four benches ranged diagonally in the middle of the space. I presume they haven't moved collectively or individually, or that or near identical bench has not exchanged places with another…

How many screens asked the policeman, as a single woman makes a similar excursion across the space.
It is too late for them. Too late to start reading a different newspaper
Learning the piano or another language.
Whereas a group of boys watching…
One catches a glimpse
Did you see the mouse?
This instils a new vigilance in some, in others confirms that nothing more spectacular will ensue
Peter Pan and Tinkerbell
The one had no shadow and the other was represented by a moonbeam a flashlight
In corporeal

DAY 18. February 24, 10:13
There's a ghost in my house
R. Dean Taylor only white man to have a hit at Motown
The pale green is the most luminous of hues – the two filing cabinets in the corridor are clearer than at any previous point. A mouse fearlessly essays a couple of circles.
If you tuned into the radio what would you hear in New Mexico at 4 in the morning? Someone can't sleep and the vast blackness reflecting back from the kitchen window.
Everything plumbed in miles from any visible water source.
All those artists who went south for the light who either went mad or drove others crazy as if they were bloody moths flying at the sun. Someone with a steady eye for profit locks them in long enough to build a myth. Basquiat in the basement.
The Romans found a way to cast concrete underwater. This bunker is filled with something denser that air
It is like falling asleep and then catching oneself on the brink. Dreaming the dream of the artist, slightly nauseous with the hiss and crackle, nothing settling down to its proper shape or form. Down in the crypt of Milan Cathedral there in the holy rooms, then through a door to the caretaker, the lockers, the sink
upstairs that would be a font
and the lockers secure some pieces of the true cross next to St Bartholomew standing with his flayed skin tossed insouciantly over his left shoulder.
Do you go upstairs or downstairs for your inspiration. Earth and Air, You can see how belief systems develop.
Then the world turns upside down then back to front, so each location is reproduced in four different ways, In three we can determine the correct image by the writing on the bow or on the wall.
Because the pixels cannot fix on detail the floors are as flat to the wall as Matisse's Red Studio.

The Russian Linesman: Frontiers, Borders and Thresholds
The Hayward Gallery, 2009

Wallinger was invited to curate a show for Hayward Touring Exhibitions
and to create a book to accompany it. *The Russian Linesman* is the
result – more an artist's book than a catalogue.

The cranes are still poised above Famagusta. A small sandy beach
runs up to the fence, the barbed wire and the Turkish security post.
A bored soldier waits to see how near we might come. The beach is
deserted, apart from a couple of teak-coloured English pensioners.
These mercenary retirees are big business on the North Coast of
Cyprus. Homes stolen from their missing Greek owners are sold by
a range of implausibly English sounding goons: Bentley, Churchill,
Henry Charles Estates, Cherie Blair, you name them. Not dissimilar
in a way to our original tawdry bargain with Turkey over safe passage
to the Suez Canal. It was the Greeks that chased us out of here.[37]

Cross the Green Line and you tacitly acknowledge Turkish
authority, which is still too much for many Greek Cypriots. Then
you walk past the ubiquitous white painted oil cans with the UN
letters, past the Ledra Palace Hotel and back in time to Turkish-
occupied Nicosia. Kids play in the streets and the cars date back to
the early 70s (lots of Renault 4s). The clothes are cheap and tacky,
and the covered food market is dilapidated.

Two minarets now top the twin towers of what was an Orthodox
Cathedral. Inside Moorish lattice work covers the windows. On the
floor there is a myriad of carpets which ignore the orientation of the
Church, being fixed on the diagonal towards Mecca. Everything else
crafted over the centuries is extraneous, immaterial.

Linda Herzog, *Lake Van*, Turkey, 2006

54

55

UN-

13. UN-

There is cruelty in Muybridge. When you examine the photos carefully you see that the grid before which a whole frieze of human presence and absence is played out is in fact like the peripheral fence at the end of a camp. The past is refracted through a future it could not fathom. Who sanctioned these actions? How were they persuaded or coerced into such un-human, inhumane activity?

The grid is a photographic negative of the Alberti screen which, since 1435, has served artists in their painstaking quest for verisimilitude in translating three dimensions into two. Muybridge's measure of time has become reified as the conquest of modular space – the grid, a key part of capitalism: from the one point perspective of the church and crown land to real estate, where the sky's the limit.

In the Green Zone you see the United Nations initials, black on white painted oil-cans. After a while I found I had started reading UN as UN-

The hyphen acts like a soothing balm to our sinful nature. Even if it never solved anything, even if redemption is a hangover from faith, we couldn't give it up.

What has been done cannot be un-done.

Pages from Mark Wallinger's essay
'Awake in the Nightmare of History'
in *The Russian Linesman*
Opposite 'Cyprus 2006'
Above 'UN-'
Overleaf 'In An Ideal World'

Albrecht Dürer, *Illustration to the Work on Measurement,
Showing an Interior* [Man Drawing a Lute], 1525

15. In An Ideal World

Why is the illusion of three dimensions so restful? Perhaps the modernist grid and the flat screen which we attend to each day mean that this extraordinary function of the mind's eye stimulates the full extent of our powers and gives us the magic of a shared hallucination. Perhaps it is the fact that we can conduct our own tour of this phenomenon. Ordinarily, sight is a thing of sheer presence: seeking, reacting, looking, staring, concentrated, oblivious. The stillness it describes is not the restless way we would interrogate a moment. The eye can only focus on one thing at time.

At a recent demonstration of 3-D imagery, at the very theatre where the Lumière Brothers first screened their films in London, David Burder takes us through a range of imagery. The audience is equipped with Polarising spectacles.

Twin carousel projectors give us the image of a peacock. We reach inside the frame and register its iridescent turquoise plumage, a function of our marvellous stereoscopy. The head-on image of Concorde has the nose projecting towards each spectator in turn, its degree of projection into the room governed by the distance of the viewer from the screen.

AWAKE IN THE NIGHTMARE OF HISTORY

Anon, *The Queen visits her people in Nigeria II,
Her Majesty at Itu Leper Colony,* [stereoscopic
photograph – left and right eye] 1956

116

IN AN IDEAL WORLD

A rainbow's end can never be reached because the rainbow is inside us. Everyone has their own rainbow; the angle of incidence of the prismatic spectrum as it is projected on to the retina is apprehended alone. It will have a different end for everyone, and only then if we recognise its existence.

At the optician's there is no one else to consult. It is for you to make a judgement of your own senses.

On our foundation course, we decamped to a large country house where we were given a crash course in perception, with lectures, activities, competing teams and a tour de force from Fred Schick, who gave a two hour disquisition covering everything from rods and cones to colour theory and making a heroic comedy of Brunelleschi's one point perspective depiction of the Baptistery from the front gate of the unfinished cathedral in Florence. The painted panel was constructed with a hole at the vanishing point. It was observed from the unpainted side and the reflection of the image was viewed in a mirror through the hole, giving the illusion of depth.[57]

In this new republic the one-eyed man is king.[58]

117

CHRONOLOGY

1959	Born in Chigwell, Essex
1977–78	Loughton College
1978–81	Chelsea School of Art, London
1983–85	MA Course, Goldsmith's College, London
1998	Henry Moore Fellowship, British School at Rome
2001–02	DAAD Artists Programme, Berlin
2002	Awarded Honorary Fellowship, London Institute
2003	Awarded Honorary Doctorate, University of Central England
2007	Awarded Turner Prize
2009	Awarded Honorary Fellowship, Goldsmiths, University of London

Lives and works in London

PUBLIC COLLECTIONS

All collections are in the UK unless otherwise stated.

ARCO Foundation at Centro Galego de Arte Contemporánea CGAC, Santiago de Compostela, Spain
Arts Council Collection, Hayward Gallery, London
British Council Collection, London
CAM Calouste Gulbenkian Collection, Lisbon, Portugal
Denver Art Museum, Colorado, USA
Duomo di Milano, Provincia di Milano, Italy
Emanuel Hoffman-Stiftung, Basel, deposited in the Öffentlichen Kunstsammlung, Basel, Switzerland
Ferens Art Gallery, Hull City Museums & Art Galleries, Kingston-upon-Hull
FRAC Nord-Pas de Calais, Dunkirk, France
Government Art Collection, London
Hocciccho LandœBank, Frankfurt, Germany
The Israel Museum, Jerusalem, Israel
Leeds City Art Gallery
Magdalen College, Oxford
Museum Ludwig, Cologne, Germany
Museum für Gegenwartskunst, Basel, Switzerland
Museum of Modern Art, New York, USA
Nasjonalmuseet for kunst, arkitektur og design, Oslo, Norway
Southampton City Art Gallery
The Speed Art Museum, Louisville, Kentucky, USA
Stoke on Trent Museums
Tate Collection, London
ZKM Museum of Contemporary Art, Karlsruhe, Germany

PUBLIC COMMISSIONS

1999	*Ecce Homo*, the Fourth Plinth, Trafalgar Square, London
2007	*Zone*, for Skulptur Projekte Münster, Germany
2008	*Folk Stones*, for the Folkestone Triennial, Kent
2009	Y, Magdalen College, Oxford
2009	*The White Horse* (winning proposal), Ebbsfleet Landmark Project, Kent
2010	*Sinema Amnesia*, My City project, Çanakkale, Turkey

EXHIBITIONS

All exhibition venues are in the UK unless otherwise stated.
Dates refer to the year in which each exhibition started.

Solo Exhibitions

1983	The Minories Art Gallery, Colchester
1986	'Hearts of Oak', Anthony Reynolds Gallery, London
1987	'Mark Wallinger: Recent Paintings', The Serpentine, London
1988	'Burgess Park', Nottingham Castle Museum
	'Passport Control', Riverside Studios, London
	Anthony Reynolds Gallery, London
1990	'School', Galerie Sophia Ungers, Cologne, Germany
	'Stranger²', Anthony Reynolds Gallery, London
1991	'Capital', Institute of Contemporary Art, London, touring to Manchester City Art Gallery
	Daniel Newburg Gallery, New York, USA
	'Capital', Grey Art Gallery, New York University, New York, USA
1992	'Fountain', Anthony Reynolds Gallery, London
1993	Daniel Newburg Gallery, New York, USA
1994	'The Full English', Anthony Reynolds Gallery, London
	Deweer Art Gallery, Otegem, Belgium
1995	Serpentine Gallery, London; Ikon Gallery, Birmingham
1997	'God', Anthony Reynolds Gallery, London
	'The Importance of Being Earnest in Esperanto', Jiri Svestka Gallery, Prague, Czech Republic
	'Dead Man's Handle', Canary Wharf Window Gallery, London
	Dolly Fiterman Fine Arts, Minneapolis, Minnesota, USA
1998	'The Four Corners of the Earth', Delfina, London
1999	'Mark Wallinger is Innocent', Palais des Beaux-Arts, Brussels, Belgium
	'Prometheus', Portikus, Frankfurt, Germany
	'Ecce Homo', the Fourth Plinth, Trafalgar Square, London
	'Lost Horizon', Museum für Gegenwartskunst, Basel, Switzerland
2000	'Threshold to the Kingdom', The British School at Rome, Italy
	Galeria Laura Pecci, Milan, Italy
	'Ecce Homo', Secession, Vienna, Austria
	'Credo', Tate, Liverpool
2001	'Cave', Milton Keynes Gallery; Southampton City Art Gallery
	'Time And Relative Dimensions In Space', Oxford University Museum of Natural History
	British Pavilion, 49th Venice Biennale, Italy
	'No Man's Land', Whitechapel Gallery, London
	Anna Schwartz Gallery, Melbourne, Autralia
2002	'Mark Wallinger: Ecce Homo', Glynn Vivian Art Gallery, Swansea
	'Promised Land', Tensta Konsthall, Spanga, Sweden
	'Forever and Ever', commission for Bloomberg SPACE, London
	'Mark Wallinger – Seeing Things', Minoriten-Galerien im Priesterseminar, Graz, Austria
	'Cave', Millenium Forum, Derry
2003	'Spacetime', Carlier Gebauer, Berlin, Germany
	'Via Dolorosa', Städtische Galerie im Lenbachhaus, Munich, Germany
	'The Sleep of Reason', The Wolfsonian – Florida International University, Miami Beach, USA
	'Populus Tremula', Tate Britain, London
2004	Anthony Reynolds Gallery, London
	'The Underworld', Laing Art Gallery, Newcastle
	'Presence 4: Mark Wallinger', Speed Art Museum, Louisville, Kentucky, USA
	'The Underworld', Carlier Gebauer, Berlin, Germany
	'Sleeper', Neue Nationalgalerie, Berlin, Germany
2005	'Easter', Hangar Bicocca, Milan, Italy
	'Via Dolorosa', permanent video installation, Milan Cathedral, Italy
	'W-E', Galerie Krinzinger, Vienna, Austria
2006	Museo de Arte Carillo Gil, Mexico City; touring: Museo de Arte Contemporáneo (MAC), Santiago, Chile
	'Threshold to the Kingdom', Convent of St Agnes of Bohemia, National Gallery, Prague, Czech Republic
	'The End / A ist für Alles', Anthony Reynolds Gallery, London

2007	'State Britain', Tate Britain, London
	'The End', Carlier Gebauer, Berlin, Germany
	'Mark Wallinger', Kunstverein Braunschweig, Germany
	'The Human Figure in Motion', Donald Young Gallery, Chicago, Illinois, USA
2008	'State Britain', MAC/VAL, Vitry-sur-Seine, France
	'Billboard for Edinburgh', Ingleby Gallery, Edinburgh
	Aargauer Kunsthaus, Aarau, Switzerland
2010	Kunstnernes Hus, Oslo, Norway
	Carlier Gebauer, Berlin, Germany
	Anthony Reynolds Gallery, London
2011	De Pont Museum of Contemporary Art, Tilburg, the Netherlands

Selected Group Exhibitions

1981	'New Contemporaries', Institute of Contemporary Art, London
1982	'Space Invaders', Colchester Art Centre
1984	'Whitechapel Open', Whitechapel Art Gallery, London
1985	'New Art', Anthony Reynolds Gallery, London
	'Prelude', Kettle's Yard, Cambridge
1986	'Canvass: New British Painting', John Hansard Gallery, University of Southampton and the Exhibition Gallery, Milton Keynes
	'Unheard Music', City Museum and Art Gallery, Stoke-on-Trent
	'New Art 2', Anthony Reynolds Gallery, London
	'Neo Neo-Classicism', Edith C. Blum Art Institute, Bard College, Annandale-on-Hudson, New York, USA
1987	'Stuart Brisley, Ken Currie, Glenys Johnson, Mark Wallinger', Serpentine Gallery, London
	'Appropriate Pictures', Anthony Reynolds Gallery, London
	'State of the Nation', Herbert Art Gallery and Museum, Coventry
	'Palaces of Culture: The Great Museum Exhibition', City Museum and Art Gallery, Stoke-on-Trent
1988	'Cries and Whispers, Paintings of the Eighties in the British Council Collection', touring Australia
	'Sculptures', Koury Wingate Gallery, New York, USA
	'Something Solid', Cornerhouse, Manchester
	'Object and Image: Aspects of British Art in the 1980s', City Museum and Art Gallery, Stoke-on-Trent
	'The New British Painting', Contemporary Arts Center, Cincinnati, Ohio, USA, and touring
1989	'Territories', Chisenhale Gallery, London
	'Einleuchten: Will, Vorstel und Simul in HH', Deichtorhallen, Hamburg, Germany
	'Excommunication: Some Notions on Marginality', Grey Art Gallery, New York University, USA
	Anthony Reynolds Gallery, London
	'Über Unterwanderung', Galerie Sophia Ungers, Cologne, Germany
1990	'The Köln Show', Cologne, Germany
	'Australian Sculpture Triennial', National Gallery of Victoria, Melbourne, Australia
1991	'Kunstlandschaft Europa,' Kunstverein Karlsruhe, Germany
	'Confrontaciones', Palacio de Velásquez, Madrid, Spain
1992	'Whitechapel Open', Clove Building, London
	'Let Me Look', San Miniato, Italy
1993	'Young British Artists II', Saatchi Collection, London
	'Spit in the Ocean', Anthony Reynolds Gallery, London
	'You've Seen the Rest, Now Try the Best', City Racing, London
	'Mandy loves Declan 100%', Mark Boote Gallery, New York, USA
	'Maurizio Cattelan, Colette Hyvard, Mark Wallinger', MA Galerie, Paris, France
	'Junge Britische Kunst', Art Cologne, Germany
1994	'Jet Lag', Galerie Martina Detterer, Frankfurt, Germany
	'Every Now and Then', Rear Window, Richard Salmon, London
	'Not Self-Portrait', Karsten Schubert Gallery, London
	'Five British Artists', Galleri Andréhn-Schiptjenko, Stockholm, Sweden
	'Here and Now', Serpentine Gallery, London
	'Untitled Streamer Eddy Monkey Full Stop Etcetera', Anthony Reynolds Gallery, London
	'Art Boutique', Laure Genillard Gallery, London
	'Seeing the Unseen', nvisible Museum, Thirty Shepherdess Walk, London
	'Idea Europa', Palazzo Publico, Siena, Italy

1995
'A Painting Show', Deweer Art Gallery, Otegem, Belgium
'Art Unlimited', Arts Council touring show
'The Art Casino', Barbican Art Gallery, London
'John Moores Exhibition 19', Walker Art Gallery, Liverpool
'The British Art Show', Manchester and touring
'The Turner Prize', Tate, London

1996
Rhona Hoffman Gallery, Chicago, Illinois, USA
Anthony Reynolds Gallery, London
'Offside!', Manchester City Art Galleries
'10th Biennale of Sydney', Australia

1997
'Animal', Centre for Contemporary Arts, Glasgow
'Pledge Allegiance to a Flag?' London Printworks Trust
'Pictura Britannica', touring exhibition: Museum of Contemporary
 Art, Sydney; Art Gallery of South Australia, Adelaide; Te Papa,
 Wellington, New Zealand
'Dimensions Variable: Works from the British Council Collection',
 touring exhibition, Helsinki City Art Museum, Finland, and tour
 to Stockholm, Sweden; Kiev, Ukraine; Warsaw, Poland; Chemnitz,
 Germany; Darmstadt, Germany; Prague, Czech Republic;
 Bratislava, Slovakia; Zagreb, Croatia; Vilnius, Lithuania; Budapest,
 Hungary; Bucharest, Romania
'Sensation', Royal Academy of Arts, London; Hamburger Banhof,
 Berlin, Germany
'5th Istanbul Biennale', Turkey
'2nd Johannesburg Biennale', South Africa
'P..er.sonal...Absurdities', Galerie Gebauer, Berlin, Germany
'Treasure Island', Centro de Arte Moderna José de Azeredo Perdigâo
 Lisbon, Portugal
'Between the Devil and The Deep Blue Sea', Beaconsfield Gallery,
 London

1998
'Wounds', Moderna Museet, Stockholm, Sweden
'Dissin' the Real', Lombard-Fried Gallery, New York, USA; Galerie
 Ursula Krinzinger, Vienna, Austria
'Feeringbury VIII – Cultivated', Feeringbury Manor, Essex
'Drawing Itself', The London Institute
'Heatwave', touring exhibition, The Waiting Room, Wolverhampton;
 Electricity Showrooms, London
'Made in London', Museu de Electricidade, Lisbon, Portugal
Anthony Reynolds Gallery, London
'UK Maximum Diversity', Benger Areal, Bregenz, Austria
'Book', Djanogly Art Gallery, Nottingham
'1st Biennale de Montréal', Canada
'Il Passato nel Presente', The Tannery, London
'Shunted', Sheffield
'Contemporary British Artists', Denver Art Museum,
 Colorado, USA

1999
'L'Art et l'Ecrit', Espace Sculfort, Maubeuge, France
'Fourth Wall', National Theatre, London, curated by Public Art
 Development Trust (PADT)
'Il Passato nel Presente', Maze Art Gallery, Turin, Italy
'Il luogo degli angeli', San Michele and Museo Laboratorio d'Arte
 Contemporanea, San Angelo, Italy, and touring
'Changement d'air', Musée d'art moderne Lille Métropole,
 Villeneuve d'Ascq, France
'Officina Europa', Villa delle Rose, Galleria d'Arte Moderna, Bologna,
 Italy, and touring
'Art Focus 1999, the Sultan's Pool', Israel Festival, Jerusalem
'Sublime, The Darkness and the Light', touring exhibition, Wolsey Art
 Gallery, Ipswich; Laing Art Gallery, Newcastle; The Potteries
 Museum and Art Gallery, Stoke-on-Trent; Angel Row Gallery,
 Nottingham; Storey Gallery, Lancaster; Atkinson Gallery,
 Street; John Hansard Gallery, University of Southampton

2000
'Vision Machine', Musée des Beaux-Arts, Nantes, France
'On the Frac Track (Text as Image)', Touring Kent: Sevenoaks Library
 Gallery; Maidstone Museum & Bentlif Art Gallery; Rochester Art
 Gallery; Maidstone Library Gallery; The Royal Museum & Art
 Gallery, Canterbury; Sassoon Gallery, Folkestone
'Seeing Salvation', National Gallery, London
'Ghosts', Delta Axis, Memphis, Tennessee, USA

2001
'City Racing 1988-1998: A Partial Account', Institute of
 Contemporary Art, London (curated by Mathew Higgs)
'Heads and Hands – Washington Project for the Arts (WPA)
 at Decatur House Museum', Washington, DC, USA

'Century City: Art and Culture in the Modern Metropolis',
 Tate Modern, London
'Looking at You - Kunst Provokation Unterhaltung Video',
 Kunsthalle Fridericianum, Kassel, Germany
'Purloined', The Studio Museum in Harlem, New York, USA
'Project: Film and Video', Cheltenham Pump Room,
 Cheltenham

2002
'Sidewinder', Centre of International Modern Art (CIMA), Kolkata;
 The India Habitat Centre, New Delhi; Prince of Wales Museum,
 Mumbai, India
'Painting as a Foreign Language', Edifício Cultura Inglesa
 and Centro Brasileiro Britânico, Sao Paulo, Brazil
'Con Art: Magic / Object / Action', Site Gallery, Sheffield
 and tour to Glynn Vivian Gallery, Swansea
'Family', Aldrich Contemporary Art Museum, Ridgefield,
 Connecticut, USA
'THE GAP SHOW – Young Critical Art from Great Britain', Museum
 Ostwall, Dortmund
'Faux/Real', Borusan Art and Culture Centre, Istanbul, Turkey
'Location: UK', Gimpel Fils Gallery, London
'The Anatomy of the Horse – Mark Wallinger and George Stubbs',
 Harewood House, Leeds
'Ommegang-Circumflexion', Bruges, Belgium
'Blow up your TV', York City Art Gallery, York
'Les Enfants du Paradis', Galerie Yvon Lambert, Paris, France
'Sphere – An Exhibition of Contemporary Art', Sir John Soane's
 Museum, London
'In Light', Art Gallery of Ontario, Toronto, Canada
'Real Life', Tate St Ives
'Mensaje de Texto', Galeria Helga de Alvear, Madrid, Spain

2003
'Someone to Watch Over Me', Smart Project Space, Amsterdam,
 the Netherlands
'Body Matters', The National Museum of Contemporary Art, Oslo,
 Norway
'Thatcher', The Blue Gallery, London
'Micro/Macro – British Art 1996–2002', Kunsthalle Mucsarnok,
 Budapest, Hungary
'Sanctuary', Gallery of Modern Art, Glasgow
'Rituals', Berlin Academy of Arts, Berlin, Germany
'Horse', The Study Gallery, Poole, Dorset
'Nation', Frankfurter Kunstverein, Frankfurt, Germany
'Warum! Ebenbild – Abbild – Selbstbild', Martin Gropius Bau,
 Berlin, Germany
'Independence', South London Gallery, London
'A Bigger Splash: British Art from Tate 1960–2003', Pavilhão Lucas
 Nogueira Garcez, Sao Pãulo, Brazil
'Round Table', MOT, London
'Contemporary Art in the Traditional Museum', Russian Museum,
 St Petersburg, Russia
'La Vista y La Visión', Institut Valencià d'Art Modern, Spain

2004
'Between Above and Below', Bard Center for Curatorial Studies,
 Bard College, Annandale-on Hudson, New York, USA
'Pause', Milan Cathedral, Italy
'The Human Condition. The Image of Man in Art', Museu d'Historia
 de la Ciutate de Barcelona (MHCB), Spain
'Presence – Images of Christ for the Third Millennium', Lincoln
 Cathedral and the Usher Gallery
'Things Domestic (selected work from the Arts Council Collection)',
 Towner Art Gallery, Eastbourne
'On Side', Centro de Artes Visuais, Coimbra, Portugal
'Gifted', The Arts Gallery, University of the Arts, London
'De Leur Temps', Collections Privées Françaises, Musée des Beaux-
 Arts de Tourcoing, France
'About Painting', Tang Museum, Saratoga Springs, New York, USA
'Contested Fields', Des Moines Art Center, Iowa, USA
'Il colore della vita – omaggio a Piero Siena', Castel Mareccio,
 Museion, Bolzano, Italy
'Art Focus 4', International Biennial of Contemporary Art, Jerusalem,
 Israel

2005
'OUTPOST', Stephen D. Paine Gallery, Massachusetts College of Art,
 Boston, USA
'Critics Choice', FACT, Liverpool
'The World is a Stage', Mori Art Museum, Tokyo

'The Fifth Gospel', Likovni Salon, Celje, Slovenia
'Monuments for the USA', CCA Wattis Institute for Contemporary Art, San Francisco, California, USA
'Chronos', Centro Sperimentale per le Arti Contemporanee, Caraglio, Cuneo, Italy
'London Calling', Galleri Kaare Berntsen, Oslo, Norway
'The Experience of Art', Italian Pavilion, Venice Biennale, Italy
'Miradas y Conceptos', MEIAC, Badajoz, Spain
'When Humour Becomes Painful, Migros Museum für Gegenwartskunst, Zurich, Switzerland
'Rundlederwelten', Martin Gropius Bau, Berlin, Germany
'Variety', De La Warr Pavilion, Bexhill-on-Sea

2006
'Responding to Rome 1995–2005', Estorick Collection, London
'Crivelli's Nail', Chapter Gallery, Cardiff
'New Mystics', Instituto Cabrera Piuto, La Laguna, Tenerife, Canary Islands, Spain
'Mark Wallinger, Une vision du monde: La Collection vidéo d' Isabelle and Jean-Conrad Lemaître', La Maison Rouge, Paris, France
'Human Game', Stazione Leopolda, Florence, Italy
'Emanuel Hoffman Foundation: Group Works and Installations', Museum für Gegenwartskunst, Basel
'Eretica: L'Arte contemporanea dalla trandescenza al profane', Palazzo di Sant' Anna, Palermo, Italy
'The Calouste Gulbenkian Foundation and British Art', Tate Britain, London
'How to Improve the World', Hayward Gallery, London
'Choosing my Religion', Kunstmuseum Thun, Switzerland
'Wandering Stars', Gana Art Center, Seoul, Korea
'Protections', Kunsthaus Graz at the Landesmuseum Joanneu, Austria
'The Line of Enquiry', Kettle's Yard, Cambridge
'Out of Place', New Art Gallery, Walsall
'Belief', Singapore Biennale
'Darkness, Visible', Ferens Art Gallery, Hull, and touring
'Aftershock – Contemporary British Art 1990–2006', China Art Gallery, Beijing. touring: Guandong Museum of Art; Shanghai Art Museum; The Three Gorges Museum, Chongqing, China
'You'll Never Know: Drawing and Random Interference', touring exhibition, The New Art Gallery, Walsall, Tullie House Museum and Art Gallery, Carlisle, The Lowry, Salford, Glyn Vivian Gallery, Swansea; Harris Museum and Art Gallery, Preston

2007
'Scary Movie', Adelaide Film Festival, Contemporary Art Centre of Australia
'Lights, Camera, Action', Whitney Museum of American Art, New York, USA
'Schmerz', Nationalgalerie im Hamburger Bahnhof, Berlin, Germany
'Darkness, Visible', Southampton City Gallery and touring
'Timer 01 Intimita/Intimacy', Milan Triennale, Italy
'Dark Mirror', Netherlands Media Art Institute, Montevideo, Amsterdam, the Netherlands
'Skulptur Projekte 07', Münster, Germany
Centre Pompidou, Paris, France
'The Turner Prize', Tate Liverpool
'Dateline Israel: New Photography and Video Art', The Jewish Museum, New York, USA
'Stardust ou la dernière frontière', Musée d'Art Contemporain du Val-de-Marne (MAC/VAL), Vitry-sur-Seine, France

2008
'On Time: The East Wing Collection VIII', The Courtauld Institute of Art, London
'History in the Making: A Retrospective of the Turner Prize', Mori Art Museum, Tokyo
'Collection Videos and Films; Isabelle and Jean-Conrad Lemaître', Kunsthalle zu Kiel, Germany
'Revolutions: Selected Works from the Collection of Isabelle and Jean-Conrad Lemaître', University Art Gallery, University of California at San Diego, USA
'Comme des Bêtes', Musée cantonal des Beaux-Arts, Lausanne, Switzerland
'Space Now!', Space Studios, London
'Selected Works by Gallery Artists', Anthony Reynolds Gallery, London
'Tales of Time and Space', Folkestone Triennial

2009
'Angel Dust', MMK Museum für Moderne Kunst, Frankfurt am Main, Germany
'5 Sculptures', Anthony Reynolds Gallery, London
'Contemporary Video Art', Pennsylvania Academy of the Fine Arts, Philadelphia, USA
'Inappropriate Covers', David Winton Bell Gallery, Brown University, Providence, Rhode Island, USA
'PLOT09 This World and Nearer Ones', Governors Island, New York, USA
'Get Your Juicy Plums Here!' Omni Color and K2 Screen, London
'Passports', British Council Collection, PAC (Padiglione d'Arte Contemporanea), Milan
'Heaven, 2nd Athens Biennial', Athens, Greece
'Only The Lonely,' Anthony Reynolds Gallery, London
'British Subjects 1948–2000', Neuberger Museum of Art, New York, USA
'The British Pavilion at the Venice Biennale', Whitechapel Gallery, London

2010
'Face History', Anthony Reynolds Gallery, London
'Dopplereffekt Bilder in Kunst und Wissenschaft', Kunsthalle zu Kiel, Germany
'CUE: Artists' Videos', Vancouver Art Gallery, Canada
'The Beauty of Distance: Songs of Survival in a Precarious Age', Biennale of Sydney, Australia
'Grand National', Vestfossen Kunstlaboratorium, Norway
'Restless Empathy', Aspen Art Museum, Colorado, USA
'A Horse Walks into a Bar…', Castlefield Gallery, Manchester
'Hope!' Palais des Arts et du Festival, Dinard, France
'Mortality', Australian Centre for Contemporary Art, Melbourne, Australia
'Let's Dance', Musée d'Art Contemporain du Val-de-Marne (MAC/VAL), Vitry-sur-Seine, France
'Made in Britain – Contemporary Art from the British Council Collection 1980 – 2010', Sichuan Provincial Museum, Chengdu; Xi'an Art Museum; Hong Kong Heritage Museum; Suzhou Art Museum
'Freedom of Speech', Kunstverein Hamburg, Germany

2011
'Blink!', Denver Art Museum, Colorado, USA
'Southbank Centre Celebrates Festival of Britain', Southbank Centre, London
'Among Heroes. Pre-Images in Contemporary Art', Kunsthalle Nürnberg, Germany
'The Big Society', Galerie Valois, Paris, France

Curated Exhibitions

2009
'The Russian Linesman', Frontiers, Borders and Thresholds', Hayward Gallery, London; Leeds Art Gallery; Glynn Vivian Gallery, Swansea

Screenings

2003
Threshold to the Kingdom, State Russian Museum St Michael's Castle, [PRO]SMOTR Festival of Contemporary Video Art, St Petersburg, Russia

2004
Third Generation, 57 Festival Internazionale del film Locarno, Switzerland
The Lark Ascending, Prince Charles Cinema, London

2005
The Lark Ascending, Film & Media Arts Festival, Berwick-upon-Tweed
Threshold to the Kingdom, Stroom, The Hague, the Netherlands
Threshold to the Kingdom, The Projection Room, Dun Laoghaire, Dublin, Ireland

2006
The End, Prince Charles Cinema, London

2007
The End, Whitney Museum of American Art, New York, USA
Sleeper, Artprojx, Anthology Film Archives, New York, USA

2008
The Lark Ascending, Sonic Illuminations, BFI, London
The End, Glasgow Film Festival, Scotland

2009
Image: Music;…sampler, Morris Gallery, Pennsylvania Academy of Fine Arts, Philadelphia, USA

SELECTED BIBLIOGRAPHY

Solo Exhibition Catalogues

1988 *Burgess Park: Interview with the Artist*, Nottingham: Nottingham
 Castle Museum
 Passport Control, London: Riverside Studios; Anthony Reynolds
 Gallery
1994 *Mark Wallinger*, text by Jo Coucke, Otegem, Belgium: Deweer Art
 Gallery
1995 *Mark Wallinger*, text by Jon Thompson, Birmingham and London:
 Ikon Gallery and Serpentine Gallery
1997 *Mark Wallinger*, text by Donald Kuspit, Minneapolis: Dolly Fiterman
 Fine Arts
1999 *Mark Wallinger is Innocent*, text by Pier Luigi Tazzi, Brussels and
 London: Société des Expositions du Palais des Beaux-Arts de
 Bruxelles and Delfina
 Mark Wallinger – Lost Horizon, interview with the artist
 by Theodora Vischer, text by Andrew Wilson, Basel: Museum
 für Gegenwartskunst
2000 *Mark Wallinger – Prometheus*, Frankfurt: Portikus
 [Limited ed. book]
 Mark Wallinger – Ecce Homo, texts by Mikhail Bulgakov
 and Adrian Searle, Vienna: Secession
 Mark Wallinger – Credo, texts by Lewis Biggs, Ian Hunt,
 Donna de Salvo and David Burrows, London: Tate Publishing
2001 *Cave: Mark Wallinger*, essay by Ian Hunt, FACT
 Time and Relative Dimensions in Space, text by Marco Livingstone,
 Oxford: Oxford University Museum of Natural History and Ruskin
 School of Drawing and Fine Art
 Mark Wallinger – British Pavilion, The 49th Venice Biennale 2001,
 text by Ralph Rugoff, London: British Council
2002 *Mark Wallinger, Ecce Homo*, essay by Adrian Searle, Glynn Vivian
 Art Gallery, Swansea
2004 *Presence*, edited by Julien Robson, Louisville: Speed Art Museum
2006 *Mark Wallinger, Une vision du monde: La Collection vidéo
 d'Isabelle et Jean-Conrad Lemaître*, Paris
2007 *State Britain*, texts by Clarrie Wallis, Mark Wallinger, London:
 Tate Publishing
2008 *Mark Wallinger*, edited by Madeleine Schuppli and Janneke
 de Vries, Zurich: JRP/Ringier
2010 *Mark Wallinger*, essay by Sally O'Reilly, Oslo: Kunstnernes Hus

Group Exhibition Catalogues

1986 *Unheard Music*, text by Emma Dexter, Stoke-on-Trent: City Museum
 and Art Gallery
 Neo Neo-Classicism, Annandale-on-Hudson, New York: Edith C. Blum
 Art Institute, Bard College
1987 *State of the Nation*, text by Sara Selwood, Coventry: Herbert Art
 Gallery and Museum
 Palaces of Culture: The Great Museum Exhibition, text by
 Graham Evans, Stoke-on-Trent: City Museum and Art Gallery
1988 *Cries and Whispers: New works for the British Council Collection*,
 text by Lewis Biggs, London: British Council
 Something Solid, text by Marjorie Allthorpe-Guyton, Manchester:
 Cornerhouse
 Object and Image: Aspects of British Art in the 1980s, text by Ian
 Vines, Stoke-on-Trent: Stoke-on-Trent City Council
 The New British Painting, texts by Edward Lucie-Smith, Carolyn
 Cohen and Judith Higgins, Oxford: Phaidon
1989 *Einleuchten: Will, Vorstel und Simul in HH*, texts by Harald
 Szeeman, Heinz Liesbrock, Christoph Schenker and Stephan
 Schmidt-Wulffen, Hamburg: Deichtorhallen, Christians
 Über Unterwanderung, text by Jutta Koether, Cologne: Galerie
 Sophia Ungers
1990 *Nachschub, The Köln Show*, edited by Isabelle Graw, Cologne:
 Spex *Australian Sculpture Triennial* National Gallery of Victoria,
 Melbourne: Australian National Gallery

1991 *Kunstlandschaft Europa*, texts by Andreas Vowinckel, Henry Meyric
 Hughes, Jonathan Watkins, Stefan Berg, Hans Gercke and
 Martin Stather, Karlsruhe: Kunstverein
 Confrontaciones, texts by Henry Meyric Hughes, Felix Guisasola,
 Andrew Renton and Teresa Blanch, Madrid: Instituto de la
 Juventud
1992 *Whitechapel Open*, London: Whitechapel Art Gallery
 Let Me Look, text by Valeria Bruni, Stella Santacatterina,
 Rita Selvaggio and Jon Thompson, Commune di San Miniato
1993 *Young British Artists II*, text by Sarah Kent, London: Saatchi
 Collection
 Junge Britische Kunst, text by Werner Krüger, Cologne: Art Cologne
1994 *Jetlag*, text by Gert Rappenecker, Frankfurt: Galerie Martina Dretter
 Every Now and Then, London: Richard Salmon
 Seeing the Unseen, texts by Mark Wadhwa, Walter Meyer,
 James Roberts, London: nvisible Museum
 Idea Europa, texts by Valeria Bruni, Omar Calabrese
 and Rita Selvaggio, Siena: Contemporanea Editrice
 Art Unlimited: Multiples from the 1960s and 1990s, texts by
 Hilary Lane and Andrew Patrizio, London: South Bank Centre
1995 *John Moores Exhibition 19*, text by Julian Treuherz, Liverpool:
 National Museums and Galleries on Merseyside
 The British Art Show, texts by Richard Cork, Rose Finn-Kelcey
 and Thomas Lawson, London: South Bank Centre
 The Turner Prize, text by Virginia Button, London: Tate Publishing
1996 *Jurassic Technologies 10th Biennale of Sydney*, edited by
 Lynne Cook, Sydney: The Biennale of Sydney
1997 *Virginia Button, The Turner Prize*, London: Tate Publishing
 Pledge Allegiance to a Flag?, interviews with artists by Stewart
 Russell and text by Nikos Papastergiadis, London: London
 Printworks Trust
 Pictura Britannica, edited by Bernice Murphy, Sydney: Museum
 of Contemporary Art
 Dimensions Variable: New Works for the British Council Collection,
 text by Ann Gallagher, London: British Council
 Sensation: Young British Artists from the Saatchi Collection,
 texts by Norman Rosenthal, Richard Shone, Martin Maloney,
 Brook Adams and Lisa Jardine, London: Thames & Hudson
 5th International Istanbul Biennial, text by Rosa Martinez,
 Istanbul: Foundation for Culture and Arts
 Treasure Island, texts by Jorge Molder, Rui Sanches,
 Ana de Vasconcelos e Melo, Alan Bowness, Richard Cork,
 Gill Hedley, Andrew Renton, Bryan Robertson and Richard
 Shone, Lisbon: Centro de Arte Moderna *José de Azeredo
 Perdigâo*, Calouste Gulbenkian Foundation
 Between the Devil and the Deep Blue Sea, text by Julian Stallabrass,
 London: Beaconsfield/AMPCOM
1998 *Feeringbury VIII – Cultivated*, texts by Stephen Hepworth, Katherine
 Wood and Sonia Coode-Adams, London: Firstsite and Curtain
 Road Arts
 Drawing Itself, text by Gerard Wilson and Janice Hart, London:
 The London Institute
 Made in London, text by Richard Shone, London: Simmons &
 Simmons
 UK Maximum Diversity, text by Matthew Higgs, Benger Areal,
 Bregenz, Vienna: Galerie Krinzinger
 Book, texts by David Bickerstaff and Paul Bonaventura, Nottingham:
 Djanogly Art Gallery, University of Nottingham
1999 *L'Art et L'Ecrit*, Espace Sculfort, Maubeuge: Idem + Arts FRAC
 Nord-Pas de Calais
 Il luogo degli angeli, San Angelo: San Michele and Museo
 Laboratorio
 Officina Europa, texts by Renato Barilli, Bologna: Edizioni Gabriele
 Mazzotta
 Sublime: The Darkness and the Light, texts by Jon Thompson,
 Christopher Kool-Want, London: Arts Council
2000 *Seeing Salvation*, texts by Neil MacGregor and Erika Langmuir,
 London: BBC Publishing
2001 *Looking at You*, Kassel: Kunsthalle Fridericianum
2002 *Sidewinder*, texts by Gerard Hemsworth, et al., Kolkata: CIMA Gallery
 Painting as a Foreign Language, texts by Gerard Hemsworth,
 Suhail Malik, São Paulo: Edifício Cultura Inglesa / Centro
 Brasileiro Britânico

Family, Ridgefield, Connecticut: Aldrich Contemporary Art Museum
Faux/Real, Istanbul: Borusan Art & Culture Centre
Ommegang-Circumflexion, Bruges
THE GAP SHOW – Young Critical Art from Great Britain, Dortmund: Museum Ostwall

2003 *Micro/macro – British Art 1996–2001*, text by Alex Farquharson, Budapest: Mucsarnok Kunsthalle
Sanctuary – Contemporary Art and Human Rights, Glasgow: Gallery of Modern Art
Warum! Bilder diesseits und jenseits des Menschen, Berlin: Martin Gropius Bau
La Vista y La Visión, curated by Pedro Azara, Valencia: Institut d'Art Modern

2004 *The Human Condition The Dream of a Shadow*, Barcelona: Barcelona Forum and Institut de Cultura de Barcelona, Museu d'Historia de la Ciutate de Barcelona (MHCB)
On Side, Coimbra: Centro de Artes Visuais
Gifted, curated by Eamonn Maxwell, foreword by Rosie Millard, London: University of the Arts
Art Focus 4, Jerusalem International Biennial of Contemporary Art, Jerusalem: Biennial Organization

2006 *Wandering Star*, text by Sacha Craddock, Jeremy Akerman, Seoul: Gana Communications
Belief, Singapore Biennale, Singapore: National Arts Council

2007 *Schmerz*, Berlin: Nationalgalerie im Hamburger Bahnhof

2008 *History In The Making: A Retrospective of The Turner Prize*, London: Tate Publishing for Mori Art Museum, Tokyo
Collection Video & Film, Isabelle & Jean-Conrad Lemaître, Kiel: Kunsthalle zu Kiel
Folkestone Triennial, Tales of Time and Space, edited by Andrea Schlieker, London: Cultureshock Media

2009 *Passport: Great Early Buys from the British Council Collection*, texts by Michael Craig-Martin, Andrea Rose, et al., London: British Council
Heaven, 2nd Athens Biennial, text by Dimitris Papaioannou, Athens: Biennale Organization

2010 *Dopplereffekt. Bilder in Kunst und Wissenschaft*, edited by Petra Gördüren and Dirk Luckow, Berlin: Dumont Buchverlag and Kunsthalle zu Kiel
HOPE! Une exposition d'art contemporain sur l'Espoir, edited by Sylvie Mallet and Ashok Adicéam, Paris: Skira-Flammarion

2011 *My City*, edited by Ozge Açıkkol and Seçil Yersel, Istanbul: British Council, Andalou Kultur and Platform Garanti Contemporary Art Centre

Curated Exhibition Catalogues

2009 *The Russian Linesman: Frontiers, Borders and Thresholds*, London: Hayward Publishing (Essay 'Awake in the nightmare of history' by Mark Wallinger)

Books Edited by Mark Wallinger

2001 *Art for All? Their Policies and Our Culture*, with Mary Warnock, London: Peer (Introduction by Mark Wallinger)

General Books

1996 Jason Coburn, *Hello: Artists in Conversation*, London: Royal College of Art
Paul Bonaventura, Helen Cadwallader, *Vade Mecum: A Compendium of New Art*, Newcastle: Locus+

1998 Kevin Davey, *English Imaginaries*, London: Lawrence & Wishart

1999 Louisa Buck, *Moving Targets: A User's Guide to British Art Now*, London: Tate Publishing

2000 Paul Bonaventura, *Locus Solus*, Newcastle: Locus+
Louisa Buck, *Moving Targets 2: A User's Guide to British Art Now*, London: Tate Publishing
Siân Ede, ed., *Strange and Charmed: Science and the Contemporary Visual arts*, Lisbon: Calouste Gulbenkian Foundation

2001 Matthew Collings, *Art Crazy Nation: The Post Blimey! Art World*, London: 21 Publishing
Hubert J. Pragnell, *Invisible London*, London: Ellipsis Arts

2002 Kerstin May, ed., interview with Kathrin Rhomberg, *Sculpsit: Contemporary Artists on Sculpture and Beyond*, Manchester: Manchester University Press

2004 Marco Delogu and Massim Reale, eds, *Photofinish*, Rome: Contrastobooks
Jesper Gulddal and Mette Mortensen, *PAS! Identitet, Kultur og Grænser*, Copenhagen: Informations Forlag
Evelyn Fischer-Lenotte, *Imaginer Voir*, Brussels: La Lettre Volée

2005 Rosie Dickins, *The Usborne Book of Art*, London: Usborne

2006 Jane Connarty and Josephine Lanyon, eds, *Ghosting: The Role of the Archive within Contemporary Artists' Film and Video*, Bristol: Picture This Moving Image
Sylvia Martin, *Video Art*, Cologne: Taschen
Sheila McGregor, *New Art on View: Collections in Britain*, London: Scala Publishers

2007 Patricia Bickers and Andrew Wilson, eds., interview with Paul Bonaventura, *Talking Art: Interviews with Artists since 1976*, London: Ridinghouse
Jemima Montagu, ed., *Open Space: Art in the Public Realm in London 1995–2005*, London: Arts Council
Jürgen Zulley, et al., *Schlaf & Traum*, Cologne: Bohlau Verlag with Deutsches Hygiene-Museum Dresden and the Wellcome Collection, London

2008 Ruth Cloudman, *The Speed Art Museum: Highlights From The Collection*, London: Merrell Publishers
Eleanor Heartney, *Art & Today*, London: Phaidon
Stéphanie Moisdon, Christiane van Assche, Rachida Bouaiss, Fabrice Bousteau, *Qu'est-ce que l'art video aujourd'hui?*, Paris, Beaux Arts Éditions
Johannes Stückelberger, Sibylla Egli, Katharina Steinmann de Oliveira, Isabell Zürcher, *Religion im öffentlichen Raum*, Vienna: Kunst und Kirche 4, Springer

2009 Charlotte Bonham Carter and David Hodge, *The Contemporary Art Book*, London: Goodman Books

2010 *Art, Activism and Recuperation*, Bristol: Concept Store 3, Arnolfini Publications
Barbara Engelbach, ed., *Bilder in Bewegung: Künstler & Video & Film 1958–2010*, Cologne: Museum Ludwig

Articles and Essays by Mark Wallinger

1987 'The brick is the message', *Evening Standard* Magazine, 6 November

1995 'A brush with genius: Mark Wallinger on Velázquez's *Triumph of Bacchus*', *Guardian,* 3 July

1996 'Is he the father of modern art?', *Guardian*, 13 January
'You Are Here', *New Histories, Virginia Nimarkoh*, Institute of Contemporary Art, Boston

1998 'The Pygmalion paradox: Mark Wallinger on the new Establishment', *Art Monthly*, July–August
'Fool Britannia: Not New, Not Clever, Not Funny', *Who's Afraid of Red, White and Blue?*, edited by David Burrows, Birmingham: ARTicle Press, University of Central England

1999 'My week', *Independent*, 24 July

2000 'The god of proportion (after Leonardo)', *Independent* Magazine, 1 January
'Fool Britannia', *Guardian*, 12 December

2001 'Artists on art: Mark Wallinger on Velázquez's *Las Meninas* (c. 1656)', *Daily Telegraph*, 3 March
'Private passions: Mark Wallinger on *Whistlejacket*', *The Times*, 3 October

2002 'What's the big idea?' *Observer* Magazine, 22 September

2003 *Sanctuary: Contemporary Art and Human Rights*, The Gallery of Modern Art, Glasgow, pp. 78–79

2005 Foreword, *Journey to the Lower World, Marcus Coates*, Morning Star and Platform Projects
'Sleeper', *frieze*, 91, 31 May
'Perfect Weekend: Mark Wallinger', *Financial Times*, 5 November

2008 'What works of art would best represent earthlings to men from Mars?' *The Times*, 1 March

2009 *Leo Fitzmaurice/Post Match*, Locus +, Newcastle
 (Artist's publication with texts by Mark Wallinger and Harry
 Pearson)
 'Beyond the stable', *Guardian*, 15 December
2010 'Make Me Think Me', Bruce Nauman talk for DIA published in
 Serpentine Gallery Manifesto Marathon, König Books, London
 'Mark Wallinger', Artists' special, *Guardian,* 27 April
 'Collages that cut to the quick', *Independent*, 3 December
2011 'Alte Meister, Von Neuen Geliebt (Velázquez's *The Triumph
 of Bacchus*)', *Monopol*, January

Articles and Reviews

1985 Waldemar Januszczak, 'New Art', *Guardian*, 27 August
 Marjorie Allthorpe-Guyton, 'New Art I and II at Anthony Reynolds
 Gallery', *Artscribe*, December 1985–January 1986
 R. Costa, 'London', *Juliet Art Magazine*, December 1985–January
 1986
1986 Sarah Kent, *Time Out*, 23–29 January
 Mark Currah, *City Limits*, 31 January–6 February
 John Russell Taylor, 'Mark Wallinger: Hearts of Oak', *The Times*,
 4 February
 Waldemar Januszczak, *Guardian*, 7 February
 'A Mixed Message', *London Week*, 7–13 February
 Clare Henry, *Arts Review*, 14 February
 Monica Bohm-Duchen, *Flash Art*, April
 Marjorie Allthorpe-Guyton, 'Mark Wallinger at Anthony Reynolds',
 Artscribe, April–May
 Tessa Sidey, 'Unheard music', *Arts Review,* May
 Margaret Garlake, 'Canvas II', *Art Monthly*, July–August
1987 John Roberts, 'Mark Wallinger's history paintings', *Artscribe*,
 January–February
 Waldemar Januszczak, 'Stuart Brisley at the Serpentine',
 Guardian, 21 January
 Monica Petzal, 'Stuart Brisley, Glenys Johnson, Mark Wallinger,
 Ken Currie', *Time Out*, 28 January–4 February
 'Ken Currie, Glenys Johnson, Mark Wallinger', *Observer,*
 1 February
 Nigel Reynolds, 'Art or just brick-a-brac?', *Evening Standard*,
 14 September
 David Wickham, 'Building an art of stone', *News on Sunday,*
 20 September
 Andrew Graham-Dixon, 'A museum of mirrors', *Independent*,
 25 September
 John Glaves-Smith, 'Palaces of Culture', *Art Monthly*, December
 1987–January 1988
1988 Peter Fleissig, 'Artists for architecture', *Building Design*, 18 March
 Jutta Koether, *Artscribe,* May
 David Lovely, 'Something solid', *Arts Review,* May
 Mark Edmund, 'Something solid', *Pulp Magazine*, 10 May
 Jude Schwendenwien, 'Sculpture, Koury Wingate', *ARTnews*, 87,
 Summer
 Mark Currah, *City Limits*, 29 September–6 October
 Robert MacDonald, *Time Out*, 12–19 October
 Brian Hatton, 'Mark Wallinger', *Flash Art*, November–December
 P. H. Meyer, 'Mark Wallinger', *Juliet Art Magazine*, December
 1988–January 1989
1989 Michael Archer, 'Mark Wallinger', *Artforum*, January
1990 Sarah Kent, 'Mark Wallinger', *Time Out*, 2–9 January
1991 'Choices', *Village Voice,* 26 February
 Dorothy Spears, 'Mark Wallinger', *Arts Magazine*, May
 Andrew Graham-Dixon, *Independent,* 14 May
 Sarah Kent, 'Politics in paint', *Time Out,* 15–22 May
 Sacha Craddock, 'Truth or dare?', *Guardian,* 28 May
 Richard Cork, 'A picture of wealth', *New Statesman,* 31 May
 Jutta Koether, 'Mark Wallinger', *Artscribe,* Summer
 Fernando Arias, 'La renovacion de la pintura anglosajona', *Hoja de
 Lunes, Valencia*, 15 July
1992 Janet Koplos, 'Mark Wallinger at Daniel Newburg and Grey Art
 Gallery', *Art in America*, July
 Alessandra Gulotta, 'Let me look', *Next*, October
 Alberto Mugnaini, 'Luoghi storici del paese', *Tema Celeste*, October

 Saretto Cincinelli, 'Let me look', *Flash Art*, October–November
 Conor Joyce, 'Mark Wallinger', *Art Monthly*, November
 Alessandro Tosi, 'Quel magico accordo', *La Nazione*, 5 November
 Andrew Wilson, 'Mark Wallinger', *Forum International*, November–
 December
 Andrew Renton, 'Mark Wallinger', *Flash Art*, November–December
 Mario Manganiello, 'Artisti inglesi contemporanei a San Miniato',
 Images: Art Life, November–December
 Juliet Art Magazine, 12, December
 Stella Santacatterina, 'Mark Wallinger', *Tema Celeste*, Winter
1993 Adrian Searle, 'Fools and horses', *frieze*, January–February
 William Feaver, 'The second coming', *Vogue,* February
 James Hall, 'Diary', *World of Interiors*, February
 Sarah Kent, 'Less is gore', *Time Out,* 2–9 February
 Richard Cork, *The Times*
 David McKie, 'What you read into it', *Guardian*, 6 February
 Tim Hilton, 'Familiar signs of a misspent youth', *Independent
 on Sunday*, 7 February
 Waldemar Januszczak, 'Blood and thunder', *Guardian*,
 8 February
 Sarah Kent, 'Blood group', *Time Out,* 10–17 February
 William Feaver, 'Phew! What a freezer!', *Observer*, 14 February
 Andrew Graham-Dixon, 'Radical chic and the schlock of the new',
 Independent, 16 February
 William Packer, 'Young British Artists II at the Saatchi Gallery',
 Financial Times, 16 February
 Stephen Pile, 'Don't put the nail in the coffin yet', *Daily Telegraph,*
 18 February
 Jonny Beardsall, 'Race, sex and class!', *Racing Post*, 25 February
 Sacha Craddock, 'Young British Artists', *Untitled*, Spring
 Peter Fleissig, 'Lèche-Vitrine', *Parkett*, 35, March
 Julian Stallabrass, 'Young British Artists', *Art Monthly*, March
 Simon Garfield, 'I like it, I'll take the lot', *Independent,* 20 March
 Craig Brown, 'Time for an artful dodge', *Evening Standard*,
 22 March
 Andrew Renton, 'Young British Artists II', *Flash Art*, Summer
 Werner Kruger, 'Junge britische Künstler', *Weltkunst,* 15 October
 Kölner Stadt-Anzeiger, 5 November
 Bunte, 11 November
 Bruno F. Schneider, 'Mit drunem Licht zaubern', *Kölnische
 Rundschau*, 15 November
 Angela Choon, 'Openings', *Art & Antiques*, December
1994 Richard Dorment, 'Throw that work of art another bale of hay',
 Daily Telegraph, 17 March
 Paul Bonaventura, 'Turf accounting: Mark Wallinger interviewed',
 Art Monthly, April
 Adrian Dannatt, 'Young British Art now', *Sunday Times
 Magazine,* 17 April
 James Hall, 'Horsing around', *Guardian*, 25 April
 Roger Bevan, 'The horse as an art form', *Art Newspaper*, May
 David Lee, 'Update', *ArtReview,* May
 Mark Currah, 'Mark Wallinger', *Time Out,* 4–11 May
 Dalya Alberge, 'Artist's latest work is a racing certainty for
 controversy', *Independent,* 14 May
 Paul Bonaventura, 'An equal match?', *Modern Painters*, Spring
 Jeffrey Kastner, 'Mark Wallinger', *Flash Art*, June
 James Hall, *Guardian Guide,* 11 June
 William Harvey, 'Curator's Egg', *Untitled*, Summer
 William Harvey, 'Rear Window', *Untitled,* Summer
 Mark Currah, 'Every Now and Then', *frieze*, 17, June–August
 Mathew Collings, 'New London', *Daily Express*, 5 September
1995 Geraldine Norman, *Independent on Sunday*, 1 January
 Giles Coren, *The Times*
 'Mark Wallinger', *Blueprint*, March
 Adrian Searle, 'Self Portrait as a pantomime horse', *Guardian,*
 7 March
 William Feaver, 'Horse for courses', *Observer,* 19 March
 Philip Vann, 'Backing the right horse', *RA Magazine*, Spring
 Mark Sanders, 'Eye opener', *London Magazine*, May
 William Packer, 'An artist lays his bets', *Financial Times,*
 13–14 May
 'What's Happening', *Nine to Five*, 15 May
 Martin Vincent, 'Painters and punters', *New Statesman*, 19 May

Londoner's Diary, *Evening Standard,* 23 May
Richard Cork, 'Our nation at horseplay', *The Times*, 30 May
'London Review', *ArtReview*, June
Sarah Kent, 'Race relation', *Time Out*, 31 May–7 June
Sarah Curtis, 'Blood lines', *World Art*, 2
Andrew Graham-Dixon, 'The British art buzz', *Vogue*, June
Waldemar Januszczak, 'His sporting life', *Sunday Times,* 4 June
Martin Gayford, 'Favourite with a handicap', *Daily Telegraph,* 7 June
Robert Lloyd Parry, 'Ideas of Englishness', *This Is London,* 9 June
Louisa Buck, 'British art: Don't knock it', *Independent,* 24 June
Mike Ellison, 'No butts as Hirst is tipped for top art prize',
 Guardian, 13 July
Dalya Alberge, 'Colourful rebels vie for Turner Prize', *The Times,*
 13 July
Dan Conaghan, 'Dead mutton dressed up as sheep', *Guardian,*
 13 July
David Lister, 'Turner artists inquires within', *Independent,* 13 July
David Lister, 'It may win prizes, but is it art or orifice?', *Independent,*
 14 July
Simon Wilson and Brian Sewell, 'Mark Wallinger's *A Real Work
 of Art',* *Independent,* 14 July
Anthony Thorncroft, 'Sheep leads the horses in Turner stakes',
 Financial Times, 22 July
Mark Currah, 'Mark Wallinger in London', *Untitled*, Summer
Mark Sladen, 'Mark Wallinger', *frieze*, 24, September–October
Rupert Christiansen, 'Dark horse of the art world', *Daily Telegraph*
 Magazine, 21 October
Paul Bonaventura, 'The alternative British Art Show: Four views',
 Untitled, Winter
Dan Conaghan, 'Tate shows Turner Prize cream but not the cow',
 Daily Telegraph, 1 November
Edward Gorman, 'Leaky works of art put out to grass', *The Times,*
 1 November
James Hall, 'Turner exhibition comes alive and dangerous',
 Guardian, 1 November
Adrian Searle, 'The thirst for Hirst', *Independent*, 1 November
Richard Cork, 'Hirst commands two fronts', *The Times,*
 7 November
Richard Dorment, 'Beauty amid the beasts', *Daily Telegraph,*
 8 November
Matthew Collings, 'The art of prize fighting', *Guardian,*
 28 November

1996 Andrew Sim, 'A Real Work of Art', *Sporting Life*, 29 January
Tina Jackson, 'Mark Wallinger: Horse crazy', *Big Issue*,
 12–18 February
'He's behind you!', *Sun*, 23 February
Ian Gale, '20th century sporting art', *Country Life*, 7 March
Annie Griffin, 'Eyes on the ball', *Guardian*, 10 June
Bridget Virden, 'Stud-U-Like', *G•Spot Magazine*

1997 'Ada Adekola, Yinka Shonibare, Mark Wallinger', *Time Out,*
 22–29 January
David Burrows, 'Ada Adekola, Yinka Shonibare, Mark Wallinger',
 Art Monthly, February
Lottie Hoare, 'Mark Wallinger', *Untitled*, Spring
Martin Coomer, 'Mark Wallinger', *Time Out*, 2–9 April
Jean-Marc Colard, 'Union Mark', *Les Inrockuptibles*, 23–29 April
John Tozer, 'Mark Wallinger, God', *Art Monthly,* May
Isobel Johnstone, 'Who's buying who?', *Guardian*, 3 June
Guardian, 19 September
'The art pack', *Elle*, October
'Mark Wallinger at Jiri Svestka', *Flash Art*, November–December

1998 Carol Kino, 'Dissin' the real', *Time Out New York*, 10 March
'Von Endorphinen, Salzgurken und Stromstößen', *Der Standard,*
 5 June
'Minimalsport mit Erwin Wurm und vieles mehr', *Kurier*, 6 June
Ian Geraghty, 'Mark Wallinger', *Untitled*, Autumn
John Harlow, 'Christ to get place in Trafalgar Square', *Sunday
 Times*, 20 September
'Mark Wallinger: The Four Corners of the Earth', *Exhibit: A,*
 September–October
Art Newspaper, 10, October
Helen Sumpter, 'Mark Wallinger: The Four Corners of the Earth',
 Evening Standard, 1 October

'Mark Wallinger: The Four Corners of the Earth', *Contemporary
 Visual Arts*, 20
'Mark Wallinger', *Guardian Guide,* 3–9 October
'Mark Wallinger: The Four Corners of the Earth', *Guardian Space,*
 9 October
Mark Currah, *Time Out,* 28 October–4 November
Duncan McLaren, 'The Four Corners', *Independent on Sunday,*
 8 November
Matthew Collings, 'Battle of Trafalgar Square', *Observer,*
 6 December
Dan Glaister, 'Modern art to the rescue of Trafalgar Square's
 empty plinth', *Guardian*, 8 December
John Tozer, 'From today painting is dead', *Contemporary
 Visual Arts,* 21

1999 Neal Brown, *frieze*, January–February
Eleanor Heartney, 'Report from Montreal', *Art in America*, February
Stella Santacatterina, 'Mark Wallinger', *Flash Art,* March–April
'Centre of attention, public statues', *The Times*, 22 July
'The plinth and the people', *Guardian*, 22 July
Dalya Alberge, 'Christ stirs passion in Trafalgar Square', *The Times,*
 22 July
Will Bennett, 'Christ fills a gap in heart of London', *Daily
 Telegraph*, 22 July
Fiachra Gibbons, 'Behold Jesus, just another ordinary bloke',
 Guardian, 22 July
Alex Hendry, 'Jesus starts a new battle of Trafalgar', *Daily Express,*
 22 July
David Lister, 'Humble Christ beats war-like Thatcher',
 Independent, 22 July
Phil Miller, 'New statue of Jesus dwarfed by giants of empire,
 Scotsman, 22 July
Adrian Searle, 'The day I met the son of God', *Guardian*, 22 July
Roy Strong, 'Is this a fitting site for a statue of Jesus Christ?',
 Daily Mail, 22 July
Warren Hoge, 'Plinth seeks occupant. Nelson will be neighbor',
 New York Times, 19 August
Warren Hoge, 'A finishing touch for Trafalgar Square', *International
 Herald Tribune*, 21–22 August
Richard Dorment, 'Small figure makes a big impact', *Daily
 Telegraph,* 25 August
Lucy Lethbridge, 'The plinth's progress', *ArtNews*, October
Warren Hoge, 'A finishing touch', *Vocable,* 21 October–3 November
James Hall, 'Short of statue', *Artforum*, November
Jonathan Jones, 'Mark Wallinger's Christ', *Guardian,*
 27 December
Kate Watson-Smyth and Fran Abrams, 'Captain Cook
 and Batman fight for a place at the heart of nation',
 Independent, 27 December
Adrian Searle, 'Brush hour', *Guardian*, 28 December

2000 Lynn Barber, 'For Christ's sake', *Observer,* 9 January
Ann Treneman, 'Art, farce, politics and pigeons', *The Times,*
 11 February
The Rt Revd Richard Chartres, 'Ecce Homo', *Oremus*, March
'Ecce Homo', *Vivi Milano*, 17 May
Simon Grant, 'Soul searching', *Tate Magazine*, Summer
'Wallinger. Un Young British artist da scoprire', *Mensil di Arte,
 Cultura, Informazione,* July
'Wallinger per miracol mostrare', *Il Giornale dell'Arte,* July
Colin Gleadall, 'Edge of meaning and nonsense', *Daily Telegraph,*
 22 July
James Hall, 'Another time, another place', *ArtReview*, July–August
Marcus Mittringer, 'Sehet, welch ein Mensch!', *Der Standard,*
 3 August
Daniele Perra, *Tema Celeste Contemporary Art*, July–September
'Mostre', *Vogue-Italia*, September
Simon Grant, 'From Jesus on a plinth to an angel on Merseyside',
 Independent on Sunday, 15 October
Colin Gleadall, 'Contemporary Market', *Daily Telegraph,*
 16 October
Robert Clark, *Guardian Guide*, 21–27 October
Martin Gayford, 'An angel underground', *Sunday Telegraph*,
 22 October
Joe Riley, 'Art can be fun', *Liverpool Echo*, 24 October

Tom Lubbock, 'In the sweet hereafter', *Independent*, 24 October
Jonathan Jones, 'The magical mystery tour', *Guardian*, 28 October
Nick Crowe, 'Football, The Lords Prayer and Heavy Metal –
 a peculiar kind of nationhood' *Flux Magazine*, October–November
Helen Sumpter, 'Seeing is believing', *I-D Magazine,* November
Paul Bonaventura, 'Playful art', *New Statesman*, 6 November
Lynn MacRitchie, 'Portraits of the artist', *Financial Times,*
 10 November
Richard Ingleby, 'Mark Wallinger – Credo', *Independent, 11–17*
 November
Sean Dodson, 'Artists who paint by digits', *Guardian,* 30 November
Anna Moszynska, 'Breeding and healing', *ArtReview*,
 December–January

2001 Laura Cumming, 'An odds-on favourite', *Observer*, 28 January
Tony Godfrey, 'Mark Wallinger Liverpool', *Burlington Magazine*,
 January
Paul Bonaventura, 'The culture of command', *Modern Painters*,
 Spring
Martin Gayford, 'Artists on art – Mark Wallinger', *Daily Telegraph*,
 3 March
Stella Santacatterina, *Flash Art*, March–April
Helen Hague, 'Conceptual without cliché', *Times Higher Education*,
 25 May
Louisa Buck, 'Chigwell conceptualist', *Evening Standard*, 31 May
'Mark Wallinger unveils new work at museum', *Oxford Blueprint*,
 31 May
Craig Burnett, 'Fools walk in… ', *Modern Painters,* Summer
Rachel Withers, 'Customs man: Mark Wallinger', *Artforum*,
 Summer
Rose Aidin, 'Profile: Mark Wallinger – Race, class and sex',
 Independent, 2 June
Oliver Bennett, 'Taking a Tardis to the Venice Biennale',
 Independent on Sunday, 3 June
Rachel Campbell-Johnston, 'The art before the horse',
 The Times, 4 June
Dalya Alberge, 'Best of British misses the art of diplomacy',
 The Times, 7 June
Mark Irving, 'Briton is the big draw as Venice Biennale opens',
 Independent, 7 June
Nigel Reynolds, 'British artist flies the flag of controversy
 at Biennale', *Daily Telegraph*, 7 June
Charles Darwent, 'Flying the flag at the Eurovision art contest',
 Independent on Sunday, 10 June
Richard Cork, 'Too many tours spoil the broth', *The Times*, 13 June
Richard Dorment, 'Wallinger's act of faith pays off', *Daily Telegraph*,
 13 June
Arthur Smith, 'Watery rave', *Guardian*, 14 June
Mark Irving, 'Cultural geography: Art versus power', *Financial Times*,
 16 June
William Packer, 'Wallinger marks the spot', *Financial Times,*
 16 June
Adrian Searle, 'Lagoon show', *Guardian,* 16 June
Waldemar Januszczak, 'A curious beast', *Sunday Times*, 17 June
John McEwen, 'Pushy culture vultures', *Sunday Telegraph,*
 17 June
Michael Kimmelman, 'Arty, artful, artless', *New York Times*,
 20 June
Hans Pietsch, 'Der blinde Narr', *Art – Das Kunstmagazin*, June
Régis Durand, 'La tradition non-conformiste', *Art Press*, June
Martin Gayford, 'States of bemusement', *Spectator,* 23 June
'Exhibition of the week: Venice Biennale', *Week*, 23 June
Sarah Kent, 'Venice Biennale', *Time Out*, 27 June–4 July
Andrew Wilson, 'The zones of Venice', *Art Monthly*, July–August
Heinz-Norbert Jocks, 'Die Ausstellung im Innern des Kopfes',
 Kunstforum International, August–October
Marcia E. Vetrocq, 'Biennale babylon', *Art in America*, September
Rainer Metzger, 'The Englishness of English art', *Frame*,
 August–September
'Biennale Venedig', *Frame*, August–September
Michael Archer, 'Preview – Mark Wallinger', *Artforum*, September
Tom Lubbock, 'Wallinger and religion', *Modern Painters*, Autumn
Nigel Farndale, 'Seeing the light', *Sunday Telegraph* Magazine,
 4 November

Charles Darwent, 'A poetic moment in an electric chair',
 Independent, 18 November
Richard Dorment, 'Pick of the week – Mark Wallinger', *Daily
 Telegraph*, 10 November
Jonathan Jones, 'God's-eye views', *Guardian*, 20 November
Tom Lubbock, 'It's a hit and myth affair', *Independent*,
 20 November
Richard Cork, 'Readings from Mark', *The Times*, 21 November
Fisun Güner, 'Let's get metaphysical', *What's On in London*,
 21 November
Laura Cumming, 'A matter of life and death', *Observer*, 25 November
Martin Gayford, 'Ordinary and sublime', *Daily Telegraph*,
 28 November
'Cover story', *pLUK*, November–December
Axel Lapp, 'It ain't! Is it not? Mark Wallinger and Robert Gober
 at the 49th Venice Biennale', *Sculpture Journal*, 6

2002 Chiara Leoni, 'Ready to rumble', *Flash Art Italia*,
 December–January
Sarah Kent, 'On the Mark – the poetic logic of Wallinger's
 new show', *Time Out,* 2–9 January
Adrian Searle, 'Sculpture gives life to Christian symbolism',
 Western Mail, 4 May
Martin Gayford, 'George Stubbs and Mark Wallinger', *Sunday
 Telegraph*, 11 August
Helen Hague, 'A classy, sexy two-horse race', *Independent*,
 30 August
Kate Mikhail, 'What's the big idea', *Observer* Magazine,
 22 September
Carol Kino, 'Seeing and believing', *Art in America*, October
Jens Nordqvist, 'Han gestaltar kampen mellan tro och tvivel',
 Nya Dagen, 22 October
Av Katarina: Lööv, 'Söker andlighet i konsten', *Broderskap*,
 25 October
Cristina Karlstam, 'På tröskeln till riket', *Kultur*, 26 October
Nils Forsberg, 'Så vitt vi ser', *Observer* (Sweden), 31 October
Eva Runefelt, 'Välkommen till världen', *Observer* (Sweden),
 8 November
Stina Högkvist, 'Borde jag ha läst Bibeln först?', *Observer* (Sweden),
 11 November
Andreas Johansson, 'Tre Frågor/Har du alltid velat bli Konstnär?',
 Observer (Sweden), 22 November
Sophie Allgårdh, 'Wallinger ger oss en glimt av det förlovade
 landet', *Konst,* 24 November

2003 Gary Young, 'Much ado about nothing', *Art Papers*,
 January–February
'Hungary for British art', *ArtReview*, April
Hadley Freeman (interviewer), 'I wanted to invade her privacy
 (Thatcher)' [Five artists explain what inspired their works about
 Margaret Thatcher], *Guardian*, 16 April
Michael Binyon, 'Deface of the nation', *The Times*, 18 April
Eliza Williams, 'Thatcher', *Contemporary*, 53
Iain Gale, 'Art that will set you free', *Scotsman*, 12 May
Tobias Vogt, 'Warum! Martin-Gropius-Bau', *Zitty,* 13 June
Christian Huther, 'Welt im Wandel', *Main Echo* (Aschaffenburg)
 14 June
Luke Leitch, 'Has the Tate finally lost its baubles?', *Evening Standard*,
 12 December
Dalya Alberge, 'Tate tree gives rosary reminder', *The Times*,
 13 December
Maev Kennedy, 'Traditional trappings, artist trims Tate tree',
 Guardian, 13 December
Nigel Reynolds, 'Christ's birth inspired me, says creator
 of Tate's tree', *Daily Telegraph*, 13 December
Christina Farrell, 'Artist captures spirit of Christmas', *Catholic
 Herald,* 19 December

2004 Jessica Lack, 'Mark Wallinger', *Guardian Guide*,
 10–16 January
Fisun Güner, 'Mark Wallinger: The artist ascending',
 Independent, 14 January
Fisun Güner, 'Bring me light', *What's On in London*, 14 January
Laura Cumming, 'Family favourites', *Observer*, 18 January
Charles Darwent, 'At home in the kingdom of the strangely
 familiar', *Independent on Sunday*, 18 January

Tom Lubbock, 'Pitch-black perfect', *Independent*, 20 January
Charles Darwent, 'Mark Wallinger', *Metro*, 20 January
Adrian Searle, 'Mark Wallinger', *Guardian*, 21 January
Sarah Kent, 'Mark Wallinger', *Time Out*, 28 January–4 February
Rowan Williams, 'Imitations of Christ', *Guardian*, 31 January
Louisa Buck, 'Three degrees of separation', *Art Newspaper*,
 February
Jane Watts, 'In memorium', *a–n Magazine*, March
Norbert Bolz, 'Kunst und Sport – Sport als Ästhetik der Zukunft',
 Kunstforum International, 169, March–April
Oliver Zybok, 'Kunst und Sport – Die inszenierung von
 körperlichkeit und bewegung', *Kunstforum International*, 169,
 March–April
Sally O'Reilly, 'Mark Wallinger', *frieze*, 82, April
Catherine Parker, 'Mark Wallinger', *Art Press*, April
Rachel Withers, 'Mark Wallinger', *Artforum*, May
Oliver Bennett, 'Hellish vision', *Observer*, 9 May
Paul Glinkowski, 'Losing it in translation', *a–n Magazine*, December
Sacha Craddock, 'Embedded', *Contemporary*, 69

2005 Malise Ruthven, 'The Challenge of Chillingham', *World of Interiors*,
 February
Tom Lubbock, 'Eye contact', *ArtReview*, April
Sally O'Reilly, 'Things that go bump in the night: Mark Wallinger
 bears all', *Modern Painters*, June
Adrian Searle, 'Filth, blasphemy and big stars', *Guardian*, 14 June
Marc Spiegler, 'The Venice effect', *Art Newspaper* (daily edition at Art
 Basel), 15 June
Lynn Barber, 'Anyone for Venice?', *Observer*, 18 June
Colin Gleadell, 'Art hunters head for their prey', *Daily Telegraph*,
 20 June
Don Luigi Garbini, 'L'Angelus Novus dell'arte sacra: il Duomo home
 theatre', *Il Riformista*, 16 September
'Artist Short', *Berwick upon Tweed*, Film and Media Arts Festival,
 16–25 September
'Mark Wallinger – Via Dolorosa', *Exibart*, 21 September
Rosella Ghezzi, 'Un inglese a Milano', *Vivi Milano*, 21 September
'Mark Wallinger, Easter', *Corriere della Sera*, 22 September
'Via Dolorosa ha una cappella interamente dedicata
 all'arte contemporanea. Per sempre', *Provincia Milano*,
 22 September
Francesca Bonazzoli, 'Don Garbini, "Aiuterà la preghiera"', *Corriere
 della Sera*, 22 September
Francesca Bonazzoli, 'Credenti oppure no la mia arte è per tutti',
 Corriere della Sera, 22 September
Alessandra Mammi, 'Cristo si è fermato a Londra', *L'espresso*,
 22 September
Angela Vettese, 'Wallinger tra la cripta e l'hangar', *Domenica
 Corriere Della Serra*, 22 September
Rachel Spense, 'Spirited Designs', *Financial Times* Magazine,
 15 October
'Rundlederwelten', special edition of *Anstoss* Magazine for the
 2006 FIFA World Cup, 3, October
Rainer Metzger, 'Das Prinzip Intelligenz', *Art Magazine*,
 25 November
Markus Mittringer, 'Im Niemandsland', *Der Standard*,
 25 November
Almuth Spiegler, 'Orgasmus unter Palmen', *Die Presse*,
 5 December
Matt Saunders, 'Berlin', Best of 2005, *Artforum*, December

2006 Maurice Ulrich, 'Culture Visions du monde', *L'Humanite*, 14 March
Simon Webb, 'Crivelli's nail', *a–n Magazine*, April
Jackie Wullschlager, 'Off the wall', *Financial Times*, 29 April
Raffaella Rossello, 'La Religione da Risposta, l'Arte Fa Domande',
 Swissinfo, 16 September
Ewa Hess, 'Wozu Streiten? Kunst spielt mit allen Konfessionen',
 SonntagsZeitung, 17 September
'Meine Religion', *Berner Kulturagenda*, 21September
Critics Choice, 'Mark Wallinger', *Time Out*, 20–27 September
'Choosing my Religion', *Aufbruch*, October
Lillian Davies, 'Critic's choice: "Mark Wallinger"', *Artforum*, October
Sarah Kent, 'Mark Wallinger', *Time Out*, 4–11 October
Marcus Field, 'Films for people who don't like video art',
 Independent on Sunday, 1 October

Alice Henkes, 'Choosing my Religion im Kunstmuseum',
 Kunst Bulletin, 6 November
Charlotte Bonham-Carter, 'Mark Wallinger', *Flash Art*,
 November–December

2007 Alastair Sooke, 'In the studio', *Daily Telegraph*, 9 January
Olivia Cole, 'Tate puts artistic bomb under Blair', *Sunday
 Times*, 14 January
'Makeshift protest camp "a work of art"', *London Lite*,
 15 January
Fisun Güner, 'Exploring our freedom', *Metro*, 15 January
Tom Teodorczuk, 'Torn down by police, now Haw's protest camp
 lives again at the Tate', *Evening Standard*, 15 January
Serena Davies, 'The fine art of free speech', *Daily Telegraph*,
 16 January
Amy Iggulden, 'The modern art of protesting', *Daily Telegraph*,
 16 January
Tom Lubbock, 'Voice from the gallery', *Independent*, 16 January
Adrian Searle, 'Bears against bombs', *Guardian*, 16 January
Tim Teeman, 'Protest loses its potency off the street', *The Times*,
 16 January
Laura Cumming, 'Anti-war demo? Let's put the show on right here',
 Observer, 21 January
Charles Darwent, 'When art takes to the barricades', *Independent
 on Sunday*, 21 January
Philip Hensher, 'Is it art just because it's in the Tate?', *Mail
 on Sunday*, 21 January
Waldemar Januszczak, 'What do we want?', *Sunday Times*,
 21 January
Andrew Gilligan, 'The art of propaganda', *Evening Standard*,
 22 January
Afroditi Politi, 'From the protest to the gallery', *Eleftherotipia*
 (Greece), 25 January
Peter Campbell, 'Peter Campbell at Tate Britain', *London Review
 of Books*, 8 February
Carla Power, 'Beyond the barricade', *Newsweek*, 12 February
Charlotte Cripps, 'Cultural life, Mark Wallinger, artist',
 Independent, 16 February
Christy Lange, 'Captive audience', *Tate Etc.*, 9, Spring
Richard Grayson, 'Mark Wallinger', *Art Monthly*, 304, March
Art Observation Magazine (China), April
Yve-Alain Bois, 'Piece movement', *Artforum*, April
Martin Herbert, 'Mark Wallinger', *Modern Painters*, April
Louise Jury, 'Anti-war protest is nominated for Turner Prize',
 Evening Standard, 8 May
'Peace protest replica in running for Turner Prize', *Morning Star*,
 9 May
Arifa Akbar, 'Art takes back seat as politics and religion dominate
 Turner shortlist', *Independent*, 9 May
Dalya Alberge, 'Placards and protest put up for the Turner',
 The Times, 9 May
Richard Dorment, 'A grown-up and interesting shortlist of
 contenders', *Daily Telegraph*, 9 May
Laurie Hanna, 'Anti-war Parliament demo is up for Turner Prize',
 Daily Mirror, 9 May
Charlotte Higgins, 'Political works to the fore in incredibly strong
 year', *Guardian*, 9 May
Grayson Perry, 'Welcome to the feeding frenzy', *The Times*, 9 May
Nigel Reynolds, 'Turner arts prize turns political', *Daily Telegraph*,
 9 May
Rebecca Rose, 'War protest artist tipped to take Turner', 9 May
'Aftershock', *CGM* (China), May
Tom Morton, 'Back – Mark Wallinger', *frieze*, 107, May
Paul Bonaventura, 'Mark Wallinger: State Britain', *Parkett*, 79
Dean Kenning, 'You cannot be serious: art politics idiocy',
 Art Monthly, 307, June
Adrian Searle, 'Peek-a-boo!', *Guardian*, 26 June
Clifford Coonan, 'BritArt goes east: Tracey's bed is re-made
 in China', *Independent*, 6 July
Dietrich Diederichsen, 'Muenster', *frieze*, 109, September
'Sculpture projects in Münster', *Art Monthly*, 309, September
Matthew Higgs, 'Mark Wallinger', *Artforum*, September
Ben Lewis, 'It's Turner Prize time again', *Financial Times*,
 29–30 September

Louise Jury, 'Grin and bear it … the Turner Prize show set to raise
 a smile', *Evening Standard*, 18 October
Rachel Campbell-Johnston, 'It's a poor show – Turner disciples
 are about to have their faith tested', *The Times*, 19 October
Tom Lubbock, 'Why an artist dressed in a bear suit deserves to get
 his paws on this year's Turner Prize', *Independent*, 19 October
Fiona Maddocks, 'The bear man', *Evening Standard*, 23 October
Silke Hohmann, 'ReView', *Monopol*, October
Michelle Kuo, 'The Producers', *Artforum*, October
Lynne Cooke, 'Mark Wallinger', Best of 2007, *Artforum*, December
Rappolt, 'Tales from the city: Liverpool', *ArtReview*, 17, December
'Anti-war camp copycat wins Turner Prize', *Daily Express,*
 4 December
'Arti-war prize', *Daily Mirror*, 4 December
Arifa Akbar, 'Praise for Turner jury as prize goes to war protest',
 Independent, 4 December
Peter Aspden, 'Political art captivates Turner Prize panel',
 Financial Times, 4 December
Alexa Baracaia, 'Wallinger's grizzly win', *London Paper,*
 4 December
Dalya Alberge, 'Bearly believable? The Turner prizewinner',
 The Times, 4 December
Paul Harris, 'The bear that's just walked off with the Turner Prize',
 Daily Mail, 4 December
Charlotte Higgins, 'Wallinger takes Turner prize with re-creation
 of parliament protest', *Guardian*, 4 December
Simon Kelner, 'Bear with us', *Independent*, 4 December
Tom Lubbock, 'Wallinger is deserving winner', *Independent*,
 4 December
Tom Reilly, 'Bungle wins the £25,000 Turner', *Sun*, 4 December
Nigel Reynolds, 'War protest work wins Turner Prize', *Daily
 Telegraph*, 4 December
Adrian Searle, 'Critic's view: Accessible, funny, and serious',
 Guardian, 4 December
Charlotte Higgins, 'It's a good day for bears', *Guardian,* 5 December
'You ask the questions… ', *Independent*, 10 December

2008
Clarrie Wallis, 'State Wallinger', *Pluk*, 35, Spring
Belinda Grace Gardner, 'Die bewegende Kunst der bewegten Bilder',
 Die Welt, 22 January
Dalya Alberge, 'Artists think big for £2m gateway to England',
 The Times, 29 January
Rachel Campbell-Johnston, 'It's got to be striking and must stand
 up for a nation', *The Times*, 29 January
Nicole Busing and Heiko Klaas, 'Poesie und Irritationen im Alltag',
 Nordsee-Zeitung, 30 January
Feldmann, 'Schönheit und Brutalität des Lebens', *Dithmarscher
 Landeszeitung*, 2 February
Artnotes, 'Ebbsfleet', *Art Monthly*, 313, February
'Tube's Mod remake', *London Newspaper*, 14 March
'World War II RAF link inspires Tube artwork', *Metro*, 17 March
Pascaline Vallée, 'Revolutions artistiques', *Mouvement*, April–June
Nick Curtis, 'Giant horse among runners to be "Angel of the South"',
 Evening Standard, 7 May
'Mark Wallinger's steel racehorse proposal', *Artforum.com/news,*
 8 May
Dalya Alberge, 'Artist seeks to rival famous angel with a giant
 Stallion of the South', *The Times*, 8 May
Rachel Campbell-Johnston, 'The big bold horse wins it hands
 down', *The Times,* 8 May
Richard Dorment, 'Towering ambitions', *Daily Telegraph*, 8 May
Charlotte Higgins, 'High horse. Plan for Britain's biggest
 sculpture', *Guardian,* 8 May
Tom Lubbock, 'Colossal ideas … or the makings of a white
 elephant?', *Independent*, 8 May
Aislinn Simpson, 'Giant horse leads race to be "Angel of the
 South"', *Daily Telegraph*, 8 May
Oliver Marre, 'Mark Wallinger, the artist gets back in the saddle',
 Observer, 11 May
'Meet the Artists' and 'Creating a Centre for Art' *Folkestone
 Triennial Guide*, June
Martin Herbert, 'Shabby chic', *www.artforum.com,* 16 June
Alistair Sooke, 'Folkestone: a place where nothing ever happens?',
 www.telegraph.co.uk, 16 June

'Ingleby Gallery, Edinburgh', *www.wallpaper.com*, August
Sabine Altorfer, 'Zwischen Himmel und Hölle', *MZ*, 30 August
Michael Diers, 'Kunst, protest und politik anmerkungen zu
 "State Britain" von Mark Wallinger', *Kunst Magazin*, July
Charlotte Higgins, 'Crossing the line: How disputed World Cup
 goal inspired show about illusions', *Guardian*, 16 December
Yve-Alain Bois, Guy Brett, Margaret Iversen and Julian
 Stallabrass, 'An Interview with Mark Wallinger', *October*, Winter

2009
Eva Scharrer, 'Mark Wallinger, Aargauer Kunsthaus', *Artforum,*
 January
Fiona Macdonald, 'Art that crosses the line', *Metro*, February
'Giant horse to tower over UK countryside', *www.cnn.com/europe*,
 10 February
'Wallinger's horse chosen to be Ebbsfleet's Angel of the South',
 Guardian, 10 February
Pete Norman, 'Huge horse to be "Angel of the South"',
 www.sky.news.com, 10 February
Rachel Campbell-Johnston, 'Bold, simple design will make
 an instant impact', *The Times*, 11 February
Jilly Cooper, 'Did it have to be a horse?', *Guardian*, 12 February
Mark Hudson, 'Mark Wallinger's white horse is a winner',
 Daily Telegraph, 12 February
Melanie Reid, 'It's a racing cert this horse will be a winner',
 The Times, 12 February
Roy Strong, 'Roy Strong, scourge of so much modern art,
 champions the wonder horse', *Daily Mail*, 12 February
Peter Walker, 'The man is a genius – there's no question about it',
 Guardian, 12 February
Arifa Akbar, 'The Diary: Kate Winslet; Mark Wallinger;
 Sir Ian McKellen; Charlotte Roche', *Guardian*, 13 February
Ian Jack, 'This horse isn't so huge in Ebbsfleet', *Guardian,*
 14 February
Richard Morrison, 'Do we need serious art for serious times or
 serious fun?', *The Times,* 14 February
Paul Vallely, 'Mane attraction', *Independent,* 14 February
'Winning again by a brass neck', *Sunday Times*, 15 February
Tim Adams, 'Mark Wallinger', *Observer*, 15 February
Adrian Searle, 'Let's do the time warp again', *Guardian*,
 16 February
Alastair Sooke, 'The jumble of an ordered mind', *Daily Telegraph*,
 16 February
Esther Addley, 'Diary', *Guardian*, 17 February
Tom Lubbock, 'Spot the links', *Independent*, 17 February
Hugh Reilly, 'Illusions that can cross the line', *London Paper*,
 17 February
Ben Lewis, 'Now you see it, now you don't', *Evening Standard,*
 18 February
Alice-Azania Jarvis, 'Party of the week: making his Mark
 as curator', *Independent,* 20 February
Laura McLean-Ferris, 'Exhibitionist: The best art shows to see
 this week', *Guardian*, 20 February
Joanna Pitman, 'The Russian Linesman at Hayward Gallery,
 London SE1', *The Times*, 21 February
Charles Darwent, 'The Russian Linesman, Hayward Gallery,
 London', *Independent*, 22 February
Ossian Ward, 'Exhibition of the Week: The Russian Linesman',
 Time Out, 26 February–4 March
'Gigantic Animal News', *Art Monthly*, March
Laura Cumming, 'Roll up, roll up, the circus is in town', *Observer*,
 8 March
Deborah Orr, 'Mark Wallinger', *Independent* Magazine,
 14 March
Turia Tellwright, 'Horse for a kingdom', *Racing Post*, 30 March
Lucy Steeds, 'Mark Wallinger curates: The Russian Linesman',
 Art Monthly, April
Lydia Slater, 'Horsing about', *Evening Standard* Magazine, 17 April
Carol Vogel, 'An art-covered island', *New York Times*, 29 May
'This world and nearer ones', *Time Out New York*, 25 June–1 July
'PLOT/09 presents a public art extravaganza on NYC's Governors
 Island', *www.flavorwire.com*, 30 June
Chris Bors, 'Athens Biennial: Multinational visions of heaven',
 www.artinfo.com, July
Roberta Smith, 'Public art', *New York Times*, 2 July

Mirriam Souccar, 'Tourist attraction to draw record crowds',
 Crain's New York Business, 5 July
'This world and nearer ones', *Time Out New York*, 25 July
Yve-Alain Bois, 'To sing beside', *October*, Summer
Catherine Bradley, 'Conflict of interest', *Art & Music*, Autumn
Hal Foster, 'Precarious', *Artforum*, December

2010 Lotte Sandberg, 'Mark Wallinger', *Aftenposten,* 24 March
Lars Elton, 'Utfordrende utstilling', *VG*, 26 March
Borre Haugstad, 'Mark Wallinger stiller ut i Kunstnernes Hus, VG,
 26 March
Marte Spurkland, 'Britartveteran pa Kunstnernes Hus', *D2,*
 26 March
Arve Rod, 'Pompost grep om enkle midler', *DN Magasinet,*
 27–28 March
Amanda Birch, 'Giddy heights', *Building Design*, 30 April
Jorg Heiser, 'Berlin highlights', *Frieze.com*, May
Anna Altman, 'Mark Wallinger', *Frieze.com*, 11 May
Alexandra Peers, 'Mountaintop art', *New York Observer,*
 19 May
Anthony Byrt, 'Mark Wallinger', *Artforum.com*, 27 May
David Ulrichs, 'Berlin Gallery Weekend', *Art Monthly*, June
Rachel Campbell-Johnston, 'Mark Wallinger and the big
 white horse', *The Times*, 5 June
Kate Kellaway, 'Portrait of the artist as a revolving pope',
 Observer, 6 June
'Five best London shows', *Independent*, 19 June
Richard Dorment, 'Mark Wallinger at the Anthony Reynolds
 Gallery', *Daily Telegraph*, 15 June
Gabriel Coxhead, ' Mark Wallinger', *Time Out London,* 24 June
Maev Kennedy, 'Cinema with a view: Mark Wallinger makes
 history in Turkey', *Guardian.co.uk*, 9 July
'Jeremy Hunt picks Wallinger for his walls', *Evening Standard,* 19 July
'What's going on Jeremy Hunt's wall?', *Media Monkey,*
 Guardian.co.uk, 19 July
'Diary', *Independent*, 20 July
Maev Kennedy, 'Mark Wallinger gets the Tory vote', *Guardian,* 20 July
'Exporama', *ArtPress*, July–August
Arifa Akbar, 'Cockerels, cashpoints and cake nest for fourth plinth',
 Independent, 20 August
Dave Itzkoff, 'British artists protest a possible cut in government
 funds', *New York Times*, 10 September
Louise Jury, 'Turner winner slashes painting to highlight cuts',
 Evening Standard, 21 September
'Frieze art fair 2010: Mark Wallinger', *Guardian G2*, 13 October
Simon Schama, 'The beastliness of modern art', *Financial Times*,
 16–17 October
Tim Adams, 'Frieze Art Fair', *Observer*, 17 October
Stephanie Bunbury, 'Happily making his Mark', *The Age* (Australia),
 9 October
Rachel Spence, 'Straits ahead', *Financial Times*, 20–21 November
Martin Herbert, 'Now see this', *ArtReview*, December
'London's One Thousand Most Influential People', *Evening Standard*
 supplement, 26 November

2011 Harry Mount, 'Turkish time travel', *Spectator*, 1 January
Ossian Ward, 'Turkey: Art, war, memory', *Time Out*, 17–23 February
Ben Luke, 'Surreal world captured in perpetual motion', *Evening
 Standard*, 1 April
Adrian Searle, 'Yes, but is it drawing? London 2011 biennial
 fundraiser', *Guardian*, 26 April

TV

2001 *The Eye: Mark Wallinger*, Channel 5
2002 *Art Now: Mark Wallinger*, Channel 5
2007 *Mark Wallinger*, South Bank Show, ITV 1, 4 March
2010 *Ego: The Strange and Wonderful World of Self Portraits*,
 BBC4, 6 November
 The Genius of British Art, Channel 4, 5 October

ACKNOWLEDGMENTS

My thanks, first of all, to Mark Wallinger for his generous dedication to this project and his willingness to undergo many rounds of interviewing; to everyone else who agreed to speak with me about Mark's work, particularly Anthony Reynolds and Donald Young; to Anna Smith and Maria Stathi at Anthony Reynolds Gallery for administrative support; to the Kunstnernes Hus, Oslo; and to the team at Thames & Hudson for superb editorial steering and design. Special thanks, and much love, to Rosalind and Amy.

CREDITS

Collections

Abbatista Collection, London; ARCO Foundation, Madrid ; Arts Council Collection, Hayward Gallery, London; ArtVest Ltd; British Council Collection, London; CAM Calouste Gulbenkian Collection, Lisbon; Claudia Marchetti, São Paulo; Colección Helga de Alvear, Madrid – Cáceres; Collection Jaques and Myriam Salomon; Collection Jean-Conrad & Isabelle Lemaître, Paris; Collection Landesbank Hessen-Thüringen (Helaba), Frankfurt; Collection of Blake Byrne, Los Angeles; Collection of John Thornton; Collection of Michael and Eileen Cohen; Collection of Mimi and Filiep Libeert, Belgium; Collection Thea Westreich and Ethan Wagner; Cranford Collection, London; D. Daskalopoulos Collection; Denver Art Museum; The Deweer Collection, Otegem, Belgium; Emanuel Hoffman-Stiftung, Basel, Depositum in der Öffentlichen Kunstsammlung Basel; Emilio and Stefania Giorgi Collection; Ferens Art Gallery, Hull City Museums & Art Galleries, Kingston-upon-Hull; FRAC Nord-Pas de Calais; Georg Geyer; Goldman Sachs Collection, New York; G. Papadimitriou Collection, Athens, Greece; Hiscox Collection; The Hon Robert H. Tuttle and Mrs Maria Hummer-Tuttle; The Israel Museum, Jerusalem; James Anneler Collection; Karin and Peter Haas Collection; Kirkland Collection, London; Leeds City Art Gallery; Lonti Ebers, New York; Magdalen College, Oxford; Museum für Gegenwartskunst, Basel; Museum Ludwig, Cologne; Museum of Modern Art, New York; Nasjonalmuseet for kunst, arkitektur og design, Oslo; NORD/LB Art Collection, Oslo; Mr Ricard Akagawa Collection, São Paulo; Ricardo de Paulo, Geneva; Robert Devereux Collection; Roger De Haan Charitable Trust; Rubell Family Collection, Miami; Provincia di Milano, courtesy Artache; Simmons and Simmons Collection, London; Southampton City Art Gallery; The Speed Art Museum, Louisville; Stoke-on-Trent Museums; Sylvie Winckler; Tate Collection, London; Vanhaerents Art Collection, Brussels; Vanmoerkerke Collection, Belgium; ZKM Museum of Contemporary Art, Karlsruhe; and further Private Collections in America, Austria, Belgium, England, France, Germany, Italy and Switzerland

Commissions

pp. 132–33 Site Gallery, Sheffield (*When Parallel Lines Meet at Infinity*); p. 203 Creative Time, New York (*Ferry*); p. 115 FACT, Liverpool (*Cave*); pp. 230–33 British Council /My City (*Sinema Amnesia*); pp. 11, 235 The Ebbsfleet Landmark Trust (*White Horse*); pp. 185–87 Skulptur Projekte Münster 07, Germany (*Zone*); p. 226 Aspen Art Museum, USA (*Amerika*); p. 201 Folkestone Triennial/Roger de Haan Charitable Trust (*Folk Stones*); p. 140 The Laboratory at the Ruskin School of Drawing and Fine Art, supported by Southern Arts, Regional Arts Lottery Programme and the Calouste Gulbenkian Foundation (*TARDIS*)

Photographers

a=above, b=below, l=left, t=top
Claudio Abate 143, 144; David Aebi 94; Murat Aksu 232, 233; David Baltzer 160; Bernd Borchardt 173, 222, 223; Cannon Pictures 239t; Colin Davison 164, 165; Fred Dott / Kunstverein Braunschweig 150, 153; Hugo Glendinning 72b; Wolfgang Günzel 121, 122, 123; Christian Helmle 166; Moritz Hoffman 159b; Vegard Kleven vegard@vegardkleven.no 205, 207, 210, 211, 214, 216, 217, 218, 219; Roman Mensing / artdoc.de 186b; Dave Morgan 36, 37, 176, 179, 181, 183, 208, 212, 213, 215; Anthony Oliver 67; Susan Ormerod 24, 26, 33, 44, 46, 47; Cindy Palmano 81; John Riddy 8, 50, 64a, 65, 89, 118, 134, 135, 198; Jill Ritblat 82al; Stefan Maria Rother 7, 158b, 159a; Tom Van Eynde 188, 189a, 190a; Peter White 117; Gareth Winters 66a, 69, 74, 75, 90, 91, 92, 93; Edward Woodman 17b, 20, 48, 52, 53, 62, 63, 70, 71, 74, 75, 86

Other Illustrations

p. 15 Thomas Gainsborough, *Mr and Mrs Andrews*, c. 1750. Oil on canvas, 69.8 x 119.4 cm (27½ x 47 in.). National Gallery, London; p. 27 William Hogarth, *Self-Portrait*, c. 1757. Oil on canvas, 45.1 x 42.5 cm (17¾ x 16¾ in.). National Portrait Gallery, London; p. 64 Marcel Duchamp, *Fountain*, 1917, replica 1963. Porcelain, h. 33.5 cm (19 in.). Indiana University Art Museum. © Succession Marcel Duchamp/ADAGP, Paris and DACS, London 2011; p. 32 Carl Andre, *Equivalent VIII*, 1966. Firebricks, 12.7 x 68.6 x 229.2 cm (5 x 27 x 90¼ in.). Photo Tate, London 2011. © Carl Andre. DACS, London/VAGA, New York 2011; p. 66 George Stubbs, *Eclipse at Newmarket with a Groom and a Jockey*, 1770. Oil on canvas, 100.3 x 131.5 cm (39½ x 51¾ in.). Private Collection. Photo Bridgeman Art Library; p. 139 George Stubbs, *Whistlejacket*, c. 1762. Oil on canvas, 292 x 246.4 cm (115 x 97 in.). National Gallery, London; p. 149 Mark Wallinger, *Populus Tremula*, 2003. Installation photograph at Tate Britain. Photo Tate, London 2003; p. 174 Cover of *State Britain*. © Tate, 2007; p. 189 Eadweard Muybridge, *Animal Locomotion*, c. 1887. Black and white film copy negative. Library of Congress Prints and Photographs Division, Washington, DC (LC-USZ62-78262); p. 190 Pieter Brueghel, *Landscape with the Fall of Icarus*, c. 1558. Transferred from panel to canvas, 73.5 x 112 cm (29 x 44 in.). Musées Royaux des Beaux-Arts, Brussels; p. 249 Diego Velázquez, *Triumph of Bacchus*, 1628–29. Oil on canvas, 165 x 225 cm (65 x 88½ in.). Prado, Madrid; p. 255 Lindsay Anderson, *If...*, 1968. Film still. Photo Memorial/The Kobal Collection; p. 263 Bruce Nauman, *MAPPING THE STUDIO II with color shift, flip, flop, & flip/flop (Fat Chance John Cage), 2001*. Installation photograph at Tate Modern. Photo Tate, London 2011. © ARS, NY and DACS, London 2011

Sources of Writings

The author and publishers acknowledge the following sources of writings by Mark Wallinger reproduced in this book on the pages listed.

p. 247 'The brick is the message', *Evening Standard,* 1987; p. 248 'Letter to the editor', *Guardian,* 1994; p. 249 'A brush with genius: Mark Wallinger on Velázquez's *Triumph of Bacchus*', *Guardian,* 1995; p. 250 'Is he the father of modern art?', *Guardian,* 1996; p. 251 'Fool Britannia: not new, not clever, not funny', ARTicle Press, 1998; p. 254 'The Pygmalian paradox: Mark Wallinger on the new Establishment', *Art Monthly*, 1998; p. 256 'Art for All?' Introduction, Peer, London, 2000; p. 257 'Private passions: Mark Wallinger on *Whistlejacket*', *The Times*, 2001; p. 258 'Sleeper', *frieze*, 2005; p. 259 'Make Me Think Me', König Books, London, 2009

INDEX

Mark Wallinger is Innocent, 1997
Fly poster, Rupert Street, Soho, London, 1997